World of Art

Mary Ellen Miller was educated at the universities of Princeton and Yale, receiving her PhD in History of Art from Yale, where she held the posts of Sterling Professor of the History of Art and Dean of Yale College. Since 2019 she has directed the Getty Research Institute in Los Angeles, California. Dr. Miller has worked extensively in Central America, particularly Mexico, Guatemala, Belize, and Honduras, where she has carried out research in Maya art, architecture, and culture, and devoted years to the study of Maya paintings. She has written many articles on Mesoamerican art for learned journals, and her book with Linda Schele, *The Blood of Kings* (1986), is considered a landmark in Maya studies. With Megan O'Neil, she is the author of *Maya Art and Architecture* (2014, second edition) and, with Karl Taube, *The Gods and Symbols of Ancient Mexico and the Maya* (1993). A member of the American Academy of Arts and Sciences, Dr. Miller has delivered the Andrew W. Mellon lectures at the National Gallery of Art, Washington, D.C., and the Slade lectures at the University of Cambridge, England.

P9-AGF-261

This famous series provides the widest available range of illustrated books on art in all its aspects.

To find out about all our publications, including other titles in the World of Art series, please visit **www.thamesandhudsonusa.com**. There you can subscribe to our e-newsletter, browse or download our current catalogue, and buy any titles that are in print.

Thames & Hudson

1 Made in a mold and finished by hand by Maya artists in the eighth century CE, this figurine of a standing warrior is also a diviner, wearing a mirror in the form of a rabbit on his chest, a reference to the Mesoamerican belief of a rabbit on the silvery moon. Highlighting both the face and the feather suit, the tenacious Maya blue paint has survived for over 1,000 years.

World of Art

The Art of
Mesoamerica
From Olmec to Aztec
Mary Ellen Miller

Sixth edition

With 276 illustrations, 242 in color

Thames & Hudson

Pronunciations and spellings of Mesoamerican names require some attention. In the sixteenth century, the letter "x" in the Spanish alphabet was pronounced like the phoneme "sh" in English today. In general, names in native Mesoamerican languages with this consonant require the "sh" sound – as in Yaxchilan, for example – and a final "j" is an aspirated "ah," so that an approximation of the Copan king Yax Pasaj's name would be "Yash Pasah." Most Mayan "c"s, regardless of the following vowel, are hard. When "u" precedes another vowel, the resulting sound is similar to a "w," as in Nahuatl. Spanish words ordinarily have a stress on the final syllable unless they end in a vowel, "n," or "s" (when preceded by an "n" or a vowel) – in which case the penultimate syllable is stressed. Most words in Nahuatl, the language of the Aztecs, take the emphasis on the penultimate syllable. Words in Mayan languages are not strongly accented. Accents are generally used in this work only where they occur on names in Spanish (e.g. José). In general, place names used here are the standard ones found on maps published by national governments, although accents have been dropped where they would not be used in native pronunciation.

The Art of Mesoamerica © 1986, 1996, 2001, 2006, 2012 and 2019 Thames and Hudson Ltd, London

This sixth edition 2019

First published in 2019 in paperback in the United States of America by Thames & Hudson Inc., 500 Fifth Avenue, New York, New York 10110

www.thamesandhudsonusa.com

Library of Congress Control Number 2018958047

ISBN 978-0-500-20450-4

Printed and bound in China through Asia Pacific Offset Ltd

Contents

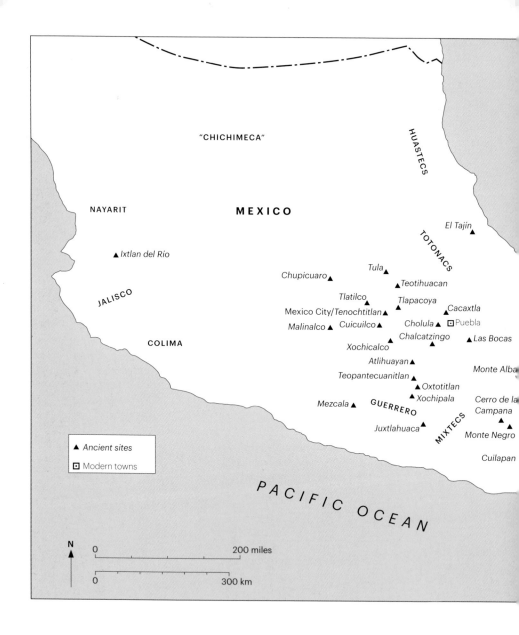

"CHICHIMECA"

HUASTECS

NAYARIT

MEXICO

El Tajín ▲

TOTONACS

▲ Ixtlan del Río

JALISCO

Chupicuaro ▲

Tula ▲

Teotihuacan ▲

Tlatilco ▲

Tlapacoya

Mexico City/Tenochtitlan ▲

Cacaxtla ▲

Malinalco ▲ Cuicuilco ▲

Cholula ▲ ⊡ Puebla

COLIMA

Chalcatzingo ▲ ▲ Las Bocas

Xochicalco ▲

Atlihuayan ▲

Monte Alba

Teopantecuanitlan ▲

▲ Oxtotitlan

Cerro de la
Campana

Mezcala ▲ GUERRERO

▲ Xochipala

▲

▲ Ancient sites

⊡ Modern towns

Juxtlahuaca ▲

MIXTECS

Monte Negro

Cuilapan

PACIFIC OCEAN

N
▲

0 200 miles

0 300 km

2 Mesoamerica, showing sites mentioned in the text.

6

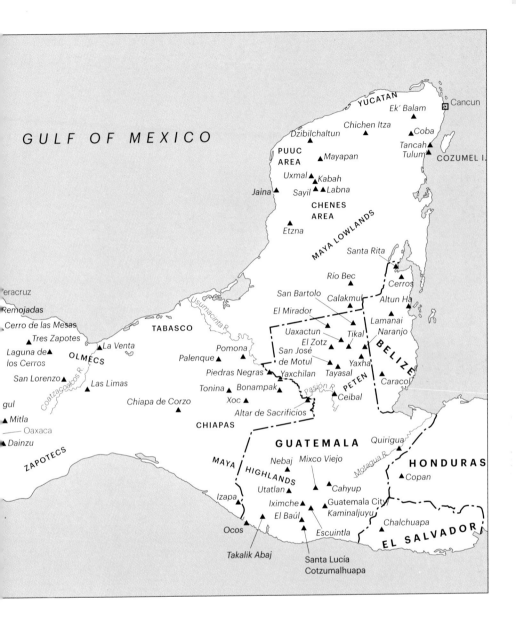

GULF OF MEXICO

YUCATAN
Ek' Balam ▲
Cancun ⊡
Chichen Itza ▲
Dzibilchaltun ▲
Coba ▲
Tancah ▲
Tulum ▲
COZUMEL I.
PUUC AREA
▲ Mayapan
Uxmal ▲ Kabah
Jaina ▲
Sayil ▲▲ Labna
CHENES AREA
▲ Etzna
MAYA LOWLANDS
Santa Rita
eracruz
Remojadas
Cerro de las Mesas
Tres Zapotes
La Venta ▲
Laguna de ▲
los Cerros
OLMÉCS
San Lorenzo ▲
Las Limas ▲
gul
▲ Mitla
Oaxaca
▲ Dainzu
ZAPOTECS
TABASCO
Pomona ▲
Palenque ▲
Piedras Negras ▲
Tonina ▲ Bonampak ▲
Xoc ▲
Altar de Sacrificios
CHIAPAS
Río Bec
San Bartolo ▲
Calakmul
Cerros
Altun Ha
El Mirador ▲
Lamanai
Uaxactun
Tikal
Naranjo
El Zotz
San José
de Motul
Yaxha
BELIZE
Yaxchilan Tayasal
Caracol
Ceibal
Pasión R.
PETEN
Chiapa de Corzo ▲
MAYA
HIGHLANDS
Nebaj ▲ Mixco Viejo
GUATEMALA
Quirigua
Motagua R.
HONDURAS
Copan ▲
Izapa
Utatlan ▲
Iximche ▲
El Baúl
Cahyup
Guatemala City
Kaminaljuyu
Chalchuapa
Ocos
Escuintla
EL SALVADOR
Takalik Abaj
Santa Lucía
Cotzumalhuapa

Usumacinta R.
Coatzacoalcos R.

7

Preface

As I have written this book for over thirty years, I have learned not to get comfortable with one set of interpretations, nor with a chronology, nor even a geography. *The Art of Mesoamerica* now starts earlier, with radiocarbon dating that reveals control of Mesoamerica's signature material, jade, back to 1800 BCE in the tropical forest of the Gulf Coast. Its end is signaled with the Spanish invasion of 1519, but the manipulation of Mesoamerica's precious materials – whether feathers or pigments or obsidian – does not cease abruptly, like the drop of a curtain, and the negotiations of the sixteenth century can be understood to be a part of the process of Mesoamerican art-making rather than a coda. New discoveries continue to change the contours of study and knowledge. The single largest Aztec monolith ever to be found came to light at the ancient capital within the heart of Mexico City in 2006; in 2017, archaeologists announced that they had found both a tower of hundreds of human skulls and a sacrificed wolf with twenty-two golden adornments. No one can predict what revelations lie ahead.

The first decades of the twenty-first century have been rife with raw, new discoveries, from Olmec heads that have rolled out of ravines along the Gulf Coast to the opening of some of the wealthiest tombs that the Maya interred deep within massive pyramids. *National Geographic* magazine continues to provide insightful coverage of archaeology, although its focus on the worldwide excavations it supports directly can result in less attention for Mexico. *Arqueología Mexicana*, on the other hand, focuses exclusively on the archaeology of Mesoamerica and combines the latest discoveries within Mexico with considerations of materials known for centuries, providing both breaking news and satisfying digestion of familiar works. News of discoveries travels faster than ever before by all means electronic: measured

coverage follows at mesoweb.com and at theguardian.com/science/archaeology. High-quality photographs and video postings can take the interested observer from armchair to fieldwork with unprecedented ease. At the same time that new information proliferates – and with generally improved Wikipedia entries that detail site walkthroughs or the careers of archaeologists – the latest technology often results in homogenized, simplified readings and interpretations, repeated from one web posting to another. The journal *Ancient Mesoamerica* covers art and archaeology, while the newly founded *Latin American and Latinx Visual Culture* will address art history exclusively, across all regions and time periods, including Mesoamerica.

Recent exhibitions continue to bring new discoveries and scholarly interpretations to a broader audience. As I write this, thoughtful exhibitions have galvanized those interested in Mesoamerica: "Teotihuacan: City of Water, City of Fire" brought the unprecedented new discoveries of the twenty-first century from that ancient capital to San Francisco and Los Angeles in 2017 and 2018, while "Golden Kingdoms" amassed treasures of gold, textiles, jade, turquoise, and stone from the Andes to the Aztecs, drawing crowds in both Los Angeles and New York City in 2018. "Made in the Americas," launched at Boston's Museum of Fine Arts in 2015, brought together a worldwide deployment of new materiality from the moment of the Spanish invasion into the eighteenth century. Special exhibitions sponsored by Mexico City's Museo Nacional de Antropología, with stunning catalogs, have resulted in long queues of visitors. More broadly in Mexico, the National Institute of Anthropology and state governments have launched museums at a number of sites to host new discoveries, from Cancun in the Maya region to Tehuacan, Puebla. Around the world, museums have put their collections online, making it possible to conduct more research from one's own computer. Museums increasingly follow guidelines that limit the growth of their collections to works long in circulation; resolving the problem of orphan collections in private hands will require long-term solutions.

At the same time that many native languages can be considered "endangered" and at risk of ceasing to be spoken, others increasingly play a role in the United States. Open-air markets in California are punctuated by the glottal stops of Mixtec; I have heard Nahuatl spoken in New Haven supermarkets. Nahuatl words, particularly names of foodstuffs, continue to migrate into common parlance: *chipotle* now seems as familiar a word in English as do tomato and avocado. Even *The New York Times* covers *pelota*, the traditional Oaxaca ballgame played by those of Zapotec and Mixtec descent in the public parks of California.

Although serving in the Yale administration made it difficult for me to conduct new research through 2014, I have been absorbed once again in Mesoamerica, particularly through new research launched as Slade Professor at the University of Cambridge, England, in 2015. Collaborations have proved stimulating. My work with Stephen Houston, Michael Coe, and Karl Taube on the Grolier Codex was particularly rewarding; Megan O'Neil and I wrote a companion volume to this one, *Maya Art and Architecture* (2014), and then launched research on the history of American collections of Mesoamerican art; Claudia Brittenham, Virginia Miller, and I are working on a project on Chichen Itza; Matthew Robb and I wrote on Mesoamerican architecture for the current Banister Fletcher architectural compendium; Diana Magaloni and I have worked together on Malintzin (La Malinche). Barbara Mundy has been an excellent sounding board for new ideas. Andrew Turner, postdoctoral fellow at Yale, has brought sharp ideas and even better eyes to the University collections; he generously read the fifth edition of this book and gave me detailed feedback. Sara Altuna and Julia Kahn also read the last edition carefully, and Sara assisted with picture research and editing for this edition. I am grateful to have had a year of research leave at the National Gallery of Art, which gave me the opportunity to synthesize my thinking in fresh ways and on all sorts of subjects.

As Winston Churchill wrote, "to improve is to change." Over the years I have continued to learn and thus to change; the close reader of this book will find that many ideas and emphases have changed in this edition. For the first time since I drafted the original edition of *The Art of Mesoamerica* in 1985, I have rethought every word you will read in this sixth edition. I've also worked to illustrate new discoveries, and to foreground objects with an archaeological context wherever possible.

Chapter 1
Introduction

At the time of the Spanish invasion, the great Aztec ruler Motecuhzoma II kept tax rolls accounting for tribute paid from regions far to the north and south, from the limits of the barbarian ("Chichimec") north to the rich, cacao-producing coast of modern Guatemala. If we extend these limits across their respective lines of latitude, 14 to 21 degrees north, we define Mesoamerica, a cultural region united by use of the ritual 260-day calendar and a locus of New World high civilizations for over 3,000 years, from 1500 BCE until the invasion of the Spanish, led by Hernando Cortés in 1519 CE. Although the Caribbean, southern Central America, northern Mexico, and the United States Southwest all had contact with Mesoamerica, these connections waxed and waned over time to a greater degree than the internal connections among the peoples of Mesoamerica. Nevertheless, these more distant contacts were important, introducing both goldworking from the south and precious turquoise stones from the north.

These borders were not real ones of course, nor would Motecuhzoma II have recognized the cultural label of Aztec, although he would have known the name Aztlan, the legendary home of his people. Both Aztec and Mesoamerica are labels that scholars have developed: Alexander von Humboldt may have first proposed the term Aztec, to capture the concept of diverse Nahuatl-speaking peoples in the Valley of Mexico; its use by William Prescott, in his bestselling *Conquest of Mexico* (1843), popularized the term in the United States – and even inspired a spate of paintings based in its narratives. Although Aztec is not an indigenous term, it will be used throughout this book. Similarly constructed, Mesoamerica captured the ring of Mesopotamia in the mid-twentieth century, and perhaps some of its authority for both place and culture.

But challenges to Mesoamerica as a cultural framework are valid to the north, south, and beyond. What were long thought to be mysterious "spatulas" found in Belize caves are now recognized as Taino vomit spoons, evidence of close connections among the Caribbean islands and Mesoamerican peoples, for example. Bernal Díaz del Castillo, the principal chronicler of the Spanish invasion, noted that a cook his ship brought from Jamaica also spoke Mayan, attesting to the vitality of circum-Caribbean connections – and also putting into keen highlight the sheer intelligence and imagination of the multilingual woman Malintzin, usually known as La Malinche, perhaps the architect of the Spanish campaign. Connections were further documented by Ferdinand Columbus, who captured a large sea-going canoe, laden high with goods and people, traveling off the coast of Honduras. Far to the north, scientists have discovered residues of a chocolate drink at Chaco Canyon, a major cultural center in the American Southwest between 850 and 1250 CE, and, moreover,

3, 4
in distinctive tall, black-and-white ceramic vessels that seem to emulate those of the Maya, on which written inscriptions name the contents as chocolate. Who carried the message that the beverage should be served in such vessels? The gold

203
disks dredged from the Sacred Cenote at Chichen Itza started

3, 4 The Maya formed tapered cylinders for the serving of frothy cacao (LEFT). Recent studies of eleventh-century CE vessels from Chaco Canyon, New Mexico (RIGHT), have revealed traces of tell-tale theobromine, the stimulant in chocolate, confirming long-distance trade between Mexico's tropical forests and the arid American Southwest. Yet more astonishing for the study of art is that the form, size, and slip patterning of the Chaco vessels emulates a Maya model.

as "blanks" brought to the Maya region from southern Central America. Only a skilled artisan from that distant region could have taught the local artisans of Yucatan how to transform the novel, precious material with the dramatic renderings of the Maya. People and goods were indeed on the move, from what is now Panama to New Mexico, and across the Caribbean sea.

Despite the narrow latitudinal range of conventional Mesoamerica, the region is characterized by climatic and topographic diversity, extremely variable in both altitude and rainfall. The tribute paid to Motecuhzoma II ranged from jaguars to eagles, and from exotic bird feathers to gold and jade treasure, materials and resources found in greatly varying ecological zones. The high, cool valleys contrast sharply with the steamy lowland jungles, and then, as now, the valleys attracted dense populations. Certain critical resources, such as obsidian, the "steel" of the New World, were found only in volcanic flows; cacao and cotton grew in moist, tropical regions. Chert and flint occur widely, but a preferred color – say, the red chert of Chalcatzingo – took on particular value in some contexts. Trade in these goods brought highland and lowland Mesoamerica into constant contact.

Origins, materiality, and culture
The date of the arrival of humans to North and South America is disputed, with the latest contested evidence coming from mastodon bones recovered in San Diego, California. Certainly, the greatest waves of people migrating from southern Siberia across a land passage that opened at times of low sea level, taking advantage of the coasts and their abundant foodstuffs to reach Mesoamerica, started no earlier than 20,000 years ago and certainly by 10,000 BCE. Early humans brought only dogs among the domesticated animals of Asia, eliminating reservoirs for diseases shared with humans – and meaning that thousands of years later there was no resistance to European diseases when the foreigners invaded. Additionally, without oxen, cattle, sheep, goats, and pigs, Mesoamerican peoples developed alternative sources of protein, especially seeds and insects, and without draft animals, humans had to carry every load, every stone, every trade good on their backs.

Despite these hardships, waves of people continued to move across the American continent, with newcomers moving from north to south right up until the Spanish invasion. These waves affected the political geography of Mesoamerica, for each succeeding movement of peoples required readjustment on the part of the others who sought to stay in place. For instance, some think that Nahuatl speakers were late arrivals,

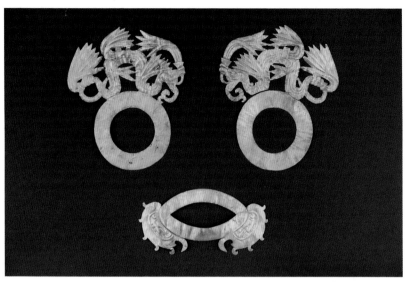

5 Hammered of gold sheet metal and then cut or pressed, these stunning elements were once attached to a wooden mask. Recovered in four crumpled pieces (the feathered serpent at right was cut from the eye ring) from the Sacred Cenote at Chichen Itza, this mask was probably worn by a priest of the Feathered Serpent with solar attributes. c. 900 CE.

entering the Valley of Mexico at the fall of Teotihuacan in the sixth century CE, and perhaps in part responsible for that city's decline. These Nahuatl speakers soon dominated the highlands, developing first as peoples known in Mesoamerican memory as the Toltecs and later into what we know as the Aztecs. Yet the extremely important people of Teotihuacan remain of unknown ethnicity. Were they also Nahuatl speakers?

By the time civilization emerged in the second millennium BCE, village life had taken hold across Mesoamerica, with underpinnings of agriculture appearing at the same time. With the rise of the Olmecs, around 1500 BCE, art and architecture appeared that would have lasting characteristics – systems of value, ideology, and perhaps social organization. But the Olmec did not survive beyond 400 BCE, leaving modern peoples to grasp at archaeology to understand their practices and beliefs, including the power they attributed to a maize deity, versions of which would later remain a central figure in Mesoamerican religion. Civilization upon civilization succeeded the Olmec, many known by the names of the languages that endure today: Maya civilization occupied both the tropical lowlands of Yucatan, Chiapas, Guatemala, Belize, and Honduras, as well as the adjacent rugged and volcanic mountains that provided

valuable mineral resources; Oaxaca would be home to Zapotec and Mixtec cultures; and in Central Mexico Teotihuacan rose to become the greatest of all Mesoamerican cities, followed by Tula and Tenochtitlan – the Nahuatl-speaking Aztec capital that would fall to the Spanish invaders in 1521.

Compared with the Old World, Mesoamerican technological development seems slow. Absence of a draft animal may explain why the wheel and its critical component, the axle, were never developed; even today in the Andes, the llama serves as a pack animal but will not pull a cart. Wheels, but not axles, turn up on toys in Central Mexico and in Veracruz, never making the leap to the pulley, potter's wheel, or even a human-propelled vehicle like a rickshaw or wheelbarrow. Obsidian tools and weapons served in place of wrought metal ones. (But obsidian, though easily chipped, in fact makes such a sharp instrument that it has been returned to use by modern ophthalmic surgeons!) Metallurgy was first developed in the Andes about 3000 BCE, and metalworking techniques were gradually passed north, traveling up through Central America and only arriving in Mesoamerica about 800 CE. Even then, however, metals did not replace stone and obsidian functional objects, and precious metals were worked instead into luxury goods: jewelry, masks,

6 Perhaps sent to Charles V by Cortés, this exotic Aztec feather headdress has been preserved in Vienna since the Spanish invasion. Some scholars have speculated that Motecuhzoma II himself might have worn it.

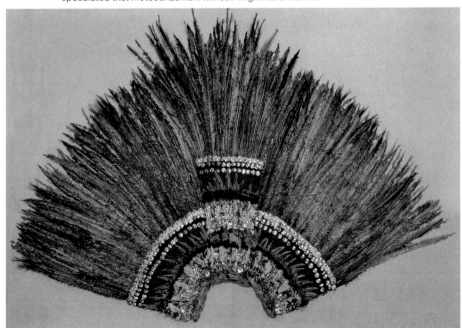

and headdress elements – although gold never completely replaced jade, nor later turquoise, as the most precious material. Cortés's men quickly learned that the people of Mesoamerica valued greenstones more than any other material, and gold was willingly traded for green glass beads. Even Spanish invaders found this to be true: on the run in 1520, Bernal Díaz del Castillo found that the jade beads in his pocket kept him fed. Dozens of fine masks of precious greenstones, including malachite, have been excavated in the past few years at Palenque, Teotihuacan, and Calakmul. Throughout Mesoamerican history, the finest objects were worked from jade and other green materials, such as feathers. What has come to be called "Motecuhzoma's headdress," was made of 400 long green quetzal, blue cotinga and pink flamingo plumes and studded with jade disks and tiny, hollow gold beads. Even if sustainably harvested, valued feathers were scarce: a male quetzal grows only two meter-long feathers at a time.

9, 33, 160

6

We know of the great importance of woven and embroidered cloth to the ancient Andes: artisans invented woven cloth before ceramics, a first in the documented history of the world. The Mesoamericans, equally, discovered wild cotton and learned to spin and weave, and no single item was more widely demanded in tribute at the time of the Spanish invasion – whether plain white weave or fancy and colorful brocade and embroidery, along with finished dresses and full warrior suits. Cloth was also a standard measure of exchange in the marketplace.

Although almost nothing survives of ancient Mesoamerican textiles today, the reader should keep it in mind as an important and valued artistic medium, one that can be traced in other aspects of art-making: a weaver sees the entire pattern unfold in her mind (and, by and large, the weaver on the backstrap loom was and is female), the part standing in for the whole. This concept of the visual synecdoche allows for the abbreviation of iconography to an element, demonstrated early on by the Olmec but equally characteristic of the Aztec. The first complex and widely shared belief system, that of the Olmec, and known principally from stone and ceramic, could be reduced to "plectogenic" designs – that is to say, those that could conform to the constraints of weaving. In turn, as an easily portable medium, weaving may have supported the dissemination of a belief system. Working with wefts and warps gives the maker an understanding of the value of right angles, helping to establish the principles of symmetry. Key to weaving is the grid, the principle that underpins the city of Teotihuacan itself. Textile workers would have mastered the skills necessary to dye threads – particularly challenging for cotton and agave

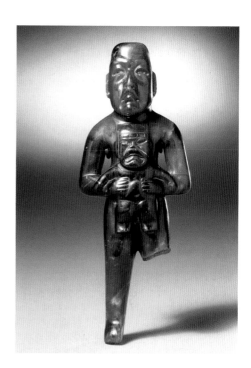

7 Olmec artisans selected translucent blue-green jade for this sober rendering of the adult who holds the Rain God, carved with baby-like features.

fibers – with indigo and cochineal, developing techniques transferable to Mesoamerican painting.

Long before the emergence of civilization in Mesoamerica, humans had domesticated manioc (cassava, the source of tapioca), beans, squash, tomatoes, avocados, sunflowers, sweet potatoes, and chili peppers; they learned to harvest wild cacao pods for chocolate and the pods of a certain wild orchid for vanilla, and they kept productive stingless honeybees in hollow tree trunks. Even in Olmec times, surpluses made it possible for groups to support full-time specialists devoted to art and architecture. By the first millennium CE, these crops supported rising populations, which in turn required the development of high-yield agriculture, including terraces, ridged fields, and raised fields. Not only were there full-time craftspeople and artisans, but also astronomers to chart the movements of the heavens and poets to tell the stories of gods and heroes. By 100 BCE, the Maya and perhaps others had put into use a calendar of interlocking cycles as accurate as any known today – and certainly more accurate than the Julian calendar used by Cortés and his men. Powerful lords commissioned monumental city plans that transformed natural geography with vast pyramids and ranging palaces, frequently with rich

7

64

burials, caches, or offerings within that testify both to the value of such materials and the power objects can gain when removed from circulation.

Chronologies and cultures

Because of its realistic system of human proportions and complex hieroglyphic writing, Maya art long seemed a reflection of a pinnacle of civilization, and by 1950, most students of its art called its florescence between 300 and 900 CE the Classic period. Preclassic and Postclassic were the terms then assigned to the predecessors and successors of the Classic Maya. Despite efforts to replace this terminology with such conventions as those used in the Andes (e.g. "Late Intermediate Period"), these terms survive, although the Preclassic is often referred to today as the Formative. Formative, Classic, and Postclassic periods should now be considered chronological markers, not descriptive terms, and wherever possible dates will simply be referred to by century, rather than period terms. The Olmecs flourished first, with signs of the first complex culture in the rainforest emerging after 1500 BCE. So-called Classic cultures are harder both to define and to align with the fits and starts of Maya civilization before the time of Julius Caesar and the burning of Teotihuacan, now pushed back to before 600 CE. Cities in Veracruz and Oaxaca persisted and even thrived after the collapse of most Maya southern lowland

8 With his elegant proportions, the Maize God of Structure 22 from Copan models an ideal human form. Local volcanic rock lent itself to three-dimensional forms.

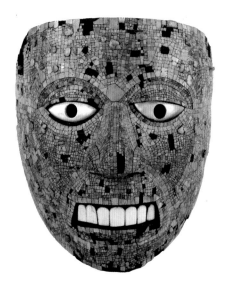

9 Brilliant turquoise tesserae cover a wooden support and yield a dramatic face of an Aztec god; pieces of shell form skeletalized teeth. This mask may once have served as part of a full deity suit used to adorn a stone or wood mannequin.

9

centers around 800 CE. Strangely enough, the years 900–1325 CE remain the murkiest in Mesoamerican cultural history, both enlightened and confused by ethnohistory and as seen through the lens of the Aztecs, who ruled supreme at the time of the Spanish invasion. Although an earlier generation of scholars insisted on reading Precolumbian cultural extinction within a generation of the Spanish victory over the Aztecs in 1521, both new materials and new interpretations now cast light on the complexities of the Nahua-Christian world in the sixteenth century.

Not all the art and architecture of ancient Mesoamerica was lost from view as culture succeeded culture. Teotihuacan in the Valley of Mexico was visited by Aztec rulers on regular pilgrimages, and no ancient Mesoamerican city has been the destination of more travelers – including early missionaries and twenty-first-century schoolchildren. Indeed, the question of the recovery and understanding of the past preoccupied the Aztecs as much as it does archaeologists today (even if in a different way), as recent excavations in the sacred precinct of Tenochtitlan have shown. Objects and treasures were uncovered by the Aztecs and brought to Tenochtitlan from throughout the realm, often with little appreciation of their original significance. These objects were then deposited in caches, leaving yet greater archaeological and chronological puzzles for today's scholars.

Sources record that Motecuhzoma II's grandfather, who ruled in the mid-fifteenth century CE, sent out wise men to seek the origins of the Aztecs, but no answers were found. In turn, the Spanish wondered whether these new people were truly human at all. Did they, so it was asked, derive from the same creation in the Garden of Eden as they themselves did? Explanations were sought for the isolation of New World peoples: were the Amerindians a Lost Tribe of Israel or refugees from Atlantis? Did they, as Father José de Acosta suggested in the late sixteenth century, enter the New World by a land bridge from Asia?

Even after it was accepted in the nineteenth century that the Americas had been populated by the means Father Acosta had suggested, as we have seen, Mesoamerica continued to be the page on which perceived resemblances would be interpreted as cultural contact. For example, the distinctive scrollwork of El Tajín and of Ulua vases has been linked to the scroll designs of China in the late Zhou dynasty. But these Chinese scrolls were worked in bronze, and ceased to be made 1,000 years before scroll designs took hold at El Tajín. Further, based on the physiognomy of Olmec colossal heads, Afrocentrists have made unfounded claims that early Mesoamericans came from Africa. But it's worth noting that many useful technologies – take the wheel, for example – were generally not shared between Old and New Worlds. Visually compelling though such suggestions may be, one must also note that these claims fundamentally come from those unwilling to accept the indigenous person today as the descendent of great city-builders of the past. Although the question of contact remains unanswered in all its details, by and large it will be assumed here that ideas, inventions, and civilizations arose independently in the New World.

The systematic recovery of ancient Mesoamerica did not begin until almost 300 years after the Spanish invasion. Starting at the end of the eighteenth century and continuing up to the present, explorers have searched for the ruins of ancient peoples. With the progress of time, archaeologists have unearthed civilizations increasingly remote in age. It is as if for each century logged in the modern era, an earlier stratum of antiquity has been revealed. Nineteenth-century explorers, particularly John Lloyd Stephens and Frederick Catherwood, came upon Maya cities in the rainforest. Twentieth-century research then revealed a much earlier complex civilization, the Olmec. It now scarcely seems possible that the frontiers of early Mesoamerican civilization can be pushed back any further in time, although new work – particularly in Oaxaca

10

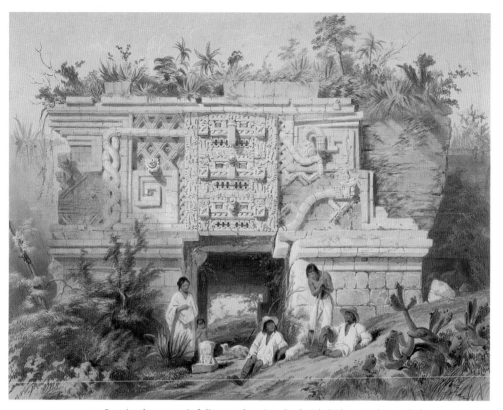

10 Despite the romantic foliage and setting, Frederick Catherwood recorded the West Building of the Nunnery at Uxmal with remarkable accuracy in the 1840s. He also made some of the earliest surviving renderings of the Maya people of the region.

and Veracruz – will continue to fill in details of the picture, and perhaps deal the twenty-first century a few big surprises.

The process of discovery often shapes what we know about the history of Mesoamerican art itself. New finds are just as often made accidentally as intentionally. In 2003, workers stabilizing a plaza at Teotihuacan stumbled upon the entrance to what would be revealed to be a remarkable tunnel leading to a hidden chamber under the Feathered Serpent Pyramid, sealed about 1,800 years ago. Archaeology has its own fashions, too: the mapping of new sites may be the prime goal in one decade, the excavation of pyramids the focus in the next; in a third decade, outlying structures rather than principal buildings may absorb archaeologists' energies. Nor should one forget that excavators seek to explore their own interests, from the social lives of objects to the roles of women in society. Modern

economic development often determines which ancient sites can be excavated. In Mexico City, for example, the building of the subway in the 1960s initiated the excavations that renewed interest in the old Aztec capital.

The study of Mesoamerican art is not based exclusively on archaeology. Much important information about the native populations was written down in the sixteenth century, particularly in Central Mexico, and it can help us unravel the prehispanic past, often framing work that the information was not meant to answer. Although there are many sources, the single most important one to the art historian is Bernardino de Sahagún's *General History of the Things of New Spain*. A Franciscan friar, Sahagún, with a team of many indigenous authors, some of whose names can now be brought to light as well, recorded for posterity aspects of prehispanic life in this encyclopedia of twelve books, including history, ideology, and cosmogony, as well as detailed information on the materials and methods of the skilled native craftsmen. Furthermore, ways of life – including, of course, language, but encompassing far more – continue among indigenous peoples of Mesoamerica, and scholars have increasingly found that sustained practice and belief can illuminate the past. Remarkably, some scholars have even turned this process around, teaching the practice of ancient writing systems to modern peoples who may use it to articulate identity in the twenty-first century.

What kind of antiquity did ancient Mesoamerican peoples see for themselves? When they looked up at the heavens, they saw a great serpent spanning the cosmos, forming the great white road that we understand to be the Milky Way. Celestial serpents, particularly plumed ones, brought bounty and culture to earth, a notion made manifest in architecture, where plumed serpents flow down balustrades. Venus, with its appearances and disappearances as both Morning and Evening Star, presided over war and sacrifice. Ancient Mesoamericans also linked stars together to form constellations, with rare examples like the Scorpion common to both Old and New Worlds. Among these constellations are three bright stars in a triangle (we know them to be stars in the constellation we call Orion) that form the hearthstones set in heaven's home by ancient gods as the founding act of civilization, when humans took up permanent residence and began to form villages. When Motecuhzoma reviewed his tribute list, he would have known that every home would have such a hearth – as indeed do many today. In a very general sense, the story of Mesoamerica's art begins with this sense of home, and with permanency in one of the most challenging locations: the tropical rainforest of the Gulf Coast.

During the past fifty years, scholars have made great progress in the decipherment and interpretation of ancient Mesoamerican writing systems, a breakthrough that has brought greater depth to our understanding of prehispanic belief and practice. Maya inscriptions, for example – long thought to record only calendrical information and astrological incantations – can now be read: most stone inscriptions glorify family and ancestry by displaying the right of individual sovereigns to rule. The carvings can thus be seen as portraits, public records of dynastic power. Although many generations of scholars believed that Mesoamerican artists did not sign their works, David Stuart's decipherment of the Maya glyphs for "scribe" and "to write" made it possible to study Maya artistic practice from the internal point of view, where at least one painter of ceramic vessels claimed relationship to a Naranjo king. Now, the names of known Maya painters and sculptors – all male – exceed most other ancient traditions and equals the complexity of what they wrote. Knowledge of the minor arts has also come in large part through an active art market since World War II, garnered at a terrible cost to the ancient ruins from which they have been plundered. In the twenty-first century, knowledge of the past must also be deployed to preserve it.

11 The Tovar Calendar was made for the Mexican Jesuit Juan de Tovar in 1585. Labeled as "Tula," this page depicts Coatepec, the "hill of snakes" where Tula was founded. The cattail reeds indicate that this is a *tollan*, and the gushing water makes it an *altepetl*, or "water mountain."

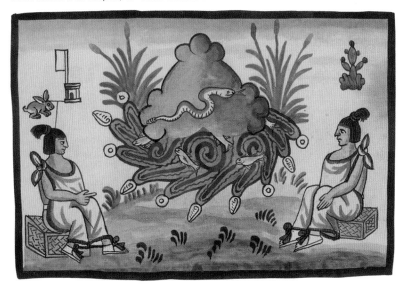

Chapter 2
The Olmecs: Establishing Mesoamerican foundations

Perhaps as early as 1800 BCE, population growth, competition, and a successful agricultural base gave rise to a remarkable phenomenon along the Gulf Coast: a group of people, probably speaking one of the Mixe-Zoquean languages, moved on from village life. They developed vast compounds rich with art and architecture to portray themselves at the center of a world characterized by four cardinal directions with an axis mundi, a fifth, cosmic direction that served as a central pivot of the universe. They gained such wealth that they could make their belief system legible and visible. They were the envy of the known world of Mesoamerica, and they spread their ideology, the subject of emulation and devotion, deploying signs and symbols imbued with meaning that outlined the very contours of Mesoamerica itself at the time of its hazy beginnings.

The people at the center of this phenomenon could not know that the twenty-first century would know them as "Olmec," a misnomer borrowed from the Aztec, who admired the Olmeca-Xicalanca, successful Gulf Coast polyglot traders of the Conquest era, but they did understand how to make an impression. The Olmec made some of the largest and most powerful images of rulers that the world has ever seen. Reaching from what is today the state of Guerrero to the nation of Guatemala, Olmec is both an art style and a culture, and its great cities lay along the Gulf Coast, in a region archaeologists have termed Olman.

All subsequent cultures, across the highlands and lowlands of the region, would look back to the Olmec, often called the "mother culture" of Mesoamerica. Most of the common elements of Mesoamerican art and architecture can be seen to have an Olmec origin: rubber balls and ballcourts, pyramid-building, bilaterally symmetrical architectural plans, jadeworking, mirror-making, and an interest in human form

that ranges from anthropomorphic deities and exquisite portraiture. Even the Olmec attention to the human head may show the first glimmers of the Mesoamerican understanding of the concentration of human sentience, especially the "hot" portion of the soul that resided in the head, or what the Aztec would call *tonalli*, the portion located at the fontanel that stayed in the body at death. One of the most fundamental of Mesoamerican gods, a Maize God in human form, survives from Olmec times. All of the known Mesoamerican world would both wittingly and unwittingly refer to this maize deity, from the beginning, when the Olmecs carved the jade that embodies the maize king, to the end, when Spanish invaders also recognized its value. Atop salt domes, the Olmecs constructed massive and brilliantly colored monumental architecture. Surrounded by the slow-moving river bends of the coast, seasonally flooded, these sites appeared as if mountains floating in pools of water, embodying *altepetl* – as the Aztec would call it – meaning "water mountain," the concept of civilized life itself.

Objects imbued with power

Long before radiocarbon dating could testify to the antiquity of the Olmec culture, archaeologists and art historians early in the twentieth century had become aware of the powerful physiognomy of Olmec art through individual objects. At first a shadowy presence recognized in jade works that appeared in collections both public and private around the world, by the 1920s and 1930s a greater awareness arose of the supernatural iconography shared between them. One of the first important Olmec objects to come to modern attention was acquired in Oaxaca in 1890 by George Frederick Kunz, the semi-precious gem expert at Tiffany & Co., New York, where the carving that bears his name still remains at the American Museum of Natural History, a rare figural form in a vast collection of stones and gems. The Kunz Axe takes the form of a celt, or axe head, although of course it never functioned as such. To its earliest admirers, it was clearly neither Aztec nor Maya; in fact, it had no features that could be linked with known Mesoamerican cultures, yet it had surely been made in Mesoamerica in antiquity, with a stunning technique not fully understood at the time.

The axe exhibits many qualities of the style we now call Olmec: precious blue-green translucent jade was delicately worked to reveal a figure in both two and three dimensions. Using tools made only of jade, and perhaps using jade powder as an abrasive, an ancient artisan sawed the block of jadeite into the rough axe form and then drilled it sharply at the corners of the mouth and eyes – the drill holes can still be

12

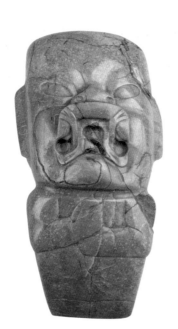

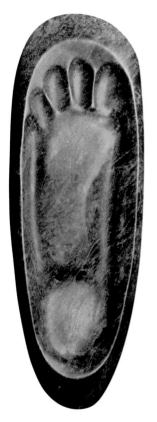

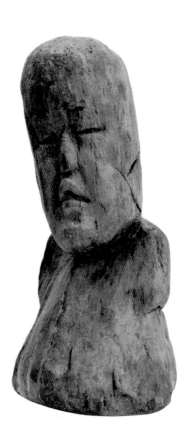

seen at the corners of the mouth. More than half the celt is devoted to the creature's face, giving it a small-scale version of a colossal head. The open, toothless mouth and closely set, slanting eyes have often been likened to the face of a howling human infant. The viewer's attention first focuses on the open mouth, and then the more subtle qualities of the rest of the creature's body become evident. His hands are worked in lower relief, and in them he grasps a miniature version of himself, a simple celt. Feet and toes are indicated only by simple lines, and incisions also mark the face, ears, and upper body, perhaps to suggest tattooing, ear ornaments, and a tunic. The jade has been worked to a silken smoothness, with a surface like that of fine, young, taut human skin.

For over two millennia, the large, precious Kunz Axe was presumably kept as a treasure or heirloom. It might once have been revered in a shrine or wrapped in cloth; pieces of jade were periodically cut from its rear, each slice perhaps carrying something of the power and magic of the whole. It was not until 1955, after several seasons of excavation at La Venta (see pp. 35–44) had produced many fine jade objects and a convincing series of radiocarbon dates in the first millennium BCE, that objects such as the Kunz Axe were at last understood by scholars to embody the principles of the first great art style of Mesoamerica. These dates would be pushed back into the second millennium BCE, first at San Lorenzo (see pp. 29–35) and then in discoveries at El Manatí. Long lost in the wet and swampy forest, waterlogged El Manatí preserved wooden objects – many of them staffs with beautifully carved heads, almost certainly to have been the chassis for a human or deity form and attire – found alongside the earliest rubber balls of Mesoamerica. Each El Manatí figure seemingly renders individual physiognomy, and collectively, they may have once formed a tableau, like that of the later La Venta Offering 4. At La Merced, close to El Manatí, stunning quantities of buried jade and serpentine axes provide evidence of the ways in which these hard greenstones, quarried in western Mexico and in Guatemala and hauled long distances, defined a materiality of value at the beginning of such cultural complexity.

13

14

30

12 OPPOSITE TOP The largest known example of its kind, the Kunz Axe is a jadeite effigy "were-jaguar" that grasps a miniature axe in its hands. Pieces of the precious greenstone have been cut away from the back of the figure. Middle Formative.
13, 14 OPPOSITE BOTTOM El Manatí, a dense swamp filled with springs, has yielded rubber balls, jades, and wooden objects. The perfect small footprint in jade (LEFT) makes the observer imagine the child it would fit; the wooden bust (RIGHT) may have been dressed, as part of a ceremonial assemblage.

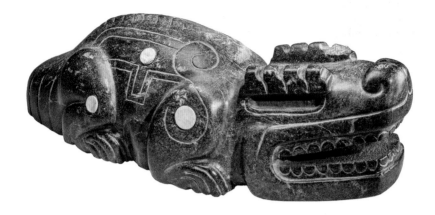

15 The Olmec dragon is a composite being based on the tropical crocodile but with both sky and terrestrial aspects. Flame eyebrows, perhaps related to the crested feathers of the raptorial harpy eagle, indicate its movement across the sky.

Early students of the Olmec style noticed a repeated pattern of imagery on the carved stone objects, including the Kunz Axe. Many "howling baby" faces were recognized, and other faces seemed to combine human and jaguar features in what was often called "were-jaguar," as if to be compared to a "werewolf." Today, while the presence of jaguar imagery is still acknowledged, it is no longer regarded as the sole subject of iconography: scholars have discovered that aspects of many other tropical rainforest fauna can be identified in the carvings. The crocodile, harpy eagle, toad, jaguar, and snake all appear in the Olmec supernatural repertoire. The sharp cleft in the forehead of many Olmec supernatural beings may be associated with the naturally indented heads of jaguars or toads, or it may simply indicate the human fontanel, access to a site of human sentience. It could also indicate emergence from the surface of the earth, especially as seen in the head of the Maize God, from whose cleft emerges the tender maize plant. The Olmec mastered the concept of *pars pro toto*, in which the depiction of one part can stand in for the whole; the equivalent literary term would be *synecdoche*. The "flame eyebrows," for example, can be shown to be an element of the Olmec dragon and signal the larger supernatural being to the viewer. This intricate symbolic code appears to have been in use from the first appearance of the Olmecs, and to have been employed consistently for more than a thousand years.

15

San Lorenzo

The earliest known great Olmec center – which achieved its peak before 1000 BCE – was the vast earthen platform at San Lorenzo Tenochtitlan, which rises 164 ft (50 m) above the swamp below. Honeycombed with drainage systems, and perhaps planned in a zoomorphic shape, the platform massed at least 9.4 million tons, in a volume that would be at least seven times that of the Pyramid of the Sun built over a thousand years later at Teotihuacan. The elaboration of the drains themselves was remarkable: Monument 52, for example, a sculpture of a kneeling Olmec rain god, was hollowed on its back to guide copious water flow that eventually gushed out into a basalt duck dramatically altered to fit into a drain pipe at the base of the massive structure, forming a duck fountain. Freestanding architectural forms were limited to low-lying mounds, including an early ballcourt of two parallel structures, the acropolis, and the Red Palace, the latter the single greatest of all structures at San Lorenzo, recognized today by the floors painted red with hematite and rooms for craft specialization. Ann Cyphers has identified "social zoning" in San Lorenzo, in which stratified living and working space pushes those with fewer skills and fewer connections to the margins, away from these spectacular structures.

In their excavations, Michael Coe and Richard Diehl found dozens of partly destroyed sculptures interred along the ridged western edge of the site. For years, this destruction seemed inexplicable – many of the defacements required

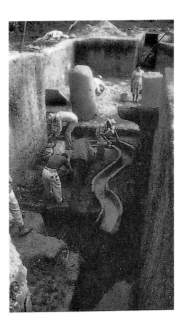

16 Olmec artisans fitted carved basalt drain sections together to channel water through the vast manmade mound of San Lorenzo. A sculpture of the Rain God, Monument 52, marked where water entered at the top; water poured into a duck-shaped fountain far below.

essentially as much energy as the original carving effort itself. Some of this destruction may have been ritual killing: Monument 34 was systematically decapitated and placed on a red gravel floor and covered with at least 6 ft 7 in. (2 m) of specially prepared limestone fill. Other monuments may have been buried so as to shelter them within the artificial sacred mountain. But the concentration of fragments and broken pieces offers another possibility: this location may have been used to transform monuments of one generation into the sculptures of a new order. The Olmec imported every boulder and pebble of basalt to San Lorenzo, and such a precious – not to mention heavy – material, brought at great human cost (surely transported on rafts for as much of the trip as possible) from Cerro Cintepec in the Tuxtla Mountains, almost 60 miles (100 km) away as the crow flies, would surely have been reused and recycled at a specialized workshop. When the end of San Lorenzo came around 900 BCE, sculptors simply abandoned the broken sculptures.

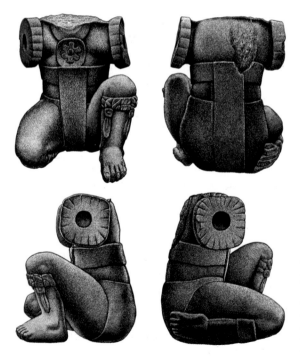

17 The ancient Olmec at San Lorenzo decapitated this sculpture and carefully buried it on colored clays. The sculptor adeptly handles two and three dimensions, flattening the calf and right foot to show the body's explosive tension.

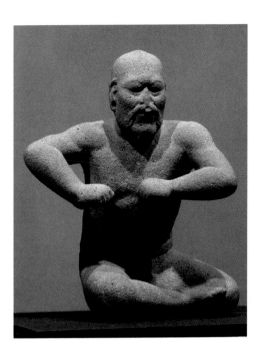

18 Long known as the "Wrestler," this dynamic male figure has the powerful upper body physique of a swimmer. The sculptor turns the arms clockwise and the legs counterclockwise.

Monument 34, clearly deliberately buried, also reveals the strong three-dimensional qualities of early Olmec art. Perishable – and movable – arms were once attached to the torso, and one feels the torsion of the figure, from the tense, compact, lower body to the moving arms. The tucked right foot coils like a spring wound tight, about to be released. Special attention has been given to costume detail, and knots in particular are carefully worked, with a relief that is tactile, begging to be touched. The Olmecs demonstrated the power of the invisible on multiple levels.

18

The "Wrestler," discovered in the early twentieth century near what is now the town of Antonio Plaza, Veracruz, about 31 miles (50 km) from San Lorenzo, and used for over a decade to prop up a chicken coop, has three-dimensional qualities similar to those of Monument 34 and other early Olmec art. Its compact size and scale may also link it to the later sculptures of La Venta, where it is like a niche figure, if completely released from the stone. Its artist must have intended the Wrestler to be viewed from all sides. The long diagonal line of the figure's back and shoulders is as beautiful and commanding as the frontal view. The beard and mustache, as well as the studied concentration, reveal a masterly portrait, one whose individuality

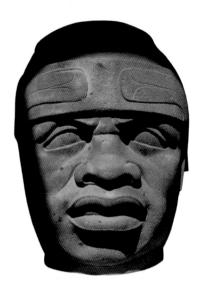

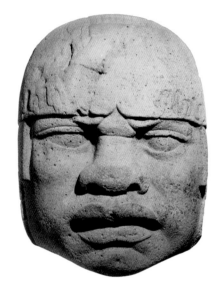

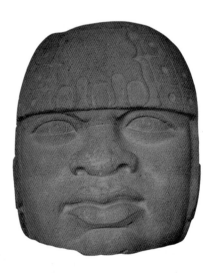

19 TOP LEFT Discovered in 1970, San Lorenzo Colossal Head 8 (Monument 61) reveals a powerful physiognomy. The count of colossal heads at San Lorenzo now stands at ten, more than any other site.

20 ABOVE Colossal Head 5, San Lorenzo. Jaguar paws, perhaps emblematic of family lineage, drape across the head and brow of this early Olmec ruler. Early Formative.

21 LEFT In 1994, Ann Cyphers Guillen discovered San Lorenzo Colossal Head 10 in a ravine at the site's edge. The distinctive helmet and chin line distinguish this 8-ton portrait.

would be enhanced by long-lost perishable attire and ornament, including ear ornaments made from the drilled piercings.

What are we to make of these early works, that emerge so fully developed and three-dimensional, so vivid and lifelike that we feel we might meet these individuals on the street? We can compare these Olmec sculptures with the Palaeolithic cave paintings of France and Spain from some 30,000 years ago, where charcoal and mineral renderings deep within natural formations are among the most powerful evocations of hunters and their prey known, executed with vividly accurate depictions of natural forms. Early cultural expression can be confident – despite the paradigm often cited for European art, in which hesitant execution yields to mastery over time, developing along a bell curve. There is no single evolutionary stream that Mesoamerican art follows, and complexity characterizes its pathways right up until the Spanish invasion. Even the Olmec practice of recycling and reusing materials can be seen in later works. At the same time, the Olmec did indeed master abstraction with their manipulation of symbols, paralleled by the way they imbued special materials with power, especially the smooth axe-shaped celts that may have been understood as the permanent compression of everything green and blue: sky and water, quetzal feathers, and maize.

19, 20, 21 Ten colossal heads formed of basalt have been found at San Lorenzo, and they exhibit mastery of the human face, with an understanding of musculature and skeletal structure. Although the original context of the heads is not known – most have washed out of the vast earthen platform – they would have been dramatic beacons atop the multicolored mound, legible

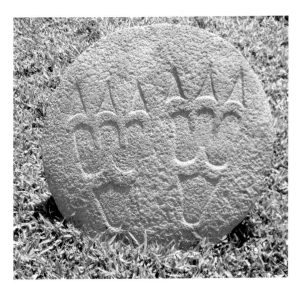

22 Featuring two oversize feet of a raptor, this work makes the human mind imagine the scale of the predatory bird that would have such powerful talons.

from a great distance. Among the most commanding of faces is the one seen on Colossal Head 5, probably a depiction of a second-millennium BCE ruler of the site. Like small-scale works such as the Kunz Axe, the features of the colossal head were drilled, giving emphasis to the deep-set eyes, nostrils, and strong, slightly asymmetrical mouth. The sharp overhang of the headdress provided a constant play of light and shadow across the eyes. Like all San Lorenzo heads, the lips of this fellow are tightly edged, sharpening the viewer's sense of the mouth. Eight round dimpled pits were bored into the head, and although the prominent examples on the chin, lip, and cheekbones do not detract from the stern gaze, they betray that this sculpture was in the process of being recycled into another form when the work was abandoned. Jaguar paws are shown draped over the figure's forehead, and perhaps the individual wore the feline pelt as a name, a lineage title or symbol of office. (Much later, in Mixtec manuscripts and Maya inscriptions, many lords received a jaguar title.) Mesoamerican peoples believed that human heat and emotion resided in the head, and the concentration of such power in the colossal head still astounds us today; the dings in the lips may have staunched the breath and, accordingly, life itself.

Not only were there workshops to recarve and resize Olmec sculptures, but Olmec sculptors remade even their largest pieces, converting huge thrones (often called "altars") into colossal heads, as first demonstrated by James Porter. San Lorenzo Colossal Head 7 retains the remnants of a deeply carved niche on the side of its head; Monument 14 once served

23 The discovery of two nearly identical Early Formative sculptures near San Lorenzo has prompted some scholars to propose that they represent the Hero Twins, known in later times as Maya culture heroes. Some viewers have wished to read an Egyptian origin into their stylized head regalia. But the pleated side accoutrements are the folded paper adornments associated with Mesoamerican rain gods, right up until the Spanish invasion. Early Formative.

as a throne, but was smashed almost beyond recognition, perhaps on its way to taking the shape of a colossal head. One can imagine a scenario in which the throne serves the living king, only to be converted into his essence, his head, upon his death, or perhaps to be sure that his *tonalli* departs after death. The ten colossal heads are of greatly varying size: they may have been posthumous records of the great kings who had led them – and the defacement, cuts, and other markings on the heads may also alert us to the transience of mortal power, once these, too, entered the great Olmec recycling project.

The impulse to the narrative emerged at this same early time frame, evident in a group of sculptures from nearby Loma del Zapote. Two identical figures kneel, the weight shifted forward as each grasps a short, thick staff in front of him. Crinkled paper headdress elements fall across their ears, giving a false impression of Egyptian headdresses – folded paper headdress elements are typical of Mesoamerican rain gods, who received offerings of rubber sap on strips of folded paper. When burned, these folded bits of paper yielded black, acrid clouds of smoke to propitiate rain. A small museum on-site featured these twin sculptures, which face a pair of carved felines, replicating their original location, until federal police seized the grouping during a surprise power blackout and removed them to the state museum in Jalapa, the capital of Veracruz. Such an assemblage may have brought a religious narrative to life: here, one thinks of the legendary Maya ancestors, the Hero Twins (see p. 68), whose story may have been permanently conveyed in a tableau visible from the river below.

Particular features of Mesoamerican art and materials come into coherent focus for the first time at San Lorenzo. Remarkable trade routes brought precious materials from distant realms: mica, jade, and serpentine were all desired materials that porters carried to San Lorenzo by the ton, probably for on-site manufacture. Rubber and iridescent tropical feathers may have been principal exports. Local builders used rock and clays readily available, but elite status depended on imports, a lasting aspect of Mesoamerican elite economy. What is also clear is that a systematic destruction of San Lorenzo took place about 900 BCE, and a new center of Olmec civilization was established at La Venta.

La Venta

La Venta occupied a small, swampy island in the Tonalá River. Twentieth-century oil derricks have finally been removed, and the site is now open for tourism, including a museum featuring the many new discoveries made in the ancient city.

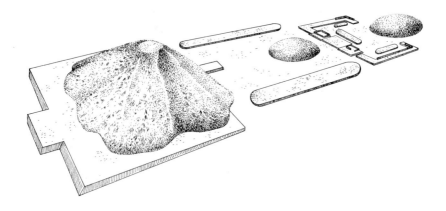

24 Reconstruction of the major mound cluster at La Venta. The ceremonial center extends north from the "fluted cupcake." Ancient Olmecs placed structures and offerings in bilateral symmetry either side of the north-south axis, in the section of the site known as Complex A.

24 During the 400- or 500-year occupation of La Venta, inhabitants built both monumental architecture and earthworks of colored clays and imported stones. The most important structure is a large pyramid toward the end of the northern axis, in the form of what has been called a "fluted cupcake." This impressive mound may have been intended to echo the shape of a Central Mexican volcano, or it may simply be the eroded remains of a pyramidal platform – the first of a long series in Mesoamerican history – designed to raise a perishable shrine above the plaza level. In the 1950s, the excavators discovered fine burials under other structures at La Venta, but they did not penetrate this main mound, which may yet hold the tomb of an individual whose portrait appears as one of the four colossal La Venta heads. Parallel mounds lead north from the pyramid to a sunken courtyard flanked by massive basalt columns.

Most – although not all – offerings follow the bilateral symmetry reflected on the surface, creating a dynamic link between what is hidden and what is seen – as archaeologist Robert Heizer discovered in the 1950s, with profound impact in the next generation on his son, artist Michael Heizer, who has devoted decades of his life to building the giant, earthen sculpture *City* in the Nevada desert; *Levitation*, at the Los Angeles County Museum of Art, recalls Olmec colossal heads and imbues a modern walkway with mystery. At La Venta, vast deposits of serpentine, granite, and jade celts were laid out and

buried at the entrance to the sunken northern court. Some of the slabs formed mosaic masks, such as the one illustrated here, which has been described as a giant god face, oriented either up or down. But in fact the masks might well be a series of tassels, as if the fringes or headdress adornments on a yet more vast divine garment.

Few of these constructions were meant to be seen, and most were buried immediately after they had been created. Such works show the relation of art to architecture for the Olmecs, and the interest in process over product. Once "hidden," Olmec architecture activated both memory and mystery.

The whole of La Venta was laid out on a specific axis, eight degrees west of magnetic north, establishing some principles of architectural planning that were repeated many times in the history of Mesoamerica: ceremonial cores laid out along astronomically determined axes; concern for natural topography – a sort of geomancy – which may have inspired the erection or overall orientation of individual structures (as for instance the "fluted cupcake" that rises 105 ft [32 m]

25 Archaeologists discovered five massive offerings at La Venta, each comprised of some 50 tons of serpentine blocks in a mosaic format and almost immediately covered with 4,000 tons of clay fill and recovered more than 20 ft (6 m) below grade. Although originally thought to be stylized deity heads, they may depict shields or textile patterns.

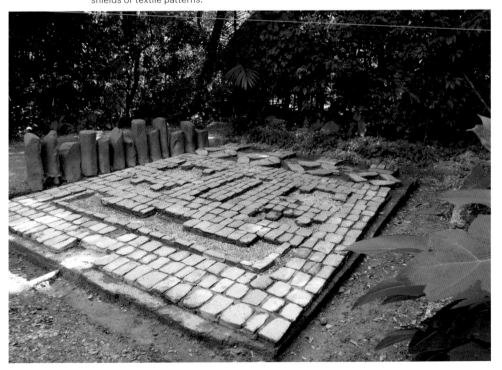

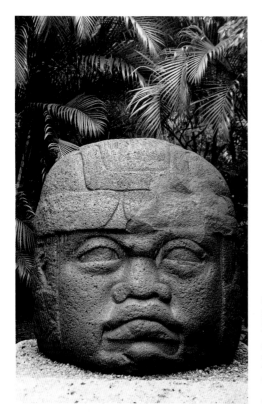

26 Giant talons, a recurring motif also seen on ill. 22, mark the helmet of Colossal Head 1 at La Venta, as if to show both blessing and authority embodied by this ancient ruler. The raw stone came from the distant Tuxtla Mountains; a massive sculpture of this sort underscored the power of local elites to "move mountains."

from its base). The plaza, a "negative space" seen in the sunken court of La Venta, was as significant as the structure or "mass" that defined it. But above all the visual emphasis fell on the pyramid. Only six miles from the ocean, pilgrims might have come up the winding river to see it, and to venerate the great heads.

The four colossal heads of La Venta were set like sentinels guarding the ceremonial core. Heads 2, 3, and 4 all stood at the north end of the complex, facing outward, while Head 1 was set just south of the "fluted cupcake." If erected during the reign of a ruler, such heads would have been effective images of royal power; if erected posthumously, fearsome memorials. The La Venta heads are somewhat broader and squatter in general than those of San Lorenzo, but they, too, suggest a series of powerful men who held absolute sway over the populace.

Other sculptural types are known from La Venta, including the altars and stelae. Through time, the monuments of La Venta became increasingly two-dimensional and specific in terms of setting, costume, and ritual paraphernalia. These developments

26

suggest a growing preoccupation with the trappings of the ruler and the specificity of their place and time.

27 Altar 4 shows a ruler carved in rich three-dimensional form seated within a niche or cave, holding a rope wrapped round the perimeter of the stone that binds two-dimensional captives in profile to the lord on the front. The lord's power is emphasized by his action, the grasping of the rope, and by the technique, which subordinates the two-dimensional figures to the architectural setting. Such monuments almost certainly 39 served as thrones; the painted figure at Oxtotitlan, for instance, is represented sitting on a throne similar to that of Altar 4, and Altar 4 may once have been finished in the brilliant colors of the painting. The surface of the monument is carved with a jaguar pelt, a royal cushion on the seat of power.

28 Altar 5 may emphasize a different aspect of Olmec rulership. As on Altar 4, a highly three-dimensional figure, about life size, emerges from a niche on the front of the monument, while two-dimensional figures are shown on the sides. The central figure in this instance, however, holds out an infant, who lies 31 limp in his lap. The Las Limas figure is also of an adult and infant, although there the child is clearly supernatural. The representation on Altar 5 may reflect a concern with legitimate descent, and perhaps the ruler is displaying an heir, as in some

27 Altar 4, La Venta. An Olmec ruler emerges from the mouth of a schematic cave at the front of the stone. Such "altars" may also have been thrones from which the reigning lord would have presided. Middle Formative.

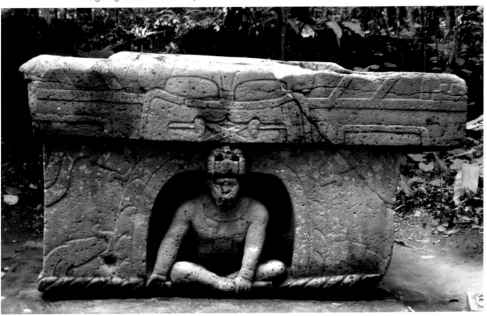

Maya paintings and carvings. The subsidiary figures on the sides of Altar 5 represent adult humans who hold rambunctious Olmec supernatural children.

On Stela 3, two men face one another while small figures, perhaps deities or ancestors, hover above. Despite some modern recarving, one can see that the man at left carries a baton, and the one at right wears what appears to be a beard, winning for this monument the nickname "Uncle Sam." Indeterminate shapes, perhaps architecture or landscape, appear behind the two men, thus suggesting that the setting for a particular event is being recorded, not just historical figures. This is a preoccupation at La Venta, and it may be an indicator of concern for historical records. Even the notion of carving an upright finished stone slab, or stela, is new, introduced at La Venta for the first time.

Offering 4, excavated at a corner of the basalt courtyard at La Venta, may record history in a different fashion, as well

28 LEFT Altar 5, La Venta. Badly battered, the massive sculptured throne may have been abandoned while being recarved into a colossal head.
29 RIGHT Stela 3, La Venta. Two Olmec lords meet in front of a schematically rendered cave. The beard and towering headdress of the figure at right has earned this monument the nickname of "Uncle Sam." The figure on the right has been recarved. Middle Formative.

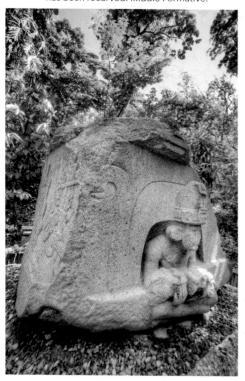
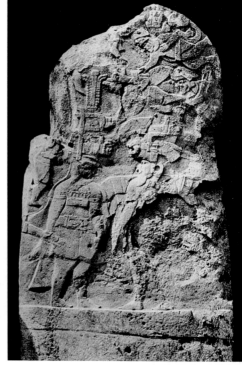

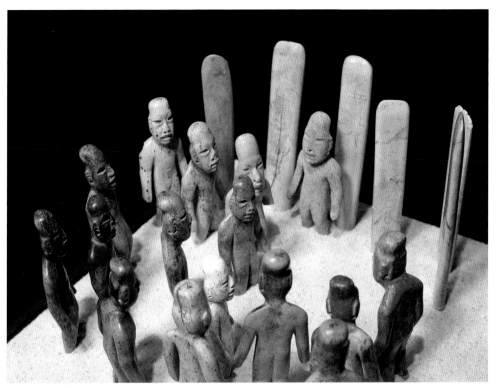

30 Offering 4, La Venta. Like the monumental deposits (ill. 25), Offering 4 was buried after being laid out in just this configuration. The single figure of granite, facing out with celts behind him, is studied by those made of precious greenstone. Middle Formative.

as in a different medium: jade and serpentine, which, carved into sinewy figures, reveal Olmec mastery of the material. The hardest rock commonly found in the Mesoamerican world, jade found its keenest masters among the Olmecs, who succeeded at the art of releasing human form and capturing veins of color from the stone. Fifteen jade and serpentine figures face a single figure made from a common stone – granite. Six celts behind the granite figure create an architectural setting, recalling the columns of the La Venta sunken court in which this offering was found. It is entirely possible that the scene recreates an action taken against the lone figure, to be memorialized in this buried tableau. About a century after its interment, Offering 4 was uncovered and then reburied, as if an important event needed to be reconfirmed. The later exhumation was made with precision, indicating that records were kept, even if through oral tradition. In this respect we see that burial did not equal

object death or loss, but rather transformation into words and memories. Other individual, sinewy jades – warm, plastic, and almost feline in their posture – that have been found may well have come from similar groupings.

The recently excavated assemblages at El Manatí and Loma del Zapote now make it possible to imagine that many Olmec sculptures were parts of tableaux. Eventually, two-dimensional depictions would provide permanent adjacencies, in which two or more face one another, as on La Venta Stela 2. Tres Zapotes, the first Olmec center to be discovered in the nineteenth century, succeeded La Venta, surviving into the Late Formative. Its two colossal heads are the smallest found in Olman; with limited detail, both retain qualities of their original boulders of basalt. Other sculpture at dispersed architectural groupings was badly battered – some of it surely recycled, in Olmec fashion, but some perhaps stripped of spiritual meaning. At nearby La Cobata, on the shoulders of the San Andés Mountains, a single massive head was abandoned after it had been carved, probably late in the Olmec period.

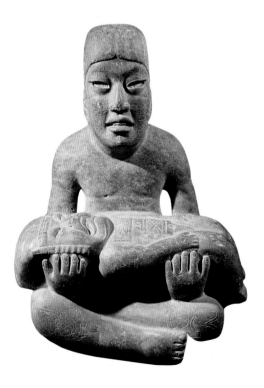

31 Rural villagers who found this large greenstone sculpture near Las Limas, Veracruz, believed it to be a Madonna and Child. In fact, it represents a youth holding an Olmec rain deity in his lap. Tiny ear ornaments would have dangled from the holes drilled in the ears. Middle Formative.

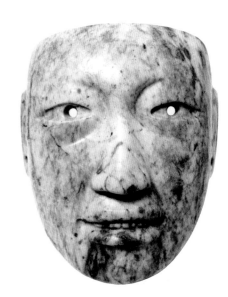

32 TOP LEFT Long part of the Museo Nacional collections, this thin piece of dark jade depicts an Olmec ruler whose face is marked, in different degrees of incision, with deities. Each divine presence activates a human aperture: the nostril, the ear, and the fontanel.

33 TOP RIGHT Most Olmec masks lack archaeological context, but this example comes from a stream flowing from the Tuxtla Mountains; that others are reported to come from streams and rivers suggests that making such deposits – like Offering 4 of La Venta – had ritual value in various settings. This mask fits perfectly on the human face: the wearer could see but not breathe.

34 RIGHT Found near La Venta with dozens of plain jade celts, this scepter of precious greenstone depicts the emergence of the maize cob from the head of the maize deity. The binding ties below the head will characterize sacrifice through Aztec times.

Of all Olmec greenstone sculptures, the largest and most beautiful is the Las Limas figure. When it was discovered in 1965, villagers considered it a miraculous Madonna and Child, and it was brought to the church of Las Limas. The sculpture, however, is no Christian mother and child. A youth, neither specifically male nor female, holds an infant in its lap. The infant has the monstrous face of the Olmec rain deity, and the knees, shoulders, and face of the larger individual are incised with the faces of other supernaturals, as if mapping out the four cardinal directions, with the three-dimensional deities at the center, the fifth direction. The incision may reflect the tradition of paint on the human body, possibly Mesoamerica's first art form.

Throughout the history of Mesoamerica, art emphasizes the human head, a practice that begins with the Olmec, and is evident in both the colossal heads and the small-scale incised heads that characterize Olmec religious imagery, sometimes in representations to promote meditation and contemplation, and perhaps even song and prayer. This same interest is revealed in jadeite stone masks, which have been recovered across Olman, generally in riverine contexts. Some have delicate incision; some may have been worn, while others may have served as parts of deity assemblages.

Olmec sites beyond Olman

At Teopantecuanitlan and Chalcatzingo, far from Olman, the Olmec established places of pilgrimage and ritual that also charted their highland routes to the sources of precious greenstones and valuable pigments. At Ceibal, Guatemala, significant discoveries of Olmec jades from possibly as early as 1000 BCE, including jade bloodletters, also suggests an Olmec foundation to Maya civilization, evident in shared ideology.

Teopantecuanitlan, which thrived between 1200 and 800 BCE, presumably hosted Olmec lords at a monumental sunken court lined with green travertine rock and marked by unusual T-shaped sculptures on the west and east sides. These sculptures feature Olmec maize gods, who define the four corners of the universe. Yet the limited and repetitive imagery does not suggest the imagination of the works in Olman. In later Maya ideology, the Maize God is reborn in a ballcourt: at Teopantecuanitlan, as if to indicate such belief, a ballcourt occupies much of the sunken patio. Nearby, archaeologists have recovered the smallest of the known colossal heads, composed of two large boulders instead of the expected single quarried stone: the concept of the colossal head evidently needed to be executed, even if the appropriate stone was not available.

35 Framing a sunken courtyard at Teopantecuanitlan, four nearly identical sculptures feature the Olmec Maize God. Although 400 miles (650 km) from the Olmec heartland, these sculptures convey standard Olmec imagery. Early or Middle Formative.

A huge natural rock formation – a pair of igneous plugs – signals a pass through the eastern end of the modern state of Morelos and the point of access to the rich Valley of Puebla at the site of Chalcatzingo. During the Middle Formative, the Olmec marked the way across Mesoamerica here, carving the larger of these monumental formations, the Cerro Chalcatzingo, with giant reliefs. Like a dwarf companion, the smaller Cerro Delgado joins the larger formation to create a gateway: from the opening between the two, the viewer can spot Popocatepetl, the living, sacred volcano that in turn guards the Valleys of Mexico and Puebla. Strange figures and fantastic creatures were carved in three distinct groups on the surface of Cerro Chalcatzingo. The most striking of these carvings is known locally as "El Rey," a representation of an enthroned ruler – probably female, given the skirt the figure wears. This may be an Olmec overlord, reflecting the extent to which power was imposed by the Olmecs in this frontier region, far from Olman, or perhaps a powerful bride, sent by Gulf Coast lords, carrying the power of royal lineage to new sites of authority. She sits within a section of a cave or niche, like that depicted three-dimensionally on Altar 4 at La Venta. Her headdress features two full-body quetzals, presaging the quetzal-feather headdress of the sixteenth century. In the petroglyph, the cave lies within a schematic landscape where phallic raindrops fall on young maize plants. Petroglyph 4, on the other hand, depicts large felines attacking human figures with supernatural characteristics. The foreshortened human forms suggest that their outlines might first have been traced from cast human shadows. Some fragments have sheared off the cliff: recent discoveries include a 5-ft (1.5-m) tall sculpture

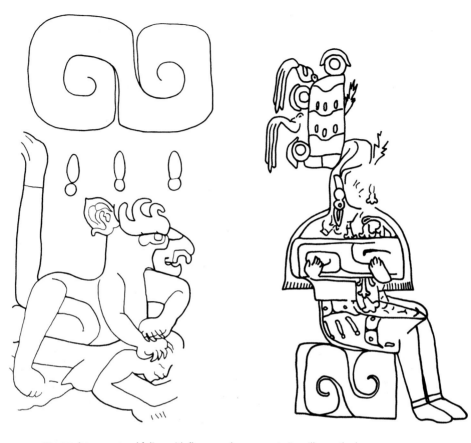

36 LEFT A supernatural feline with flame eyebrows exerts its will over the human crushed beneath it. The S-scroll indicates clouds, a sign commonly replicated across Mesoamerica for hundreds of years.

37 RIGHT The powerful woman figure within the cave wears quetzals on her headdress; these are the same birds whose feathers form the great headdress in Vienna (ill. 6). She sits atop a stylized cloud.

of three supernatural felines, probably to be connected to Chalcatzingo Stela 31, making a set of four dangerous cats with claws sunk into a collapsed human form. The petroglyphs at Chalcatzingo are remarkably varied: some portray warring Olmecs, others simple natural motifs, such as squash plants, long invisible to those who mistook the carving for the plant itself. The artist who made this rendering may have started by tracing a living plant onto the cliff.

The earliest Mesoamerican paintings survive only in caves, their condition and presentation not unlike Palaeolithic cave art in France, although not on the same magnificent scale, and

not from such an early date. Fine examples have been found at Oxtotitlan and Juxtlahuaca caves in Guerrero. A large painting at Oxtotitlan, set 33 ft (10 m) over the entrance to the cave and under new reconstruction by Heather Hurst and Leonard Ashby, depicts an Olmec lord wearing a green bird suit, cut away in X-ray fashion so that we see his face and limbs. The bird's eye was probably inlaid with a precious material, and the lord sports a jade noseplug; a vast spray of feathers backs the lord. His throne resembles Altar 4 at La Venta and the frame of Petroglyph 1 of Chalcatzingo. The color palette of these early

38 Petroglyph 1, Chalcatzingo. Set within a cave mouth in a schematic landscape where maize flourishes, an Olmec ruler, probably a woman, sits on a throne. This petroglyph is found high up on the cliff, and slightly protected by the outcropping. Middle Formative.

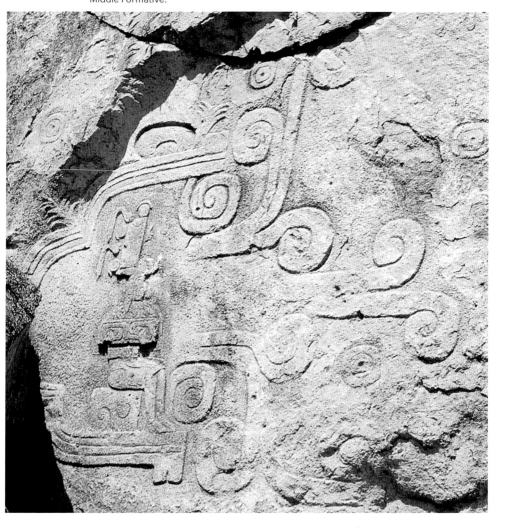

Olmec paintings was broad, including bright greens and reds, although simpler black-on-white paintings have also been found, especially at nearby Juxtlahuaca. A bird deity plays an important role in the Late Preclassic and among the Maya more broadly; the painting at Oxtotitlan may be one of its earliest depictions, impersonated by a ruler or embodied by a shaman, flying out of the cave. And years later, a powerful goddess at Teotihuacan would wear such a green owl to symbolize her powers.

Little Olmec ceramic art survives in Olman because of the wet and often oily soils, but the market for their work abroad was powerful. At the outskirts of modern Mexico City, at Tlatilco, a rich cemetery revealed deposits of formal Olmec ceramics alongside a local tradition – perhaps a cult dedicated to fertility. Swelling breasts and thighs were emphasized, as well as narrow waists. The hair and face received great attention, and these figurines are often known as "pretty ladies." Others are grotesques, and their split "Janus"-like faces appealed to artists of the early twentieth century.

The Tlatilco "pretty ladies" were found in association with large Olmec-style ceramic figures, known also from Las Bocas, Atlihuayan, Tlapacoya, and other places in Central Mexico – incomplete ones have been discovered at coastal sites too. The fine-grained, plastic white clays of Las Bocas may have freed its artists to produce the finest of these figures, along with lightweight vessels, usually with flat bottoms. Although many of the works seem at first to be babies, the loose, hanging flesh also suggests age, perhaps not unlike late medieval representations of the Christ child, where both old age and

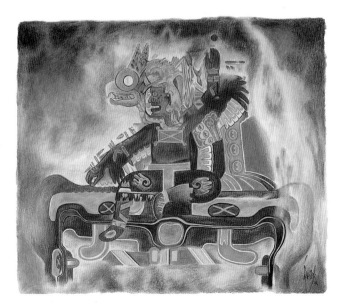

39 To make this new reconstruction with its revelation of subtle pigment deployment, Heather Hurst and Leonard Ashby constructed scaffolding atop the cave entrance. The ruler's face can be seen in X-ray fashion, within a great bird hood. The painting is large, 12 ft 6 in. × 8 ft (3.8 × 2.5 m). Early or Middle Formative.

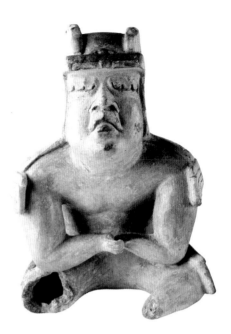

40 Found during highway excavation at Atlihuayan, Morelos, this large, hollow ceramic figure with cut-out eyes wears a supernatural crocodile on its back, a dragon of the sky that sends this figure in a trance-like state flying (see ill. 15).

infancy are portrayed in a single body. The hollow figure from the Metropolitan Museum, New York, sucks his thumb; his hair is groomed in the shape of a helmet. A red cross-bands-and-wing motif runs down this baby's back, perhaps made by a rocker or roller stamp, another common Olmec form. The seated hollow Atlihuayan figure, recovered from a road in Puebla, wears a cut-out dragon cape that drapes from the head across the back. Similar motifs carved on ceramic vessels, such as the flame eyebrows, derive from the Olmec symbolic system – consistent, coded references to particular deities – and are suggestive of writing. Other vessels were worked as three-dimensional animal effigies, particularly of fish and ducks. The stamps may have been widely used to paint the human body.

Far to the south, at Copan, Honduras, an early Maya king of the Middle Formative was buried with Olmec pomp, including jade celts, jade necklaces, and flat-bottomed vessels worked with Olmec symbols. Also distant from the heartland, at Xoc, Chiapas, an Olmec petroglyph was discovered depicting a male Olmec carrying a great burden. One wonders what this lord bore in his bundle: could it have held cult objects, perhaps even a sculpture like the Kunz Axe? A maize plant in full tassel is drawn over the bundle's exterior, revealing the significance of the plant in Olmec ideology. Yet even farther away, at

41 The Olmec marked passes and other landmarks with their own images, often showing the bundles and backpacks for sacred objects that would affirm identity. Carved on a rock outcropping at Chalchuapa, El Salvador, this image is among the most southern indications of an Olmec presence.

41 Chalchuapa, El Salvador, carved Olmec figures on boulders may have staked a distant political claim. Whatever the content of the bundle, the very presence of Olmecs far and wide raises perplexing questions.

With contacts from Honduras to Guerrero, the Olmecs came close to defining the geographic boundaries of Mesoamerica as the Aztec would perceive them to be years later. They valued jade, feathers, and fine ceramics, and they worshiped the Maize God. But at the beginning of the Late Formative, around 400 BCE, the once-thriving Olmec culture weakened and collapsed for reasons that are still unknown. The first of the great Mesoamerican civilizations to rise, flourish, and fall, it influenced all the civilizations that were to follow.

42 Carved on a rock outcropping along a mountain pass, this Olmec figure carries a flowering bundle, perhaps signaling the agricultural wealth and potential he carries with him to others who would make the journey.

Chapter 3
Late Formative: A diverse Mesoamerica comes of age

Cultural practice and belief spread rapidly across much of Mesoamerica in the Late Formative, roughly 400 BCE to 150 CE, as ideology regarding the Maize God took hold, more and more pyramids hosted shrines at their summit, and skywatchers erected giant chronographic markers. Writing, especially the first steps toward a system of representation that could replicate speech, developed in various locations, while evidence of a unified calendar written in base 20 – as opposed to the base 10, or decimal system – appears in most centers of the day. But while certain expressions of this underlying ideology were repeated from site to site, there was no uniform format to religious practice; round pyramids and shaft tombs in West Mexico bear only a small resemblance to the tombs at Monte Alban. The Late Formative period is one of the least understood in Mesoamerican history, and its art history is accordingly fragmented, driven in many cases by haphazard discovery.

West Mexico
We start by looking at the developments in West Mexico, in part because the ceramic arts from the states of Nayarit, Colima, and Jalisco are among the most familiar works of all of ancient Mesoamerica and are commonly represented in museums around the world. The art of West Mexico is also largely confined to the Late Formative: there are roots, but few successors. Early explorers accumulated vast collections in the nineteenth century, but the lively and often playful representations that characterize West Mexican art had their greatest impact on twentieth-century Mexicans, particularly artists. Diego River and Frida Kahlo, charmed by the folk-art characteristics and seeming absence of elite symbolism in the ancient art, were keen collectors and deployed the works

in their own paintings. While admiring of the tradition, archaeologists and other scholars began to hive off the study of West Mexico, seeing in it a village-based and non-hierarchical society, and thus detached from the Aztec and Maya traditions. Where was the architecture, they asked? Where were the deities?

For the sake of convenience, West Mexican artifacts have been grouped under geographic headings, principally the modern states of Colima, Jalisco, and Nayarit, plus one river, Mezcala, in a way that is quite distinct from the rest of the study of Mesoamerica, which tends to emphasize ethnicity and culture as unifying principles. What links most of these finds together is the context in which they were deposited – the shaft tomb. At anywhere from 3 ft to 19 ft 6 in. (1 to 6 m) below ground level, such tombs consisted of a chamber opening off a narrow shaft. In the chamber lay multiple burials, often deposited over a considerable period of time. Convincing dates for these tombs are rare; most belong to the Late Formative, although the chronological span extends from the Early Formative to the Early Classic. The discovery in 1993 of a complete and untouched tomb in Huitzilapa, Jalisco, revealed that families used their crypts for generations, adding new bodies and offerings through time: a single chamber held over 300 vessels, including many effigies.

But there was indeed more than the life of the dead in West Mexico. At Los Guachimontones between 350 BCE and 800 CE, in the state of Jalisco, a great assemblage of small shrines or lineage houses encircled a round pyramid that rises in sixteen distinct layers, and would have been surmounted by a shrine at the top, and with stairs on all four sides aligned to the cardinal directions. Was it dedicated to the deity Ehecatl, associated with round wind temples at the time of the Spanish invasion? Smaller circles of similar configuration align like gears, connecting to one another along streams and springs. These configurations are memorialized in the many figural groups that perform on round platforms.

Two principal types of figures have been found in the adjacent state of Colima, and they probably reflect a chronological sequence. Flat figures – often considered to be the earlier type – use a slab-and-appliqué technique, with animated postures, and are sometimes grouped together. Better known are the hollow figures of reddish clay, burnished to a high luster, and often spotted with black, white, and gray mineral accretions slowly deposited over the centuries in the tomb. The majority of such figures also double as vessels, whose pouring spouts are usually the tails of the animal effigies. Indigenous hairless dogs were worked in particularly

lively forms: playing, sleeping, even nipping one another.
Others, such as the dog with a human mask, may have had
a meaning that goes beyond anecdotal charm. Headrests
were made in the form of half-dogs and half-parrots, and
the resultant image was of a human head being borne into
the afterlife. Colima potters formed clay into the shapes of
squashes and gourds, the perishable templates for all vessels,
adorned or supported by parrots, turtles, and sliced fleshy
agave leaves, among other natural forms. Most human figures
are males with clubs poised to strike. Like the large figures
in Monte Alban II tombs (see p. 62), they may have warded
off unwanted visitors. The stylized "horn" visible on many
of these male figures is actually the tip of a conch shell, worn
to signify rulership.

Shaft-tomb deposits from Jalisco are stylistically distinct
from other West Mexican ceramics, although not unrelated
technically. The potters of this region produced both small,
solid figures and larger hollow ones. Some of the smaller ones,
with pointed heads, and typically representing musicians and
performers, have been recovered in lively assemblages.

Particularly in Nayarit, many of the objects take architectural
forms, and hundreds of small-scale objects from Nayarit feature
the platforms and temples in plazas; the frequent depiction

43, 44 Scientists at the Gilcrease Institute in Tulsa, Oklahoma, investigate
a terracotta dog with a human mask from Colima (RIGHT). They discovered
that the mask was of modern manufacture, without any of the internal
patination characteristic of the rest of the animal. Purchased in 1952,
the dog with a mask commanded a premium at the time. Great numbers
of native hairless dogs were immortalized in Colima clay sculpture, but the
mask of this one, part of the National Museum of Mexico's collections since
the nineteenth century, makes it an overtly supernatural creature.

of what seem to be houses in fact depict the shrines atop temples and tombs. Most striking among these architectural groupings are scenes of the ballgame, which evidence that by 200 BCE teams of players across West Mexico played a game that shared standard rules and practice. In the first millennium CE, this game would come to be played all across Mesoamerica. A ballgame model in the Yale University Art Gallery is one of about a dozen such scenes, in which players take the court while more than twenty spectators look on. Drummers, men, and women huddle together under blankets or hug children in an artistic expression that captures the warmth of everyday life. No subject is more characteristic of Mesoamerica than the ballgame: in the centuries to come, it would be a subject that unites and even defines that known world.

These models fully relate in costume and action with large, hollow figures from Nayarit. Some are ancestral pairs, perhaps marriage portraits, interred with the dead for sustained veneration. The bright patterning of the ancient textiles worn – and now lost – is recorded in the slip painting of the figures' costumes. The shifts, as well as the small shoulder-bag pouches, donned by Nayarit men were uncommon in ancient Mesoamerica, but popular in the Andes during this period, possibly revealing otherwise undocumented contact along the Pacific coast between North and South America. The couple in the example here may be of high status, to judge by the elaborate ornaments they wear in the ears and nose, and they bear instruments, perhaps to provide musical accompaniment in death. The technology to create these large, hollow figures may well have developed from the skillsets of the Olmec, centuries before.

The drainage of the Mezcala River in West Mexico has yielded a great number of fine stone pieces. These attracted a different category of modern artist, particularly Abstract Expressionists, including Barnett Newman, who owned an example now in the Yale University Art Gallery. The Aztecs coveted these serpentine, granite, and cave onyx (the Aztec *tecali*) carvings so much that they demanded them in tribute and ritually interred them in Tenochtitlan's Templo Mayor. The date of these objects had long been the subject of speculation, but Louise Paradis secured good radiocarbon dates for the Mezcala stonework, confirming the early date (around 300 BCE) that artists such as Miguel Covarrubias suspected intuitively.

Using the same string-saw technology that became common in Costa Rica during the first millennium CE, Mezcala artists produced small temple models in abundance. The temple

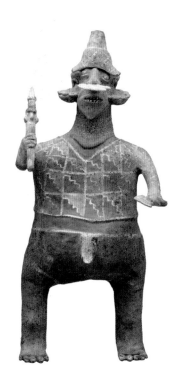

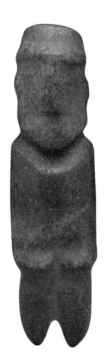

45, 46 OPPOSITE TOP A male and female couple, Nayarit style. Such male–female pairs, in matching clothing, were frequently placed together in shaft tombs, perhaps to accompany interred married couples. The man at top wears a beaver skin on his head, a pelt still associated with shamanic transformation. The woman (RIGHT) wears a pouch across her body, perhaps to hold hallucinogens.
47 OPPOSITE BOTTOM Stone temple model, Mezcala style. Miniatures like this may record the perishable temple façades of long-lost architecture.
48 RIGHT During the twentieth century, artists were drawn to the prehispanic past for inspiration. Diego Rivera collected thousands of objects; Henry Moore studied *chacmools*. Research by Matthew Robb has shown that Barnett Newman owned this Mezcala stone figure.

façades they represent are not matched by the architecture so far known from Mezcala, instead resembling those of, for instance, the Late Formative Mound X at Monte Alban, suggesting a familiarity with developments in Oaxaca. It is interesting to note that similar ceramic temple models have been recovered from Monte Alban II contexts.

After the Olmecs in Mesoamerica

The Olmecs continued to hold sway in some areas of Mesoamerica into the Late Formative, but the great center of La Venta followed its predecessor San Lorenzo into eclipse and oblivion by 400 BCE. Olmec contacts across distant regions apparently broke down; the ceramics of Central Mexico, for example, were no longer infused with the symbolism of elite Olmec culture. Of the major Olman sites known today, only Tres Zapotes enjoyed sustained occupation and development during Late Formative times (that is, 400 BCE –150 BCE) and continuing on for perhaps 200 years more.

Yet there was a minor florescence of Olmec culture in highland Guatemala at this time, and several smaller, but still

colossal, heads were made of local basalt, an Olmec-favored rock. Even more surprisingly, perhaps, it was at just this point that early Mesoamericans made one of their most lasting contributions to New World high civilization: the creation of sophisticated writing and calendrical systems. The very disorder of the period may have fostered the development of a uniform symbolic system that could underpin communication. What linguists call "incipient writing" appears at many locations, although with concentrations in Olman, even in the Middle Formative, as may be seen on the Cascajal block. Our understanding of this writing system begins to develop with its Late Formative manifestation.

The disintegration of Olmec long-distance trade routes probably made it possible for strong regional and ethnic styles of art and architecture to develop under the patronage of independent local elites, perhaps as early as Middle Formative times. It was probably no later than 500 BCE that the Zapotecs first flourished at Monte Alban, Oaxaca, which was to be their capital for 1,500 years. Among the Maya, the first cities of the Peten rose up from the rainforest floor, some as early as 900 BCE, along with substantial seacoast settlements. In recent years, stunning works have come to light from the most ancient Maya cities, where sophisticated paintings reveal a fully developed religious narrative in place no later than 100 BCE.

What made all this growth possible? The end of the first millennium BCE brought swift changes to ancient Mesoamerica – volcanic eruptions would annihilate habitation and agriculture in one part of Central Mexico for a generation. But more importantly, intensive agriculture took root. Although maize agriculture had been a part of the Olmec florescence, archaeologists do not know when corn dough, prepared with ash or quick lime, became a staple foodstuff; it was never a feature of the Andean diet, but it traveled up the Mississippi and is known as grits in the United States. When prepared this way – the process generally called *nixtamal* – maize is far more than a filling carbohydrate: the alkaline materials enrich the amino acids in maize, releasing proteins and making it the key building block of Mesoamerican nutrition. The corn tortilla and tamale made it possible for populations to grow and for city life to emerge. These foods remain at the heart of Mexican and Guatemalan diets today, particularly among indigenous people, but they are readily available in supermarkets around the world as well.

Monte Alban

The most spectacular early development in Oaxaca took place at Monte Alban. Founded by 500 BCE, the Zapotec capital occupied a mountainous outcrop overlooking three important valleys of central Oaxaca, reworked into a great, leveled acropolis. In the first era of occupation, a main axis running roughly north–south was established, and structures were erected to define the main plaza as the ritual core of the city.

Monte Alban has no natural source of water, and one might legitimately surmise that advanced social organization was necessary to sustain a community so high above the fertile valleys. Various theories have been proposed to explain the selection of this remote mountain for settled life, and all depend upon its most important early temple, the Temple of the Danzantes, and the nature of its reliefs. While some scholars have imagined Monte Alban as a site of peaceful unification, others have seen in its early writing and art patterns of conquest and domination in keeping with the political landscape of the rest of Mesoamerica. The Danzantes, or "dancers," were so named in the nineteenth century because

49 Danzantes at Monte Alban. These limp, mutilated figures, long thought to be "dancing," may be sacrificed captives of war. Monte Alban I.

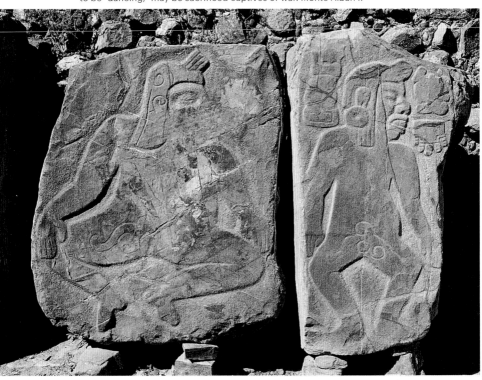

of their free, loose postures. By Late Formative times, over 300 individual slabs were carved with these figures, and about 140 were incorporated into the Temple of the Danzantes. About the same number were set into Mound J, a slightly later structure, and others were reused in later contexts.

In the Temple of the Danzantes, the slabs are set so that some face outward, away from the main plaza, while others line a narrow passageway of the building, and yet others flank the main façade. Some, particularly those called "swimmers," form a flight of stairs. No single figure is arranged with regard to another, insofar as can now be determined. Each slab is unique in its imagery, but all were worked in a simple incised technique with little relief. One assumes that the carver simply followed a charcoal sketch made directly on the stone. Most bodies are shown frontally or in three-quarter view, while the heads are in profile. All are male. Hands and feet hang limp. The closed eyes of most figures indicate that they are dead. Although some retain a necklace or an earplug, they are all naked, an indication of humiliation in Mesoamerica, and scroll motifs streaming from the groin reveal an ancient practice of genital mutilation in Oaxaca. A few figures are accompanied by glyphic cartouches, probably names. In all likelihood, these slabs show the victims of war, a particularly common practice in Late Classic Maya art (see pp. 155–56). If we were to repopulate

50 LEFT Mound J, Monte Alban. From the south, the dramatic, arrow-like positioning of the structure can be seen. Monte Alban II.
51 RIGHT Incised on a slab from Mound J, this glyph for "hill," indicating a place name, includes the upside-down head of a lord, probably recording his defeat.

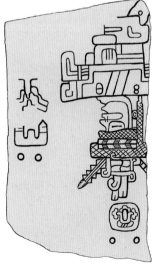

the "swimmer" staircase of the Danzantes, we would see triumphant lords atop their flattened trophies.

Somewhat later, after 200 BCE, the Zapotecs erected Mound J in the center of Monte Alban's plaza. By this time, the symmetrical guide lines of the plaza had been laid out, but Mound J was set prominently off-axis and given an unusual form. The structure looks like an arrow pointing to the southwest, yet its abnormal configuration cannot be observed from the north or east. From the northeast, the building shows only a wall of steps, flanked by broad balustrades. The pointed head of the building is honeycombed with tunnels that are vaulted with stone slabs slanted to touch one another, creating a visual pointed archway but with no structural strength. Both these odd tunnels and the unusual shape of the structure itself have given rise to the idea that Mound J may have had an astronomical function. Some 31 miles (50 km) to the east, at Cabellito Blanco, a structure nearly identical to Mound J has been found, and at zenith passage – when the sun passes directly overhead, such that shadows are not cast – both mounds point to particularly bright stars. If this was a deliberate orientation, then Mound J is one of the first buildings in Mesoamerica that we can consider a giant chronographic marker. Its purpose was to acknowledge the passage of time through an event and – interestingly enough – it appears about the same time as the proliferation of the written calendrical system (see pp. 72–78).

The continued evolution of the writing system is evident in Mound J. A rough incision executed with tight control of the chisel characterizes the Mound J carvings, and is in keeping with a lapidary style common throughout Mesoamerica at the time. On several of the carvings, a human head is shown upside down under a place name, indicating conquest, and the accompanying glyphs suggest a date in the 52-year calendar. The carved slabs, technically similar to those of the Temple of the Danzantes, were set along the façade, the projectile wall, and within the tunnels. On these slabs, although the genital mutilation persists, the figures show more costume details.

Monte Alban was the largest center in Oaxaca during the Late Formative, but it was not unique. To the southeast, at Dainzu, another great mountainous outcrop was the focus of occupation. Here, the main architecture arose on the valley floor, and a large temple structure had inset carved slabs of a similar style and execution to the Danzantes, depicting individuals with masks or helmets, perhaps boxers or ballplayers. Above, on the peak itself, steps and chambers were carved from the living rock.

Monte Alban tombs in the Late Formative

The careful excavation of the tombs at Monte Alban produced a dependable chronological sequence long before radiocarbon testing could provide a second check. Most of the tomb goods from early in the days of Monte Alban were simple offerings of gray-colored ceramics. Strong affinity with Olmec conventions of physiognomy can be seen in the earliest effigy pots, particularly those from nearby Monte Negro. Slightly slanted eyes and a strongly downturned mouth are typical of these early wares. By the end of the Late Formative, the technical qualities that characterize later Monte Alban tomb offerings are evident, particularly in the hollow effigy sculptures made in animal and human forms. Technically, large ceramic figures may have derived from Olmec precedents, like those of West Mexico, and the turn to full-figure representations took root across Mesoamerica, but the imagery is particular to Oaxaca.

A carefully formed large standing figure of this period holds his hands out as if to warn away tomb robbers, and Alfonso Caso found these figures at tomb entrances. Life-size hollow pumas and jaguars wear scarves and adornments, like later Maya deities, indicating the supernatural qualities appropriate for the guardians who would deter potential violators of these entries to the underworld. But the figures represented encompass a wide range of human expression.

Javier Urcid has demonstrated that three nearly identical large, hollow figures of the period – one in Cleveland, one in Oaxaca, and one fragmentary example at the Museo Nacional in Mexico City – have mold-made heads and were probably once members of a set of four. Although often described as scribes, Urcid has dismissed this concept, and points to the similarity with the heads of Maize Gods elsewhere in Mesoamerica, although the slight asymmetry, uneven shoulders, and partly opened mouth seem simply to capture a portrait of a contemplative young man.

Fine pieces of Olmec jade, among them the Kunz Axe, have been collected in Oaxaca, perhaps treasures originally held by early Zapotecs. By the early years of the first millennium CE, the

52 OPPOSITE TOP LEFT Masters of large-scale ceramic modeling, Zapotec clay sculptors conceived here of a supernatural puma. The scarf around the neck probably indicates a sacrificial ritual.

53 OPPOSITE TOP RIGHT The gentle asymmetry of this seated young male figure – alert and attentive, and just over 12 in. (32 cm) tall – draws in the observer, who then turns to study the two incised day glyphs, each marked by the coefficient 13. Two other matches are known for this example, perhaps once altogether a set of four.

54 OPPOSITE BOTTOM An early Monte Alban king was buried with this jade bat assemblage. He probably once wore it on his chest, like the lord of La Mojarra (cf. ill. 66), or as a belt adornment, as demonstrated by later Maya lords (cf. ills 134, 135). Monte Alban II.

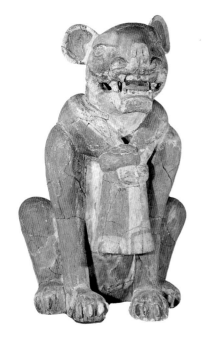

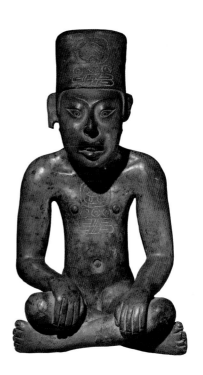

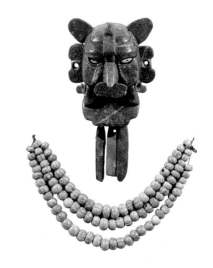

Zapotecs themselves were skilled lapidaries and had secured access to ample jade. One of the most splendid of their works of the Late Formative is the jade leaf-nose bat belt assemblage. This object would have been worn at the waist or chest, the three shiny jade plaques dangling from the belt. (The famous Leiden Plaque was once part of such an assemblage made by the Maya.)

54

135

The Maya region

Exciting discoveries continue to make the links between the Olmecs and Maya both more evident and more nuanced, including the discovery of Olmec materials in early contexts at Ceibal, for example (see p. 44). During the Late Formative, various population centers emerged in which art and architecture of a new style were erected, particularly in the Chiapas/Guatemala highlands, at Izapa, Kaminaljuyu, Takalik Abaj, and El Baúl, and by persons who may not all have been ethnically "Maya." Excavations in the Central Peten – at Uaxactun, Zotz, Tikal, and elsewhere – have shown that settlements had been established at these places by the Late Formative. It was another Peten site, however – El Mirador – which apparently outstripped them in size and importance at this early date. Elsewhere, along the Caribbean coast, Cerros is the best-known site, and paintings of unprecedented complexity have now come to light at San Bartolo, Guatemala, revealing Maya creation accounts from over 2,000 years ago.

Late Formative building materials were often perishable, leaving only large collapsed adobe mounds in the highlands. Moreover, at Kaminaljuyu (with very probably the most substantial highland Late Formative architecture of all), only a handful of structures could be excavated before the modern development of Guatemala City covered the greater part of the ancient ruins. In other locations, later structures still house earlier constructions.

Probably the finest of known highland buildings is the great platform E-III-3 at Kaminaljuyu, which covered two rich tombs, in the pattern that later Maya architecture followed. However, at Cerros, Belize, we see dramatic architectural expressions that participate in the foundations of a new public ideology. Around 100 BCE there was an sudden spurt of building: all previous constructions were razed and new ones, some exceeding 65 ft 6 in. (20 m) in height, were built with clean, new rubble cores. Giant stucco mask façades flanking the stairs are common in these new buildings. The masks seem to display a new, codified imagery, of *k'in*, or sun, symbols in association

55

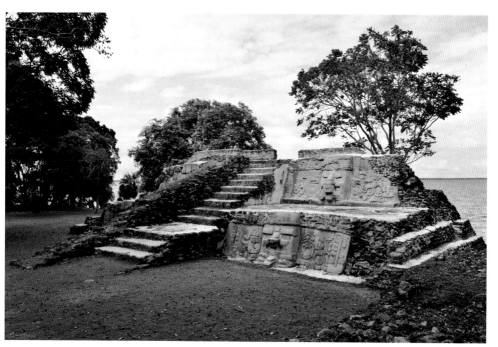

55 At sites across the lowlands, the Maya erected new pyramids with massive stucco decoration. Cerros Structure 5 features huge jaguar heads with solar attributes.

with jaguar elements. This imagery of the Jaguar Sun appears along with other concepts emerging at the time and taking the forms in which they would be recognizable for centuries.

Notions of sacred mountains became central to Maya pyramids, particularly the Water Mountain, the *altepetl*, which we have already seen among the Olmecs, sometimes overlapping with what Karl Taube has called the "Flower Mountain," a place of paradise and emergence. The Plumed Serpent – later known as Quetzalcoatl among the Aztec – must be of great antiquity as well, and is found fully formed among the early Maya, as we shall shortly see. The notion of the Snake Mountain, or Coatepec, had sustained legibility in Central Mexico from Teotihuacan onward. Across Mesoamerica, combined imagery and architecture spread – almost as if it were some new orthodoxy – providing an ideological unity that the Maya in particular would consolidate through narrative art and writing.

At El Mirador and Nakbe, also in the Peten, archaeologists have uncovered vast cities built and abandoned between 600 BCE and 100 CE, testimony to the authority mustered

by early Maya kings, as well as their wealth and power. Some of the largest pyramidal forms ever constructed in ancient Mesoamerica were erected in Late Formative lowland Guatemala, promoting the shared notions of Flower Mountain, Jaguar Sun, Principal Bird Deity, and the Plumed Serpent. Few carved fragments of stone sculpture have been recovered to date, but at Nakbe a nearly complete Middle or Late Formative carved stela depicts two standing figures, or what may well be an early representation of the Hero Twins. At El Mirador's demise, when Tikal and Uaxactun were already growing into powerful polities, El Mirador's enemies may have stormed through the center of the declining city, smashing every sign of its former glory.

Luckily, some structures were buried intentionally within later ones before this targeted destruction took place. In 2001 archaeologist William Saturno found himself in a looter's tunnel in what is now called San Bartolo Structure 1 (Pinturas), Sub-1 chamber, in northeast Guatemala. His flashlight came to rest on two painted figures, just a small part of what was found to be a much larger group of murals. Some portions were carefully chipped off the wall, piled in stacks, and others intentionally buried. The paintings are uniform in style and pigments, arguing for a single phase of painting around 100 BCE. Set over halfway up the wall, the paintings ran about 3 ft (1 m) high, and the unusual post-and-masonry roof may have remained at least partly open to facilitate the process of painting. The figures are about one-third life size. The north wall depicts the birth and dressing of the Maize God in a

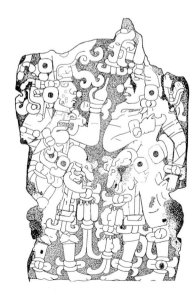

56 Stela 1, Nakbe. These two carved figures may be the earliest Maya depiction of the Hero Twins to survive. At left, the figure with jaguar pelage on his cheek may well be Xbalanque, facing his brother Hunahpu. Middle/Late Formative.

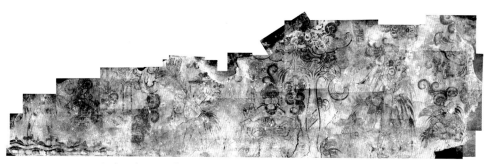

57 Archaeologist William Saturno directly scanned the west wall paintings of Structure 1 at San Bartolo and stitched them together to reveal a stunning scene of sacrifice.

typical Olmec style, attended by four maize goddesses; the west wall shows the systematic sacrifice of blood from the penis by four lords in supernatural guise, at four world trees, with four sacrificial offerings (deer, flowers, turkey, fish), topped by four Principal Bird Deities. A fifth world tree stands apart, attended by the Maize God: this tree marks the cosmological center, while the other four indicate the cardinal directions.

A seasonal god, the Maize God dies only to be reborn and to serve as human sustenance: he is eternally youthful, and the ideal of human beauty. Rendered in slim, lanky proportions, and standing taller than any other figure, the red-painted Maize God of San Bartolo has strong Olmec facial features, an intentional reference by the Maya painter to the antiquity of the deity and his life in their present. The San Bartolo paintings are important in many respects, but first and foremost, they make it obvious that the heart of the Maya religious narrative – the story of the Maize God and his cosmic setting – was intact in 100 BCE. Along with the Ceibal discoveries, they reveal a Maya familiarity with the Olmecs that scholars had only guessed at before.

The San Bartolo murals also remind the modern-day viewer that painting may well have been the principal medium throughout ancient Mesoamerica, whether on paper, in books, on ceramics, or on walls. These paintings are not hesitant first attempts, but full-blown – dare one say? – masterpieces that speak in turn to a yet deeper background. One can see here that narrative art, with obvious sequence and story, is making not just a debut but a confident appearance. In the context of the murals' complexity, many sculptures of the period now make more sense, as if an entire underlying cultural and narrative stratum has been revealed.

The story of the Maize God goes hand in hand with that of the Hero Twins: they are the Maize God's children and the actors who bring him back to life at the end of the dry season. They are also skilled masters of the ballgame, suggesting that its performance had taken hold by this time as well, and the spread of the ballgame continues during later periods, inculcating the ritual everywhere.

New developments – and a shared new ideology – also swept across the adjacent Guatemala and Chiapas highlands, built in large part on Olmec forms. Boulder carvings – the ones most likely to have had Olmec precedents – were made at many sites, but other forms, particularly the stela, a late Olmec invention, now paired with an accompanying altar, predominated at Izapa, Kaminaljuyu, and Takalik Abaj.

Later Maya reset the monuments of Izapa, but most of the stelae and altars there were carved during the Late Formative. Many of the altars appear in the shape of large toads or frogs, symbols of the earth. An additional segment of Mesoamerica's religious narrative appears on the Izapa stelae, all representing part of the shared cosmology that would be recognized by the time of the Spanish invasion. Stela 21, for example, depicts a standing figure, one arm ripped from his body, who appeals to the Principal Bird Deity perched in a caiman tree, an apparent rendering of the story of the Hero Twins and Vuqub Kaquix from the *Popol Vuh*, as written down in the mid-sixteenth

century. On Stela 1, Chahk, god of rain and lightning, stands

58 Izapa Stela 1 and Altar 1. Fishing creel on his back, Chahk the Rain God stands in water to net his catch. Altar 1 suggests the toad-like earth.

in water and fishes with a net, his already well-stocked creel on his back. As the god of storms, Chahk was the patron of fishermen. In this early representation of one of the most important Maya deities, Chahk already has his characteristically reptilian snout, a feature he would bear into colonial times. A millennium later, on a pair of bones found at Tikal, three squabbling Chahks catch fish in their bare hands, and store their catch in similar creels. That rather humorous depiction of the eighth century CE can be juxtaposed with the sober Stela 1, which stood on the main plaza of Izapa with a paired altar that in this case took the form of a giant toad, symbolizing the earth. Embodied rain and lightning, then, rose up behind the toad, piercing the untamed natural world. Other Izapa stelae feature rulers embodying the Principal Bird Deity; Stela 5 depicts a mythic origin from a central tree. This world tree can also be seen in light of the San Bartolo works: centuries later, this notion of human origins from a "world tree" was well known, appearing in manuscripts of the sixteenth century. Dense and difficult to decipher, the scene on Stela 5 may be designed for oral reading, with components recorded as if in simultaneous narrative. Other stelae depict deities and heroes that would play a role in later religious narratives. Izapa stelae emphasize mythological or supernatural settings, but rulers probably are important here as well, marked by size and scale, and commanding authority in both civil and religious arenas.

Borders above and below the Izapa scenes would seem to mark heaven and earth, quite possibly the first use of such conventions, although they emerge simultaneously at Kaminaljuyu, and they may yet come to light at San Bartolo. The rectilinear "hill" sign introduced in this era would take its most characteristic form in the Late Postclassic, where it is a standard component of place names recorded on early colonial tribute lists, suggesting the importance of specificity of location to these Late Formative lords.

The greatest florescence of the Late Formative in the highlands took place at Kaminaljuyu, where the richest burials of the era have been recovered, and many monuments have been found in its style over a 50-mile (80-km) radius. Extremely hard rocks were mastered by Kaminaljuyu artists, who may have sought to make a durable message to the future. Finely carved stelae at the site show both supernatural figures and humans. Some of these forms are worked in silhouette with cut-outs, a novel style of very limited distribution. Massive thrones may have recorded systematic genealogies, as on Monument 65. Stela 10 features a long and as-yet undeciphered

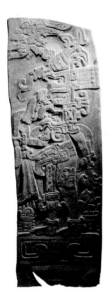

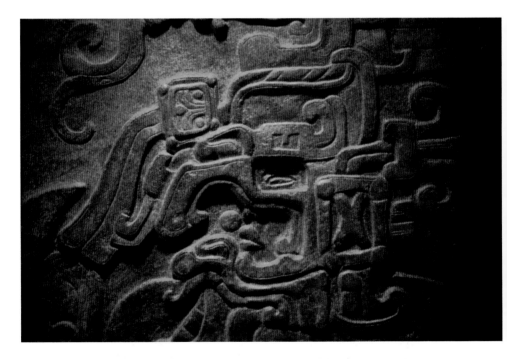

59, 60 TOP LEFT AND BOTTOM (DETAIL) Stela 11, Kaminaljuyu. The standing warrior appears in the guise of the Principal Bird Deity. He stands on a place sign, and his feet are framed by blazing censers. Late Formative.

61 TOP RIGHT Monument 65, Kaminaljuyu, a sequence of three enthroned lords, each of whom receives abject captives. This surface of the stone served as a throne itself.

62 Stela 5, Takalik Abaj, shows two standing lords – perhaps an ancestor and a ruler, as on later Maya monuments – who flank a legible pair of dates, each running top to bottom, using bar-and-dot numeration, noting 8.4.5.17.11 at left and 8.2.2.10.5 at right, dates in 126 and 83 CE, respectively.

59, 60 text, but composed with some recognizable syllables. Stela 11
 depicts a standing lord dressed as the Principal Bird Deity, like
66 the roughly contemporary ruler at La Mojarra, Veracruz. But he
 could also be understood in light of the San Bartolo paintings,
 where an individual like this one is splitting a gourd with an
 axe. His eye peers out from the mask, and his cape flares out
 behind him, as if wings. An ancestor floats in the sky, and two
 smoking braziers rest at his feet. His deeply carved feet press
 into the toponym he stands on, and the lifelike and life-size
 knapped surface of the hafted blade at right reveals a skill at
 carving in stone that the lowland Maya did not achieve until
 centuries later.
 At Takalik Abaj, stone monuments were also erected in stela/
 altar combinations, as they were at Izapa, but the imagery
 differs. Stela 2 shows two figures flanking a central column
 of text with a Cycle 7 (that is, before 41 CE) date. Like La Venta
29 Stela 3, Kaminaljuyu Stela 11, and the Early Classic portraits
 of Tikal, the upper margin has a supernatural figure. The two
62 humans below were probably historical figures. On Stela 5,
 two persons also flank a column of text, in this case a
 legible Long Count date of 8.4.5.17.11, or 126 CE (see p. 76).
 The impossible posture of frontal torso with profile legs
 and face was a widespread convention that was, within a
 few generations, to prove typical of Maya representations.

The second century CE brought an end to these achievements in the Guatemalan highlands, and the focus of progress shifted to northern Guatemala, where a new iteration of Maya culture began to take shape in the lowlands. From the forms established at Izapa, and already known in the lowlands, the Maya derived mythic imagery; from Takalik Abaj, the conventions of historical portraiture. When the Early Classic emerged in full flower at Tikal and Uaxactun, it clearly drew upon precedents in the highlands for sculpture and from the Caribbean coast and El Mirador for architecture. Indeed, in most of Mesoamerica, first-millennium CE achievements in art and architecture were founded upon those of the Late Formative.

Central Mexico

During Early and Middle Formative times, an Olmec presence had made a profound impact on sites – and their grave goods, in particular – in the valleys of Central Mexico, but this presence ended in the Late Formative period. These established centers were not cities, and they did not have major ceremonial centers. At Tlatilco, for example, during the Late Formative period, figurines continued to be made; to the west, at Chupicuaro (now under an artificial lake in Guanajuato), charming figurines and vessels with distinctive red geometric slip patterning were produced, with material and visual relationships to West Mexico, where this chapter began.

By 100 BCE at the latest, two new centers had emerged in the Valley of Mexico: Teotihuacan to the north, and Cuicuilco to the south, the latter essentially surrounded by the high-end shopping center PeriSur. Positioned like rivals at extreme ends of the Valley, each grew dramatically in size and population. At Cuicuilco, a huge round platform (443 ft or 135 m in diameter at the base) – grander than the contemporary examples at Los Guachimontones, to which it may be related (see p. 53) – was the focus of construction, rising in four concentric tiers like a giant wedding cake. About 50 BCE, the volcano Xitli erupted, burying much of Cuicuilco. Another eruption occurred about 150 years later. Like Pompeii's population of 79 CE, the people of Cuicuilco fled. Teotihuacan no longer had a rival, and it grew rapidly in power and size. We will return to this great center in Chapter 4.

Writing and calendrical systems

The roots of all Mesoamerican calendrical systems – highly varied though they subsequently became – lie in the Late Formative era. Two such means of recording time, the 260-day calendar and the 365-day calendar, evolved at the very

beginning of the period – and perhaps a little earlier – and were generally used simultaneously. In terms of intellectual achievement, however, the most important system was a slightly later development: the continuous record called the Long Count, used in conjunction with the 260- and 365-day calendars. Its successful manipulation required the understanding of the concept of zero. Although the lords of Central Mexico, from Teotihuacan to Tenochtitlan, must have known of this count, they chose not to use it, a rejection that is surely meaningful. Nevertheless, an appreciation of the intricacies of all three systems as they appear in ancient inscriptions is necessary, not only to help us date monuments, but also to understand the concepts of time and thought expressed in Mesoamerican art and architecture.

Among all Mesoamerican calendars, the 260-day cycle is the oldest and most important. Stone monuments in Oaxaca indicate its use as early as the sixth century BCE, when Zapotecs began to chart achievements publicly, and it is still employed in Guatemala today for ritual divination. Indeed, use of the 260-day calendar effectively defined the limits of high civilization in ancient Mesoamerica and provided an aspect of cultural unity. Yet its origins have remained obscure. Some have noted that 260 days is the period of time that elapses between solar zenith passages (when the sun lies directly overhead at noon) at a latitude of fifteen degrees north – the latitude along which the important sites of Izapa and Copan (see pp. 6–7) lie. Zenith passage is a phenomenon that is relatively easy to observe in the tropics, but it seems an unlikely basis for a calendar first recorded to the north of the fifteen-degree latitude. A much more fundamental unit of 260 days in the human life cycle is the length of gestation, from first missed menstrual flow to birth. Mesoamerican peoples were named for the day of their birth in this calendar, and were perceived as having completed a 260-day round at birth. Midwives, rather than astronomers, may have launched this calendar.

The 260-day calendar was not subdivided into weeks or months as our year is, but into a cycle of twenty different day names. Counting systems around the world on the whole use a base of either ten or twenty depending upon whether fingers or fingers and toes are used, and throughout Mesoamerica the base was vigesimal rather than decimal. But the twenty day names were also associated with a cycle of thirteen day numbers, which ran at the same time. Each day, therefore, had one of twenty day names and one of thirteen day numbers, so the cycle would take 260 days to complete.

63 The calendar governed life outcomes: those born on the day 2 Rabbit would be drunkards, according to the Florentine Codex of 1577. Here, men drink with straws – likely a prehispanic invention – from a fountain adorned as a rabbit. The curly and disorderly hair of the drinkers is juxtaposed with the neat hair of the others.

This cycle always had its own name in various Mesoamerican languages: the Aztecs, for example, called it the *tonalpohualli*, and the written version of the cycle – the fundamental tool of the diviner – was called the *tonalamatl* (*amatl*, or *amate* in modern Spanish, refers to the fig-bark paper on which such a manuscript was often written). The 260-day system is the "almanac" of Mesoamerican calendrical cycles.

Children were named for the day on which they were born in this cycle – 13 Monkey, for example, in the *tonalpohualli* – and the diviner or calendar priest was consulted to study the augury both for that day and for the period of thirteen days within which it fell. According to the Aztecs, some entire such periods were afflicted by either certain shortcomings or gifts. Those born under the period of 1 Death, for example, would suffer drunkenness. To try to alter the prediction, a naming ceremony was often held on a more auspicious day.

In conjunction with the almanac, a 365-day calendar was used. This corresponded roughly with the solar year, and was divided into eighteen "months" of twenty days each, plus five "nameless" days at the end of the year. Each group of twenty days had its own month name, and was linked with a number from 1 to 20 or 0 to 19, depending on the region. Each year took a name, usually the day name and number of the day in the 260-day calendar that coincided with the 360th day of the solar calendar. Because of the nature of the calculation, only four days can be "yearbearers." These four day names were paired with coefficients 1 to 13, yielding a 52-year cycle. There is no evidence that the approximate solar year was ever corrected

63

64

in the calendar to allow for the extra days that accumulate in the true tropical year, but the Maya calendar priests at Piedras Negras, Guatemala, noted true tropical anniversaries in their records. This was a problem addressed by Julius Caesar in 46 BCE in Rome, through the creation of a leap day. Without the addition of leap days, the 365-day calendar drifted backward slowly through the seasons, roughly stepping back 13 days during a 52-year cycle, eventually passing from one season to the next, and requiring movable agricultural feasts.

The 260-day calendar was perhaps the most basic to Mesoamericans. It is the first one for which written records survive, and it is the one still in use today among some Highland Maya. It is composed of twenty day names (outer wheel) and thirteen day numbers (inner wheel), both of which rotate endlessly. It takes 260 days for all the combinations to occur.

The 365-day calendar is composed of eighteen months, each of which has only twenty days, numbered 0–19 or 1–20, depending on the region, and the five unlucky days (known as Uayeb among the Maya). In this larger wheel, the end of the month of Cumku and the five unlucky days (the Aztec called them *nemontemi*, or "nameless" days) are shown – other month glyphs are at right.

Here, 13 Ahau (left) and 18 Cumku interlock. It will take 52 × 365 days (in other words, 52 years) before the cycles will all reach this point again. This is the calendar round.

When the 260-day and 365-day calendars were set in motion, it took exactly 52 years of 365 days for a given day to recur. The end of this 52-year cycle was widely celebrated, particularly by the Aztecs, who held a New Fire ceremony at its completion. The five nameless days which preceded the end of the cycle were especially dangerous: the gods might choose that moment to end life on earth. Certain behavior was required: all pots had to be smashed, pregnant women kept indoors, and fires doused. At midnight before the first day of the new year, a sacrificial victim

64 All Mesoamerica observed the 52-year cycle, created by the intermeshing of the 260-day calendar (LEFT) and the 365-day calendar (RIGHT). It is drawn here as a system of interlocking cog wheels and follows standard Maya notation, although the days and months had different names and symbols in each culture.

had his heart ripped out, and there, in his open chest, a flame was started with a fire drill. The burst of light assured the light of the morning sun and the opening of a new 52-year cycle.

The calendrical systems described so far were based on relatively short periods of time that could be easily related to human experience. Over longer periods of time, dates in the calendar round may have been difficult to order chronologically, since any given year name recurred once every 52 years. The use of the last two digits of our calendar produces a similar effect: is '19 a reference to the Spanish invasion of Mexico, or to the imprint date of this edition of this book? At some point during the Late Formative, perhaps to eliminate just such ambiguity in historical records, another calendrical system, the Long Count, was introduced, and it was perfected by the Maya in Classic times.

Long Count dates record the complete number of days elapsed since a starting point corresponding to a date in 3114 BCE in our calendar – hence the alternative modern name, "Initial Series" for these dates. The Maya later held that the "zero" date fell within an era of divine activity (as, incidentally, does the "zero" date in our current calendrical system). But even this starting point was no blank slate, but rather the end of a previous grand cycle. For the Maya, the first day of the calendar, 4 Ajaw 8 Cumku, was also the last day of the old cycle. On this day, the gods set three hearthstones of creation in place, giving rise to the era of civilization, so the Maya believed.

In the Long Count, time was normally recorded in periods of 400 years, 20 years, years, 20 days, and days – i.e. to five places running from largest to smallest, much as we record our years to four places, e.g. 2025. The Mayan date 9.10.0.0.0, for example, records the day 22 January, 663 CE. In the vigesimal (rather than decimal) system the places "fill" at 20, although in the "20-days" space, second from right, the count fills at 18, noting a calculating period of 360 days. Most dates recorded archaeologically begin with the coefficient 9, referring to the 400 years (of 360 days each) from 435 to 830 CE. After 13 periods of 400 years, a new grand cycle begins. The current one launched on 23 December, 2012.

The achievement of the Long Count was the ability to pinpoint events in time without ambiguity. Particularly for the Maya, this very record was a focus of artistic achievement, and Maya artists transformed what could have been simple notations into beautiful works of calligraphy. Although other cultures must have known of the inscribing of these dates with their formulaic notations of time, only in the late Olmec culture and among the Maya did the practice take root.

65 The Maya used three basic symbols in their numbering system: a dot for one (a), a bar for five (b), and, to represent the null cipher similar to our zero, a Maltese cross (d) on stone monuments and a stylized shell (e) in the codices. The number six, for example, was made up of a dot and a bar combined (c) – the space either side of the dot being filled by so-called "spaceholders," which are not counted. As well as this standard notation, the Maya sometimes introduced a head or full figure as variant: the number nine, for instance, in its common form (f) also appeared as the head in (g) or the full figure in (h).

65 Long Count dates can be easily read. They were always placed at the beginning of inscriptions and recorded in a system of bar-and-dot numeration, in which the bar equals five dots. The development of the null cipher, a placeholder similar to our zero, was a crucial step forward intellectually. In the history of mankind, it was achieved only in the Indo-Arabic and Mesoamerican numerical systems. The Maya generally represented this symbol as a cruciform, perhaps derived from the human body with all four limbs outstretched, indicating the twenty digits. In late manuscripts, a shell is used for the null cipher, and in Maya inscriptions a head or full-figure variant could be substituted. With place notation of this sort, Mesoamericans could have also kept track of large numbers of things, whether cacao beans or warriors, and added, subtracted, and multiplied them. It's worth noting here that the cumbersome Roman system of numeration was inherently limiting to the sorts of calculations and accounting possible, whereas the Maya did real math. The earliest known Long Count date is 36 BCE, recorded on Stela 2 at Chiapa de Corzo. The cessation of the system in the tenth century (909 CE at Tonina is the last Long Count date known) generally marks the close of the Classic era. The *k'atun* (the period of twenty years) count persisted up to the sixteenth century, thus allowing a correlation to be established between the Mesoamerican and European systems.

An accurate calendar that can be correlated to the modern one is invaluable to the art historian and archaeologist: when inscriptions are present, the calendrics precisely document Maya chronology in a way not known elsewhere in the New World. A subtle difference of style between monuments,

66 LEFT Worked of fine, dense limestone, this stela from La Mojarra features a lord in the elegant attire of the second century CE. The Principal Bird Deity imagery evident in the headdress also prevails on other monuments of the period.
67 RIGHT Lintel 8, Yaxchilan. Bird Jaguar, at right, captures "Jeweled Skull," whose name is emblazoned on his thigh and at the bottom of the column of glyphs at left. Bird Jaguar's name is the second in the column of glyphs at far right, and it is followed by the Yaxchilan emblem glyph. 755 CE.

for instance, can be shown to reflect as little as a ten-year difference in their erection, and this knowledge can be used subsequently to date monuments and ceramics without such calendrical inscriptions, even those outside the Maya area.

The Maya recorded hundreds of dates, generally of the first millennium CE, but on occasion they reckoned mythological dates deep into the past and future. In some inscriptions, calendrical information can occupy one-third to one-half of the glyphs. Non-calendrical writing first appeared during Late Formative times, both in association with and independent of calendrical statements. Glyphs occur with human figures, perhaps as names or events, and in long passages. Some of the earliest Maya inscriptions, however, are recarved Olmec objects, as if an Olmec heirloom were later worked with a new owner's name. Characteristically, Maya lords named things new and old,

inscribing, for example, "my earspool" on a jade earflare that must have been especially prized.

The 1986 recovery of a huge carved stela from La Mojarra in Olman, the region thought of as the Olmec "heartland," revealed previously unknown sophistication and skill in early writing during the Late Formative. Two Long Count dates run in columns at the center of the monument, recording dates in 143 and 156 CE. Although signs and some syntax can be recognized, they cannot yet be "read" and deciphered. Adorned in the headdress of the Principal Bird Deity, the standing lord wears regalia that the Classic Maya would subsequently emulate, including the celt assemblage on his chest.

When John Lloyd Stephens visited the Maya area in 1839, he found inscriptions that he accurately recognized as a single system used from Copan in the south to Chichen Itza in the north. Writing in the era when the Rosetta Stone was decoded, Stephens felt sure a scholar would one day read names and places of the ancient Maya kings. But after the decipherment stalled with the decoding of calendrics, the decipherment of Maya writing became political, and leading scholars argued that ancient Maya had been peaceful timekeepers, rather than flesh-and-blood leaders. This is a story Michael Coe has told well in his book, *Breaking the Maya Code*. In Coe's account, Tatiana Proskouriakoff is one of the heroes, confronting the powerful grip Sir Eric Thompson held on the study of Maya hieroglyphics. A look at Yaxchilan Lintel 8 shows why she began to suspect that such inscriptions had historical content. A skull within a beaded cartouche is inscribed on the thigh of the captive at right: this same glyph appears as the fourth glyph in the text above it, at left. The first two glyphs yield a date in 755 CE; given modern Maya syntax and the frequency of the third glyph in passages associated with armed men and captives, Proskouriakoff then hypothesized that the third glyph was a verb, probably meaning "to capture," since that activity is depicted. To the right, the text continues, where the final glyph could already be identified as a Yaxchilan emblem; the glyph preceding it is a jaguar head with a small bird superfixed. Based on its frequency in texts dating from about 750 to 770 CE, Proskouriakoff proposed this glyph to be the ruler's name in that era, and she called him "Bird Jaguar." Thus, if we ignore the caption material that appears in the middle of the scene, the text might be paraphrased: "On 7 Imix 14 Tzek [in 755 CE] was captured Jeweled Skull by Lord Bird Jaguar, of the Yaxchilan lineage."

By this time, studies had also been completed by Yuri Knorosov in St. Petersburg, who was able to show the phonetic

values of many glyphic elements. Unlike Proskouriakoff, Knorosov took the sixteenth-century manuscript of Diego de Landa, bishop of Mérida, and the three Postclassic Maya manuscripts surviving in Europe as his focus of study. Landa had asked an educated Maya source to write Maya characters beside the letters of the Spanish alphabet. In this way, some thirty-odd Maya glyphs had been written down. Knorosov used these to begin to determine the phonetic value of the texts.

The "capture" glyph in the passage decoded by Proskouriakoff was one to which Knorosov had already turned his attention. He read the three elements of the third glyph of the column at right as *chu-ca-ah*, or *chucah*, a word used in many Maya languages today for hunting. With the publication of Proskouriakoff's work, the phonetic interpretations of Knorosov began to gain acceptance. A full decipherment was under way, and it continues apace even as I write these words.

The interplay between writing and art has led to productive scholarship among art historians and anthropologists alike. As David Stuart first demonstrated, on a panel from Emiliano Zapata, the glyph for "yellow" labels the stone that the seated lord carves; the words "yellow stone" appear directly overhead in the inscribed passage. Maya glyphs were the foundation of the ancient viewer's cultural literacy, which spanned image and text.

Decipherment is particularly challenging when the corpus is small; there are thousands of Mayan texts and relatively few of other scripts. The Zapotec writing system was also used to record names and places, and most examples come from the Late Formative. Names were indicated by their position in the 260-day calendar, and the places recorded were those conquered by the successful lords of Monte Alban. Later Mixtec manuscripts, many made around the time of the Spanish invasion, used logographs, or word pictures, to record genealogical histories. Names are either the calendrical day names or logographs, which first appear attached physically to given individuals, almost like cartoon bubbles, such as the six dots and the head of a primate, to be read 6 Monkey, a great heroine. Events are symbolized by widely understood signs: an umbilical cord denotes birth, a couple seated on a reed mat marks marriage. With this kind of record, the reader must provide the words to a story for which places, dates, events, and persons are specifically indicated.

Among the Aztecs, dates and logographic writing also prevailed. Writing was used by individuals for divining manuscripts and genealogies and by the state for keeping track of the tribute collected from the whole of Mesoamerica. At the time of the Spanish invasion, Aztec writing had developed substantial phoneticism, which continued to develop under

68

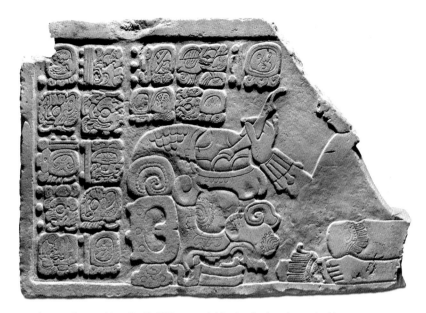

68 After a Palenque king died in 702 CE, a neighboring lord took up a tool to carve a "yellow [the word yellow is embedded in the forehead] stone [the monstrous head is the word for stone]," as the text also records.

Spanish rule, even as Nahuatl scribes quickly adopted the Roman alphabet. New situations may have driven linguistic developments: a map at Yale University's Beinecke Library, for example, features phonetic names for local lords, including the image of a banner, *pan*, against a background of salt, or *itza*, yielding Itzapan, or the Spanish name Esteban, as Gordon Whittaker has shown. Multiple female landowners were tagged by the Aztec glyph of twisted cords, or "ma," indicating the Christian name Maria.

Effective as these scripts were, no system replicated the sounds of speech in written form the way the Mayan script did. The elegant poetry recited by Aztec nobility was not written down until the introduction of the Roman alphabet, but when a Mayan text from the eighth century CE is read today, these are the very words, the sounds, the phrasing even, that authors set down 1,300 years ago; what had once been lost is returned to life, and with it the articulation of the meanings and beliefs inherent in Mesoamerican art.

Chapter 4
Teotihuacan:
City of fire, city of water

We know the greatest city of all Mesoamerica by the name
Teotihuacan, "the place of the gods," as the Aztecs would later
call it. In recent years, the signature buildings of Teotihuacan
have not changed, nor has its characteristic grid, nor have the
tripod vessels that signal the long reach of Teotihuacan traders
and the powerful attraction of the goods manufactured there.
But much has changed in what is known of Teotihuacan's
material world, as revealed by the most recent archaeology,
transformative in the twenty-first century. Even at distant
Copan, Honduras, Maya lords referred to Teotihuacan as "Pu,"
or the "Reed" place. This is a translation into Maya of Tollan, as
Teotihuacan was known both in its own day and in memory, as
a Rome and a Jerusalem, but also a Troy to those who never saw
the abandoned ruins. To all Mesoamerica and perhaps beyond,
the city was legend in its own time.

Centuries after the site's abandonment, the Aztec ruler
Motecuhzoma II made regular pilgrimages there, traveling
by canoe across Lake Texcoco to follow a well-established
route that linked his city, Tenochtitlan, to Teotihuacan and
to valuable resources beyond. The invading Hernando Cortés
and his men would pass near the site on their march to the
Aztec capital, although no chronicler of the invasion made note
of the ancient city. Teotihuacan's greatest pyramids, and its
powerful north–south axis, or "Way of the Dead," are all known
by the names given to them by the great successor civilization,
the Aztec; colonial maps marked Teotihuacan's two greatest
pyramids with a sun and moon.

Decades of archaeological research have produced one vision
of Teotihuacan after another, starting with the reconstruction
of the Pyramid of the Sun for the 1910 Centennial of Mexico's
War of Independence; narrow-gauge railroad could then bring

69

visitors easily to what quickly became – and remains – Mexico's most important ancient destination, with well over three million visitors annually at the time of writing. Restoration of the Temple of the Feathered Serpent ensued, to be followed by the investigation, excavation, and reconstruction of residential compounds and the discovery of programmatic paintings lining the walls of spaces for the living. In the 1960s, while the exterior of the Pyramid of the Moon was under reconstruction, René Millon and his team produced the single most detailed map in existence of any Mesoamerican city, and demonstrating unequivocally that Teotihuacan *was* a city, not a shrine. In 1971, workmen installing wiring on the Pyramid of the Sun for its sound and light show fell down a hole, revealing a remarkable tunnel running underneath the huge building. In the 1990s, Saburo Sugiyama led a project that produced shocking discoveries of great numbers of sacrificed warriors within the Feathered Serpent Pyramid. Ruben Cabrera, Leonardo Lopez Lujan, and Sugiyama subsequently launched a full-scale exploration of the Pyramid of the Moon, to be succeeded by Sergio Gómez Chávez, who continues to lead the explorations, with what are the most astonishing discoveries to date. These most recent excavations have brought to light major tombs, mysterious tunnels, and repurposed body parts, finally making it possible to ask the questions, even if no answers are forthcoming: what was Teotihuacan? How was it conceived of and built? Who ruled it, and *how*?

70

69 Drawn and colored late in the sixteenth century, the Map of San Francisco Mazapan clearly depicts the Teotihuacan Pyramid of the Moon at lower left, part of a landscape that includes paths and roads for human movement, marked by footprints, Christian buildings, and indigenous elite leaders.

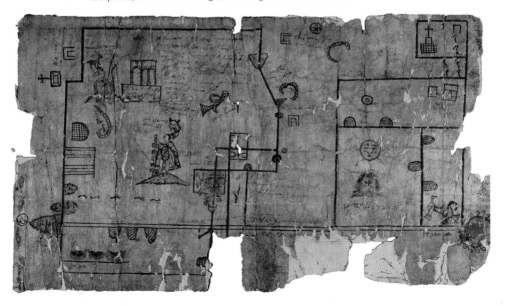

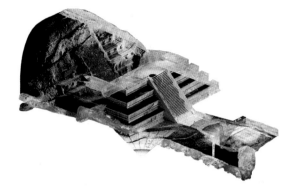

70 Since 2003, archaeologist Sergio Gómez Chávez has led a team of excavators deep into the ground, following the man-made tunnel that leads to the heart of the Feathered Serpent Pyramid. The tunnel ends in pools of mercury, where four figures stood at the liquid's edge.

Although the Maya peoples to the south were long ago acknowledged to have had independent, hereditary kings who commissioned vast building projects, stone monuments, and tiny precious works, the notion of such rulership has resisted traction at Teotihuacan. Key questions remain about Teotihuacan, including the very ethnicity of its powerful, urban population, and so the current campaigns of archaeology have much to tell us. With the raw evidence of power marshaled in the control of the life and death of hundreds, if not thousands, of other humans, alongside the discovery of great tombs, the hand that ruled the site no longer seems invisible. The first millennium CE, when dozens of Mesoamerican cities flourished and when cultures across the continent thrived, is shaped by the rise and, ultimately, by the fall of this great city. Sitting astride the narrow waist where the Valley of Mexico and the Valley of Puebla converge, Teotihuacan's fortunes were never private.

Excavations since 2003 have yielded over 100,000 objects, dizzying in their similarities but also in their individuality. But perhaps no single sculpture encapsulates the city as completely as does the largest freestanding Teotihuacan sculpture, the

71 great female figure discovered long ago in rubble between the Pyramid of the Moon and the Palace of Quetzalpapalotl. Nineteenth-century explorers thought she had once been atop the Moon itself, and she may well have presided there until Spanish invaders toppled her from her dominant position in a campaign against idolatry; her thick, stable base was intended to keep her in position forever. In her architectural form, in which the line of her hands bifurcates the andesite prism, she is like a building itself: one can draw lines from her chin to her feet, giving a pyramidal form topped by the massive head and clefted headdress. Atop the Moon, the cleft in the sculpture's head would have been aligned with the depression in Cerro

Gordo, the mountain behind the pyramid, a dead volcano with a sunken cone. As the figure brings her hands to her body, she seems to wring water from her *huipil*, or upper-body garment, as if releasing water upon those who venerate her. The cleft in her head recalls Olmec works, but the "blockiness" bears little resemblance to the plastic three-dimensional Olmec sculpture. A cavity would have held an embedded jade or obsidian, activating her divine status. Like the Aztec maize and water goddesses who succeed her, this water goddess portrays beautiful woven textiles in stone form.

If not a unique sculpture atop the Moon, she may have belonged to a set that also included a badly battered but less orthogonal sculpture that remains in the Moon Plaza today. Female, also with a cavity for a stone, and perhaps a successor to the earlier sculpture, this figure was possibly of Aztec manufacture. The Aztecs turned to earlier sculptural forms time and again, in dialogue with their illustrious predecessors. That these figures and forms of Teotihuacan were widely known, initiating part of a pan-Mesoamerican phenomenon, is attested by their presence in contemporary Veracruz and among the later Aztecs. When the Aztec made their set of colossal female deities – including the great sculpture usually known as Coatlicue – for Tenochtitlan's Templo Mayor, they may have been looking back to these very sculptures (see pp. 255–56).

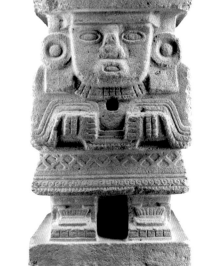

71 Powerful in her rigid geometry and masked face, the so-called "Great Goddess" is the largest sculpture found at Teotihuacan. The cavity at her breastbone may have held a jade or obsidian inlay.

Architecture

Random settlement during the Late Formative included elaborate cave precincts, perhaps occupied by refugees fleeing volcanic eruptions to the southwest. At the time of the millennium's dawn, an architectural mastermind – or a cluster of them – launched a new idea. From the entry to the subterranean passage constructed and carefully dug to a point under what would be the Pyramid of the Sun, a siting line aligned with the steps of the pyramid was drawn that linked the pyramid, the rising of the Pleiades during the two annual passages of zenith, and the arc of the sun across the sky at that same occurrence, forming a powerful, yet invisible, east–west axis. Perpendicular to this alignment was drawn another great axis, called the "Miccaotli," or the "Way of the Dead" by the Aztecs, running north–south and terminating at the mountain today known as Cerro Gordo. By the end of the first century CE, these two axes, one firmly material and underground, the other invisible but ordained by the sky, had determined the grid that informed all positioning at Teotihuacan, with ritual focused at the Pyramid of the Moon (by 100 CE, according to the latest radiocarbon dates), the Temple of the Feathered Serpent (by 200 CE), and the Pyramid of the Sun (by 225 CE). These three monumental buildings united heaven and earth, connecting the world underground with the clouds above. Low-lying apartment complexes of ranging structures filled the interstices in the ensuing centuries, and the great cosmopolitan center flourished, reaching its apogee in the fifth century CE. Archaeology has produced evidence of ethnic neighborhoods and barrios of craft specialists in an urban environment of immense diversity, but all lived along the immutable grid, a tyranny of geometry. Miles away, isolated structures still conformed to the city's right angles, the orientations determined by the invisible and insistent order of Teotihuacan.

 With a population that archaeologists now estimate to have been possibly as large as 150,000 at its apogee – but quickly dropping off after 500 CE – Teotihuacan would have been one of the largest cities in the world in an era when the half-million people of Constantinople formed the world's biggest urban center and when one-third of the world's population of 300 million individuals lived in China. Cities have long been places of poor sanitation and ill health; not until the invention of modern sewers and purified water systems would they cease to depend on immigration for growth. Teotihuacan was no different, even as it spread across 8 square miles (21 sq. km). During its rise, the magnet of the great city drew people in, depopulating valleys in surrounding areas. Conversely, when

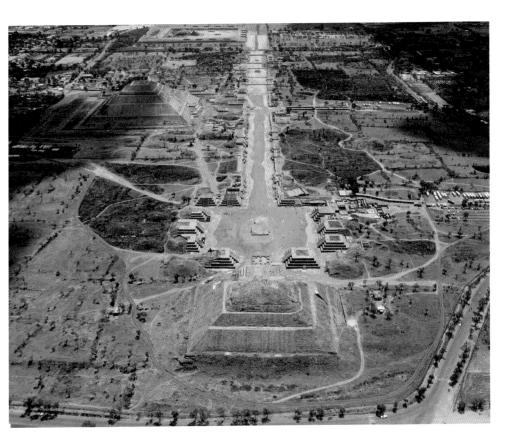

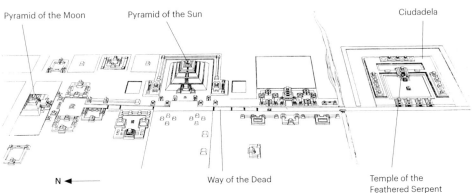

Pyramid of the Moon Pyramid of the Sun Ciudadela

N ◄──────── Way of the Dead Temple of the
Feathered Serpent

72, 73 Teotihuacan. An oblique airview (TOP) is oriented with the Pyramid of the Moon's back to the viewer; an isometric view (BOTTOM) of the buildings along the north–south axis, the "Way of the Dead." Residential complexes filled the interstices of Teotihuacan's grid, and it became a true city.

Teotihuacan declined, other Central Mexican cities began to expand.

Within the city, the architecture is of both mass and space – mass in the great temples, open space in plazas, temple enclosures, ritual walkways, and interior volumes within the palace compounds. Although it is often difficult to distinguish palatial or bureaucratic structures from religious edifices or domestic dwellings in ancient Mesoamerica, the distinctive profile known as "*talud-tablero*" delineates much sacred architecture at Teotihuacan, particularly among the smaller structures and within palace compounds. The sloping *talud* (talus) supports the vertical *tablero* (entablature), which is often the surface for architectural ornament or stucco paintings. Perhaps more than any other aspect of its culture, *talud-tablero* architecture marks the presence of Teotihuacan abroad: the execution of such profiles in adobe at Kaminaljuyu, for example, nearly 700 miles (1,125 km) to the south, is a provincial manifestation of the city's power. The axes themselves took on architectural qualities, not only in orienting the city, but in ordering particular views of the city for participants in ritual. The Aztecs' name for the "Way of the Dead" may refer to the ancestral shrines that line it, some of which may yet hold undiscovered tombs and offerings to the dead. Annabeth Headrick has suggested that the shrines held mummy bundles of revered ancestors, perhaps like the ceramic mummy-bundle image from Monte Alban. Brought out for veneration, the mummy bundles would have kept the past present in a tangible way, and some may have been perceived as cocoons, a preparatory state for transformation after death. Often thought of as a "street," the Way of the Dead changes elevation several

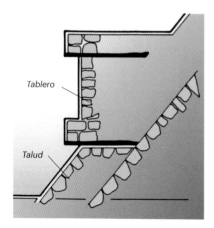

Tablero

Talud

74 In *talud-tablero*, the vertical *tablero* sits on the sloping *talud*. This schematic drawing shows the sort of workmanship typical of many Teotihuacan structures. The exterior is finished with fine plaster and polished.

times, forcing pedestrians up and down stairs and commanding its own attention as an architectural feature. This processional requirement recalls the passage in the tunnels under the Pyramid of the Sun and the Feathered Serpent Pyramid, which forced supplicants to shift from kneeling and crawling to walking upright at various points. On a map this axis appears easy to access, but in fact visitors may reach it only through the modern gated portals, whose purpose is to control paid admission but which replicate the limited access of the past.

The great pyramids

Teotihuacan's Ciudadela ("citadel"), a large, residential compound that was perhaps the palace of an early charismatic ruler, has long been the subject of speculation: its footprint is equal to that of the Pyramid of the Sun. The highly ornamented Feathered Serpent Pyramid within its enclosure was systematically covered by another building, the Adosada, around 300 CE. At the end of the nineteenth century, archaeologists had found the buried western façade, and at the end of the twentieth century, Ruben Cabrera and Saburo Sugiyama found 133 bound human skeletons distributed systematically at its foundations, with the attendant sacrifices suggesting at least 200 deaths. Dressed as warriors, the bodies were bound with their hands behind their backs and dumped in pits lining the sides of the structure, an immolation that may have lived on in memory for generations. The discovery revealed the chilling presence of war at the heart of this society. But no one was prepared for what Sergio Gómez Chávez would encounter in 2003, when he started investigating what seemed to be a sunken depression in front of the Adosada. He tied a rope around his waist, and workers lowered him into what turned out to be a 40-ft (12-m) deep shaft, clearly man-made, and leading to a tunnel heading west. Exploring the 330-ft (102-m) long tunnel, Gómez found himself 50 ft (16 m) below the surface of the earth, perhaps the first to enter this space in 1,800 years, or even longer. Between 2009 and 2016, Gómez led a team to explore the passage, which led directly under the Feathered Serpent Pyramid, ending in three pools of mercury, a miniaturized landscape of male and female stone sculptures. The makers pressed shards of mica into the tunnel's ceiling, forming a starry sky. The tunnel was completed by 100 CE, and about hundred years later, having closed and reopened it at intervals, the Teotihuacanos sealed it for what they thought was eternity.

This entire complex can now be recognized as the indisputable religious center of early Teotihuacan, and

a signal to a changing religious belief system that would require the Feathered Serpent façade to be effaced. Although later partly covered by a plain pyramid, the original Temple of the Feathered Serpent was never entirely obscured, with its elegant display of severe, frontal War Serpent headdresses floating atop the undulations of a Feathered Serpent. At the center of the Ciudadela, the Temple of the Feathered Serpent celebrates and commemorates warfare. When Sugiyama and Cabrera explored the heart of the structure in the 1990s, they found evidence that a major tomb at its center had been looted in antiquity.

The Way of the Dead leads to the Pyramid of the Moon, and then to Cerro Gordo. Slightly smaller than the Pyramid of the Sun, the Pyramid of the Moon also features a huge open courtyard in the rough configuration of the Mesoamerican completion sign that flows from the smaller *talud-tablero* structure that abuts the pyramid. Framed by the clefted mountain, the pyramid appears to possess the mountain and channel its forces into the city, acknowledging and calling upon the greater rainfall and abundance at the still-gurgling volcano once known by the name Tenan, "our mother of stone." The setting of mountain and pyramid is visually compelling at Teotihuacan, as if humans sought to place their works in perfect harmony with the landscape. The concept of *altepetl*, or "water mountain" to the later Aztecs, characteristic across Mesoamerica from Olmec times onward and referring to a

75 The Pyramid of the Moon at Teotihuacan, framed by Cerro Gordo, a dead volcano, in the distance.

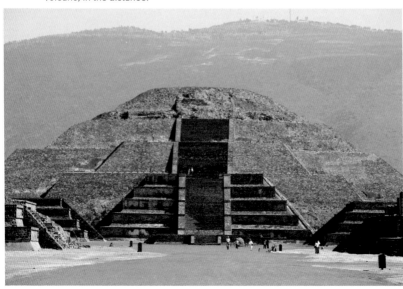

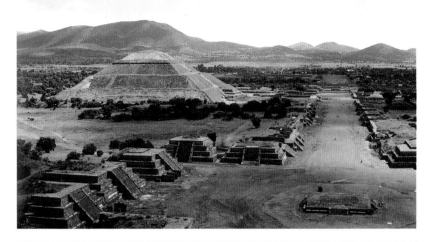

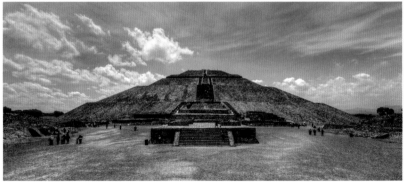

76 TOP Not only is the Pyramid of the Moon framed by Cerro Gordo, but the Pyramid of the Sun is framed by the ridgeline of the Sierra de Puebla.
77 ABOVE The compelling geometry of the Pyramid of the Sun juxtaposes the vast breadth of mass with the strong verticals of the staircases, which seem to vanish into clouds at the summit.
78 RIGHT The Pyramid of the Sun, seen from the air.

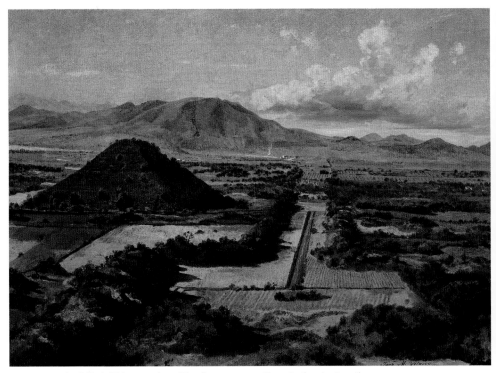

79 José Maria Velasco painted Teotihuacan many times in the nineteenth century. Here, in 1878, he captured the Pyramid of the Sun before archaeological explorations began.

place of civilization, may have been manifested in various ways at Teotihuacan.

76, 77, 78 Like the Pyramid of the Moon, the Pyramid of the Sun was built in various levels, with secrets kept intact for archaeologists of the future to reveal. Today, the pyramid rises in five distinct and massive levels, as can just barely be discerned in the nineteenth-century paintings made

79 before the advent of reconstruction. The broad staircase is the focus of the building, a fully integrated visual element, in contrast to the fussier Adosada of the Moon. A single flight of steps divides into two and then merges together again: as attendants progressed up the stairs, they would have vanished and reappeared several times to the viewer on the ground. The stairs narrow to a thin stream toward the summit, and then flow like coursing water down its slope, appearing and disappearing. Like all Mesoamerican architecture, the structures at Teotihuacan formed specific backdrops for rituals and public events.

Excavations have now been launched at the Sun, and ongoing excavations may yet surprise the twenty-first century.

Residential compounds of various size fill out the Teotihuacan quadrants – perhaps as many as 2,000 at the city's apogee. Access to these compounds was extremely restricted, often through a single door, providing security and privacy within. Given the inevitable noise and confusion in this city of busy merchants and craftsmen, the inhabitants must have felt relief at escaping from the hubbub of the street to the seclusion of their quiet residences. Walk-in cisterns would have made it possible for some members of the community, whether religious personnel or women, to be secluded from public life for periods of time. Such urban life can be compared to that of pre-modern Old World cities, but this was the first time it appeared in the New World.

Each residential grouping included shrines and a platform for semi-public rituals, as well as many dwellings. Built to conventional standards and using stock materials, the compounds at Teotihuacan appear to have been the result of state construction. Where did the workers for these building projects live? Only recently have archaeologists found evidence for slum-like dwellings pressed up against the apartments. By some estimates, 15 per cent of Teotihuacan's population lived in marginal conditions, outside the fine palaces, eking out a living, and building the great city. The grand compound of Quetzalpapalotl, adjacent to the Pyramid of the Moon, has long been thought to have been a priestly residence, offering both private and discreet access to the city's public architecture that would otherwise have been approached by the Way of the Dead.

Apartment compounds sometimes housed foreigners, as the discovery of a "Oaxaca" barrio has shown. Here, residents lived in typical Teotihuacan housing, but their mortuary rites

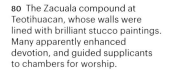

80 The Zacuala compound at Teotihuacan, whose walls were lined with brilliant stucco paintings. Many apparently enhanced devotion, and guided supplicants to chambers for worship.

included traditional Zapotec extended burials with Oaxaca urns. The Zapotecs at Teotihuacan imported utilitarian ceramics from Oaxaca as well. Luxury goods in foreign style for the local inhabitants may also have been prepared in some compounds. Evidence suggests that Maya and Veracruz enclaves existed within the city, and some quarters may have been embassies or merchants' retreats. At La Ventilla, one such residential compound, forty-two individual glyphs have been found painted onto the smooth white plaster floor, perhaps suggestive of taxes or tribute to be deposited and accounted in specific locations, but unlike other Teotihuacan writing, these glyphs would seem to be names of days or of people, rather than of places. In such constant contact with people from across Mesoamerica, Teotihuacanos may have been pushed to enforce their standards and order while notating specifics in ways that only writing can encompass. Notably absent from the architectural record is any formal ballcourt. Teotihuacan was a cosmopolitan city within a regional framework, both a receiver of and donor to Mesoamerica's cultural landscape. And yet despite all that, Teotihuacan remains profoundly local.

Sculpture

The stone sculpture of Teotihuacan is massive and prismatic, retaining the "stoniness" that attracted the twentieth-century sculptor Henry Moore to Mesoamerican styles. In its sense of materiality, Teotihuacan sculpture aligns with its architecture, like the great water goddess. Static and serene, both Teotihuacan sculpture and painting long resisted interpretation, the absence of individuality and personality so keen that artistic expression was long considered a reflection of a corporate mentality that idealized the self-consciousness of uniformity, in distinct opposition to the Maya pattern, where individual rulers are the focus.

In residential compounds throughout the city, archaeologists have recovered blocky, squat, seated sculptures of wrinkled and toothless old men, their backs hunched with osteoporosis. Recently, Matthew Robb has shown that these figures, long known as Huehueteotl after an Aztec deity known as the "old old god," may have served a role in terminating a compound's use. However, no physiognomy or form from the later period can be tied with certainty to this deity's name, These old gods may be associated most specifically with the hearth, the heat of life extinguished, like the expiration of life itself: the object was turned upside down or smashed when a building's life also ceased. The Aztecs turned to earlier sculptural forms time and again, in dialogue with their great predecessors. That these

81 Jadeite offerings, Burial 5, Pyramid of the Moon, Teotihuacan. The richest burial to come to light at Teotihuacan, it contained three cross-legged individuals, one of whom may be represented by this seated figurine. The jewelry and adornments in the tomb may have been made by the Maya, although this seated figurine is unlike any previously known work.

figures and forms of Teotihuacan were widely known, part of a pan-Mesoamerican phenomenon from this point onward, is attested by their presence in contemporary Veracruz and among the later Aztecs.

Teotihuacan sculptors easily worked at all scales, from the colossal to the hand-held, and perhaps according to the value of the material. Carved into miniature human form, precious materials, such as jade, retained prismatic and block-like forms characteristic of Teotihuacan's geometric order, especially at the heart of the Feathered Serpent Pyramid. Stunning examples have recently been excavated at the Pyramid of the Moon, in the most important tombs yet found at the site, as well as a brutally and intentionally shattered one within the Xalla residential compound. Leonardo Lopez Luján and his colleagues have looked at the pattern of destruction and burning of religious objects, especially in the sixth century CE, seeing in this pattern an iconoclastic contempt for the ritual object. At the same time, what would seem to be abstracted symbols – the mouthpiece that stands in for a deity, the sections of rattlesnake tail that imply the deadly bite of the serpent – can take colossal form, to be read with ease at distance and to explain and articulate monumental architecture.

An unusual sculpture was found at La Ventilla, the residential compound where glyphs would later be found painted on the floor. It seems to have been a marker, or perhaps a banner stone, for a ballgame played without a masonry court. The sculpture has four individual components, each worked

81
82

83

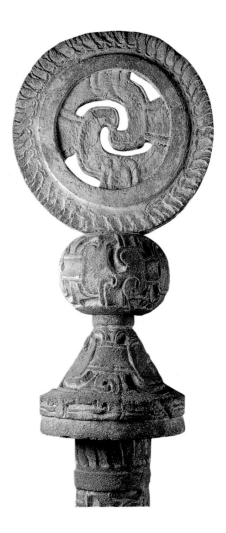

82 ABOVE LEFT The Xalla figure may have been bound before being brutally destroyed by dozens of blows. The work has now been carefully restored.

83 ABOVE RIGHT Made in four parts, the topmost of which represents a feathered shield, this kind of marker was used in play of a game outside the conventional ballcourt. A similar object was excavated at Tikal.

84 OPPOSITE TOP LEFT Discovered in 1921 in Malinaltepec, Guerrero, this Teotihuacan mask reveals the sorts of ornamentation – a mosaic of *spondylus* shell and turquoise across the face, and penetrating pupils of obsidian – that brought out the individuality of these works.

85 OPPOSITE TOP RIGHT Mostly produced of standardized parts both large and small and finished with brilliant post-fire paint, this large urn with eagle imagery served the Teotihuacan cult of warriors. Clouds of smoke from fragrant incense, from copal to rubber, would have ringed the object.

86 OPPOSITE BOTTOM LEFT During the second century CE, Teotihuacanos interred an unprecedented human sacrifice of at least 100 victims, many of whom wore necklaces featuring human jaws and teeth, the harvest of previous sacrifices.

87 OPPOSITE BOTTOM RIGHT Small clay figurines from Teotihuacan, modeled in animated postures. Early Classic.

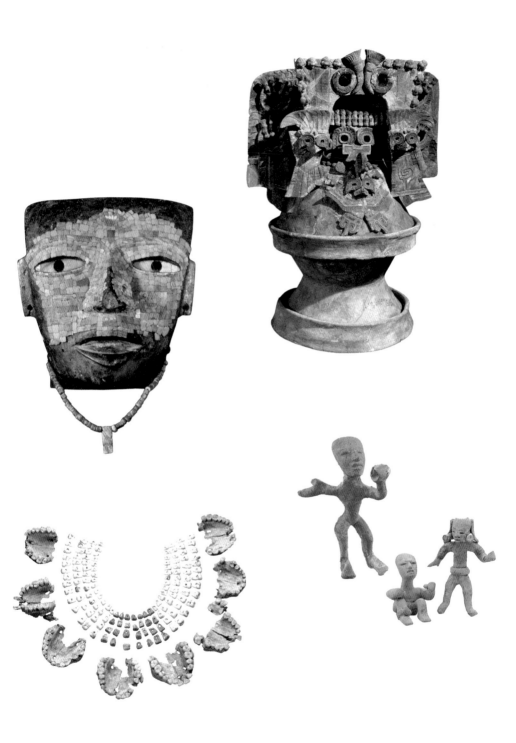

with an elaborate interlocking scroll design. This type of scroll characterizes Veracruz stone sculpture of the era, particularly at the site of El Tajín, where the ballgame is celebrated with no fewer than eleven courts. One of the sloping *talud* paintings of the Tepantitla compound shows small, animated figures who play a game around a monument similar to the La Ventilla piece. In the period of Teotihuacan domination of the Peten Maya in the last quarter of the fourth century CE, Tikal sculptors worked an object of similar form, yet in a single piece, and inscribed it with Maya texts.

Perhaps best known of all Teotihuacan sculptures are the fine masks. The best examples help us see how the artists could "read" the stone, working the grain so that it heightened facial detail. Some may have been attached to perishable supports to form large assemblages that might have been dressed and venerated; others may have been attached to funerary bundles. Made of serpentine, cave onyx, or granite, these masks present clear, ageless faces, neither male nor female, neither young nor old. Each one seems to shield individual identity, like the mask that covers the face of ill. 71, executed with flat, prismatic forms. Despite their seeming uniformity, the stone masks reveal a great range of representation, and some may even portray individuals.

Ceramic figurines were made throughout the history of Teotihuacan, and the early ones, tiny, agile, and perhaps once dressed in perishable materials, are the most appealing. Like the stone carvings, these miniature figures seem to wear the anonymous mask of Teotihuacan, yet the face is genuine, gentle and engaging, especially when cocked to one side. They are found in abundance, and by 450 CE or so were mold-made and mass-produced, rich in iconography but limited by their technology to static poses. Large-scale ceramic sculptures also survive. Brightly polychromed urns show human and animal faces peering out from almost architectural constructions of mass-produced, stamped elements. The flatness of the surface planes directs attention to the recessed, three-dimensional face. The Teotihuacanos themselves may have taken these assemblages apart and reconfigured different deities from the constituent parts. A general move to mass production characterizes all Teotihuacan production, from that of ceramics to stone figurines.

A compound to the north of the Ciudadela may have been a place of manufacture. Obsidian and precious shells were worked into fine objects that frequently accompanied burials. The Feathered Serpent excavations have yielded forty necklaces, each of which features shell worked into the shape of human teeth, sometimes accompanied by whole maxillae, the upper

"jawbones," forming what must have been potent and eerie symbols of prowess in warfare and sacrifice. These necklaces concentrate death and sacrifice, power that could also be transmitted through examples that merely imitated human bone. Countless pieces of obsidian have been recovered from all recent excavations in the city's main pyramids, some in dazzling serpentine forms, others as rough references to the human body. Paired offerings of flint and obsidian blades in the Pyramid of the Moon's burials suggest the sort of poetic juxtapositions characteristic of formal Mesoamerican speech.

Painting

The histories of painting and architectural sculpture at Teotihuacan cannot easily be separated, for thick polychrome applied to exterior sculptures on early buildings would appear to give rise later to flat wall painting, the tradition of painted sculpture returning late in the sequence. Of all architectural ornament at Teotihuacan, the finest is that of the Pyramid of the Feathered Serpent, set at the western margin of a large enclosure, perhaps the palace of the ruler. On the *talud-tablero* façade uncovered and restored between 1917 and 1920, the huge feathered serpent heads of the balustrade weigh over four tons apiece, and elaborate tenons hold the complete assemblage in place. Because these sculptures were painted, we may consider this the earliest programmatic painting to survive at Teotihuacan, and daubs of blue, red, white, and yellow can still be seen, aided by the recent repainting of the main façade.

The early Building of the Feathered Shells featured repetitious painted panels with burnished stucco painting of strong greens and blues, some made with ground malachite,

88 Burial 6 within the Moon Pyramid included twelve sacrificial victims and at least forty-three sacrificed animals. At the center, where the earth had been tamped down and two concentric circles drawn into it, officiants first laid down nine pairs of obsidian blades – one an undulating serpent and the other a carved blade – as if to concentrate the power of air and lightning in a centering ritual before making sacrifices of living creatures.

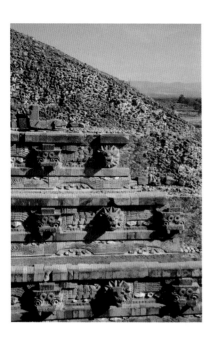

89 The Temple of the Feathered Serpent, Teotihuacan. Early in the twentieth century, archaeologists explored the structure, revealing the perfectly preserved western façade, long hidden under a later, abutting structure.

before being buried within the very late Quetzalpapalotl structure. But by the third century CE, painting replaced most sculptural ornament, and the palette brightened, with an emphasis on shades of clear reds, most of which depend on hematite as the essential pigment, and resulting in images that bring to mind medieval tapestries or Persian carpets. Murals covered both *taluds* and *tableros* throughout Teotihuacan, and the apartment complexes in particular were brightly painted. With little emphasis on line, and with a conspicuous consumption of red pigments, the works can be hard to decipher, particularly when partly eroded. But many paintings are also highly repetitious, and reconstruction of the whole can often be determined from fragments. Despite efforts to develop a sequence for paintings, both the range of subjects and nature of paintings from 400 CE until the period of rampant destruction in the sixth century CE seem to have been fairly consistent, with images of warriors, deities, and sacrifice prevailing. At the Atetelco complex and elsewhere, standard templates must have been used to achieve a repetitive patterning that looks like wallpaper to the casual visitor, especially when executed in only one or two colors, the steady line also suggesting the stencil, rather than the whiplash of the free hand. Burnishing marks underscore the sense of process and erasure that denies the individual gesture. Yet such

templates were restricted to individual complexes and are not seen beyond a single precinct.

Many paintings are didactic and would seem to instruct observers to conduct themselves appropriately, and particularly to carry out sacrifice, exemplified in the many images of figures in profile, carrying incense bags and standing beside maguey spines and grass balls. Rows of profile figures, including the Netted Jaguar (perhaps embodied by the netted felines offered in Pyramid of the Sun burials), flank doorways, guiding processional movement, and perhaps referencing ritual practice in the city. Elaborate backgrounds reveal temples, clouds, and abundant foliage. Processional warriors from the Techinantitla compound follow a footprint-dotted path and speak "flowery" scrolls; rare name glyphs appear in front of each one. The three-droplet tassel in many headdresses represents an extruded heart; what may seem to be necklaces turn into draped intestines upon closer examination.

Frontality may have identified deities, and representations of goddesses were painted all over the city. Remarkable frontal images dominate the so-called Tlalocan patio paintings of Tepantitla, so named by Alfonso Caso as an image of the Aztec paradise of water long before female deities were identified at Teotihuacan. On the upper *tableros* of each wall, a female cult figure painted with yellow skin gives forth blue-green droplets while a pair of acolytes in profile attend and make offerings. From her head sprout plants along which butterflies flutter and spiders crawl. We might read this repeated mountain imagery as an invocation of the concept of *altepetl* once again. Other *taluds* reveal what may be raised agricultural fields.

90 Reconstruction of one of two mirror image paintings that framed a doorway at Tetitla, Teotihuacan. On a path marked with footprints, a priest in a netted jaguar suit approaches a temple. Supplicants may have taken on the priest's role in stepping through the doorway.

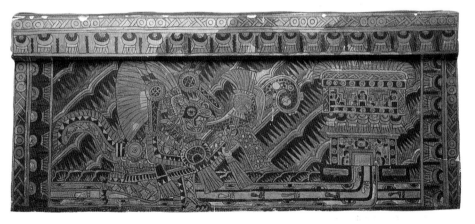

On the *talud* below, myriad tiny individuals frolic in water flowing from a mountain; exuberant speech scrolls suggest happy sounds and glyphs articulate speech as "butterfly," "stone," or "flower," among other words. Bodies are red, blue, or yellow but with strongly stylized faces, as if to unify diversity. Some form teams in a ballgame; others play a game resembling *bocce* (a form of bowling). The lively figures are among the few actors in Teotihuacan art, which is more typically nominal rather than verbal; here the figures perform the verbs, while nouns attach themselves to things or dot the background.

Many paintings have eluded identification. One strange clawed goddess features an upside-down head and bosom, perhaps a prototype for the image of a decapitated woman deity, prevalent in Aztec art, who similarly throws her head backward, but with blood usually spewing from the neck. In another, a mountain deity presides over the three-mountain image. Supernatural coyotes and pumas may relate to the recent discoveries of these animals in Moon burials.

Most paintings, with the exception of Tepantitla, deploy large areas of uniform pigment, especially the blue-green malachite color used for feathers and then outlined or divided with thin red

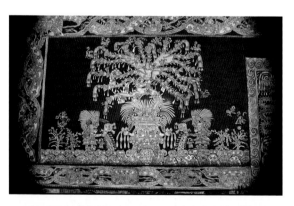

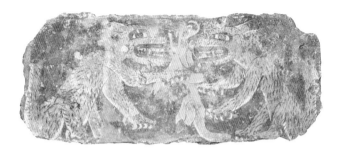

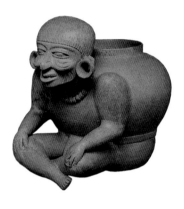

91 OPPOSITE TOP One of several nearly identical representations in the Tepantitla patio, this panel features the hands and head of a female figure at center. Under her, an overturned basin spills streams that fertilize the plants in the margins.
92 OPPOSITE BOTTOM Teotihuacan artists used templates to map outlines onto fresh white plaster, creating standardized images that repeat like wallpaper patterns. Burnishing yielded flat, even colors that have endured 1,500 years or more. Using a highly restricted palette, artists rendered a frontal and insatiable eaglet whose beak drips gouts of blood; the room at Tetitla may have been a place of training for young warriors.
93 TOP Found along the Way of the Dead, this painting depicts two coyotes who grasp a deer – recognizable by its antlers – in their front paws. A bleeding heart is ripped from the deer's chest, liquid drops falling to the ground.
94 ABOVE LEFT Teotihuacan potters crafted ceramics that were prized everywhere in Mesoamerica for their extraordinary thinness. This hunchback may have borne maize or gruel on his back.
95 ABOVE RIGHT Excavated in the Tetitla compound, this stuccoed vessel with characteristic openwork tripod feet retains the colors of ground cinnabar and malachite applied to the fired vessel. It probably once had a lid. A striding warrior with goggled eyes holds out an obsidian blade (see ill. 88), from which a colorful heart drips precious liquid.

Teotihuacan **103**

lines. Shifting background colors at Tetitla, for example, separate a
92 *talud* and *tablero* of eaglets, painted in white and red, and which
the viewer reads differently depending on the field behind.

Across Mesoamerica, other cultures imitated and emulated
the signature form of Teotihuacan ceramics, the lidded
tripod cylinder, especially the Maya. West Mexico peoples,
although poorly understood in this period, adopted both the
Teotihuacan *olla*, or open-mouthed jar; thousands have been
excavated since 2000. The form and the typical stucco with
which many elite ceramics were finished generally shows a
chronology and imagery similar to the monumental paintings.
94 Ceramics of a thin orange clay found a wide market across
the region. Many stuccoed or carved vessels feature heavy,
lipped lids with ornament to match the body; tiny slab cut-outs
function as tripod feet.

Although imagery is typically repeated twice or three times
on a vessel, with an emphasis on the uniformity characteristic
of monumental works, some show continuous imagery that
95 wraps the vessel on the diagonal. Goggled warriors approach
mountains or wield weapons. At the time of the Aztecs, the
Tlalocs were said to pour water onto the earth from their
heavenly palace, causing downpours.

96 Teotihuacan artists also produced hollow "host" objects
that bear tiny solid mold-made figures and adornments inside
their bodies. Examples have been found in distant Guatemala
and Mexico, with the most extraordinary find coming at
Becan, Mexico, 750 miles (1,200 km) from the great city.
There, probably in a fifth-century context, a host object held
ten warrior figures and a number of miniature adornments,
including accouterments of shell and jade. Placed into a Maya
tripod of local manufacture, the works collectively dedicated a
Maya structure around 550 CE, just at the time of Teotihuacan's
destruction, perhaps making reference to the complex
relationships of power and authority between the two cultures.

The end of Teotihuacan: Water and fire

Constant rain and water crises at Teotihuacan probably
exacerbated the difficulty of building and maintaining the city.
The preparation of lime for mortar and stucco required vast
amounts of firewood to burn limestone or seashells, and the
more Teotihuacan grew, the more the surrounding forests were
depleted. With deforestation came soil erosion, drought, and
crop failure. In response, Teotihuacan may have erected ever
more temples and finished more paintings, appealing to their
deities to reverse the situation, but merely perpetuating the
cycle. Tlaloc may have turned to war to supplant agriculture; the

powerful water goddess must have wrung her hands without profit, for the city was doomed. According to radiocarbon dating, the center of Teotihuacan was probably ravaged as early the beginning of the sixth century CE. Teotihuacan's destroyers burned the central temple precinct and sacked the city. The perpetrators may have been semi-nomadic peoples just to the north, those most disrupted by the expansion of Teotihuacan, and perhaps occasionally in Teotihuacan employ as miners or laborers, or edging into the city, squatting wherever possible. The Teotihuacan map itself reveals greater density of construction along the northern perimeter, forming a wall to what had been an open city. Although some occupation of Teotihuacan continued, the production of fine art and architecture rapidly declined, and the city never regained its importance, becoming instead the ancestral model for the subsequent generations of city-dwellers in Central Mexico.

Far to the south, in highland Guatemala, Kaminaljuyu was apparently the locus through which Teotihuacan had invaded the Maya region, taking advantage of trade relationships that had previously been established. Although Kaminaljuyu had flourished in Late Formative times, a number of structures were built there in Teotihuacan style before 500 CE. Principal

96 In the middle of the sixth century CE, Maya lords at Becan buried a Teotihuacan "host" figure inside a Maya-made tripod vessel, itself a form adapted from the great city.

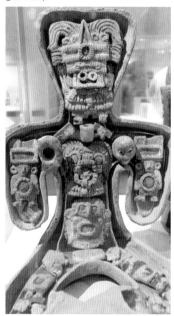
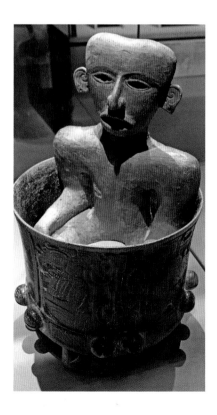

98 among these is a small-scale reproduction of the Pyramid of the Moon, carried out in adobe. Tombs at Kaminaljuyu were filled with luxury goods, indicating the wealth accumulated by those who mediated between Teotihuacan and the Maya, and with patterns shared by both Burial 10 at Tikal and some of the recent discoveries at Teotihuacan itself.

 The notion of a "Classic" era was first conceived to define the span of time during which the Maya used Long Count inscriptions, or about 250 to 900 CE – a period originally thought

of as peaceful and theocratic throughout Mesoamerica. Though the idea of peaceful theocracy has since been abandoned, the problematic term Classic remains in use, if only to characterize the richness, variety, and growth of the art and society of the time. What is often called the "Classic" starts in Central Mexico with the rise of Teotihuacan, and even after the city's demise, its traditions were sustained, if strained, at Cholula and other sites in the Valley of Puebla. Rather than use such a term, we may be better off simply thinking of this "Classic era" as the first millennium CE.

During the era of Teotihuacan's rise and development, Cholula, in the Valley of Puebla, also thrived. Curiously, about the same time as the burning of Teotihuacan, Cholula likewise underwent depopulation. During the Postclassic, however, this city was rebuilt and expanded. Most ethnohistoric sources link Cholula to Quetzalcoatl, at least during the era of Spanish invasion, but the relationship may well be ancient.

The main pyramid at Cholula was used and rebuilt for nearly 2,000 years, ending with a Catholic church on its summit. Archaeological explorations by the Mexican Instituto Nacional de Antropología e Historia (INAH) have revealed many aspects of the pyramid's construction. During the Teotihuacan era, for example, paintings covered the *talud-tablero* temple exterior. These sprawling stucco paintings record drinking rites and may reveal the drunkenness of the painters themselves.

Cholula's identity in the apogee of Teotihuacan is not well understood, but its sculpture, ceramics, and architecture are all distinct. Stelae survive today with only paneled frames, as if slates for painted depiction of rulers – in which case they would have been more analogous to Maya examples of the period. The sloping *talus* of the architecture profile, longer than that known at Teotihuacan, may have underscored local identity, and we may surmise that the city's population steered clear of Teotihuacan domination, despite the proximity. Years later, Cholula's rulers, like those of nearby Tlaxcala, fought to preserve independence in the face of Aztec imperialism. At the time of the Spanish invasion, Nahuatl speakers occupied the site and it is possible that distinct members of this large linguistic family dominated the Valleys of Mexico and Puebla in the first millennium CE, ruling rival kingdoms. In this mix, the ethnicity of Teotihuacan remains the most enigmatic.

97 OPPOSITE TOP The main pyramid at Cholula flourished in many periods, and it probably benefited from Teotihuacan's decline. A colonial church caps at least 1,500 years of prehispanic construction. Most of the terraces revealed by archaeologists date to the first millennium CE.
98 OPPOSITE BOTTOM Reconstruction of B-4, Kaminaljuyu. At this site, in modern Guatemala, buildings in pure Teotihuacan style were executed on a diminutive scale in simple adobe during the great city's apogee.

Chapter 5
Classic cities from coast to coast

The first millennium CE produced the most widespread flowering of culture in Mesoamerican history. As we have seen, in Central Mexico, Teotihuacan was the largest, most powerful and prestigious city to rise in the history of the ancient New World. To the south, in Yucatan, Guatemala, Honduras, and Chiapas, the Maya were equally important, although known for their diversity and variety rather than the monolithic power that characterized Teotihuacan. However, other regions fostered important contemporary developments as well. Independent styles of art and architecture flourished in Oaxaca at Monte Alban, in Veracruz at various sites, among them El Tajín, and on the Pacific coast of Guatemala at Cotzumalhuapa. At no other time in Mesoamerican history were so many fine and different kinds of works of art and architecture created. It was also an era of great contact among cultures: just as there was interchange between Teotihuacan and the Maya, so too was there contact between Oaxaca and Teotihuacan and between El Tajín and Cotzumalhuapa, although some of these developments took place quite late in the first millennium CE.

Nothing so exemplifies the first millennium CE as does play of the ballgame, and the multiplicity of play, from Teotihuacan to the Maya region, equally characterizes cultural diversity of the era. In Olmec times, Mesoamerican peoples had learned to harvest the sap of the rubber tree and make a ball with "bounce," a concept unknown anywhere else in the world. The ball itself may have spawned the notion of a "team" sport, largely unknown outside of North America, where both lacrosse, in colder climes, and the soccer-like rubber ballgame were invented. El Tajín, on the Gulf Coast to the north of the Olmec "heartland," became a great center for play of the ballgame and the locus of a dramatic local architectural style

no later than 600 CE. Eventually, at least twenty ballcourts were built across the rolling topography of the site; most take the conventional form of two parallel structures designed for the ricochet of the ball between them and could have accommodated three to six players on a team. Works of art show that players generally struck the ball with hip and leg: the rubber ball was dangerous and heavy, and players wore thick padding on legs, arms, and around the waist, to protect vital organs. Was El Tajín a sort of Mesoamerican Olympia, designed for ritualized play? Depictions of the ballgame make it clear that it was often played to re-enact supernatural ritual or to ritualize warfare, with losers suffering the highest stakes of all: heart sacrifice or decapitation.

Specialized stones used as armor during play – basically three kinds of objects: yokes (for the waist), palmas (arched stones coming up from the navel, both like the flaring palm of the hand and the fronds of the palm tree), and hachas (for the lower back, like a shield; fitted into the yoke and often shaped like an axe) – abound, thousands of them known without archaeological context. Yokes are found only in Veracruz; a plain one buried over the head of an individual suggests the tomb of a ballplayer. Usually made of serpentine, the yokes feature deep carving, often with images of earth and nocturnal creatures,

101

particularly toads and owls. Palmas, more typically made of rough stones like granite, attached to the yokes by some as yet

99

unknown means, and often incorporated images of sacrifice. The smallest ballgame stones, the hachas, are most common in Guatemala, along the Pacific coast, perhaps introduced to

102, 103

Cotzumalhuapa and perhaps also to serve as court markers. Their subject is almost always the head – human, animal, or skeletal – perhaps a reference to decapitation in the game, and possibly to the ball itself. Most of these stones come from Veracruz, but at both Palenque and Copan, Veracruz ballgame paraphernalia were found in a context contemporary with the abandonment of these sites. Ballcourts would proliferate after the fall of the first-millennium cities, but these specialized stones would become heirlooms, occasionally depicted but no longer made of such fine materials.

Leveling the mountain at Monte Alban

At Monte Alban, the step from the advanced Zapotec architectural and artistic styles of the Late Formative to a Classic stage was easily taken and without visible rupture. The traditions of Oaxaca, whether Zapotec or Mixtec, show continuity and shared practices through time, even for generations after the Spanish invasion. At Monte Alban, some

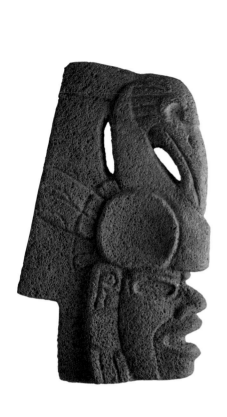

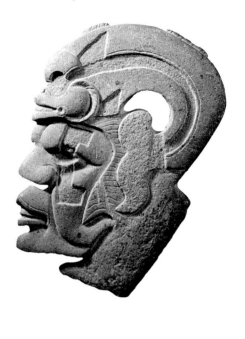

99 OPPOSITE LEFT The heart has been removed from this unfortunate fellow. In ill. 117 a similar object springs from the waist, as if directly inserted into the yoke. The thick knotted strands of hair also characterize Maya captives.

100 OPPOSITE TOP RIGHT Artists crafted ballplayers of clay, often using molds for all or part of the figure, along the Gulf Coast, and particularly in what is now the state of Veracruz. This standing figure wears a yoke open to one side of the body (cf. ill. 101), as if ready to play, but also a rope, as if prepared for sacrifice.

101 OPPOSITE BOTTOM RIGHT Ballgame yokes take many forms. South ballcourt panels (ill. 117) show ballplayers wearing similar yokes.

102, 103 ABOVE Hachas – quite literally "axes" in English – may have been worn at the back of the waist for ceremonial occasions, or used to mark play of the game. Many depict human or animal heads, perhaps responding to the shape of the stone. The shredded cloth earstrip of ill. 102 (LEFT) characterizes captives among the Maya (see Chapter 7).

Classic cities from coast to coast

104, 105

sophisticated works of art and architecture survived from Late Formative times, and the acropolis had already been artificially flattened. Most of the structures that flank the main plaza, however, date to the Classic era. Yet despite being home to some of the first profound excavations at a major archaeological site, Monte Alban's architecture remains enigmatic in its function.

73

A plan designed to reproduce the rhythm of natural land forms may help to explain the approximate bilateral symmetry of the acropolis. Unlike the plan of Teotihuacan, structures are not laid out on an axis or grid, and they do not radiate from a central point but rather frame the negative space of the plaza. In its general north–south orientation, however, the plan of Monte Alban suggests an axial orientation far more than the organic site plans of Maya cities do. Its citadel setting is grand, but the ceremonial core of Monte Alban is small by comparison with Teotihuacan: the Monte Alban plaza and its surrounding temples could all be placed underneath Teotihuacan's Pyramid of the Sun, or within the Ciudadela.

Constructions of the era made the Monte Alban acropolis a gem, with new buildings that offered additional definition of the ceremonial precinct. A wall enclosed over 1 square mile (2.6 sq. km) of the acropolis. Access to the plaza, both actual and visual, from the east, for example, was blocked by the replacement of numerous individual structures almost contiguous with one another. The proportion of balustrade to stair of these buildings is ponderous, and emphasis falls on the alternation between the two forms.

Over time, the lords of Monte Alban closed the corners of the plaza: at the northeast, they built an I-shaped ballcourt. On the west side of the plaza, two similar compounds were erected to flank the earlier Temple of the Danzantes. Known as Systems IV and M, these buildings have been considered mini-

104 The view across the plaza of the mountaintop of Monte Alban toward the North Barrier Mound. Buildings echo the topography, channeling nature's power to the site's core.

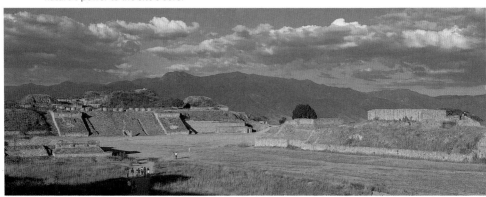

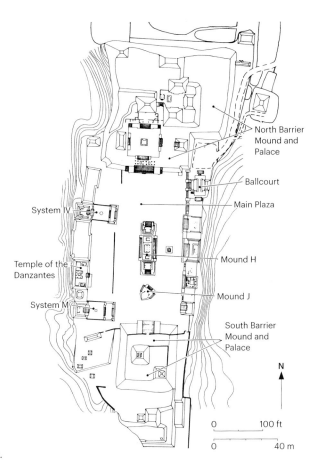

Labels on plan (clockwise):
North Barrier Mound and Palace
Ballcourt
Main Plaza
Mound H
Mound J
South Barrier Mound and Palace
System IV
Temple of the Danzantes
System M

N

0 100 ft
0 40 m

105 Plan of Monte Alban.

amphitheaters, shrines where supplicants would gather in the closed court while attending rites performed on the principal façade. As with all Monte Alban structures, the perishable superstructures are gone. Tomb façades and small stone temple models found in tombs show that the distinctive Monte Alban profile molding was also repeated at the cornice level. Wrapped around exterior corners, this molding consolidated the structure, as did the apron moldings of Maya structures of the same period or the *talud-tablero* of Teotihuacan, a diversity within a shared practice of finishing the setbacks of large architectural forms. In its two separate layers, the Monte Alban molding bears a similarity to the symbol for sky, perhaps indicating the generally sacred quality of architecture so delineated. Its consistent application across the site created a harmonious visual unity.

By the eighth century CE, the North Palace compound grew in size and became increasingly inaccessible. By the end of the period of construction, one climbed the North Barrier Mound, passed a colonnade – to be compared to Mitla, a nearby city probably constructed after Monte Alban's abandonment – and descended into a small courtyard, sunken in relation to surrounding structures. One then proceeded along a narrow passageway and up and down stairs before gaining access to the palace chambers. Such restricted access has a parallel at Teotihuacan, particularly in the Quetzalpapalotl compound, and in the Maya region, where for instance the core of compound A-V at Uaxactun became virtually impenetrable in Late Classic times. The leaders of Monte Alban chose to live behind walls, sometimes making them more secure but also restricting human movement.

To the south, an early palace was dismantled, and carved lintels were set upright, like stelae, one side of their imagery now disoriented. Like the South Palace stones, many other monuments were reset through time, and most of them were grouped at the south end, honoring Zapotec lords. Some individuals are Oaxaca warriors. Others engage in dialogue with what appear to be visiting Teotihuacanos; their images were subsequently removed from view when the panel was turned, with one carved face hidden. Although no single work characterizes all of Monte Alban, Stela 4 helps us see some of the wide-ranging connections across Mesoamerica in the first millennium CE. The stela form itself is characteristic of the Maya region in this era, although its origin was at La Venta in the Formative era (see pp. 38–40), and like a Maya monument, the finely prepared shaft features a single lord; he stands on a single leg, as if dancing. His headdress features two rings: this is the same motif of the headdress carried on the back of the Feathered Serpent at Teotihuacan, thus recognizing Maya and Teotihuacan influences together at Monte Alban. Like a Teotihuacan lord, his speech scrolls probably indicate song, and he dances atop a large place sign, within a hill shape,

128

106,
107

108

106 OPPOSITE TOP South Palace slabs were reset at least once at Monte Alban, reorienting what may have been originally lintels, with carving on adjacent sides of the stone.

107 OPPOSITE BOTTOM LEFT Monte Alban, Stela 7. With arms tied behind his back, a captive stands atop a place sign and issues a "flowery" speech scroll. One side of the monument depicts four Teotihuacanos in tassel headdresses, much like the figures of ill. 141.

108 OPPOSITE BOTTOM RIGHT A ruler in dance pose drives his staff into the place sign he stands atop. His headdress is adorned with the goggles associated with Teotihuacan's storm deity; the glyph in front of his body reads "8 Deer," a name that would be associated with a cultural hero of Oaxaca at the time of the Spanish invasion.

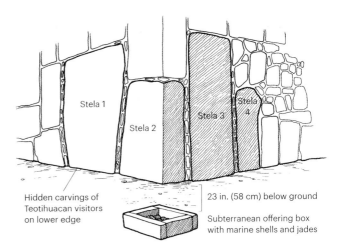

Stela 1

Stela 2

Stela 3

Stela 4

Hidden carvings of
Teotihuacan visitors
on lower edge

23 in. (58 cm) below ground

Subterranean offering box
with marine shells and jades

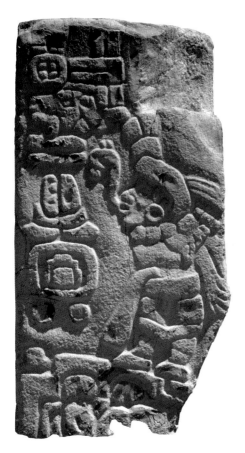

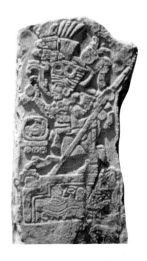

celebrating his conquest over one of the mountains surrounding Monte Alban. The monument held great value at Monte Alban: it may have started life as a lintel or a freestanding monument, but its final location was at the South Barrier Mound, assembled among others, as if an archive of the past.

Tomb architecture at Monte Alban

Alfonso Caso directed excavations on behalf of the Mexican government at Monte Alban throughout the 1930s. He looked for burials in addition to cleaning and restoring structures, thus bringing many underground tombs to light, both within the main, more accessible precinct and in residential areas. It remains to be established whether the structures that flank the compound were primarily dedicated to ancestor worship, as were many Maya buildings. Caso discovered fine burial chambers containing treasures from the earliest era right up to the Spanish invasion. Many tombs of the Classic period were found to be painted, and, of these, Tombs 104 and 105 are the best preserved. Tomb 104 is thought to precede 105, based on color scheme and style. The palette of 104 emphasizes blue and yellow, while 105 has many more red tones, like later Teotihuacan paintings. Both had been quickly prepared and show signs of hasty work, such as drips and spills, and repainting may have taken place when new offerings were made.

Tomb 104 displays a unified use of architecture, sculpture, and painting. The chamber entry at the base of a stairway is framed by a doorway with the usual Monte Alban overhanging profile molding, and the door is surmounted by a very fine

ceramic figure wearing a Cocijo, or rain-god, headdress.

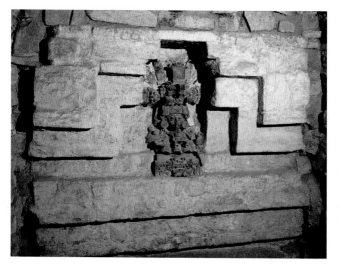

109 The façade of Tomb 104, Monte Alban. A fine ceramic urn remains in place over the entry to the tomb. Monte Alban IIIa.

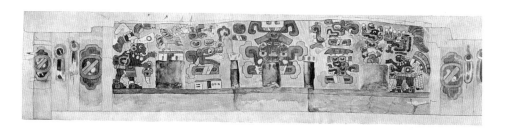

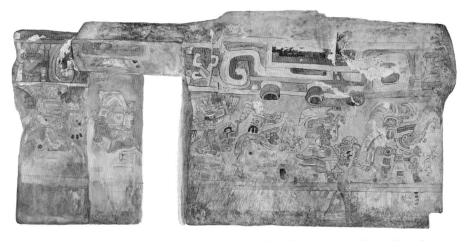

110 TOP Interior painting, Tomb 104, Monte Alban. Hasty workmanship – indicated by spills and drips of paint – would suggest that the final decoration of this elaborate tomb was executed at the last moment. Reconstruction painting. Monte Alban IIIa.
111 BOTTOM Interior painting, Tomb 105, Monte Alban. The painters here chose a darker, redder palette, more like that of many Teotihuacan works. Monte Alban IIIb.

A single skeleton was found extended in the tomb, feet at the chamber door. Sets of small, identical urns had been placed along the body, and other vessels positioned in the three cut-out niches of the wall. Two painted figures flank the side walls, in profile, attending the frontal cult image at the head of the tomb. One of them is an old god with a netted headdress, possibly related to trade or wisdom. The central cult image seems to rise out of the central niche, as if sustained by the offerings placed within. Such paintings may have guided the attendants at the funeral rites of the interred and perpetuated those rites.

Compositionally, the painting resembles the central scene of the Tepantitla mural of Teotihuacan, the unwrapped composition of Tikal Stela 31, or even the more iconic Río Azul paintings. The use of such similar conventions at Monte Alban and Tikal shows both the profound effect of Teotihuacan and

110

91
134,
137

the ability of regional artists to interpret its art for their own traditions. Like Teotihuacan painters, Monte Alban painters mapped large areas of color, particularly for feathers, limning individual feathers within great panaches, but leaving the general impression of trimmed, clipped feathers. The Tomb 104 paintings and Tikal funerary offerings from Burial 10 both show the widespread use of rich blue pigments, particularly slate blue; Maya blue, a unique color achieved by dying palygorskite clay with indigo, also came into use in this period.

111 The side and rear walls of Tomb 105 show nine male–female couples in procession, accompanied by glyphs that name them. A single calendrical day sign and coefficient occupies the front wall, probably naming the occupant or the date of his death; the nine couples represent ancestors who welcome the interred into the afterlife. Some headdresses include what would have been old-fashioned Teotihuacan elements, perhaps a sort of "period" dress to indicate their antiquity. Tomb 105 includes substantial use of glyphs; symbols in headdresses – such as the trilobe, indicating blood – show further development of the regional writing system, as well as connections to Teotihuacan.

 The tradition of making large, hollow effigy vessels, and deploying molds in the process, had been fully developed in Late Formative times at Monte Alban (see p. 62). By the first millennium CE, the urn had supplanted the hollow vase as the dominant form of tomb sculpture. These urns consisted of cylindrical vessels attached to the backs of great clay assemblages, and they were usually made in sets, with four small vessels accompanying the larger urn, often all anthropomorphic. Evidence of burning in the vessels is rare, and it is more likely that they held foodstuffs or beverages for the interred rather than burnt offerings. They have been recovered both from tomb doorways and from the tombs themselves, though many are without provenience. Most bear the headdresses of deities. That of Cocijo is worn by the

112 Tomb 104 figure. Lines around the eyes mark it as the "God of Glyph L," a maize god, as does the maize of the headdress. As more and more of the imagery of ancient America has been determined to be of historical persons, the strong individual physiognomies of many Oaxacan urns also suggest portraiture, masked within powerful deities.

 The ornamentation of the urns was built up in layers of pliable clay slabs until a rich three-dimensional texture was achieved over the hollow human form. Eventually, just as at Teotihuacan, individual elements came to be mass-produced. Some human faces are also mask-like and resemble contemporary Teotihuacan stone masks. Many urns have strong

rectilinear qualities, despite their three-dimensionality, and can be described geometrically within a rectangle. In this way, they conform to a geometry like that seen in many Teotihuacan paintings. Adam Sellen has documented the early twentieth-century workshops that yielded hundreds of forgeries.

Tomb 103, in addition to a large urn, yielded an assemblage of figurines that may illuminate the funerary process itself. A single, oversized planar figure at the center represents a bundled corpse, adorned with a Teotihuacan-like mask. Five be-feathered attendants hold mirrors; eight members of a musical band perform, and a seated figure may be a miniature

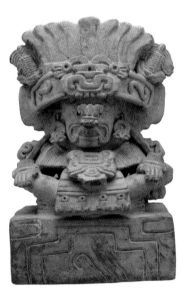

112 RIGHT One of several fertility gods in ancient Oaxaca, this maize god bears distinctive facial markings. He sits on what is probably a "hill" glyph, indicating a toponym, perhaps "hill of maize."
113 BELOW Excavated in the courtyard in front of Tomb 103, this engaging set of figurines focuses attention on a "mummy bundle" at center. The standing lords wear bird masks; two feature eagles and three the War Serpent on their removable headdresses. The nine musicians recall the nine attendants in Burial 10, Tikal, some of whom carried instruments.

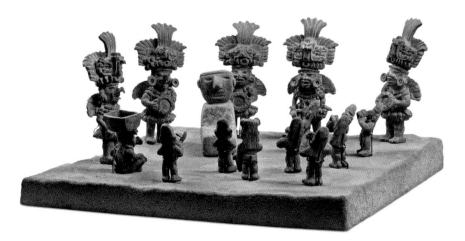

Old Fire God, a common form of sculpture at Teotihuacan and associated with termination rituals.

By 800 CE or so, Monte Alban suffered slow and steady depopulation, as the focus of culture in Oaxaca moved to other centers, some of them Mixtec. Finally, Monte Alban became simply a necropolis and a place of pilgrimage, and it remains a place of pilgrimage for modern-day travelers who marvel at the magnificence of space and setting. The publication in 2012 of the massive mud sculptures and wall paintings in the Cueva Rey Condoy has suggested the complexity of Zapotec practice and pilgrimage.

After the Olmecs: Cultural diversity in Veracruz

Distinctive art styles also flowered along the Veracruz coast during the first millennium CE. Today, Totonacs live in the region, but it is not certain that they were the makers of high culture in Classic times; 1,500 years ago, Huastecs and Otomis undoubtedly occupied some of the same territory, while in the days of the Aztecs the Olmeca-Xicalanca dominated trade along the coast. We will simply consider the various elements to be "Classic Veracruz," as these many quite disparate sites have been called, without ethnic assignation. Connections with Teotihuacan and the Maya area were evident during the period,

114 Seen here early in the twentieth century, before complete reconstruction had taken place, the Pyramid of the Niches, El Tajín, features 365 niches, each setting up a play of light and shadow to make the building shimmer in the sunlight.

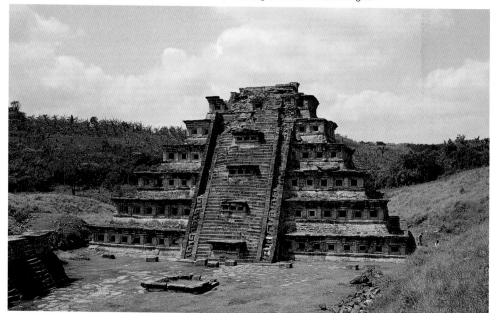

but the art and architecture of Classic Veracruz also depended upon an Olmec heritage from the Formative era.

Architecturally, the most important city of the region is El Tajín, named after the Totonac lightning god. Heavy rainfall yields dense rainforest where mountain meets plain. The Veracruz coast was known for its verdant croplands in prehispanic times, and the Aztecs coveted the maize, cacao, vanilla, and cotton that was grown in the area. El Tajín was discovered toward the end of the eighteenth century, just about the time that Maya sites began to catch Western attention. In 1829, the German explorer Carl Nebel visited the site, and the fine color lithographs he later published evoked the same kind of mystery as Catherwood's renderings of Maya ruins. Early travelers believed the Pyramid of the Niches to be the most important structure at El Tajín, which indeed it is in the sense that it dominates the main ceremonial core, at the center of hundreds of acres of ruins, despite its relatively small size: approximately 85 ft (26 m) on each side and less than 66 ft (20 m) high.

The Pyramid of the Niches rises in six distinct tiers of an unusually fussy *talud-tablero* and houses within it a smaller, and therefore earlier, similar pyramid; Instituto Nacional de Antropología e Historia (INAH) explorations have demonstrated that the two layers were made in rapid succession and completed around 800 CE. Each entablature supports a row of niches, making 365 niches in all, which implies that the pyramid refers to the solar year. The niches are each about 2 ft (60 cm) deep, and although it is tempting to think that they held offerings, no evidence is available that they did. Perhaps the niches were for purely visual effect: on a bright day they reflect and shimmer in the sun, giving the illusion of constant motion.

The Pyramid of the Niches has some unusual features that link it to Maya architecture at Copan. Both the Hieroglyphic Stairway at Copan and the Pyramid of the Niches have balustrades with similar running fret designs. In fact, the abutments of the Pyramid of the Niches may have featured seated lords during public festivals, creating a diminutive assemblage closely akin to Copan's Hieroglyphic Stairway. Moreover, the only true stela from El Tajín was found at the base of the Pyramid of the Niches. In some ways it looks like a rough Maya effort, and in its three-dimensionality, costume, and posture, it bears closest comparison to the formats of Copan.

The low-lying galleried structures of Tajín Chico, set on a great rise above the Pyramid of the Niches and ballcourts, seem to have been largely for noble residential use in the ninth and tenth centuries CE. Geometric patterning worked

115 LEFT Battered by time, El Tajín Stela 1 features a standing ruler clutching insignia in his hands. The very idea of the freestanding stela, although introduced by the Olmecs, may have been borrowed in this era from the Maya.
116 ABOVE The South Ballcourt at El Tajín frames the mountain behind, channeling its power to the plaza.

on the building façades may correspond to the contemporary designs at Uxmal, Yucatan, or they may have toponymic value. Dominating the group is the Building of the Columns, now collapsed, but once a very large structure with colossal carved columns. Narrations wrap around the columns on a small scale, many featuring the exploits of 13 Rabbit, a summary of local belief and history. On one panel, the newly installed king sits with arms crossed as he receives his insignia.

116 At least twenty ballcourts have been located in the central core of El Tajín; about 125 miles (200 km) to the south, the less-known site of Cantona had at least twenty-seven. El Tajín seems to have been a major center for the collection of natural rubber, and perhaps the solid black rubber balls with which the game was played were made there, using a process of cooking the latex and shaping it in a mold, as is still practised in parts of Mexico today. Various lineages could have sponsored their own court, or each successive ruler could have been obliged to commission a new one. For whatever purpose, the courts were made in profusion here, and their walls preserve the most extensive architectural sculpture of Veracruz. As at other Mesoamerican sites, El Tajín lords sited buildings to powerful features of the landscape, and this can be seen most clearly with ballcourts, where risers typically frame the ends of playing alleys.

Six narrative panels along the vertical surfaces of the South Ballcourt relate a ballgame story or myth. In the first panel, the

participants dress for the event; in another, one player conceals a knife behind his back. In the illustration shown here, set within a ballcourt (but oddly enough depicting an architectural profile different from that of the South Ballcourt itself), two players hold down a third and prepare for sacrifice. A twisting skeletal monster descends from the upper margin, presumably to take the offering, while another rises from a jar at left. As the narrative unfolds at El Tajín, the Rain God perforates his penis, perhaps yielding *pulque*, the intoxicating beverage of ritual.

At the time of the Spanish invasion, the ballgame was known to be played for various motives. As an athletic event, it was frequently the subject of much gambling. It could also be a gladiatorial contest, where a captive's or slave's strength and desire to avoid death were tested. The sacrifice of losing players also informs us that the game was designed to offer human blood to the gods. The game may have been played for all these purposes, not only at El Tajín but also in the Maya area and at Cotzumalhuapa, and understood as a cosmic metaphor as well, necessary to the sustenance of the sun. Furthermore, the ballgame often plays a specific role vis-à-vis warfare; set in the ceremonial precinct, it provided the means for controlled re-

117 Carved panel, South Ballcourt, El Tajín. An unfortunate loser at the ballgame is being sacrificed by two victors while a third looks on. A death god descends from the skyband above to take the offering.

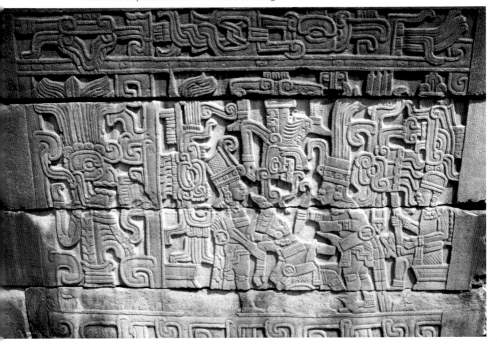

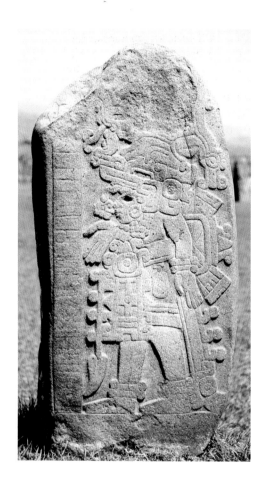

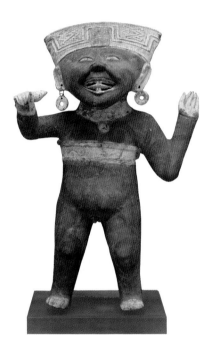

enactment of battles. The use of the ballgame as a metaphor for other struggles was recorded in Early Colonial documents and is perhaps most clear in a K'iche' Maya text, the *Popol Vuh*, where the confrontation of life and death is couched in terms of the game.

The reliefs of El Tajín's South Ballcourt were probably worked in situ, since several flat stones form a single carving surface, like those of Chichen Itza. A distinctive double outline is used to work all the designs, but particularly the scrolls. The reliefs would now appear to have their origins in Middle and Late Formative Olmec styles, as well as in the curvilinear Late Formative style of Izapa. This double-outline workmanship is so characteristic of Classic Veracruz that it indicates the origins and relative date of materials found as far away as Teotihuacan or Kaminaljuyu; when it appears on the fancy ballcourt paraphernalia, it often serves as a frame, a suggestion of place, or as the detail of a garment.

Full-scale stone carvings of Classic date have been found elsewhere in Veracruz, particularly at the site of Cerro de las Mesas, which may be best known for the huge cache of jade, some of it Olmec, and including at least one piece reworked in Costa Rica, buried in a fourth- or fifth-century context. Stone stelae at the site bear Initial Series inscriptions that correspond to Maya dates. Stela 8 records a date in 514 CE, just at the end of direct Teotihuacan influence, and shows an individual who was presumably a ruler of that era. Curiously, he wears a shield emblem in his headdress of the type prominent in the name glyph of Pakal of Palenque, the Maya king who came to power about a hundred years later.

Fine hollow clay sculpture was produced at various centers throughout Veracruz during this era, almost certainly continuing a tradition established by earlier Olmec artisans and shared in Oaxaca as well. It was a tradition sustained through Aztec times, with the result that even the relative date of some of these pieces is in doubt. Uncertain, too, is the specific provenience of the majority of the sculptures. Some have been traced to particular sites, generally looted, but most are isolated finds. Those of Remojadas are particularly lively and are often characterized by "smiling" faces, which may in fact be the result of ecstatic rituals. Charming couples are found in pairs

118

152

119

118 OPPOSITE TOP LEFT Stela 6, like Stela 8 at Cerro de las Mesas, records a date in the counting system of the Maya, 9.1.12.14.10, which corresponds to a date in 468 CE. The ruler wears a backrack, and on the loincloth, a Maya symbol for yellow or maize.
119 OPPOSITE TOP RIGHT A hollow ceramic male figure holds a rattle in one hand and prepares to dance. The frozen smile of his face may be a sign of ecstatic transformation.
120 OPPOSITE BOTTOM Mesoamericans did not use the wheel for practical purposes. Nevertheless, miniature forms, like this jaguar, provide surprising evidence of some knowledge of the wheel.

or on swings, and little animals turn on wheeled feet. Such toys are the only known use of the wheel in ancient Mesoamerica. The makers painted many of these sculptures with shiny black asphalt, locally called *chapapote*, a naturally occurring petroleum tar (no other use was known in prehispanic times for the plentiful oil of Veracruz).

Probably of later date are the large-scale hollow figures at El Zapotal, found not far from Cerro de las Mesas, many of which represent gods better known in Aztec times, although the chronology is far from certain. There, an underground chamber centered on a great death god, Mictlantecuhtli, made of unfired clay; nineteen fired, nearly life-size female death goddesses stood in attendance, while four more sit. Snakes form their belts, and they represent a *cihuacoatl*, or "woman snake," a maleficent old female deity. Some 200 human skeletons lay in the chamber, along with hundreds of small figurines, all at the court of the great death god.

Along the Pacific Coast of Guatemala: Cotzumalhuapa

A web of artistic and trade connections focused on Teotihuacan during its apogee; later, especially in the eighth century CE, the network became more complex, particularly as local, regional expressions took root and held on even as Maya cities were abandoned around 900 CE. Fresh research has brought to light the importance of the regional style of art and architecture known from Santa Lucía Cotzumalhuapa and its environs. Despite its location on the Guatemalan coast and proximity to the Maya area, Cotzumalhuapa rejected Maya writing and imagery, participating instead in the cultural tradition of the Isthmus of Tehuantepec, where contact flowed from Veracruz to the Pacific Coast.

The makers of Cotzumalhuapa art were probably not Maya, and, although they have often been identified with the Pipil (Nahuatl speakers in Guatemala at the time of the Aztecs), we will probably never know their ethnicity. We do know, however, that they carved stelae and panels rife with images of the ballgame, human sacrifice, and the sun. Glyphs were inscribed in round cartouches – some appear to be part of a Central Mexican calendrical system. The figures on the monuments are generally long and attenuated, of proportions similar to those drawn on Maya vases from such highland Guatemalan sites as Nebaj, but right and left hands and feet are often reversed or flipped in the Cotzumalhuapa depictions, much as they are on Maya vases. Cacao pods – the source of valuable chocolate – frequently adorn these Cotzumalhuapa figures, suggesting the origins of their wealth.

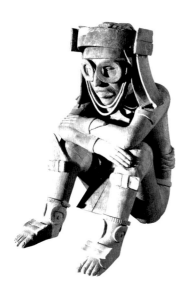

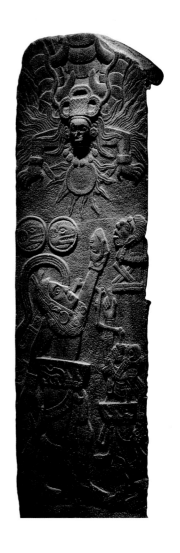

121 TOP LEFT Nineteen Cihuateteo, or "woman deities," were found at El Zapotal in attendance on a large, seated death god, all set within an underground shrine. This nearly life-size example, 4 ft 5 in. (136 cm) tall, comes from nearby Cocuite, and may have been made in the same workshop.

122 BOTTOM LEFT Found in the El Zapotal complex, this unique hollow ceramic figure takes a meditative pose, engaging in some unknown way with the "woman deities" and the great Death God. The goggles characterize the Storm God of Teotihuacan and the Aztec deity Tlaloc.

123 RIGHT Stela 3, Santa Lucía Cotzumalhuapa. A ballplayer and a death god, both in ballgame yokes, stand in front of a temple. They reach toward a scorpion sun to offer a human heart.

124 Sylvanus G. Morley kneels beside this fragmentary stela from Pantaleon in Cotzumalhuapa style. Comparable three-dimensional portraits of the Classic period are known from Tajín and Copan.

Ballgame rituals played between humans and supernatural beings appear on several stelae. Whether or not divine, the individuals wear ballgame equipment similar to that of Veracruz, and hachas have been widely collected at Cotzumalhuapa sites and across highland and Pacific Guatemala. Descending solar deities on the upper parts of the monuments may prefigure the Postclassic "diving gods" of the Caribbean coast. These deity faces are worked frontally in three-dimensional relief, in striking contrast to the low relief of the profile figures that sit beneath them. Some fully three-dimensional monuments were also created, and they may relate to the tradition of sculpture in the round at Copan, which, like Teotihuacan, was known as a *tollan* – a "place of reeds," a great bearer of culture that radiated across ancient Mesoamerica, underpinning the shared sense of place.

Chapter 6
The rise of Classic Maya cities

Some Maya cities had thrived during the Late Formative period; many of these seem to have gone into decline around the year zero, but some, like Ceibal, may have been continuously occupied from early Olmec times onward (see p. 44). In this, as in all things Maya, there is no one Maya, no single trajectory, no unified empire. Yet the message of San Bartolo (see pp. 66–67), long buried, was not forgotten: there was one fundamental belief system, in which the life cycle of maize was central. Meanwhile, in Central Mexico, Teotihuacan was the opposite, a single city, on a rocketing trajectory, and it had become an important center and cultural force ahead of the Maya, by 150 CE. About a hundred years later, the Maya cities entered upon their period of greatest prosperity and influence, and they would jostle with one another in their relationships with Teotihuacan. Maya temples with signature corbeled vaults were being constructed, and stone stelae with Long Count dates and ruler portraits erected. All these elements appeared independently long before 250 CE, but it was the beginning of their combined, continuous, and widespread use that roughly establishes the Classic era among the tropical rainforest Maya of southern Mexico and northern Guatemala.

In 378 CE, Teotihuacan lords and warriors invaded Uaxactun, Tikal, and other cities in the central Peten of Guatemala, marrying into local elite families and usurping traditional dynasts. David Stuart believes that the founder of Copan, Honduras, journeyed to Teotihuacan to receive authority to establish a new city in 426 CE. In the sixth century yet other Maya sites started to expand, as Teotihuacan influences waned, and there may have been payback for having succumbed to foreigners. The resulting competition led to warfare, and the largest and most powerful of the Maya cities, Tikal, suffered

terrible devastation at the hands of lesser but allied polities, essentially bringing the Early Classic to an end. Teotihuacan motifs and costume elements did not vanish, but they became so thoroughly incorporated into the Maya repertoire that they ceased to be foreign. The Maya were united by the common use of the hieroglyphic writing system, but their monumental carvings and architecture reflect both regionality and innovation, and despite allegiances among them, no single empire emerged.

Architecture: From simplicity to extravagance, from center to periphery

125, 126 The Rosalila temple of Copan, probably dedicated in 571 CE, shows us the complexity of architectural achievement and identity during the Early Classic. By the eighth century, the completed structure stood nine levels tall. Archaeologist Ricardo Agurcia launched excavations, expecting it to be funerary in nature, and indeed it was, but not in the way that characterizes temples at Palenque or Tikal of that later period (see pp. 161–63, 167–68). What Agurcia found instead was building atop buried building, hidden deep inside the final eighth-century structure, holding important burials of fifth- and sixth-century dynasts, including women. The Early Classic sequence was capped and closed by the giddy polychromy of Rosalila of 571, and, within that, the full polychrome building Margarita, which clearly had the name of the founder – K'inich Yax K'uk' Mo', "Radiant First Quetzal Macaw" – manifest in the entwined quetzal and macaw flanking his own deified solar image over the doorway, all taking place at a sacred maize mountain, captured in the roofcomb. Later Aztec myths recounted how deities entered sacred mountains to retrieve maize or to search for ancestral bones from which humans might be regenerated: the lords of Copan made of this building such a mountain, layer by layer, and at the end of the sixth century it would have been the tallest structure at the site. The stucco of Rosalila (and the associated buildings below) was thick, consuming vast quantities of firewood to yield the pure white cement; thick paint then articulated the structure, and a final application of

125, 126 OPPOSITE The brilliantly painted building featured in both images bears the nickname Rosalila, dedicated in 571 CE, and eventually fully encased in the eighth-century Structure 16 and the surrounding acropolis, cut away here (TOP). Deep within Rosalila lay yet earlier structures with elaborate stucco program (BOTTOM). Archaeologists believe that the first structure, Hunal, for which only a modest platform survives, held the founder, Yax K'uk' Mo'. One of the wealthiest burials of the sequence contained a venerated fifty-year-old woman, whose tomb was re-entered several times to make burnt offerings.

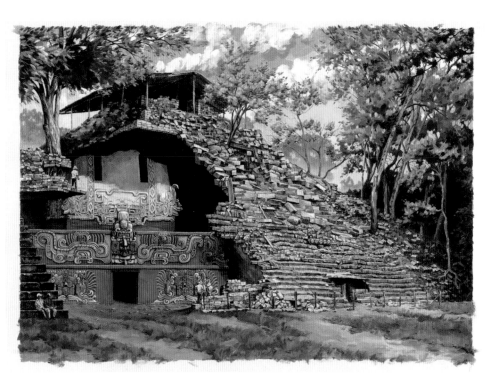

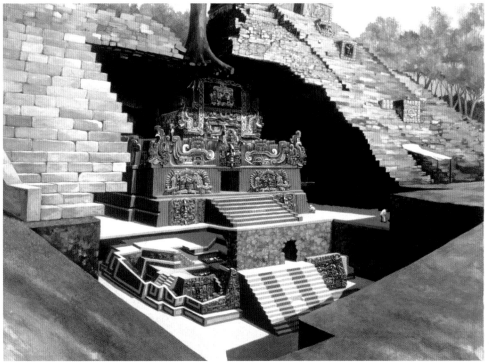

mica made the building dazzle, the radiance making manifest the founder's name. Not a right angle was to be found in stone or stucco. This building was then carefully packed with sand inside and out, preserving it intact, as it, in its time, had preserved Hunal, which seems to have been the foundational building within it. Maya architecture was in this way almost "wordy," spelling out meaning to be read at distance even by those with only basic literacy in Maya belief. To those who knew, the later buildings signaled the earlier ones, texts within texts.

The Maya builders of the Rosalila used a relatively small inventory of simple architectural forms and little more than limestone and paint, from block masonry to the cement formed by burning limestone, unchanging over centuries. Archaeological work at Tikal and Uaxactun (literally "eight stones," a name given by Sylvanus G. Morley to refer to the early Cycle 8 dates there and also a near homophone for "Washington," in honor of the Carnegie Institution of Washington, the excavation's sponsor) has long established much of what we know today about the Early Classic. But when adopted at cities on the periphery, such as Copan, the exuberant results outstripped the model.

Building materials are universal, but the Maya at different sites introduced novel building types. Preliminary architectural and ceramic studies at Uaxactun early in the twentieth century indicated to the archaeologists that Group E, an isolated cluster of buildings, was the oldest part of the site. In a search for the origins of Maya high civilization, Structure E-VII was dismantled layer by layer, revealing a series of building phases. 127 The earliest structure, now known as E-VII-sub, is a small, radial pyramid just over 26 ft (8 m) high, with staircases on all four sides flanked by giant mask façades. The principal orientation of E-VII-sub is to the east, indicated by a stela at the base of the stairs on that side. Postholes on the upper level mark the remains of a perishable superstructure, which suggested to the archaeologists that the pyramid might antedate the general use of permanent superstructures. Indeed, E-VII-sub does seem to date from the first century CE, preceding the widespread erection of dated stone monuments.

Functionally, E-VII-sub was a simple observatory. From a point on the eastern stairs, the lines of sight that can be drawn to the three small facing pyramids mark the lines of sunrise on the days of the solstices and equinoxes. The Maltese-cross plan of E-VII-sub resembles the Maya completion sign, as do plans of some other radial structures, and most such structures record the completion of some period of time. At E-VII-sub, it is the solar year that holds significance, as it is at the Castillo,

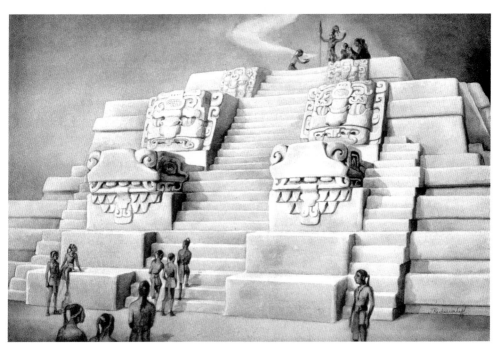

127 In the 1920s, archaeologists of the Carnegie Institution of Washington peeled away layers of a large building, revealing the building known as E-VII-sub at its core. Constructed before the era of stone monuments but with vast stucco masks, it was surmounted by a perishable structure.

Chichen Itza, built much later (see pp. 223–24). Twin radial pyramids at Tikal were erected on platforms to commemorate the completion of *katuns*, the twenty-year periods, from the late sixth to eighth centuries CE, while the Maltese-cross emblem that functions as a frontispiece to the Aztec-period Mexican Codex Féjerváry-Mayer is a 260-day calendar. Thus, radial configurations, from their earliest appearance at Uaxactun, and as found at Chichen Itza until the Spanish invasion, mark the passage of time, and structures in such form are generally giant chronographic markers.

128, 129 Excavations in Group A at Uaxactun revealed a different pattern of construction at the outset, perhaps more like those now also seen for San Bartolo and Copan (see pp. 66–67). A three-temple complex, A-V, was transformed over a period of at least 500 years, its growth inspired by interments of important lords and stone monuments, the latter often ritually battered before burial. The term "temple" generally refers to an elevated platform with a relatively small superstructure where offerings were made. Because new temples were erected over rich tombs

of important individuals, or in some cases the inscribed records of those individuals, one can only suppose that the structures were shrines to memorialized ancestors. As we shall see, a focus of Maya religion and architecture was ancestor veneration.

At complex A-V, by the end of the fifth century CE, small temples obscured the courtyard of the three original temples, which had also been expanded through time. In the seventh

128 TOP Based on the archaeological exploration of Uaxactun, Tatiana Proskouriakoff drew reconstruction drawings (after which these are adapted) of the eight major phases of architectural development at the site. Single shrines atop platforms of the third century CE gave way to a vast complex by the end of the eighth century CE.

129 BOTTOM The Maya at Uaxactun built massive architecture on firm bedrock, connecting clusters with causeways. Swampy low-lying areas supported agriculture; gently sloping and paved plazas filled reservoirs.

century, these single-chambered shrines of A-V gave way to multi-chambered galleried structures, the type of building normally considered a palace (and often called "range-type" structures by archaeologists). These palace buildings drastically altered access to the old interior platform and shrines, and presumably function changed along with form. Although burials were deposited in the new structures, they were not elaborate and were limited to women and children. At the end of its life, when galleries had replaced all but one of the shrines, A-V had become a great administrative or bureaucratic complex, where most events took place away from public view, and where secular or family activities dominated sacred ones. A separate temple raised beside A-V can be interpreted in this light as a new focus for religious activity, and it probably housed a rich tomb at the end of the eighth century.

Many elements of Maya city planning can also be observed at Uaxactun. The gently rolling karst limestone topography of the Peten provides islands of solid foundation separated by marshy swamps. Typically, the Maya developed their sites so that clusters of monumental architecture on firm ground were connected by *sacbes*, elevated, stuccoed white roads that spanned the swamps. The result is a skyline of towering structures broken by open stretches. We might compare the result with modern Manhattan, where less firm rock long precluded the building of skyscrapers between Midtown and Wall Street. The skyline thus appears as islands of construction, connected by the great north–south avenues. At Uaxactun, Groups A and B are connected by a single causeway, and address one another across the north–south axis of the *sacbe*. During heavy seasonal rains, the temples would have seemed to float above water, invoking once again the concept of *altepetl*.

At Tikal, many years of large-scale archaeological exploration in the grandest of all ancient Maya cities revealed an intricate pattern of architecture and urban planning. Like Uaxactun, Tikal featured a massive radial pyramid with badly damaged stucco masks at the center of what is today called the Mundo Perdido ("Lost World") complex, but unlike the radial structure at Uaxactun, it did not function as a giant chronographic marker. One large building of the complex features something like Teotihuacan-style *talud-tablero*, but in proportions that are unknown at the site of Teotihuacan itself, perhaps an accommodation of foreign worship after the invasion of 378.

Before 250 CE, the North Acropolis and the Great Plaza of Tikal were laid out to define the strong opposition of mass and space, north-to-south, that prevailed for the rest of the city's history. (The equally strong east–west axis created by Temples I

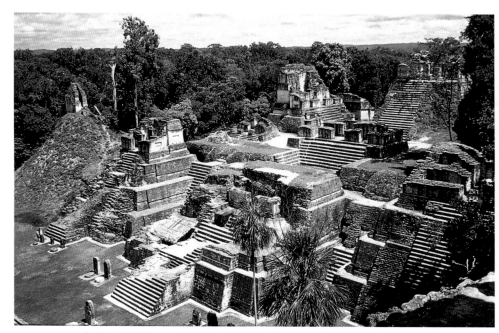

130 Early kings of Tikal were buried in North Acropolis structures (center). In the eighth century CE, Temple II (at left, out of the picture) and Temple I (from where this picture was taken) framed the ancestors.

and II was not established until the eighth century.) Massive temples clustered on the North Acropolis functioned primarily as funerary monuments of Early Classic rulers of Tikal. Structure 34, for example, housed the richly furnished tomb of King Yax Nuun Ayiin, nicknamed "Curl Nose." Structure 33 held the tomb of his successor, and may have been the last tomb added to the program. Once completed, the North Acropolis must have embodied the spirit of ancient kingship, an invisible yet known gathering of ancestors, dwelling within sealed chambers.

Typical features of these Early Classic funerary pyramids are their squat proportions and the massive apron moldings that wrap around corners. As deeper archaeology yields discoveries at Holmul, El Zotz, and other Maya cities, the more the culture and practice of giant stucco architectural adornment in the fourth and fifth centuries CE can be recognized.

In these early structures, we see the most prevalent types of Maya architecture: great chronographic markers, memorials to ancestors (probably religious structures), and bureaucratic structures. Were we to examine buildings of such different function from another part of the world, we would probably

find that they were executed using different forms, perhaps separate architectural orders. Among the Maya, there was no architectural style linked exclusively to religious structures that differentiated them from civic buildings. All Maya architecture was composed of elevated platforms and corbel-vaulted chambers, organized in a variety of configurations. This makes the identification of function challenging.

The corbel vault has sometimes been disparaged as a "false" arch, but achieving the Roman keystone arch was not a goal of Maya architecture. To form a corbel, masonry walls were built to the desired height. At the spring of the vault, flat stones were placed closer and closer together until they could be spanned by a single capstone. The weight and mass of the walls helped prevent collapse, as did crossties, many of which remain in place today. They were probably useful in raising the vaults and then served for hammocks and other furnishings. Exterior mansard roof profiles often followed the lines of the corbel, resulting in a stone architecture almost perfectly reproduced by the forms of Maya thatched houses today. The stone capstones conform to the hip roof of the thatched house, as if both to sanctify and exploit the domestic space, some of which is more explicit in Late Classic architecture. Almost all Maya interior spaces, then, repeat the forms of the Maya house. The corbel vault is not a "false" anything, but a "true" Maya transformation of simple forms into elevated permanent ones.

Sculpture: Setting a pattern for the millennium

An expanded history of Maya art reveals the early date – 100 BCE – of a developed religious narrative at San Bartolo, in the tropical rainforest, and historical rulers on stone stelae in the Guatemala highlands. By the third century CE, at Tikal and elsewhere in the Maya lowlands, at about the same time that the Maya began to use the corbel vault, they also started to erect stone monuments carved with portraits of rulers and writings of their deeds. With these monuments, royal individuals demonstrated the power to have themselves honored in a permanent medium during their lives, and probably to be commemorated posthumously as divine. The earliest of these new monuments with secure date and provenance is Stela 29 at Tikal, discarded to an ancient dump and rediscovered in 1959 by archaeologists. The roughly hewn shaft of Stela 29 was carved on one surface with a portrait of a seated Tikal ruler; the other face records a Long Count date, 8.12.14.8.15, or 292 CE. Such dates denote important events and the names of their protagonists; unfortunately, in this case the butt of the stela was broken off and lost in antiquity, thus

131

depriving us of the complete record. Other stelae at the site were found tossed into piles of refuse or cut into building stone, but some had been reverentially buried and still others had evidently never been removed from public view in Maya times.

Typical of the representation of these early Maya lords are the very round and irregular forms, characteristic, too, of architectural ornament, with the right angle absent. The right hand is drawn curled, as if in a mitten, and it presses a ceremonial bar to the body – many Maya kings throughout the period are shown carrying this object. An ancestor figure looks down from the upper portion of the stela. With his left hand, the ruler supports an image of a solar and fire deity generally known as the Jaguar God of the Underworld, identified by his tau-shaped tooth, jaguar ear, and "cruller" – so named for a donut popular a century ago – over the nose. All early Tikal rulers carry this deity, and he is probably a patron of the city. The king himself wears a mask, and his hair is shaved into a crest that runs from the forehead to the nape of the neck, a hairstyle also known among Native North Americans, particularly warriors.

Stela 4 of 380 CE records the first Teotihuacan interloper, Yax Nuun Ayiin, to rule Tikal. Politics can be topsy-turvy, and nowhere is this more evident than at Tikal: years later the monument was reset upside down in front of Yax Nuun Ayiin's funerary pyramid, his head hidden and his feet visible, a punishing and humiliating desecration. Was he viewed as traitor or usurper, in a story to be publicly retold after his death? The monument is a modestly worked boulder, itself an anomaly, with stone occlusions, uneven surfaces and low relief,

131 Stela 29, Tikal, records the earliest contemporary Maya Long Count date, 8.12.14.8.15, corresponding to a day in the year 292 CE.This early king wears a deity mask and holds out another god, while his father's portrait faces downward in the upper margin. Drawing by William R. Coe.

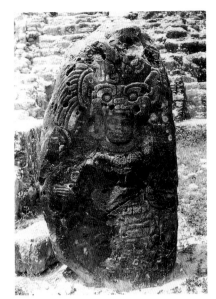

132 LEFT In his frontal representation, Curl Nose – the modern nickname of Yax Nuun Ayiin – presents himself as a foreigner from Teotihuacan. Later lords buried the stela upside down, leaving only the feet visible.
133 RIGHT Karl Taube has drawn out the bundle with rain-god insignia that the king holds in the crook of his arm.

and the image, too, is distinct. The ruler is seated in profile, but he is shown with a fully frontal face, like no other king before him: he has been rendered as if he were a Teotihuacan deity, and his headdress comes straight from the walls of that distant city. He bears the solar Jaguar God of the Underworld on his right hand but cradles what may be a bundle or jar in his arm, adorned by the headdress of the Rain God. In this, the fundamental juxtaposition of water and fire, *atltlachinolli*, later understood to be the metaphor for warfare among the Aztecs, is present in this hybridic representation of the fourth century CE. In his monuments, in his burial assemblage, and even in writing that suggests lack of attention to rigorous Maya script conventions, Yax Nuun Ayiin demonstrates bilingual skills, articulating his power through monuments, deities, and architecture that spoke to both Central Mexico and the Maya.

Despite the political intrusion, the next generation returned to the format of representation established by early Tikal kings, at least in the characterization on the front of his principal monument, Stela 31, erected in 445 CE. Perhaps the child of a local Tikal woman and Yax Nuun Ayiin, Siyaj Chan K'awiil, nicknamed "Stormy Sky," sought to invoke legitimacy on both sides of his family. He had the polished shaft of stone

134

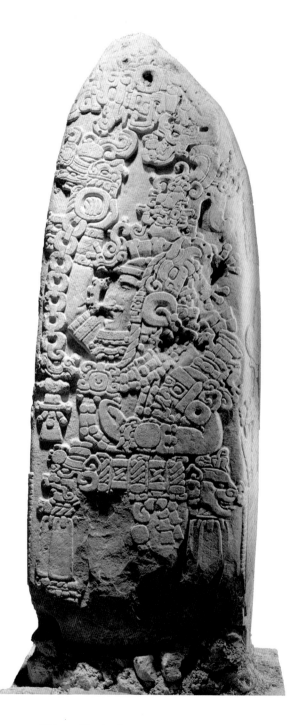

134 Siyaj Chan K'awiil, also known as Stormy Sky, dominates the front of Stela 31, just as he cast a long shadow over Tikal's history. The back of the monument bears the most complex historical text recorded at the site.

carved on all four sides. The two sides flanking his portrait depict a pair of Teotihuacan warriors in an uncluttered format that suggests Teotihuacan more than the Maya, yet does not resemble works made at Teotihuacan itself. Each warrior bears an *atlatl*, or spearthrower, and a shield that depicts Tlaloc on one side. In these representations we see two profile views of the same individual, for shield and weapons are reversed, as if we were looking at a single individual, standing behind Siyaj Chan K'awiil. Both bear a glyphic text above that identifies a single person, and it is none other than the father, Yax Nuun Ayiin, apparently revealed as a young warrior at the height of his power. The monument, then, has an almost three-dimensional presence, of the king with his father standing behind him, and a multi-dimensional presence, in which past and present coexist.

The stone of Stela 31 is of fine grain, a hard, dense, and superior limestone ideal for recording detail, and among the finest such material ever used at Tikal. The sculptor recorded the most complex inventory of ritual paraphernalia of any Maya king: Siyaj Chan K'awiil holds the Jaguar God of the Underworld in the crook of his left arm, and with his right, he holds forth the headdress of rulership, crowning himself. His own face bears a small "X-ray" mask, helping to emphasize that this is a portrait of the trappings of office more than a portrait of an individual. Like Stelae 4 and 29, Stela 31 was removed from public view in antiquity, as Tikal wrestled to revise and codify its past. In the eighth century CE, Stela 31's broken shaft was hauled to the top of Structure 33 and burned, where it would be found in the 1960s, charred but in near-perfect condition.

156

During the era when Teotihuacan warlords seemingly marauded across the rainforest, Uaxactun was particularly afflicted and its monuments badly damaged. But at the end of the Early Classic, as Teotihuacan lost its grip, monuments were erected at many other sites, some quite distant, as if staking out a new definition of the Maya world. In a number of cases, even these first hesitant works indicate the regional styles that later flourished at these places. Monument 26 from Quirigua, a site not far from Copan, shows a ruler in frontal pose, like all later monuments at that site. In style, it probably drew on both the wraparound conventions of Tikal stone monuments and early cache vessels: portable goods might have influenced provincial developments. Multifigural designs appeared first on stone sculpture far from the Peten, and Copan's Mot Mot panel of the mid-fifth century CE may be the earliest work found in context with two lords facing one another across a panel of glyphs. The establishment of strong regional styles in the Late Classic finds its roots in the earlier period.

136

In 1864, workers exploring for a potential canal near Puerto Barrios, Guatemala, came across one of the most remarkable of early Maya sculptures, together with a Postclassic cache of copper bells. Now known as the Leiden Plaque, this beautiful piece of translucent jade was once a fancy costume element, one of three jade plaques hanging from a jade bar or head worn at the waist. The imagery suggests that the object may have been a kind of portable stela, for the ruler portrait on the front and the inscription on the back conform to monumental Tikal works of the time. The Maya lord stands over a prone, bound captive, and bears a pliable serpent bar in his arms. Mitten-like hands and the parted profile legs confirm the early date.

Painting
Several Early Classic wall paintings have survived the ravages of time. Perhaps the most beautiful of these are found in the tomb emptied by 1970s looters at Río Azul, in northeast Guatemala. An early fifth-century CE Maya date and text were drawn using guidelines, which artists then scraped away. The writing is framed by deities, including the Maya Sun God, at right, with a glyph for *k'in*, or sun, in his cheek. The side walls are marked with wavy, beaded symbols that indicate liquid, probably the watery surface of the underworld. The deceased would have been laid with his head at the text, and his body just within the liminal, watery world that the Maya perceived as the entrance to the afterlife. The niches for offerings are similar to those of contemporary Tomb 104 at Monte Alban.

The Río Azul painting is monochrome, a reddish-brown hematite pigment on creamy stucco, and the line is sure, strong, and highly calligraphic, each stroke ending in the whiplash of the confident painter. Contemporary paintings in Tikal's Burial 48 are by comparison less well executed, although the configuration is similar: a Long Count date is surrounded there by symbols of preciousness, asymmetrically painted across the walls of the chamber. A bright polychrome scene at Uaxactun found by archaeologists, copied, and then vandalized when the archaeologists departed, revealed musicians, families, ritual bloodletting, and a meeting of important lords within a palatial setting.

At Calakmul, a monumental painted stucco frieze adorned the façade of Group A, North Acropolis; below, archaeologists came upon a vivid painting 656 ft (200 m) in length, featuring a stylized world of aquatic abundance. Brilliant blue and red pigments define water signs and glyphs; subtler colors bring waterbirds to life, with shading added to their wings. Both frieze and painted wall closely resemble pots of the fifth

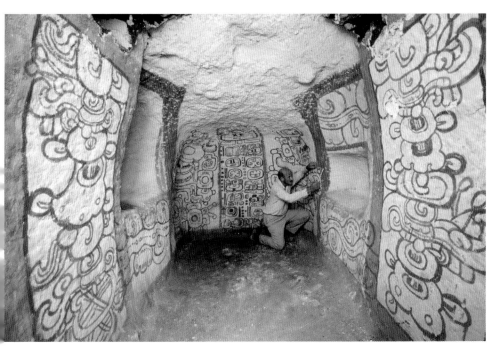

135 TOP LEFT The Leiden Plaque. On this handsome jadeite ornament – perhaps it was a "portable stela" – a Maya lord proudly stands on the captive underfoot. The date recorded, 8.14.3.1.12, corresponds to a day in the year 320 CE.

136 TOP RIGHT Mot Mot Panel, Copan. Deep within the Hieroglyphic Staircase, this panel capped an early tomb of an important female dynast from an early phase of the building. Rich Teotihuacan-affiliated offerings attest to Copan's sustained, external relationships during the fifth century CE.

137 BOTTOM Dug into bedrock, this monochromatic painted tomb at Río Azul features a text that begins with the notation 8.19.1.9.13, a date in 417 CE. Archaeologist R.E.W. Adams stands beside the swirling designs that suggest the watery surface of the underworld.

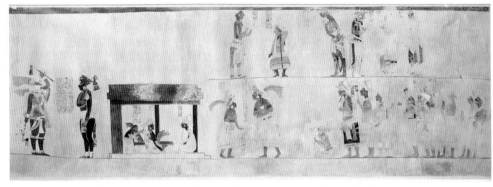

138 Painted across one side of a doorway, this Uaxactun mural depicts the family members of a fifth-century CE court. Visitors arrive at left; women gather in a palace chamber beside an empty throne; musicians attend at far right.

century CE, suggesting the interaction and shared work of painters and modelers of both the small and large scale.

Funerary rites and the offerings in the tomb

The great tombs uncovered at Tikal brought to light the finery and pomp of Maya funerary practices, and in many cases also gave meaning and context to the many objects known without such clear provenience. When deceased Maya kings were prepared for interment, they were splendidly equipped for their journey and spiritual transformation in the underworld, and funerary furniture often reflected these concerns in its iconography.

When Yax Nuun Ayiin died, around 404 CE, his body was set within a perishable structure at the base of what would become, after his interment, the building we call Structure 34. His funerary march was probably accompanied by a great procession of musicians, who laid down their instruments, consisting of turtle shells and deer antlers, in the tomb. Others in the procession, like those depicted in the later Bonampak murals (see pp. 155–56), may have worn exotic costume: a set of crocodile scutes was also recovered from the tomb. Nine individuals, perhaps among them these very procession members, were then sacrificed and placed alongside the dead king. Many fine ceramics were placed in the tomb, some filled with frothy chocolate beverages or maize gruel, as hypothesized from the texts on numerous pots and now confirmed by the testing of residues. Many of these show strong Teotihuacan influence in terms of imagery, shape, and technique, but most were made locally. Many resemble those also produced at Kaminaljuyu, in the Guatemalan highlands. In fact, burial

complexes there contained a similar configuration of exotic materials, and both may reflect a Teotihuacan tradition, although they also differ from the Teotihuacan burials which have come to light in recent years.

139 Lidded, stuccoed vessels, mainly with tripod supports, dominated Maya royal funerary offerings during the late fourth and fifth centuries CE. Shape and technique derive from contemporary Teotihuacan pots, but the Maya products taper at the "waist," and the less weighty Maya lids may have anthropomorphic or zoomorphic knobs. Some vessels were made expressly for tombs: potters must have responded to urgent demands when a king died. Like all ceramics of Mesoamerica, the vessels were made by coiling clay "snakes" into surprisingly thin-walled cylinders, and occasionally pressing molds or carving the moist clay. In certain instances, an artist combined stucco technique with incision of clay at the leather-hard stage, and the two techniques are masterfully executed together. Some of the pots, including an example

140 from Río Azul, have "screw-top" lids; others have rattles fired into the base of the bowl. Many ceramics of this era depict traditional Maya imagery in the stucco painting, but

141 Teotihuacan influence is also strong: a ring-stand bowl from Curl Nose's tomb shows Central Mexican deities. Copan archaeologists have excavated examples made in Central Mexico, but specifically, in this case, for a local market: the stucco imagery here shows the founder of the Copan dynasty as the embodiment of an ancestral shrine.

 Two-part ceramic effigies have also been recovered from

142 Early Classic tombs. An especially fine one from Yax Nuun Ayiin's tomb depicts a squat old deity on a stool of crossed human femurs holding a human skull in his hands. About twenty-five years after Yax Nuun Ayiin's death, a Tikal lord was interred without head, femurs, or feet. Although he might have been brought back from the battlefield in this state, his mutilated skeleton could also bear witness to the practice of collecting relics from royal persons. Years later, Jasaw Chan K'awiil of Tikal was buried with a collection of carved bones, some of them cut from human femurs. This old deity, then, may be the patron of a particular form of sacrifice, associated with ancestor veneration and dismemberment.

 Other types of fine ceramics were made, including the fourth-century CE basal-flange bowls that pre-dated the advent of tripod vessels in the Maya area, many with dome-shaped lids, and that continued to be made throughout the fifth century. Painted with colored slips, some pots reveal a remarkably wide range of colors and a brilliant sheen, despite

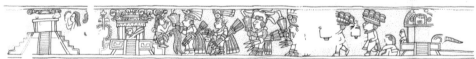

139 TOP LEFT Nicknamed the "Dazzler," this extraordinary vessel came from the tomb of a woman connected to the founding dynasty at Copan. Tests reveal a Central Mexico origin of the clay, but the vessel would seem to have been made for the Copan founder, whose masked face stares out from a temple shrine.
140 TOP RIGHT David Stuart first identified this vessel as bearing the glyphic notation equivalent to "his chocolate pot." Scientists at the Hershey Company tested the residues and confirmed the presence of theobromine, the active ingredient in chocolate. The unusual handle with jaguar pelt tops a lid that locks in place.
141 BOTTOM Made at Tikal and excavated from a disturbed cache, this vessel depicts six individuals in Teotihuacan attire approaching a series of temples. As if a meditation on architecture, three well-differentiated structures suggest the architectural variety at both Tikal and Teotihuacan.
142 OPPOSITE This two-part effigy was found in the tomb of Yax Nuun Ayiin at Tikal. Smoke from burning incense placed within would have billowed from the mouth and forehead tube of the old deity, who holds out a severed head in his hands. He sits on a stool of crossed femurs.

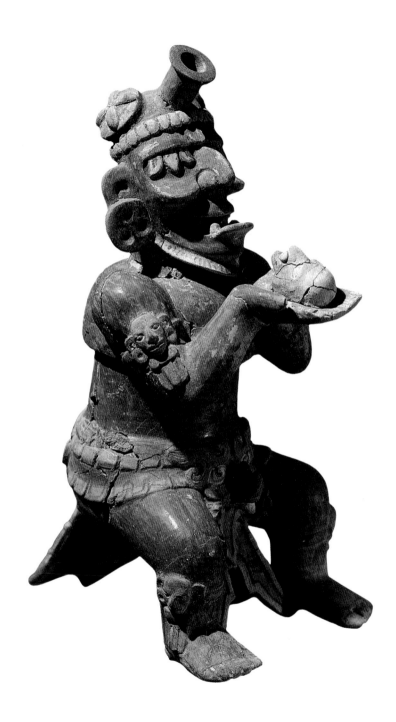

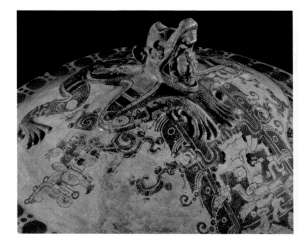

143 TOP Archaeologists at El Zotz, Guatemala, uncovered a rich tomb, filled with two-part lidded basal flange bowls. This example features a peccary whose head is three dimensional, with the body and legs painted in two dimensions.

144 BOTTOM LEFT Many Early Classic lidded vessels feature water birds; the incised wings of this example seem to float on the surface of the water while the bird grasps a tiny fish in its beak.

145 BOTTOM RIGHT A tomb excavated at Becan, in southern Campeche, yielded this extraordinary vessel. The knob of the lid is formed by a supernatural lizard with human head in its mouth, which presses down on the two-dimensional bloody stump of an upside-down human trunk.

the low temperatures at which they were fired. It would be easy to mistake the surface for glaze, which it is not. Quadrupod vessels occur with the basal-flange bowls, and many are jaguar or bird zoomorphs. The finest are of dark clay, incised at the leather-hard stage and then burnished after firing, including discoveries from Calakmul, Holmul, and Zotz. The artists enjoyed the interplay between two and three dimensions on these vessels, seemingly playing with the forms. On one, a three-dimensional cormorant eagerly eats a fish that shifts from a two-dimensional drawn figure to a three-dimensional sculptural one. A huge and heavy example excavated at Becan depicts a three-dimensional lizard man, whose bloody and anthropomorphic prey drape the lid in two dimensions, as if sliding down a huge mound.

143
144

145

147

Carved and appliquéd cache vessels are also found, many of them formed of two parts – the lower part often with a human face, the upper, one or two supernatural headdresses. Others simply show deities, and one imagines that offerings were placed in these pots. Chahk, god of rain, dominates these representations. He is marked by the curl in his eye, shark tooth, fish fins on cheeks, and shell over the ear, a guise that also characterizes the ruler on Tikal Stela 2.

Early Classic jade was often worked in soft, curving lines, rather than with the sharper drill-and-saw technique of the Late Classic, in this resembling monumental sculpture and

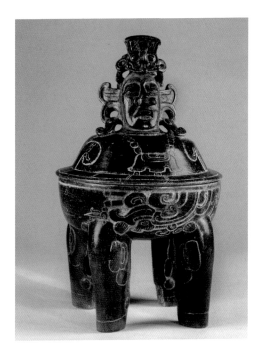

146 Recovered by archaeologists in the tomb of a Calakmul king or queen, this lidded vessel features unusual cut-outs in the earflares and headdress. The pendant is worn by scribes and scribal deities, underscoring the literacy of the deceased individual.

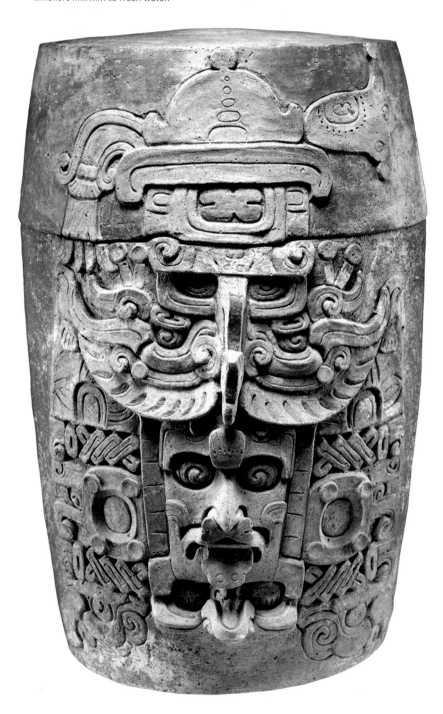

147 Chahk's face stares out from this large two-part cache vessel. His catfish whiskers link him to fresh water.

architectural forms. In other cases, the jade was incised, as on the Leiden Plaque; in others, the hard stone was cut into human and animal shapes. Mosaic masks served funerary roles, and particularly fine ones were excavated at Calakmul, where one dead king's body was bundled under layers of cloth, forming a segmented image like that of a caterpillar in a chrysalis, the mask then applied atop the cloth. Jade celts made bell-like percussive sounds; worn at the waist, they announced the king's presence.

Internal and external relationships: Neighbor pitted against neighbor?

For some Maya cities, their relationship with Teotihuacan defined the fifth century CE. Their leaders – men and women alike – wore Central Mexican dress, added Central Mexican gods to their pantheon, and probably understood distant Teotihuacan to be the heart of culture. Some other Maya cities may have defined themselves by their resistance to Teotihuacan. The vast city of Calakmul surely resisted all attempts that were made to incorporate it into the Central Mexican orbit. Yet despite clear and indisputable Maya records about the arrival of Teotihuacan overlords, the essentially Maya character of the fourth and fifth centuries CE, as expressed in writing, architecture, and much of the iconography, remains equally undeniable.

The salient physical characteristic of the city of Teotihuacan is the city plan, with its grid of right angles and its architecture of right-angle geometry. It bears no resemblance to the more random, asymmetrical, and clustered plan of Tikal, with its architecture of rounded moldings and variable proportions. Only a single *talud-tablero* structure has been excavated at Tikal, within the Lost World group. Nearby Yaxha, where Teotihuacan influence was also strong, developed an urban layout that in part followed "streets," perhaps an accommodation of Teotihuacan city planning to local geography, but it, too, is truly a Maya city. Despite the reluctance to adopt the monumental forms of Teotihuacan, contact with that city clearly resulted in an increasingly cosmopolitan and luxurious life for the royalty of Tikal, and occasional offerings juxtapose the two cultures' material wealth.

Because no inscriptions were known from Tikal or Uaxactun for the period from 530 to 580 CE, early twentieth-century Mayanists recognized a cessation of cultural production, calling it the "hiatus," and used it to divide the Early Classic period from the Late Classic. At Tikal, where Teotihuacan

influence had most potently affected religion, ritual, and artistic style, such influence ended abruptly. Although various explanations had been put forward to explain the lapse, and the absence of any true "hiatus" outside the Central Peten had become clear in recent years, discoveries at Caracol, Belize, seem to provide the clearest explanation of all: according to Caracol Altar 21, in the mid-sixth century CE Tikal was besieged and defeated by its enemies, particularly the rulers who would lead the city of Calakmul, as Simon Martin has argued, with the help of Caracol. Calakmul, where Teotihuacan's ideological presence had never taken root, had maintained a Maya orthodoxy, now deployed to punish Tikal. If Teotihuacan had already been burned, as seems likely, then Tikal could not turn to its old overlords for help. Whatever the absolute goals of such warfare, Calakmul, Caracol, and their allies, including Xunantunich, Belize, enjoyed an economic boom while a reduced population at Tikal suffered grinding poverty and the destruction of their city's monuments and buildings. The Tikal dynasty itself fractured, with a branch of the lineage establishing itself in the Petexbatun region, leading to further seventh-century CE wars. Cities and lineages far from this interminable conflict seem to have benefited by their distance, capturing trade and talent, but perhaps warily: the flamboyant Rosalila building, dedicated in 571 CE, carefully preserved early tombs at Copan and then, in turn, went silent. When cultural production at Piedras Negras, Palenque, and Copan gained renewed vigor at the beginning of the seventh century CE, styles in art, architecture, and ceramics all showed dramatic changes, underpinning the early versus late designation for the Classic Maya.

Chapter 7
Late Classic: Maya cities at their height

Abandoned around 800 CE – some earlier, some later – the Maya cities at the end of the first millennium CE have long exemplified the mystery of archaeology and a lost past, even forming the backdrop to the rebel planet in the *Star Wars* movies. Over the course of the nineteenth, twentieth, and twenty-first centuries, one city after another has emerged from the rainforest, revealing an increasing complexity of art, architecture, and political organization. The latest technology on the scene, LIDAR (Light Detection and Ranging), is revealing that the Maya of this period had built far more densely than previously imagined, even in areas where surveys on the ground undertaken just a few years ago had not revealed clustered structures and connecting roadways. This dense occupation was not sustainable, and Maya population outstripped resources of wood and cropland. Competition for increasingly scarce resources led to attempted, but failed, centralization, warfare, conflagration, enslavement – and ultimately the abandonment of great cities.

Yet this same growth led to exuberant and remarkable works of art, much of it focused on the human form. Moreover, what has always been apparent in the Late Classic is the simultaneous flowering of different styles in a profusion of artistic production. That there was wealth to be spent on conspicuous consumption while the wider economic situation destabilized and deteriorated by 800 CE is not a contradiction. Two remarkably complete sets of Maya paintings, one at Calakmul and another at Bonampak, make good bookends of the period, and both serve as exemplars of the largely lost tradition.

Ramon Carrasco headed up the twenty-first century excavations at Calakmul that upended views of the Maya: the paintings deployed across the giant setbacks seemingly depict

148

a busy market. Markets are hard to document, since they require little more than open space, but the widespread belief had been that the Maya did not have them. Designed as exterior works, enveloping a non-calendrical radial pyramid that was then carefully buried, the paintings are simple panels with one or two individuals at about two-thirds life size that stud a structure at the center of an open plaza, perhaps once the location of a great market or a scene of great shared wealth, akin to the potlatch ceremonies of Northwest Coast indigenous peoples. Tobacco, snuff, salt, tamales, nutritious maize gruel are all on offer, revealing a bounty not previously known or documented from the mid-seventh century CE. Here we see the Maya artist in easy mastery of the human form, the weight of the heavy *olla* shifting to the woman at left. This woman has also absorbed the weight of color in the scene: her diaphanous blue dress and adornments dazzle, juxtaposing her wealth with the mousy gray dress of the smaller servant or slave in front of her, yet both conform to the convention in which only women wear body paint on the face. Not only the color but also the absence of transparency of her garment may indicate the lower status of the servant woman, indicating the very coarseness of the cloth she wears. The larger woman speaks, her mouth slightly parted to reveal teeth, rarely shown except by captives and on figurines in Maya art; a distinctive red line outlines her lips.

148 In the Calakmul painting, the artist follows traditions known to both the painter of ceramics and the muralist: the flat, grasping hands so typical of work by ceramic painters can be juxtaposed with the fleshy hands of the male attendant at

148 Like a Maya pot, this painting at Calakmul is framed by a red border. Rarely does a Maya woman dominate a scene the way this powerful lady in blue does.

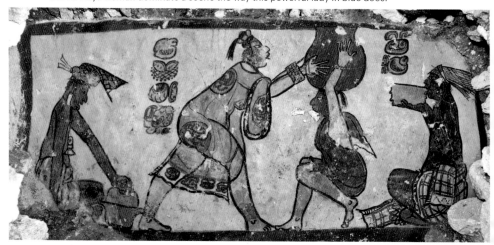

right; the gauzy blue cloth that reveals the voluptuous female body at left shares commonalities with the group of enthroned women in Bonampak Room 3, but here, the artist has paid particular attention to the breast, right down to the nipple, along with the soft curves of her torso. In short, the painter reveals himself to be a master of convention, revealed in the familiar representations of hands and feet, but also perhaps a comfortable innovator, especially in the rendering of the woman in blue. The less adept artist who painted the northeast corner of the building, including the first known record of a purveyor of salt, rendered women with heads too small for their bodies – perhaps because at one point there might have been a plan for them to wear painted hats. The red framing lines also link this monumental project to the tradition of vase paintings (see p. 195).

About 150 years later, in 791 CE, artists at Bonampak decorated the walls, benches, door jambs, and vaults in a modest three-chambered building known as Structure 1, painting in bright colors on damp stucco. Hundreds of Maya are depicted in a unified work celebrating the festivities and bloodshed of the last major dynastic rituals at Bonampak in 791. On three walls of Room 1, nobles in white mantles present tribute to the royal family while three young lords dance at the court's center, with musicians and performers contributing to a great celebration. Central to both the artistic program and to Maya kingship is the great battle covering three walls of Room 2, which might have taken place some time in the past, perhaps when King Yahaw Chaan Muwan was at the height of his power in the 780s. On the north wall, in a scene that encompasses the open doorway, sacrificial victims are displayed on broad steps, like those found at the site itself. In Room 3, amid dancing led by the three young lords of Room 1, the captives are led to sacrifice, on the steps of the pyramid. Beautifully rendered, enthroned women draw blood from their tongues as they watch the captives below. The red sketch of their bodies is visible through the white paint of their gauzy dresses, but not a drop of blood stains their attire. The complexity of the deployment of the figures across the three rooms, the number of pigments applied to wet stucco, the rendering of architecture, and the layering of pigments to create new colors contributes to the perception that this was a tour de force of planning and execution, exemplified by the final black outline, executed with confident calligraphic flair. Yet the paintings' survival was a fluke: shortly after their completion in 791, the site was abandoned, caught up in the warfare that wracked the region throughout this period. Water

149

150,
151

149 TOP In this reconstruction of Room 1, Bonampak lords receive visiting dignitaries in white capes amidst musical entertainment. From within a throne room, the Bonampak king accepts tribute of shells and chocolate.
150 BOTTOM LEFT Following a battle, warriors on the North Wall of Room 2, Bonampak, triumph over dead and dying captives on a monumental staircase. The king stands frontally, just off-center, flanked by kin on his right.
151 BOTTOM RIGHT Blood spurts from the hands of a scalped captive who raises them before King Yahaw Chaan Muwan; pentimento under the elbow reveals the artist's process.

seeped through the poorly made limestone vault, building a layer of calcifications that encased the fragile paint, preserving them to this day. Lucky Bonampak remained hidden from view until the mid-twentieth century.

Architecture: Exuberant and innovative Palenque
Having already been abandoned to the tropical rainforest for centuries, most Maya cities of the dense high-canopy forest were too remote to be pillaged in the sixteenth century. Starting

a b c

152 Variant spellings of K'inich Janaab Pakal the Great's second name glyph, *pakal*, or shield: (a) The logogram for shield has flayed face infixed; (b) The infixed "propeller" has the phonetic value of *Janaab*, conflating the elements of Pakal's name; (c) Pakal can be spelled as three phonetic signs: *pa-ka-la*, read left to right to bottom, and in which the final "a" is silent.

with reports in the late eighteenth century, city after city came to light in the nineteenth – first Copan, Palenque, Yaxchilan, and Tikal – and major discoveries in the twentieth, including Uaxactun and Calakmul; finally La Corona was identified and Plan de Ayutla came to light in the twenty-first. Only since 1980, coinciding with civil war in Guatemala, has widespread exploitation of the rainforest run riot, with far-reaching implications for flora and fauna, ancient cities, archaeologists, and the modern Maya. Conditions have generally been better in Yucatan, where the Puuc cities have been known and generally preserved, with continuous occupation around, if not in, them since the days of their very construction.

Around the year 600 CE, in the foothills of the Chiapas Altiplano, Palenque, the most westerly of major Maya cities, embarked upon a period of expansion. Over about 150 years, under the aegis of just a handful of rulers – in large part, the great King Pakal (whose name can be read phonetically in Maya, and which means "shield"), his two sons, and Pakal's grandson and great-grandson – the city grew in size, splendor, and importance, despite periodic incursions from greater powers. Its layout follows the rolling topography of the site, and temple structures crown and emphasize natural rises. Recent mapping and hydraulic studies have revealed the various streams that course from the mountains above Palenque. Roughly seven streams surge like arteries through the body of the site, making Palenque an *altepetl*, or "Water Mountain," denoting a place of civilization, as we have already seen elsewhere in Mesoamerica. The greatest of these waterways, the Otulum, flows from a spring high above the site; its name means "stone-walled water,"

152

154

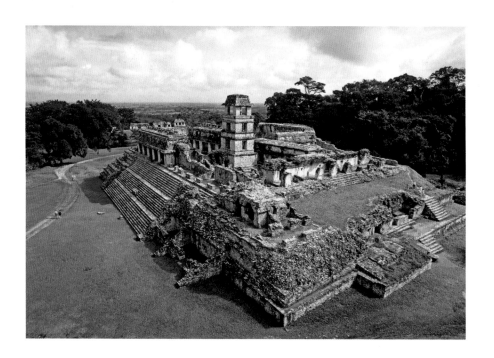

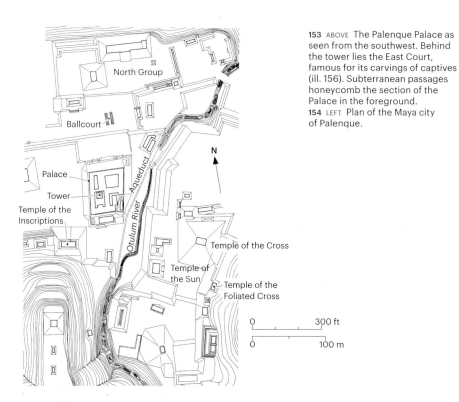

153 ABOVE The Palenque Palace as seen from the southwest. Behind the tower lies the East Court, famous for its carvings of captives (ill. 156). Subterranean passages honeycomb the section of the Palace in the foreground.
154 LEFT Plan of the Maya city of Palenque.

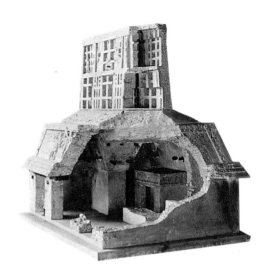

155 Cutaway model of the Temple of the Cross showing the light roofcomb resting on the central wall dividing the two parallel corbeled vaults. The ritual sweatbath can be seen at far right.

153 and it was canalized to bring running water to the Palace. No *sacbes* characterize the architectural plan, but three distinct levels of construction can be discerned down the hillside.

Early masonry at Tikal and elsewhere was thick and heavy, weighty roofcombs leaving little interior space. At Palenque, a different aesthetic prevailed; its architects set corbeled vaults parallel to one another, in a Y-form, with a light, cut-

155 out roofcomb over the central wall. Not only did this allow for greater interior space, but it also stabilized the whole construction, and it is partly because of this innovative technique that Palenque architecture is so well preserved today. Solid mass gave way to a web-like shell for the first time in Mesoamerican architectural history.

What one sees today of the Palenque Palace was probably built over a period of a hundred years or so. An inscription names House E as the "white flower house." Its white color – unique to this structure – contrasted with the city's otherwise red palette and was repainted many times, always retaining the scheme of blue, yellow, and black flowers across its surface. The T-shaped openings that represent the Maya word for wind, *ik'*, brought fresh air into the chambers – quite literally "wind"-ows. Panels and thrones celebrating the accession of several rulers were set inside Palace structures;

Late Classic **159**

scenes on such panels capture courtly life at the time, with attention to dynastic succession. The East Court was ornamented by oversized slabs of subservient figures of gross and distorted features, including one with a huge scarred penis. The wealth and luxury of the court was thus figuratively underpinned by tribute payments and regional fealty. Yet Maya lords may always have wanted to speak to humble roots, whether true or not: at Palenque, the conceit of the thatched house was emphasized in the buildings of the Palace, where sheets of shale were sheared off to look like thatch at the overhang of the mansard (see p. 137).

The final phase of construction in the Palace gave rise to the graceful three-story tower, a unique survival in Mesoamerican architecture and a structure without roots in humble practices. Narrow stairways wind around a solid core, leading to a viewpoint overlooking the plain to the north, a region that paid tribute to the city. The tower also provided a visual connection to the nearby Temple of the Inscriptions (see below), linking the dynasty's greatest ruler with the last.

Supplied with water directly from the ancient aqueduct, the Palace was a comfortable building. It seems to have served as the focus for the various royal ceremonies, rather than exclusively as a residence for the royal family. For other dwellings, we look east of the aqueduct, where extensive excavations by Mexican archaeologists have restored the graceful palaces that sat alongside spectacular waterfalls

156 Individual carved slabs were placed together to create the great sloping *talud* of carved captives in the East Court of the Palenque Palace. The figure at far right displays a scarred, oversized penis. Late Classic.

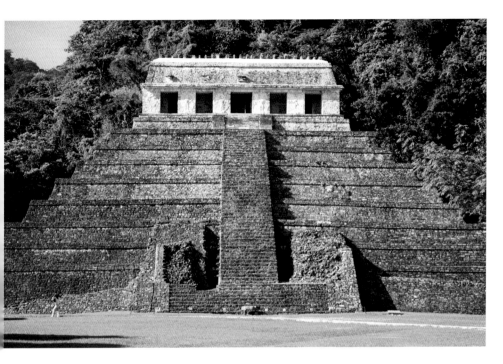

157 ABOVE The Temple of the Inscriptions rises in nine distinct setbacks. King Pakal's architects built his burial chamber into bedrock at the base before the rest of the construction went up.
158 RIGHT Reconstruction, Temple of the Inscriptions, Palenque; inset shows the burial chamber and tomb of King Pakal within, accessible only by stairs from the chamber at top.

and pools. Here, we might well have heard the sounds of children and dogs, seen women at their looms, and smelled the wafting scent of spicy sauces stewing.

The nine-level Temple of the Inscriptions stands just south of the Palace. Set directly into the hill behind, it is highlighted and framed by the landscape. After discovering that floor slabs of a rear chamber could be lifted to reveal interior constructions, archaeologist Alberto Ruz cleared the staircase and in 1952 found the extraordinary tomb at the base of the pyramid, set on an axis, north–south, with the stairs. Within, a large corbeled chamber held the uterus-shaped sarcophagus

197

157, 158

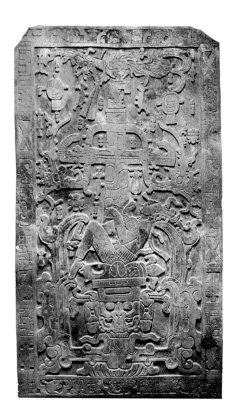

159 As if in the moment of death, the seventh-century CE king Pakal is depicted being swallowed by skeletal jaws on his sarcophagus lid at the base of the Temple of the Inscriptions, Palenque.

of the great King Pakal, whose remains lay covered with jade and cinnabar. The sarcophagus lid shows the king at the moment of death, falling in rapture into skeletal maws of the underworld. The sides of the sarcophagus display Pakal's ancestors, emerging from the earth, while nine stucco attendants flank the burial chamber's walls, animated by Pakal's death. The construction was designed to last for eternity: even the crossties were made of stone (the only examples known) and a small stone tube, or "psychoduct," as it is nicknamed, connects the tomb to the upper level and thence to fresh air. To date, the Temple of the Inscriptions is unique among all Mesoamerican pyramids in having been built before the ruler's death, probably to his specifications.

Three panels of lengthy inscriptions in the upper chamber relate Pakal's life and the legendary history of the dynasty; the exterior stuccos show his son as an infant deity, demonstrating the bloodline's divinity even during the king's lifetime. Immortalized within funerary pyramids, Maya kings were venerated after death, great ancestors united with deities and

visible in the constellations of the night sky. Pakal's funerary monument may conform to the idea of an underworld of nine levels, with the lord's tomb placed at the nadir of the pyramid. At the time of European contact, Mesoamericans believed the heavens to have thirteen levels, a vision of the universe likewise reflected in the stratified Maya world of Pakal, for thirteen distinct corbels connect the tomb to the upper galleries. Later lords anchored themselves to Pakal's apotheosis, with burials in smaller funerary pyramids to the west. The Red Queen, whose tomb was discovered in 1994 in Temple XIII, was Pakal's wife. Thick cinnabar – the raw mineral that yields mercury – coated her delicate bones, and a stunning malachite mosaic mask covered her face. The scientific study of her physical condition has been remarkable: imagine, she even flossed her teeth!

160

East of the aqueduct, the three temples of the Group of the Cross (the Temples of the Sun, the Cross and the Foliated Cross) show yet another architectural innovation. In this design – common to each of the temples – the two parallel galleries are intersected at right angles by another corbeled passage, creating a larger interior space. Each temple also has an inner shrine at the rear of the building. The post-and-lintel doorway, as well as the usual mansard roof, conceals the interior space. At Palenque, the achievement of private interior space is as significant as the negative public space defined by the volumes of the buildings.

Inscribed panels within the Group of the Cross shrines celebrate the births of three patron deities of Palenque back in supernatural time, at the dawn of the fourth millennium BCE.

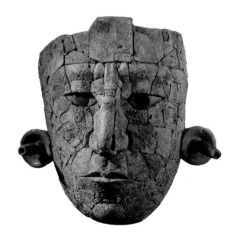

160 Malachite mask placed over the face of the "Red Queen" buried at Palenque.

These shrines were erected under the sponsorship of the late seventh-century CE King K'an Bahlam, Pakal's oldest son; the texts link divine actions to those of the living king. Symbolic sweathouses, these shrines may have been places for the birth of deities; K'an Bahlam probably stored cult figures like the ones depicted on the panels here, wrapped in the cloths that can be seen draping underneath their representations. Their depicted scale is comparable to wooden examples documented at Tikal.

South of the Group of the Cross and creeping up the hillside, Temples 19, 21 and 22 all attest to continuous architectural innovation under Pakal's grandson, Ahk'ul Mo' Naab. New vaulting techniques made it possible to span larger rooms with beams and stucco; other buildings may have had perishable roofs. A new style of royal bench featured multifigural composition and made it possible for several lords to preside or confer at once. The more hidden location and the opportunity for private consultation of large numbers of individuals in interior settings may point to shifting political structures and strategies.

Architecture: River cities

The Usumacinta and Pasión Rivers, east of Palenque and home to political rivals, witnessed a burst of development too, beginning at the end of the sixth century CE and continuing until about 800 CE. River commerce along the Usumacinta was certainly one of the driving forces behind the growth of both Yaxchilan and Piedras Negras. At Yaxchilan, the river rounds an omega-shaped spit of land. Remnants of stone pilings in the silt indicate that there was once a bridge or pier here, perhaps to control river traffic or to collect tribute from passing vessels. Ranging single-gallery structures are set both at plaza level near the river and on the surrounding hills. Structure 40 and Structure 33 celebrate the inaugurations of the two most important Late Classic rulers at Yaxchilan, nicknamed Shield Jaguar and Bird Jaguar. Rising up from great terraces built into the rugged natural relief, both buildings command the river below.

The architects of Yaxchilan created a few buildings of the double-galleried sort common at Palenque, but in general they were more traditional in their use of interior space and rarely deployed the engineering knowledge developed elsewhere. Moreover, they positioned roofcombs directly over vault capstones, which exacerbated the natural tendency of corbeled constructions to collapse, making it necessary to erect ponderous interior buttresses for added support. Most

161

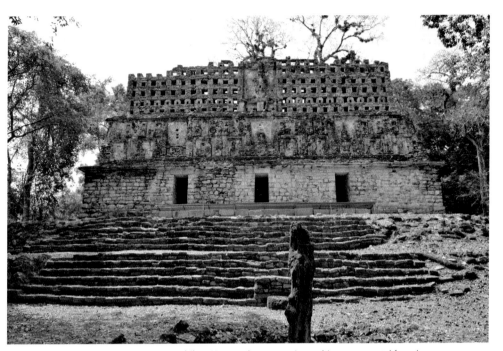

161 Structure 33, Yaxchilan. Narrow doorways pierce this monumental façade dedicated to Bird Jaguar, king in the 750s, whose stucco representation dominated the roofcomb at center. A carved stalactite (foreground) denotes a symbolic cave.

Yaxchilan structures have multiple doorways, and many have finely carved lintels.

At nearby Piedras Negras, only a day or two downriver, different influences are evident. Buildings address one another, rather than the river, and they cluster in groups similar to those of Palenque. The inscriptions suggest a general development of the site from south to north that took almost 200 years. The early structures to the south are heavy and massive, with great rounded insets similar to those of the Tikal North Acropolis. The West Acropolis at Piedras Negras consists of a central palace compound flanked by two great funerary pyramids, probably the shrines to dynastic rulers; the palace structures feature double-corbeled galleries like those of Palenque.

Architecture: Cities at the center

At Tikal, the "hiatus" drifted on into the seventh century CE, as Tikal sustained further military and political losses. At the end of the seventh century, however, a program of major new building work began that was sustained for about a hundred years. Instrumental in this revitalization of Tikal was Jasaw

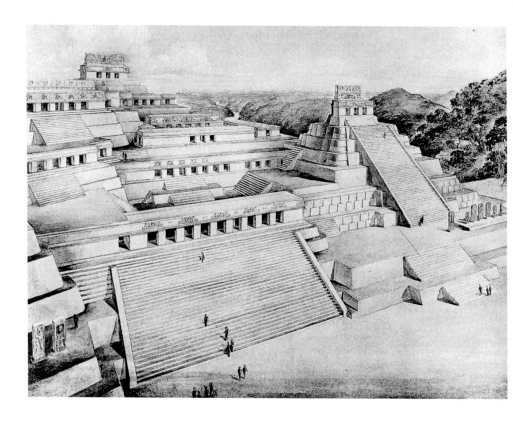

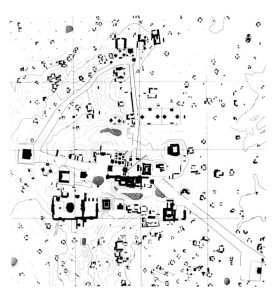

162 TOP Piedras Negras kings
developed a new complex on
the West Acropolis during the
seventh and eighth centuries.
Within galleried palaces, kings
reviewed their retinues from
elegant thrones, framed by
funerary pyramids that rose in
great setbacks. Ruler 3's eight
stelae stand in a line at right.
163 LEFT Plan of the central
part of Tikal. Great elevated
causeways connect the city,
appearing here as a triangle.
Temples I and II face one
another across a plaza near
the triangle's southeast corner.

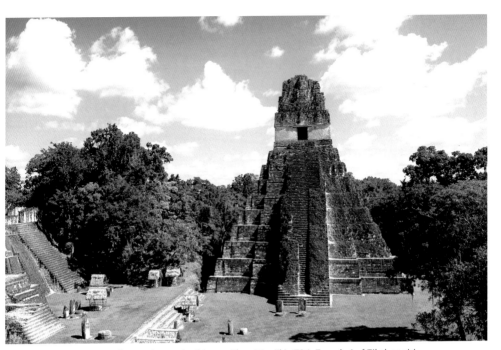

164 Built over the tomb of Jasaw Chan K'awiil in 734, Temple 1 of Tikal would establish the model for all subsequent memorials to Tikal kings. The staircase visible today is the one that the builders used to haul rubble and finished stone to the top. Lintels of durable *zapote* (sapodilla) wood spanned the narrow chambers at the summit. Temples I, at right, and II, which faces it, frame the ancestral tombs of the north acropolis, just visible at left.

Chan K'awiil (also known as Ruler A), who was buried in 734 CE in Temple I, a pyramid located directly across the Great Plaza from Temple II, which had itself been completed just a few years before. Temples I and II dramatically altered the core of Tikal, changing the old north–south axis, conveyed by accretions of buildings with rounded corners and fussy moldings, to an east–west one, defined by just two towering structures with clean lines.

164 Temple I, like the Temple of the Inscriptions at Palenque, is a nine-level pyramid, and like the Palenque building it was designed as a memorial, from the carved wooden lintels spanning the doorways to the funerary chamber within. Such an elaborate building must surely have been conceived before the king's death. Unlike the Palenque temple, however, the construction work cannot have started until the body of the ruler was sealed in the tomb at the base of the temple. With its single carved wooden lintel of a woman, Temple II may have

been dedicated to Jasaw's wife – although no tomb has been found – in which case husband and wife would have faced each other through eternity, framing their ancestors to the north.

Like great beacons rising above the jungle, other temples surround the symbolic founders – Temples I and II – of the Late Classic dynasty. These unexcavated pyramids appear to be funerary monuments of later rulers, who respectfully address their forebears. Temple IV is the greatest in both mass and height, rising to 213 ft (65 m) – roughly the height of the Temple of the Sun at Teotihuacan. The Tikal pyramids remain visible 12 miles (19 km) to the north, from the last great rise before Uaxactun. Although freestanding and devoid of many of the ornamental moldings typical of earlier Tikal, these pyramids retained characteristics of the North Acropolis that are not limited to their funerary nature. In Temple I, for example, a heavy roofcomb was set over the narrow, dark chambers that are accessible through a single doorway, and its weight runs down the spine of the structure. Inset moldings, more streamlined than those of the North Acropolis, both cover the corners of the structure and create a play of light and shadow across the surface.

The strong east–west orientation dominated not only the Great Plaza in the eighth century CE but also the rest of the site, in outlying groups known as Twin Pyramid Complexes. At least nine of these architectural clusters were erected in sequence, presumably to celebrate the twenty-year *katun* cycle which is recorded in each group. The elevated platform of each cluster has the shape of the Maya symbol for completion, and the two radial pyramids on the east–west axis recall the chronographic marker at Uaxactun, E-VII-sub. With a range structure to the south and a shrine to a ruler in the open structure on the north, this repeated and well-defined Tikal configuration would seem to reproduce the Great Plaza at its every appearance along the causeways.

No sculpture and little architectural ornament remain in situ to help us understand the function and meaning of the Central Acropolis, but its interlocking galleried chambers

165 Reconstruction of a Twin Pyramid Complex, Tikal. Limited to Yaxha and Tikal only, these complexes were erected in the eighth century CE to celebrate *katun* endings. Although they might have been painted in antiquity, all the altars and stelae in the row at right are plain today.

resemble palaces elsewhere, even if organized with less concern for overall plan. Furthermore, the presence of a victor and his captive in eroded stucco – recorded on one of the structures flanking a trapezoidal court at the core of the Acropolis – hints that it may have been a place of sacrifice, like the East Court at Palenque, where humbled captives are depicted. A bank of four large hearths sustained a sort of institutional kitchen for the scribes, traders, priests, scholars, and nobles at work in the Central Acropolis.

Architecture: To the south

Using the same fundamental elements of Maya architecture – platform, stairs, and corbel vault – the architects of Copan, Honduras, developed a distinctive aesthetic. The local stone is an easily worked volcanic tuff, ranging from pink to brown to green, so that building stones could be cut and fitted together with a precision rare in the limestone structures of Palenque or Tikal. (The stone, of course, was cut with stone tools.) At Copan, as elsewhere, stucco coatings would have hidden the imperfections of the underlying stone. Emphasis was placed on tuff architectural ornament, in full three-dimensional relief, and it is the best-preserved iconographic guide to the meaning of Mesoamerican architecture. Surviving façades retain a sheer vertical profile, rather than the usual mansard roof. These clean lines are echoed in the façades of Central Yucatan and the Puuc region, and may in fact originate at Copan.

The Copan valley provides superb possibilities for the dramatic siting of architecture. The ancient city planners realized this and located their buildings to take advantage of specific views of the valley and surrounding mountains, especially the saddle through the mountains to the north. The ballcourt seems to reproduce the valley itself in its layout and orientation, drawing attention to the clefted pass through the mountains to the north.

Eighth-century CE pyramids and structures dedicated to the rites of kingship crowd the acropolis, the final layer in what was at least a 600-year accretion. Kings ruled from Structure 22, where the private, elevated rear chamber framed by a double-headed dragon is reached through a great open monster mouth, a symbolic cave entry to a sacred mountain. Young maize-god sculptures once graced the exterior cornices, and the symbolic mountain may have been where the king brought forth the first corn from the underworld.

An international team of archaeologists has worked to reveal Copan's mysteries, both at its center and along its margins. Just beside Structure 22, a reconstructed Structure 22a apparently

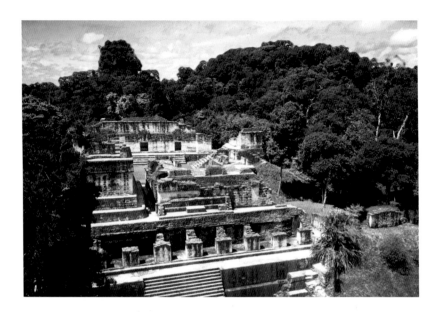

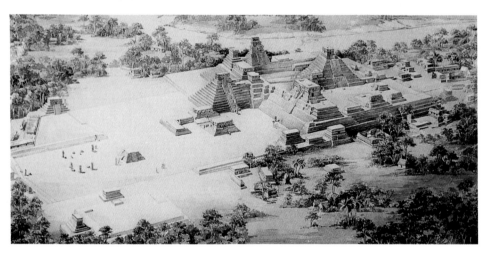

166 TOP The Central Acropolis, Tikal's royal palace, invites the observer from the Great Plaza, although access is carefully restricted.

167 BOTTOM By the mid-eighth century CE, Copan's Main Acropolis and Main Plaza had achieved their full growth, although nearby compounds of wealthy lineages continued to expand. The Copan River, to rear, later ate away structures until the U.S. Army Corps of Engineers constructed a new course for it in the 1930s.

168 OPPOSITE TOP The inner doorway, Structure 22, Copan. One first steps through the fragmentary remains of a great monster mouth to gain access to this remarkable carved doorway, which had collapsed from earthquake tremors. The king who built this structure was eventually captured and sacrificed by neighboring Quirigua lords.

169 OPPOSITE BOTTOM Apparently to unite the powerful and wealthy lineages, Copan lords built a *popol nah*, or council house, where they might gather to advise and guide the king in his adjacent palace. Now known as Structure 22a, it features a fish on the front façade, probably a reference to the Fish family, whose compound lies south of the Main Acropolis.

served as a *popol nah*, or council house, where the king's advisers would have conferred. Local lineages, including the Fish family, promote themselves from its façade, their names juxtaposed with woven mat, or pop, glyphs. The discovery of this same Fish family glyph at a compound away from the Acropolis reveals how constituent lineages built luxurious quarters for themselves a few miles from the core and yet retained representation there as well. Some new residential areas began to compete with the city center. The House of the Scribes, for example, in the Sepulturas group, one of the new luxurious compounds, reveals sophistication and wealth at the end of the eighth century CE, juxtaposed with nearby tiny and poorly constructed buildings of unknown purpose.

One of the last Copan kings, Yax Pasaj (ruled 763 to 810 CE), rebuilt many acropolis buildings, including Structure 11, his royal palace, and Structure 18, which may have held his tomb, although it was looted in antiquity. Structure 16 is the largest building on the acropolis, housing within it the ancestral structures dubbed Rosalila, Margarita, and Hunal (see pp. 130–32), the earliest funerary pyramids known at Copan, and its nine levels seem to refer to ancestry and the royal lineage in general, rather than to a single dynast.

125, 126

Below the 82-ft (25-m) drop-off from the acropolis lies

170

the Copan ballcourt, the largest and most beautiful of all Classic courts. Like many smaller examples elsewhere, the ballcourt unites two different areas of the central city. Unusual

170 One of the most beautifully sited of all Maya buildings, the ballcourt at Copan guides the eye from the Main Plaza to the steep hills beyond.

171 Carved with 2,200 glyphs, the text of the great Hieroglyphic Stairway at Copan is among the longest known. A supplicant would climb back in time as he or she ascended the stairs, reaching a shrine dedicated to the founder of Copan at the top. Eighth century CE.

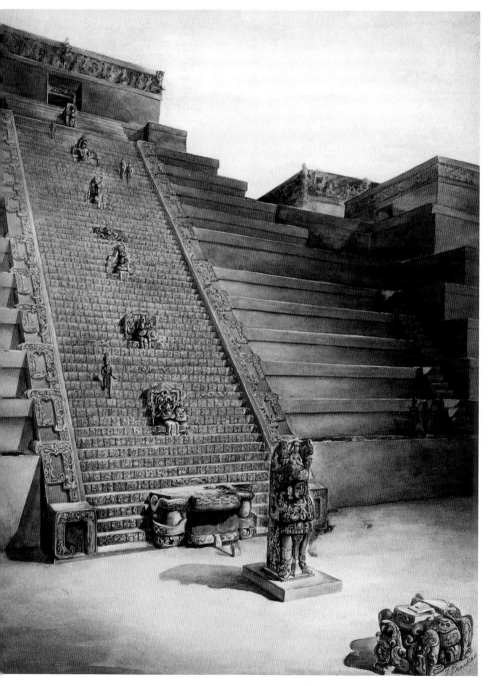

superstructures surmount the parallel buildings on its eastern and western sides. In its final phase, giant sculptural macaws flanked each side of the court, in this way generating a sacred setting, "Macaw Mountain," for the competition along the sloping sides of the alleyway.

171 Just to the south of the ballcourt stands the great Hieroglyphic Stairway, a large pyramid whose steps are inscribed with 2,200 glyphs that relate the history of Copan's Late Classic dynasty. Five three-dimensional rulers sit on projections from the staircase, and some are set directly over two-dimensional captive figures. In no other Maya building are sculpture, writing, and architecture more sensitively united. The carved scroll balustrade is an unusual element in Maya architecture, resembling the balustrade of the Pyramid of the Niches at El Tajín (see p. 121). The long Maya text runs from the top of the stairs to the base, from legendary time to the present, so that a supplicant would climb back into time, visiting ancestors in reverse chronological order on the way to the summit.

Architecture: North to Yucatan

The traditions that may have originated at Copan also thrived in Central Yucatan and the Puuc region. At Chicanna, as at most Chenes and Río Bec centers, the principal structures

172 have great monster-mouth façades – presumably here again associated with ceremonies of kingship and symbolic sacred mountains. Perhaps the proliferation of structures with monster-mouth façades in Central Yucatan reflects the widespread celebration of shared elite rituals and beliefs. The mouth of the Chicanna structure is similar to the largely destroyed exterior of Structure 22 at Copan, where the interior double-headed monster framed a removed, interior chamber for private rites. Blocks of ornament fell off the Chicanna building in 1994, revealing painting on stucco underneath.

Chenes structures are generally low-lying, galleried

173 buildings. Architects at Xpujil and elsewhere in what is known as the adjacent Río Bec region – the dry rainforest of southern Campeche – engaged in masterful deception: both the towers that rise from the platform and the chambers at their summits are illusory, with steps that cannot be surmounted and rooms that cannot be entered. In fact they may be funerary pyramids, directly combined with palaces, and conflations of the patterns established at Palenque or Tikal. At Ek' Balam, north of Chichen Itza, a vast pyramid with monster-mouth doorways, adorned with large, feathered stucco figures, encased an important tomb of the ruler who died in 801 CE; after his reign,

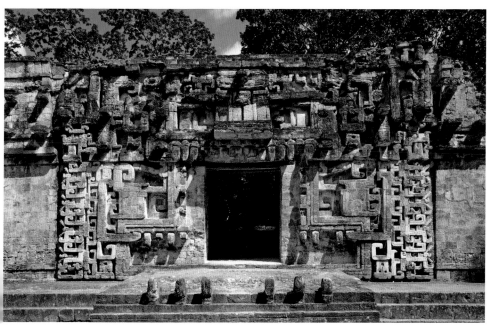

172 Across what is now southern Campeche, Maya lords erected dozens of structures articulated by what seem to be "monster" mouths. Several buildings at Chicanna feature clearly defined teeth and jaws, surmounted by great eyes with scrolls, so that one stepped into the mouth of the animate being in entering the building.

the city may have been subsumed under the larger neighbor's control, and subsequently abandoned.

Late Classic Puuc architecture first captured the imagination of modern Europeans and Americans through the writings and illustrations of John Lloyd Stephens and Frederick Catherwood. They visited Uxmal, Kabah, Sayil, and Labna to study the ruins there and to make drawings. There is still no finer introduction to the region and its ancient remains than their report of 1843. What attracted them, and what still attracts the traveler today, are the elegant quadrangles, fine veneer masonry, and beautiful mosaic façades that reflect shifting patterns of light in the hot clear sun of the Puuc hills.

Most of what is visible at Uxmal today seems to belong to the ninth century CE, ending with a final hieroglyphic date of 10.3.18.8.12 (907 CE). With two distinct profiles, the Pyramid of the Magician must have been constructed in at least two phases. On its west side, a precipitous stairway leads to a Chenes-style doorway in the form of a monster mouth; a gentler slope on the east leads to a Puuc-style chamber at the top. The

174

eastern profile seems to trail away, like the train of a dress, as the structure appears to gather itself up and address the quadrangles on its western face.

The juxtaposition of quadrangles – such as the Nunnery – with pyramids like the great Magician recalls the Palace and Temple of the Inscriptions at Palenque, although the physical expression of Puuc architecture is new. The Palenque Palace, however, evolves from the inside out, while the Nunnery would seem to have been designed as a quadrangle in the first event, and from the outside in. Indeed, the Nunnery exemplifies the pioneering techniques of Puuc architecture: specialized "boot" stones in vaults, providing increased stability and making possible some of the tallest vaulted spaces of ancient Mesoamerica; flying façades, the light, airy roofcombs set directly over the front weight-bearing wall, like the false storefronts of the American Old West; and veneer masonry, well-cut stones fitted together without mortar, masking a rubble core.

Many elements of the Nunnery structures are repeated and elaborated in the House of the Governor, the finest of all Puuc buildings. Was it conceived to be part of a quadrangle, never completed? The plan of the House itself suggests three semi-detached structures, linked by sharp, corbeled doorways, innovatively used to open cross-corbel vaults within. The greater breadth of the central doorway and the uneven spacing of the flanking doorways (all of post-and-lintel construction), as first attempted in the east and west Nunnery buildings, alleviate the monotony that would result from such a long expanse, and the two pointed, recessed corbels vanish from view at sharp angles. The slight outward lean, or negative batter, of the structure gives it the appearance of lifting off its platform, a remarkable conceit. The upper part of the vertical façade is, like most Puuc buildings, covered with a rich stone mosaic. Such mosaic designs may have been emblematic of certain rituals or certain families, and could be related to textile design. The decoration on the House of the Governor includes many iconographic elements: serpents, step frets, hundreds of Venus or star signs, netted motifs, Maya thatched houses, and human busts. In the complexity of this ornament, the Uxmal artist seems to have drawn specifically on the east and west buildings of the Nunnery. The ruler of the era, Lord Chahk, presides over the structure, the courtyard, and the range of hills before him from his three-dimensional representation over the central doorway. With its twenty-four rooms, the House of the Governor must have been the greatest

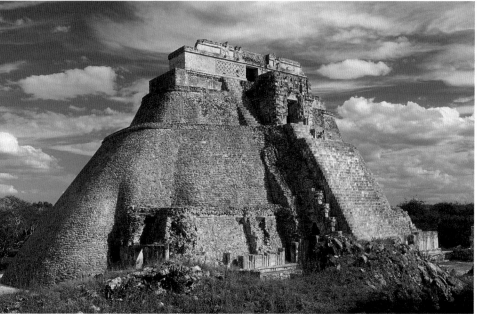

173 TOP What seem to be separate but clustered palaces and temples at Xpujil are in fact a single building. False openings beckon atop equally illusory stairs, in an architectural style of the seventh and eighth centuries widely known as "Río Bec" and "Chenes."

174 BOTTOM The Pyramid of the Magician, eastern façade. The doorway at the summit of the projecting staircase forms a symbolic entrance to the earth, making of the entire structure a great man-made mountain. The uppermost story adopts a different architecture style and faces west.

175 TOP The Nunnery Quadrangle, as seen from the Pyramid of the Magician. Seen here in dry season, the four buildings of the Nunnery formed a great palace. North, at upper right, preserved a roofcomb over the front load-bearing wall. West, in full view, captured visual refinements in its shifting double-framed doorways and dense architectural ornament.

176 BOTTOM Built c. 900 CE by Lord Chahk, the House of the Governor was the crowning achievement of his reign. A slight outward lean of the structure, or "negative batter," as it is called, makes the building seem to rise from its platform. The twentieth-century American architect Frank Lloyd Wright is known to have taken inspiration from the building.

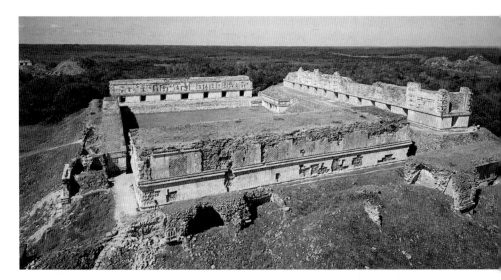

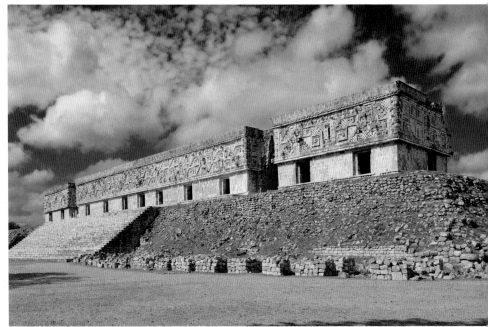

administrative structure of its time, overseen by the ruler himself and with ample space to store tribute.

Perhaps the most remarkable feature of nearby Kabah is its monumental, freestanding arch. A *sacbe* 7½ miles (12 km) long connects Kabah to Uxmal, and the arch marks the end of this elevated roadway. Unlike European city arches, which either denoted the opening in a wall or commemorated triumph, the arch at Kabah appears simply to proclaim the entrance to the city.

Sculpture

At the beginning of Late Classic times, strong regional styles emerged in monumental Maya sculpture. In the west, particularly at Palenque and Yaxchilan, two or three individuals were represented on a single relief, and the limestone slabs

177 The Great Arch, Kabah, is set just at the edge of the city. The massive flight of stairs grants access to the *sacbe*, or causeway, linking Kabah to Uxmal.

were set as wall panels or lintels, protected from the elements. Conservatism, on the other hand, generally prevailed at Tikal and in the Central Peten, where stela imagery continued to conform to canons established in the Early Classic; but some innovative forms were introduced, such as carved wooden lintels and bones, shell, and jade worked at small scale. In the south, an impulse to three-dimensionality transformed the sculpture of Copan, while at Quirigua, monuments of huge proportion were erected.

The Palenque artists selected a very fine-grained limestone, one that could be quarried in thin sheets, for the interior wall panels that record dynastic history. Pakal launched his program with the unusual Oval Palace Tablet, set inside House E, to be a visual cushion for the enthroned ruler. The Palace Tablet commemorates the accession of the second son of Pakal, who became king of Palenque in 9.13.10.6.8, or 702 CE. On the panel, the young king sits between his deceased parents, who offer him attributes of kingship: a jade-plated headdress and a shield. The figures are all simply costumed, and one senses that their individual identity, not simply their ritual paraphernalia, ensures their right to dominion. New, seemingly less formal postures characterize Late Classic Palenque sculpture, and the courtly scenes depicted engage in some fashion with something of the actual life that went on within the Palace chambers where most such sculptures were found.

The jades of Pakal's tomb included a mosaic portrait mask. As Laura Filloy has demonstrated, many of these jades were recut heirlooms, intensifying the sense of ancestral veneration

178

178 The Oval Palace Tablet, Palenque. In commemoration of his accession in the eighth century CE, Lord K'an Hok' Chitam II was portrayed in the act of receiving the symbols of office from his late parents. Pakal is shown at left, and he holds out a headdress of thin jade squares.

in Pakal's interment. Two stucco portrait heads were found wedged under the sarcophagus, presumably of Pakal and his wife, whose stern expression is revealed in the malachite mosaic face found in the tomb known as that of the Red Queen. Other stuccos from Palenque convey an interest in recording human physiognomy unparalleled in ancient America.

These fine, sensitive portraits of the ruling family find a foil in the exaggerated depictions of subjugated persons in the East Court. The captives make gestures of submission to the individuals who would have stood above them on the terrace. On these oversized slabs, hands, feet, and faces are crudely worked. Even the stone chosen reflects its subject: the buttery limestone of the accession panels is replaced by porous limestones of different colors, presumably from different regions, less suitable for fine carving. Each figure is worked on an independent slab, and the compressed space for each person suggests oppression. The slabs may also have been reused and recut to conform to a new configuration. Across the courtyard, sculptures of tributary lords flank a hieroglyphic staircase; their names appear in their headdresses, in carvings that wrap around the sides of the stones, in fact a format like that of one of Pomona, a subject polity to the north, who may well have provided the tribute labor.

For years, scholars had puzzled over the seeming gaps in the sculptural record at Palenque, especially following the capture of the Palenque king in 711 CE by enemies at Tonina, in the highlands to the south. Now Structures 19, 21, and 22 have revealed that King Ahk'ul Mo' Naab's programs included some of the most stunning work achieved at the site. A limestone panel from Temple 19 shows the king pressing the hand of an attendant to his right, capturing the sensual charge in the soft sculpting of the stone. The foreshortened torsos and the carved drapery of the two attendants reveal the ability of Maya artists to master the body while confining it to a minimal and fine relief. Additional discoveries at Tonina reveal continued attention to the representation of both two-dimensional and three-dimensional captives, which may have been assembled into a frieze, and which attest to the bellicose practices of the site across generations.

Often integrated with the architecture of Yaxchilan in the form of lintels or steps, the finest sculptures display a regional style in which relief was executed on two distinct and removed planes. The resulting high relief brings the figures to life, with glyphs as framing devices that suggest architecture. On Lintel 25, the richly garbed Lady K'abal Xok' kneels in the rear chamber of a structure; on Stela 11, the figures stand inside

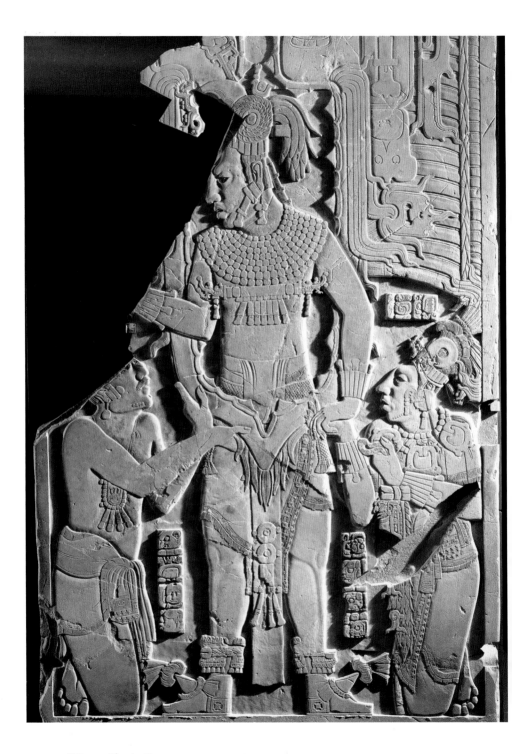

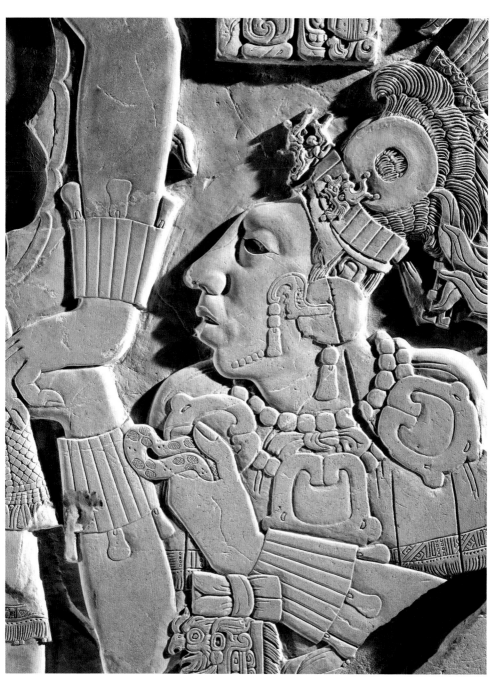

179, 180 OPPOSITE AND ABOVE (DETAIL) The Palenque King Ahk'ul Mo' Naab developed a program just up the slope from his predecessors and featured works where the king acknowledges the fealty of his subjects. Structure 1 has yielded extraordinary sculptures: despite having been smashed in antiquity, this panel retains the eloquence of the sculptor's art and the intimacy of human interaction.

a corbeled vault. Rituals associated with royalty were often recorded on Yaxchilan monuments: capture, sacrifice, auto-sacrifice, and visions of ancestors – all of which may derive from royal manuscripts. On Lintel 25, Lady K'abal Xok' receives the vision of a warrior who appears in the mouth of a great serpent amid plumes of smoke. Traces of red, green, and yellow polychrome remain on this and other Yaxchilan lintels, which were protected from the elements, confirming what is supposed of most Maya sculptures – that they were once brilliantly painted.

On Stela 11, in the guise of Chahk, the great King Bird Jaguar stands over three bound captives, poised to carry out sacrifice. Bird Jaguar's cutaway mask recalls the Oxtotitlan painting of Olmec times, but the conceit particularly characterizes Late Classic Maya warriors. The dead parents of the ruler sit above, separated from the scene by a skyband, indicating their posthumous place in the heavens. Whether presiding over a scene or flanking it, as at Palenque, venerated parents were frequently recorded, as if to confer legitimacy on a descendant.

The obverse of Stela 11 shows the accession of Bird Jaguar, an event supported by the military success on the other side. Stela 11 and Lintel 25 were probably carved by a small atelier of sculptors whose work spanned two generations of rule, from about 700 until 755 CE. Subsequent sculptors emulated their craft, but none equaled it.

67 The Yaxchilan artists also pioneered the introduction of new, active postures into normally staid stone sculpture. Lintel 8, for example, shows Bird Jaguar and another lord each grasping the hair of a captive, who bear their names emblazoned on their thighs. Such dynamic compositions culminate in the paintings of Bonampak (see pp. 155–56), attesting to the rich and imaginative artistic practice at the end of the eighth century CE, even as the future of elite culture itself was in jeopardy.

185, 186 A higher relief distinguishes the sculpture of Piedras Negras, especially on the monuments commemorating the accession to office of the kings of the city: the handsome niche stelae. Each niche stela at the city launches a sequence of monuments celebrating warfare and victory, marriage and alliances.

181 OPPOSITE TOP LEFT Lintel 25, Yaxchilan. Lady K'abal Xok', wife of Shield Jaguar, kneels to receive a vision: a warrior, bearing a shield in hand and wearing a Tlaloc mask in "X-ray," emerges from a serpent mouth. The rich drapery of the woman's garment is piled at her knees. The bloodletting tools that brought on this vision lie in a basket at her feet.
182 OPPOSITE TOP RIGHT One of a pair of captives discovered at Tonina in 2011 in the great ballcourt, this larger-than-life figure exhibits the stoic beauty of Maize God physiognomy. Like many captive figures at Tonina, this pair celebrates the site's victory over Palenque and its environs.
183, 184 OPPOSITE BOTTOM Stela 11, Yaxchilan. On the rear of the stela (LEFT), Bird Jaguar, in an "X-ray" costume of Chahk, prepares to sacrifice three captives who kneel in a doorway. The obverse (RIGHT) shows Bird Jaguar, standing on the right, with his father. Mid-eighth century CE.

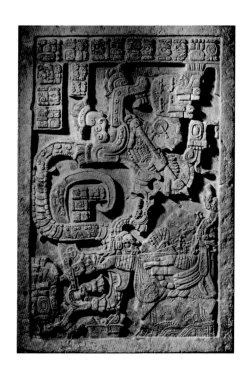

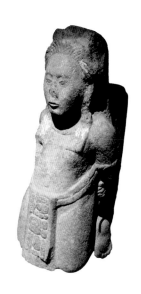

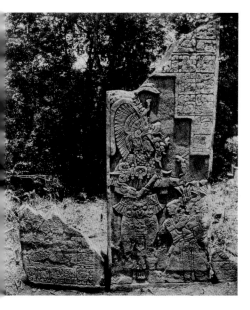

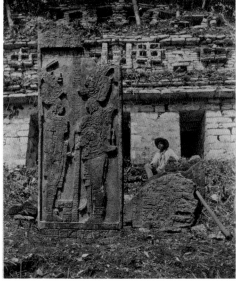

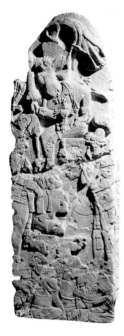

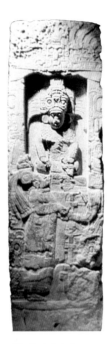

185 LEFT Stela 12, Piedras Negras. The last dated monument (795 CE) of Piedras Negras shows a ruler presiding over a group of naked captives. At lower right, the sculptor has carved an old, humble man with great realism – this seems to be a portrait of an aged scribe.

186 RIGHT Stela 14, Piedras Negras. A young king, richly three-dimensional, sits within a niche, typical of representations of accession at Piedras Negras. He accepts instruments of office from his two-dimensional mother, below. Swag curtains are pulled back at top.

186 Characteristic is the near three-dimensionality granted the ruler's frontal face: on Stela 14, the young lord's tangible three-dimensionality plays against his mother's flat two-dimensional representation. Footprints mark the cloth draping the scaffold or ladder set in front of the niche, and swag curtains are pulled back at the top of it, as if the scene has just been revealed.

At the destruction of the site, enemies of the Piedras Negras dynasty smashed Throne 1 on the steps of the West Acropolis palace, where it remained for archaeologists to retrieve in the 1930s. Made at the end of the eighth century CE, the carving replaced an earlier throne figured on Lintel 3, another late carving, but whose subject treats *détente* with Yaxchilan a half century earlier. Along with Stela 12 (see below), these late eighth-century CE sculptures are among the most dazzling of Late Classic efforts and their workmanship runs counter to an identification of artistic decline coupled with societal collapse.

Twelve individuals are grouped on four levels, probably steps, in a pyramidal composition on Stela 12. Eight captives are tied together in the lower register, and many show signs of bodily harm and damage. Two captains deliver the well-dressed, uppermost captive seated on draped cloth to the lord above. The text records a war event, and we see its aftermath: victorious Piedras Negras displaying its trophies. Interestingly, the named victims may be from Pomona, a defeated site known for its fine, Palenque-like carvings; the workmanship of this monument resembles that style, not the more three-dimensional style with frontal faces of Piedras Negras. Artistic tribute may have been an aspect of elite warfare, and captives – especially evident at Tonina – were worked in the manner of their place of origin.

Static, single-figure compositions prevailed in the Central Peten throughout the eighth century CE, conforming in some instances to canons established earlier. At Tikal, the texts on stone monuments were also laconic, unlike most monuments of the western region. Stela 16 presents a formal, frontal view of Jasaw Chan K'awiil, the king later buried in Temple I; the carving was once screened from easy view within a twin-pyramid group. Even less public sculptures, such as the carved sapodilla-wood lintels of Temples I, II, and IV, display more complicated imagery and texts. The two lintels of Temple IV show Yik'in Chan K'awiil (also known as Ruler B) within a supernatural world. One depicts him being borne on a litter and enthroned under an overarching feathered serpent. On the other, a giant anthropomorphic jaguar deity forms an architectural frame over the ruler. Graffiti at Tikal depict such litters in action, trophies that Maya lords stripped from one another in battle.

At Naranjo, many monuments depict female dynasts, and the woman on Stela 24 stands over a humiliated captive. The cramped space of the lower register heightens the abject state of the prisoner: in such two-dimensional carvings at this city, frontal faces were generally reserved for captives. In the eighth century CE, sculpture at southeastern Maya sites moved from mere frontality to a near three-dimensionality, and at Copan, larger-than-life portraits of standing rulers were carved nearly in the round. As at Tikal, many stelae were erected on Copan's Great Plaza. By the reign of Yax Pasaj, the open space was heavily populated by royal ancestors. During his reign, however, there was also a return to two-dimensional works, perhaps reintroduced by his mother, a woman from Palenque. Carved steps, benches, and altars record numerous seated two-dimensional figures in profile. Altar Q, long misread as

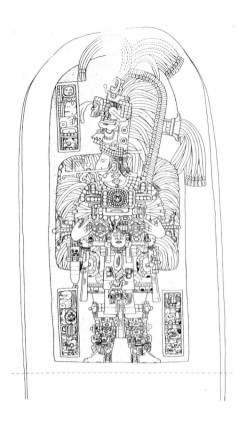

187 Stela 16, Tikal. On this stone monument erected to celebrate the *katun*, or twenty-year period, Ruler A holds a ceremonial bar and wears a great feather backframe. Note the hand gesture of the king and its glyphic analogue in the text, at left above the ruler's head.

a gathering of astronomers, actually shows the sixteen historic rulers of the city, all seated on their names, at the end of the eighth century CE. The living king, at center right, receives his authority to rule from the first, Yax K'uk' Mo', center left, whose goggle mask indicates his antiquity, and whose tomb lies in the building behind, within Rosalila (see pp. 130–32).

During the reign of K'ak' Tiliw Chan Yopaat (also known as Cauac Sky), nearby Quirigua grew wealthy, and according to the inscriptions this monarch captured and killed the ruler at Copan in 738 CE. K'ak' Tiliw Chan Yopaat was celebrated with a series of stelae, among them Stelae E and F, the tallest stone carvings of the ancient Maya. His face is worked in high relief, but the rest of his features are shown in two dimensions. Like their counterparts in tuff at Copan, these great prismatic shafts of sandstone were laid out in the clear expanse of the open plaza for public view.

Infused by wealth, Quirigua developed one of the most innovative types of Maya sculpture: the zoomorph. Huge river

190

189

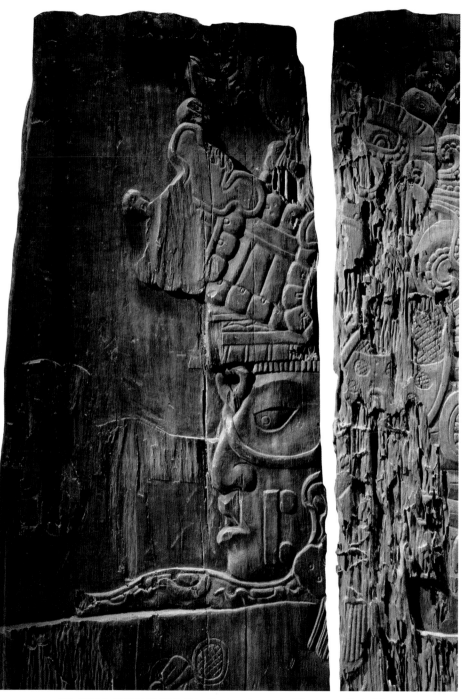

188 Lintel 3, Temple IV, Tikal. Ruler B wears the mask of the Jaguar God of the Underworld, denoted by the twisted cord on the nose and the bar-and-dot number 7 on his cheek. Made of sapodilla wood that is now over 1,200 years old, the lintel still bears the chisel marks that bring lips, eyes, and nose to life.

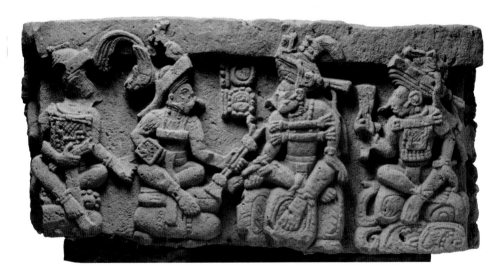

189 TOP Quirigua Stela E. Carved of a dense sandstone, like all other Quirigua monuments, Stela E is the tallest stone monument ever erected in the New World. Dedicated in 771 CE by Cauac Sky, the monument was meant to be seen by nearby river traffic.

190 BOTTOM On the front of Copan Altar Q, the first king (wearing goggles at left), Yax K'uk Mo', faces Yax Pasaw, the sixteenth, while the fourteen interposing monarchs line the monument. The nineteenth-century traveler John Lloyd Stephens had proposed that these figures are shown sitting on their names, an interpretation finally confirmed late in the twentieth century.

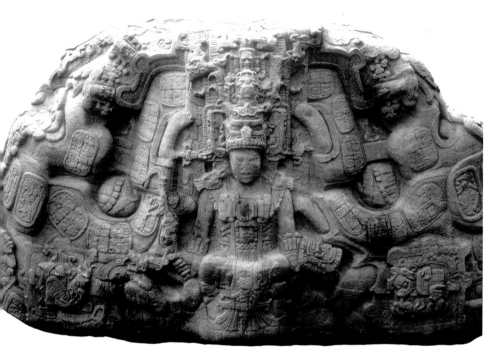

191 Zoomorph P, Quirigua. One of the final rulers of Quirigua sits within the open maw of a great monster on this carved river boulder.

boulders were carved on all exposed surfaces as great composite jaguar, toad, crocodile, or bird forms. On Zoomorph P, K'ak' Tiliw Chan Yopaat emerges from a gaping front maw as if set within supernatural architecture of the sort created in Structure 22 at Copan. Elaborate full-figure personifications of hieroglyphs were often inscribed on these great boulders as well, turning script into narrative sculpture. The unprecedented size of Quirigua sculpture commands attention, but it also disturbs, feeling quite out of balance with the modest architectural program.

191

168

Hand-held sculpture

Most fine Maya objects of small scale have been recovered from royal burials, and many carry information relating to the life or afterlife of a given individual. The jade-mosaic jar from Burial 116 at Tikal, for example, is probably a portrait of a dead member of the royal family. Jade-plated vessels of this sort are known only from Tikal, and the type is conservative, retaining Early Classic characteristics, such as the knob in the form of a human head; many of the individual plaques may have been recycled from other objects. At Altun Ha, Belize,

192

a ruler was interred with a 9.7 lb (4.42 kg) three-dimensional jade head, an unusual representation of the Principal Bird Deity. Its shape suggests a miniature version of a Quirigua zoomorph. Fine jade plaques showing rulers accompanied by dwarves have been recovered from Nebaj, in the Guatemalan highlands, perhaps a place of manufacture and not too far from the source of the raw material, but they have also been found far from the Maya region.

A number of incised bones (some human) were deposited as a single cache in Tikal's Burial 116, the scenes on some of them illustrating what we can presume to be the posthumous journey. On one pair of bones the artist delicately incised and then filled with cinnabar a drawing showing the king as Maize God, the deified ideal of both rulership and renewal, in a canoe, being paddled to the underworld in the company of howling animals. In a gesture of woe, he raises his hand to his brow.

Flint and obsidian were worked by Maya craftsmen into many shapes, and these are generally termed "eccentrics" because of their rough edges and occasional odd placement of heads. An exceptional cache at Copan included six flints that archaeologists have concluded were executed by two individual masters. They may have sat side by side, knapping flakes and producing yield sparks from the material, which itself embodied lightning.

Figurines

Since the middle of the nineteenth century, Late Classic figurines of exceptional quality have been found on Jaina Island, just off the Campeche coast, probably an enclave of traders. Figurines must have been manufactured nearby, if not on the island: hundreds and hundreds are known from the island itself. Most were made in molds, in part, especially heads, but most of the finest have bodies modeled by hand. Tenacious pigments have survived on the finished figures, especially blue, white, and yellow. Many Jaina figurines also function as whistles, ocarinas, or rattles.

Occasional supernatural beings are depicted among the figurines, such as the Jaguar God of the Underworld; among the most common subjects are males with skeletal jaw markings and seated noble women, some of whom work at a backstrap loom. A persistent, perplexing pairing is the old man with young woman; some of these women show ropes around the neck, and the rope may indicate enslavement. Few figurine cults in the world have produced such animated, compelling human miniatures as has this Maya tradition, now amplified by discoveries at Río Azul, Palenque, and elsewhere; at Waka',

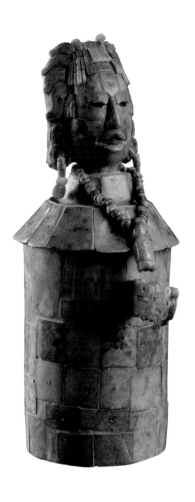
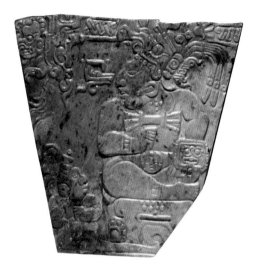

192 ABOVE LEFT Early eighth-century CE tombs at Tikal held unique and precious treasures, including vessels made of thin jade plaques, some of which recalled old-fashioned forms. The hairstyle of this example from Burial 196 would suggest a female.

193 ABOVE RIGHT Collected at Teotihuacan early in the twentieth century, this large Maya jade plaque depicts an enthroned Maize God, attended by a court dwarf. The green jade was identified with maize itself.

Late Classic

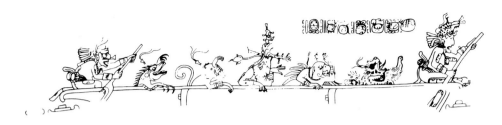

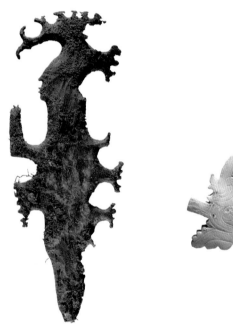

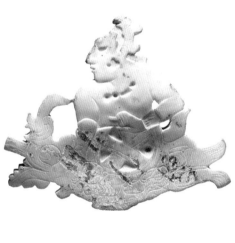

194 TOP Many finely carved bones – some of them human – were recovered from the great tomb at the base of Temple I at Tikal. On this one, paddlers guide a canoe and its occupants through underworld waters.

195 BOTTOM LEFT Copan artisans developed mastery over flint, skillfully knapping the material to yield animated figures often called "eccentrics." Recent scholarship has determined hands of different artists.

196 BOTTOM RIGHT Carved shell, Jaina Island. Along the Campeche coast, where the material abounded, conch was cut and carved into fine objects. Here, a Maya lord seems to ride a fish monster. The piece may once have been inlaid with precious greenstone.

archaeologists have discovered a grouping of twenty-three figurines that sat at the feet of a deceased ruler to guide him into the next world, along with an extraordinary Olmec figurine, further testimony of engagement with the past.

201

Ceramics

Finely painted ceramics proliferated during the eighth century CE. Many survive intact in tombs and caches, holding food and drink – particularly chocolate – for the dead. Some scenes occur without regard for geography or chronology, while other standard narrations were made only in a single style. Some mythic scenes probably prescribed behavior for success in conquering the underworld, a theme later recounted in the Postconquest *Popol Vuh*. Painted in a fine black or brown line over a cream slip, frequently with a red rim band, such pots may have derived from lost Maya books, which led Michael Coe to christen the tradition the "codex" style. The color scheme itself, "black paint, red paint," formed the much later metaphor – *in tlilli in tlapalli* – of the Aztecs to mean writing itself. Several schools and master painters of this style have been identified, but a common theme celebrates scribes and their supernatural patrons, self-referential work of the highest sophistication.

200

On a vase from Altar de Sacrificios, a site at the confluence of the Pasión and Usumacinta Rivers, a red rim and colorful highlights define a style that may have been based at Motul de San José. Dancers in shamanic transformation shimmy in ecstasy: one wears snake-patterned trousers, and as he hurls a boa constrictor into the air, he throws back his head, closes his eyes, and presses his hand right through the glyphic border. Adjacent texts name these figures as *wayob*, or shamanic other selves, many of whom may be dangerous, maleficent spirits. Self-conscious and theatrical, paintings on ceramic vessels of the eighth century CE are sophisticated in a way never matched elsewhere in the native New World; durable and abundant, they provide clues to a more ephemeral but widespread tradition of books and wall paintings – the most extensive of which launched this chapter.

202

Regional vase-painting styles prevailed across generations. In the region of Naranjo, a monochrome red-on-cream style predominated. The western Peten is the source of the "pink-glyph" style, in which rose tones were used and figures depicted in cutaway, X-ray fashion. Carved gray slateware was characteristic of northern Yucatan. In highland Guatemala, artisans preferred red backgrounds and painted the rim bands with chevron motifs. In Honduras, vases were carved from white marble, perhaps by non-Maya of the Ulua Valley, and

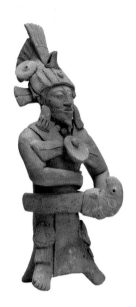

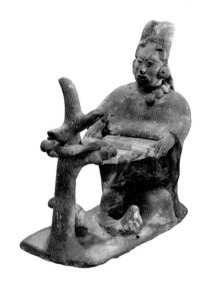

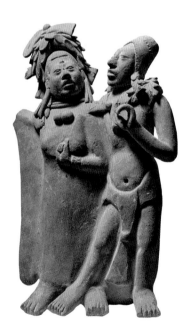

197 TOP LEFT Jaina figurines perform the roles of those who lived on the island, just off the Campeche coast. This ballplayer wears a yoke with the head of a bird, which he grasps with his left hand. He wears a different sort of bird headdress, marked by a sharp beak and striking round eyes. **198** TOP RIGHT Just four examples are known of Jaina women who weave at a backstrap loom. Here the loom is tied to a tree; the weaver controls tension by leaning in to and away from the fabric in front of her. **199** LEFT A beautiful young woman dances with her partner, but the rope around her neck may point to her enslavement. Assembled from three molds with hand-modeled details added, this example is also a whistle.

200 TOP On a small cup from the northern Peten, two supernatural patrons of Maya writing – Monkey Scribes – busily write in screenfold books covered with jaguar pelt. The limited palette of black-on-cream, with a red rim, characterizes "codex style."
201 BOTTOM LEFT Archaeologists at Waka' found these twenty-three figurines arranged in just this configuration in 2006, in a collapsed tomb. Women, dwarves and men all focus on the kneeling penitent and deer at left.
202 BOTTOM RIGHT Excavated at Altar de Sacrificios, this ceramic vessel depicts shamanic transformation by the bald dancer, who flings back his head and dances with a boa constrictor. The rim text of most cylinders indicates their use as vessels for a spicy chocolate beverage.

these were acquired by noble Maya. By the ninth century CE, a new kind of pottery appeared in many parts of the Maya lowlands, and the iconography of these modeled and carved Fine Orange vessels, some of which were mass produced using molds, differs from the earlier painted ones, probably to be associated with new people or new trading patterns.

The end of the Classic Maya

The momentum of Maya civilization began to slacken and falter in the late eighth and ninth centuries. Stone monuments ceased to be erected from as early as 760 CE in certain areas, and cities were abandoned starting about that same time, some burned and sacked: at Piedras Negras, for example, monuments were dragged out of buildings and smashed. At Palenque and Copan, the ritual paraphernalia of the ballgame were left by late visitors, or possibly invaders. Tikal seems to have suffered a slower depopulation. Fine Orange ceramics appeared at many sites. By about 900 CE, and slightly later in the north, the Classic Maya civilization had collapsed.

For the ancient Maya, blood and blood sacrifice were the mortar of dynastic life, and sacrifice accompanied the rituals of office. At the end of the first millennium CE, however, there is evidence that the pattern of capture and sacrifice gave way to more systemic warfare and dominion. The latest Yaxchilan monuments enumerate battle after battle; the final monument at Piedras Negras is Stela 12, on which the human trophies of battle are laid at the ruler's feet. Is the violence depicted in the Bonampak murals an indication of how the world came to an end? Archaeologists have sought explanations for the Maya collapse in buried material remains – was there devastating drought, or environmental change triggering a food-supply crisis? – but the art and inscriptions relate the Maya's own last documentation of life around 800 CE, and that record is of warfare. Warfare was the process, if not the cause, of the Maya collapse that the Maya themselves chose to record.

Chapter 8
Mesoamerica after the fall of Classic cities

The heart of Teotihuacan had been in ruins for at least two centuries when most lowland Maya cities were abandoned in the years before and after 800 CE, some in waves that cascaded across a given landscape as droughts – in some cases, hundred-year droughts – set in, making it impossible even to eke out a subsistence living. Surviving populations were vulnerable to enslavement, and large swaths of Mesoamerica were essentially abandoned, with occasional evidence of squatters who left behind garbage, giving rise to the Terminal Classic. This chapter will continue through the Early Postclassic and see the ancient Maya through to the invasion of the Spanish in 1519. Chapter 9 will address the last great civilization of ancient Mexico: the Aztecs.

Whether designated the Terminal or the Postclassic, the terminology does not inspire confidence, suggesting an imminent ending or that a period of greatness has passed. Yet some of the art produced in this period ranks among the most creative efforts of all of ancient Mesoamerica, whether in the paintings of Cacaxtla or the architectural designs of Mitla. If we take a close look at one of the gold disks of Chichen Itza, Yucatan, we can see many of the features that make the art of this period so exciting, including new materiality, new forms, and new ideas, executed with exquisite skill, along with a powerful destruction designed to erase the work altogether. Pilgrims from southern Central America brought what must have been blank disks of extremely pure ores, most weighing no more than two ounces, and already prepared with beaded rims, to Chichen Itza, making the long journey by canoe to reach Yucatan. Under the guidance of a master goldworker, who presumably traveled along with the gold itself, Maya artists learned to work the first gold known to reach

203

199

203 Early underwater explorers dredged up gold repoussé disks from the Sacred Cenote, Chichen Itza, and, like the paintings in ill. 228, they show Central Mexican warriors gaining dominion over their enemies. The graceful human proportions and foreshortening suggest Maya facture.

Mesoamerica, communicating in the language of technique alone. Sketching a design as an artist might have done on the round surface of a ceramic plate in the eighth century CE, the goldworker of the ninth would have begun with a charcoal sketch on the reverse of the disk, then set it face down into a pitch bowl filled with a matrix such as resin mixed with gypsum. Using a sharp tool, the artist followed the sketch, periodically turning and setting the disk anew in the pitch bowl, in order to refine the design from the front.

Like all but one of the gold disks dredged from the Sacred Cenote at Chichen Itza, Disk H was reassembled from many pieces of thin gold foil. Most pieces were tiny, and almost all crumpled beyond recognition until reassembled at Harvard's Peabody Museum in the 1930s. The pattern of burning suggests that the disk may have been scorched, punctured, and ripped, in that order, before being hurled into the murky water of the Cenote, perhaps during the tenth century CE. On Disk H, a warrior dressed as an eagle has removed a human heart, while another victim at right awaits the same fate. The absolute center of the disk falls between the sacrificial victim's extruded heart and the sacrificer's eye, pulling the viewer into the high point of drama. Four other warriors crouch at the body, convincingly using their weight to hold down the splayed victim. Their back disks have been depicted as if flexible, perhaps suggesting that the known corpus made of turquoise on wood represents something made of leather or feathers.

The sacrificing warrior is caught mid-action, his left hand grasping a flint knife behind him. The overlapping figures

who hold the body are worked so carefully – and so believably, to the modern eye – as to suggest one figure behind another through the slightest of lines. At left, one of the assistants to the human sacrifice turns frontally and captures the observer's gaze, as if to engage us directly and to suggest that he sees and hears beyond the surface and moment of the gold disk. This is artistry completely coherent with the paintings of Bonampak, but the weaponry on display and the serpent floating above the scene is an introduction from Central Mexico. This is the hybrid work that emerged after the fall of Classic Maya cities. It may well be one of the last Mesoamerican works that so grippingly captures human movement.

The turmoil of the late first millennium CE led many Mesoamerican peoples to uproot themselves and form new alliances or move to new locations, sometimes as marauding invaders. "Foreign" influences can be observed in many places during the Terminal Classic. As we can see with the gold disks, Maya – or at least Maya art styles – appeared in Central Mexico, and Central Mexicans among the Maya. It was a time of seemingly unprecedented inter-regional contact, best seen today in the rise and fall of two cities, Tula in Central Mexico and Chichen Itza in Yucatan, both built in a cross-pollinated Maya–Mexican style during the Early Postclassic and probably at their height around 1000 CE.

Problematically, the current time frames established by archaeologists leave unresolved the twelfth and thirteenth centuries, when populations may have crashed yet more. Friezes at Chichen Itza closely resemble those of earlier Teotihuacan and later Tenochtitlan, executed as if there were no cultural gap, so clearly the unsettled chronologies require additional exploration. During the Late Postclassic, the Aztecs ruthlessly exploited the weaknesses of their neighbors in order to gain dominion over the whole of Central Mexico, and simultaneously developed a new imperial art style. The Maya of the Late Postclassic remained fractured, in small communities, but with practices, such as writing and painting, that are continuous, drawing upon earlier models, especially Chichen Itza, the strongest influence on the later Maya.

One important marker used by archaeologists to chronicle change is pottery, and among elite wares there was a shift in styles and clays around 800 CE at several Maya sites. Following a precedent established in the pottery of north Yucatan, designs were modeled and carved, rather than painted – color was rarely an element in the fired slip of these vessels, although colorful stucco painting did continue, especially on perishable materials, including gourd vessels, at Chichen Itza. Other

designs appear to have been stamped out or mass-produced. Even the clay used to make the vessels ceased to be local, and most scholars believe it to be of Gulf Coast origin, suggesting a foreign presence, but one of the potential great centers, Isla de Sacrificios, off Veracruz, has been looted for 500 years, leaving little to make sense of today. What we find in the art and architecture of the Maya city of Ceibal argues for a Central Mexican or Gulf Coast infusion there about this time. Across the region, people were on the move, Maya and Mexicans, and so, too, does this chapter weave back and forth across Mesoamerica.

Ceibal

A city where Olmec materials have been discovered at 900 BCE (see p. 44), Maya Ceibal thrived modestly for most of the Classic period. Then, the Terminal Classic buildings of Ceibal exhibit a new architectural style. A great round platform was erected at the site, a rare feature in Mesoamerican, and particularly Maya, architecture, with its first appearance in this era. Round structures in use at the time of the Spanish invasion were generally associated with the Central Mexican deity, Quetzalcoatl (usually in his guise as wind god, Ehecatl), and – as we shall see – his cult was gaining adherents in this period. Moreover, a new large radial pyramid at Ceibal would seem to recall the unusual forms of Uaxactun E-VII-sub or the radial pyramids of Tikal's Twin Pyramid Complexes.

A stela was set at the base of each staircase of the Ceibal radial structure, all four commemorating the date 10.1.0.0.0 (849 CE), as if that were a momentous year. One names lords of four separate polities – Tikal, Calakmul, San José de Motul, and Ceibal itself – an attempt to draw on ancient lineages to sustain ritual practices. Most striking of all is the distinctive physiognomy depicted on Ceibal monuments. Stela 1, dated to 869 CE, for example, shows a new kind of portraiture. The ruler's face is not idealized, and the strong, slightly downturned lip suggests both harshness and the hint of a smile. Many Ceibal portraits show neither forehead modification nor the extended bridge of the nose typical of most ancient Maya. Are the men the foreigners who left ballgame equipment at Palenque and Copan after the cities were largely abandoned? Or did the Maya simply absorb foreign fashions and art styles once again?

On yet later monuments, both inscriptions and costume change. On Ceibal Stela 3, for example, a date is recorded in a non-Maya script, and one of the glyphs used is a *cipactli*, or crocodile head, the first day name of the 260-day calendar

204

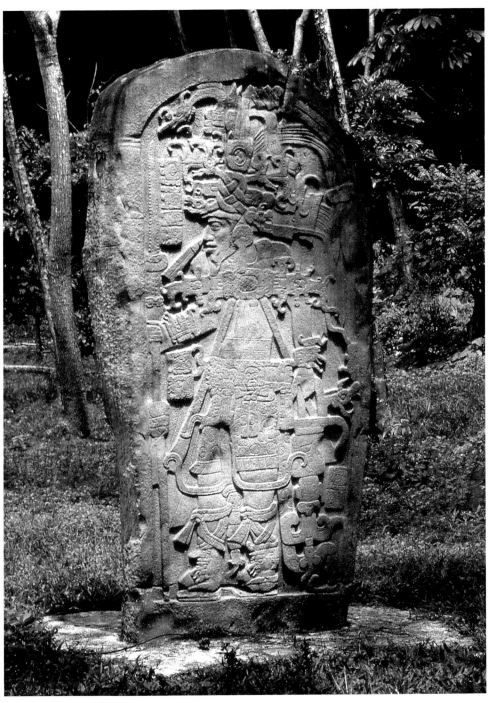

204 Stela 1, Ceibal. During the ninth century CE, new rulers – perhaps the Itza – came to power at Ceibal, adopting the traditional stela format but infusing it with new vigor, particularly in respect to portraiture.

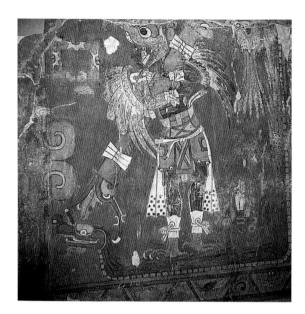

205 Stucco painting of a man in a bird suit, Structure A, Cacaxtla, 700–900 CE. Like a Mesoamerican Daedalus, this handsome young warrior in black body paint wears a full bird suit, from headdress to wings to feet.

in most Central Mexican systems. On this same monument, individuals are shown with long, flowing hair and trimmed bangs, rarely worn by earlier Maya. On other monuments, traditional Maya imagery appears in odd configurations, as if not fully understood by the elite artist at Ceibal.

Cacaxtla and Xochicalco

It is perhaps too tidy a solution to attribute simultaneous developments further north to the same people who dominated Ceibal, but powerful cosmopolitan, particularly Maya, influences undoubtedly made themselves felt at Cacaxtla and Xochicalco in Central Mexico at this time.

In 1975, a local schoolteacher led Mexican archaeologists to well-preserved, beautifully executed paintings in what seemed to be Maya style at Cacaxtla, Tlaxcala, a hilltop acropolis. One set of paintings had even been packed with fine sand by ancient inhabitants to help preserve the stucco paint. In Structure A, the doorway to the interior shrine is flanked by two stela-like portraits, one showing a standing lord in bird costume, the other a lord in a full jaguar suit. The man in the bird costume, who also wears black body paint, may be the Terminal Classic prototype of the later Aztec Eagle Knight, but the naturalistic proportions, skilled painting, and attention to both costume details and the human face reveal deep familiarity with Maya style. Other influences are evident as well: borders show

205

Teotihuacan motifs and Maya signs, and the glyphic style is not yet identified. Yet as a whole it is both something coherent and highly local, known only at Cacaxtla, and repeated through generations and layer upon layer of paint.

206 Another set of paintings framing an adjacent staircase features warriors with Central Mexican profiles in jaguar suits and adorned with the iconography of human sacrifice. They attack, defeat, dismember, and even disembowel warriors with Maya profiles who wear bird suits and lavish textiles, and at least two of the Maya figures may be women wearing upper-body garments. The naturalistic representation of spurting blood and spilling entrails derives from a Maya canon of representation, but the subject matter may have troubled those who saw it: within a few short years it was covered over and hidden from sight until the twentieth century. Did Maya forays into Central Mexico result in grinding

207 tribute payments and outright defeat? In the Red Temple, other fragments of paintings record an economic reality: the old god of Maya trade and commerce has stationed his overstuffed trading pack behind him, along a staircase that

206 Jaguar-clad warriors take on befeathered warriors with Maya profiles, driving them to the ground. Entrails pour from the chests of the defeated; one Maya warrior pulls an arrow from his cheek, while another holds a broken arrow. Cacaxtla, 700–900 CE.

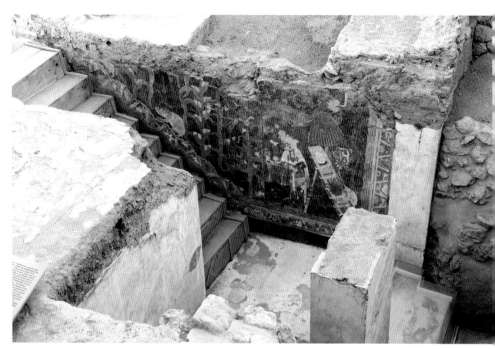

207 God L, a Maya god of trade and tribute, stands atop a stream of bounty. Ahead of him grows first a cacao, or chocolate tree; up the stairs, a plant sprouts abundant ears of ripe maize.

records both particular victories and emaciated human captives at its foot, juxtaposing luxury with degradation. The rich blue pigments and the quality of line of the paintings correspond to those of Bonampak (see pp. 155–56), and they may have been painted around the same time, in the early ninth century CE.

Some 80 miles (130 km) to the southwest of Cacaxtla lies Xochicalco, a contemporary hilltop acropolis high above the Valley of Cuernavaca. Distant influences abound here as well, and are particularly evident on the Pyramid of the Feathered Serpent. Seated figures of Maya proportion, in Maya pose and dress, and particularly similar to Maya jades, on which they might be based, are carved among the undulations of great feathered serpents; shell sections define an aquatic environment. Both serpents and shells recall Teotihuacan's Feathered Serpent Pyramid. The sculptors executed glyphic notations using an idiosyncratic system that features numerous unidentified place names, possibly indicating political consolidation or a sort of council house, what to the Maya would be a *popol nah*, like the one constructed at Copan. They also gave the images a double outline, a

208

169

technique characteristic of Veracruz art, particularly at El Tajín (see pp. 121–23).

A large, graceful ballcourt similar to that of Copan was situated at the heart of the site, adjacent to what were probably palace chambers. Other connections with the Maya are seen on the three stelae excavated at Xochicalco from a pit where they had been carefully hidden. One shows the goggle-eyed and fanged face of Tlaloc, but the two others depict a strikingly three-dimensional human face, set within a helmet, framed by a more two-dimensional calendar sign above and skyband below. These stelae show resemblances to the "niche" stelae 185, of Piedras Negras, on which enthroned, three-dimensional 186 rulers are portrayed within two-dimensional skyband borders in scenes commemorating rulership. The works of art at both Cacaxtla and Xochicalco suggest that elites throughout Mesoamerica may have retreated to isolated sites like these,

208 Carl Nebel, a nineteenth-century German explorer of Mexico, published a lavish album of his lithographs in 1836. As he documented, the front façade of the Pyramid of Xochicalco was preserved through time, revealing the head of the Feathered Serpent.

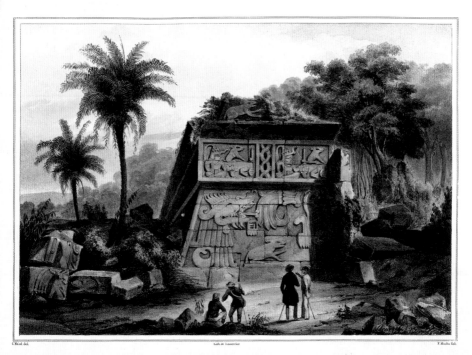

RUINAS DE LA PIRAMIDE DE XOCHICALCO.

where they left a new, hybridized material culture, but it was not to last: by 900 CE or so, these citadels, too, fell into disuse, in many cases systematically burying parts of the past as they left.

Mitla

In Oaxaca, the end of the first millennium CE brought Monte Alban's long reign as the main city of the region to a close, although the mountain continued to serve as a place of ritual activity and pilgrimage even after permanent occupation ceased. Instead, other Zapotec centers grew in the surrounding valleys, particularly to the south. Large, elegant palace complexes were constructed at both Yagul and Mitla, as well as at Lambityeco and Zaachila, rising and falling in ways that suggest the competitive families of the Mixtec manuscripts (see pp. 270–71). The name Mitla derives from Mictlan, the Nahuatl name for the underworld, and at the time of the Spanish invasion, the high priest of the Zapotecs presided there and oversaw the interment of royal lineages.

The palaces at Mitla have long been admired for their elegant proportion and ornament. Courtyards with both interlocking and open corners are arranged along a general north–south axis. In colonial times, the townspeople built a church into the northernmost quadrangle and established a chapel – a "Calvario," associated in many communities with Holy Week processions, but in Mitla principally understood to be a place for venerating ancestors – on the summit of a large adobe mound southwest of the palaces, transforming the ancient ruins into modern holy places. It still attracts pilgrims today, who come with their prayers, along with offerings of flowers, cacao, cane liquor, and candles, sometimes laid out in the form of the cross.

The Group of the Columns, Quadrangles D–E, is the largest of the palace compounds and the most refined in proportion. Quadrangle E consists of four galleried buildings arranged around the sides of a plaza with open corners, while its northern building, the Hall of the Columns, named for the vast drum columns that fill the chamber, provides the only access to D, a smaller, fully enclosed quadrangle, maze-like in its plan. The Hall of the Columns is the most striking of Mitla structures. Like the contemporary House of the Governor at Uxmal, the building has a subtle outward lean, which visually alleviates the weight of its overhanging moldings, similar to those at Monte Alban.

The façades of Mitla buildings shimmer in the clear sunlight of Oaxaca. Geometric mosaics in a variety of designs and composed of individual veneer stones are

209
176

209 Hall of the Columns, Mitla. This graceful building grants entry to private quadrangles within. Columns inside this building once supported a perishable roof.

set in rectangles across the exterior walls. In the private chambers of Quadrangle D, the interiors are also cast with intricate patterns, quite conceivably replicating in stone the fine fabrics that had once hung within palace rooms. The designs may refer to various family lineages, perhaps derived from woven textile patterns specific to group or place.

The Huastecs: Dramatic sculptures along the Veracruz coast

No later than 1000 CE, a regional style began to flourish in north Veracruz and widely across the modern-day state of San Luís Potosí. Generally called Huastec, there is only modest evidence of this ethnic presence at the San Luís Potosí sites. The Huastec language is related to the Maya; particular emphasis in the Huasteca (as at least the coastal part of the region is known) was given to the cult of Quetzalcoatl, and as we shall see this was also true at Tula and Chichen Itza.

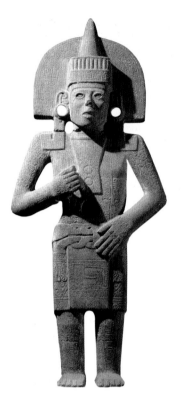
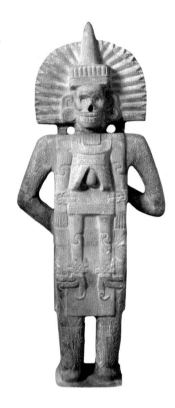

210, 211 A so-called "apotheosis" sculpture, Huastec culture (Early Postclassic). The strong three-dimensional quality of Huastec stone sculpture may be related to works at El Tajín and Veracruz ceramic sculptures. The death deity on the back of this monument (RIGHT) is carried like a burden by the human on the front (LEFT).

Circular buildings dedicated to Quetzalcoatl/Ehecatl are found at small sites throughout the region.

Characteristic of Huastec sculptures are prismatic yet slab-like three-dimensional works, most of which can be found in museums, from Jalapa to Brooklyn to Paris, leaving little evidence of the artistic mastery at the sites themselves, such as Tamtok, which thus receive little attention in studies of Mesoamerica. With dual imagery on front and back, some sculptures have been called "apotheosis" sculptures. A life-sized human figure is worked on the front of the monument, while a smaller image appears on the back – sometimes an infant, borne as if in a backpack, or in the case of the example shown here, a skeletal death image. The oversized hands and the rich, incised pattern that covers the stone can be compared

210,
211

with later Aztec workmanship. In fact, the carpeted body may represent the custom of body paint; the pleated adornments represent folded *amate* (fig) paper, shaped into radiant solar headdress, as Karl Taube has argued. Kim Richter has reconstructed male–female pairs among the sculptures.

The Aztecs conquered the Huastecs in the mid-fifteenth century and may have taken Huastec art as a model for their own imperial style. It is also possible that these Huastec sculptures have a prototype in the Maya sculptures of Copan. There, a ruler and his predecessor are often recorded in three-dimensional relief on the front and back of a stone shaft. The adult males of Huastec sculpture may be rulers, paired with wives, their infant successors, or dead predecessors.

The Toltecs

The rise of the Toltecs at Tula, in the state of Hidalgo, and at Chichen Itza is generally attributed to the tenth century CE, although both sites were occupied long before. Ironically enough it was the later Aztecs who ensured the Toltecs a prominent place in history. Aztec historical annals – some of which were transcribed into the European alphabet – provide information for events going back as far as the tenth century CE, even if for the period 1000 to 1300 CE the record is spotty. For earlier historical records in Mesoamerica, one must turn to Maya inscriptions (scarce as these are between 800 and 1000 CE) and use them to compare contemporary archaeological data from other places. Because the Aztec used the term "Toltec" to describe a skilled craftsperson, the term remains confusing and misunderstood today. The Toltecs of Tula almost certainly spoke Nahuatl, the language of the Aztecs.

Colonial documents weave a story of cyclical occurrences, where myth and history are one, and – unfortunately for us – geographical locations are often vague. We learn, for instance, of great events at the ancient city of Tula, Hidalgo. Tula, or Tollan, is a name ascribed to many important centers meaning literally "place of bulrushes, or cattail reeds," but generally understood to mean an urban settlement. To the Aztecs, both Teotihuacan and Tula were the Tollans of the past, but their own city, Tenochtitlan, was also a Tollan, as was Cholula, perhaps Chichen Itza, and even Copan, as well. The sixteenth century reveals a particular view of the Toltecs:

The tolteca were wise. Their works were all good, all perfect, all wonderful, all marvelous; their houses beautiful, tiled in mosaics smoothed, stuccoed, very marvelous....The tolteca were very wise; they were thinkers, for they originated the year count, the day

count; they established the way in which the night, the day, would work; which day sign was good, favorable.... (Sahagún, Book 10)

The later commentaries seem to have telescoped all past glories into the Toltec era, but the skill of the builders of Tula was not exceptional: all the cultures named in this book had extraordinary craftsmen.

Colonial records emphasize the story of the Toltecs and their cultural hero, Topiltzin Quetzalcoatl, the latter name meaning "Feathered Serpent," presumably a historical individual who ruled at Tula in the tenth century – only to be driven into exile. Colonial Maya sources relate the arrival of a great cultural hero, Kukulcan, in what may have been the same period. Kukulcan is a translation of "feathered serpent" into Maya, and representations of feathered snakes flourished in the art and architecture of both Tula and Chichen Itza, mostly in contexts of war and sacrifice, in what seems to have been a militaristic religious cult that swept from Central Mexico to the Maya region. A series of structures that were constructed at Chichen Itza and Tula bear close resemblance to each other. Chichen Itza clearly benefited from the Toltec relationship: distant, precious trade goods, including turquoise from what is today New Mexico and gold disks from southern Central America, flowed into the city. To the north, the Toltecs would have been the purveyors of tropical birds to Paquime, Chihuahua, and chocolate to Chaco Canyon, New Mexico, part of a brilliant network around 1000 CE. In the mid-twelfth century CE, however, the last king of Tula fled the city ahead of invading barbarians. Toltec dynasties settled in Chapultepec, on the western banks of Lake Texcoco in the Valley of Mexico and in other cities around the lake. The city they left behind was ravaged, but no later dynasty in Mesoamerica, whether Mixtec, Aztec, or Maya, would fail to invoke their glorious past.

Tula: A capital city

Tula, Hidalgo, lies farther north than any other ancient Mesoamerican city. It was not only ravaged at its abandonment, but it was also looted systematically by the Aztecs. It has taken years of patient archaeological work to reveal the nature of the ancient city. What is now clear is that dense urban housing, laid out along a rough grid, surrounded the ceremonial core. Pyramid C is the largest of the central structures, but it was trenched for treasure and stripped of its sculpture in prehispanic times. Pyramid B is just slightly smaller and stands today as the best-preserved major building at Tula.

Its contiguous colonnades, which we can imagine to have supported a perishable roof, may once have served as a royal residence. This relationship of massive pyramid to large, interior space formed by piers and courtyards recalls the arrangement at Teotihuacan, where the late Quetzalpapalotl Palace adjoins the Pyramid of the Moon, but on a reduced, even spartan, scale at Tula.

The colonnade protects the single staircase of Pyramid B, restricting access to the summit of the pyramid. Against the four distinct levels of the structure, tenons once supported a façade of carved stone, which in turn was brightly polychromed – but only a small portion of the façade survives. Where still in situ, friezes of prowling jaguars, coyotes, and seated eagles with hearts in their beaks are punctuated by frontal single images of feathered, jaguar-like creatures from whose mouths emerge the faces of supernaturals with large eyes and bifurcated tongues, sometimes thought to represent the Morning Star, or Quetzalcoatl, but who in fact represent the War Serpent, whose headdress figured at Teotihuacan and in the Maya region.

Great atlantean figures of Toltec warriors and feathered columns surmount the pyramid. The atlanteans functioned

212 Pyramid B, Tula. The French explorer Désiré Charnay first posited a direct connection between Tula and Chichen Itza, and he recognized the similarity between this pyramid and the Temple of the Warriors at Chichen (ill. 225).

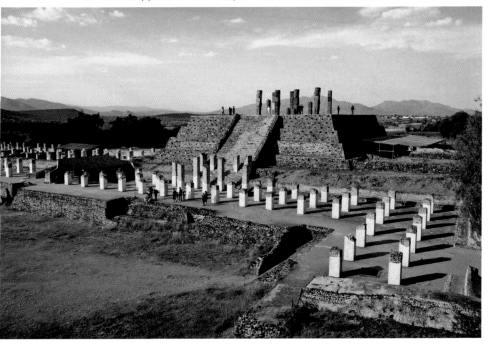

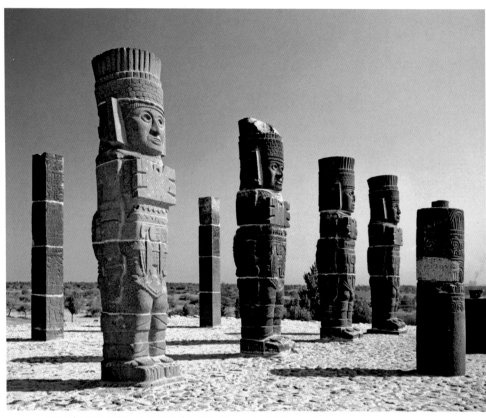

213 Atlantean columns, Pyramid B, Tula. These giant Toltec sculptures are warriors ready for battle; an atlatl is held at the side, and the butterfly pectoral and drum headdress are costume elements of those in combat.

like caryatids and probably held up a roof; the feathered columns framed the doorway. Square pillars with warriors in low relief supported a rear chamber. Within the chamber, the atlantean Toltec warriors must have been an intimidating group. Their huge, blank faces convey the anonymity of the Toltec war machine, and the *atlatls* – Central Mexican spearthrowers – borne in their hands threaten the viewer. Scant traces now remain of the bright polychrome that once colored these sculptures: the warriors' legs, for example, were painted in red-and-white candy-cane stripes, usually indicative of sacrificial victims in Aztec art. Each atlantean consists of four drums held together by tenons, and both their uniformity and method of construction speak to the control of a deep chain of production, from concept to quarry to final execution.

An innovation at Tula is the *coatepantli*, or freestanding serpent wall, which forms an L on the north side of the pyramid. With a border of geometric meanders, a single broad entablature supports a repeating relief of great rattlesnakes belching skeletal humans. Cut-out shell motifs of the sort associated with Quetzalcoatl run across the top of the *coatepantli*. Off to the north, the Toltecs built the Corral, a round building designed to align with a sacred mountain. Along the Tula River, the Toltecs built dense housing complexes, probably some for extended family living and craft production.

Elevated benches within the palace adjoining Pyramid B may have served as thrones for the elite. Three-dimensional *chacmool* sculptures stood in front of these thrones. The discovery in the nineteenth century of similar *chacmool* figures in both Central Mexico and Yucatan helped spark the notion of Toltec hegemony, but, as we shall see below, the *chacmool* may be a Maya invention. The illustration here shows a fallen warrior, knife still held in place by an armband, and he holds out a flat paten, probably a receptacle for offerings – including those of human sacrifice – brought to a ruler or deity on the throne behind. A cuirass made of Pacific shells was buried under the palace floor, a testimony to craftsmen worthy of the term *tolteca*. The *chacmool* flourished from the Lake Patzcuaro

214, 216

215

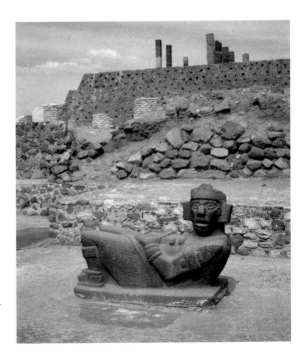

214 A *chacmool* from the Palace, Tula. These reclining sculptures of fallen warriors were set in front of thrones. The receptacle on the chest is for sacrificial offerings.

region, among the Purépacha, to Quirigua, Guatemala. Toltec practices and forms had an international impact.

Although carved stelae are not unknown in Central Mexico, they are not common, and the full-figure, frontal portraits roughly worked on Stelae 1 and 2 at Tula strongly suggest a Maya influence. Like earlier warrior stelae at Piedras Negras, the Tula stelae show the face worked in deep relief and the costume in shallow carving. The headdress of these warriors comprises three "bowties" surmounted by Tlaloc year-sign insignia and feathers. Among the Classic Maya and at Cacaxtla, Central Mexican motifs are worn both by warriors and by those engaged in sacrifice. These Tula stelae may reflect a strong Maya contact at the end of the Classic, and they may date to the early ninth century CE, when the tradition was still alive in the southern Maya lowlands. At Xochicalco, contemporary stelae called upon Maya forms and motifs in celebrating rulership; at Tula, the precedent is the Maya warrior.

During the Toltec era, a distinctive type of pottery known as plumbate ware gained a wide distribution throughout Mesoamerica, often following the same vessel shapes of Fine Orange ceramics (see p. 198). Traditionally thought of as a chronological and geographical marker of the Toltec Early Postclassic era, plumbate ware probably comes from southwest Guatemala, whence it dispersed to the rest of Mesoamerica. The name plumbate suggests a true, lead glaze of the sort used in the Old World, but in fact the glossy, metallic appearance derives from the high iron content of the clay and the reduced oxygen at the completion of firing. Indeed, plumbate may deliberately imitate the sheen of metal, in much the same way as do wares made by the Chimú in the northern Andes. Even though metal objects have not been recovered from Tula itself, the Toltec era ushers in metalworking in Mesoamerica as a whole.

The plumbate potters often made human or effigy jars, often in sets and seemingly deploying molds for standardization. Some of the human faces suggest portraits, while others seem to be those of deities, particularly the old god of trade, an appropriate subject matter. One unusual portrait is worked with mother-of-pearl over the terracotta, and the bearded face

215 OPPOSITE TOP Skilled craftsmen cut spiny oyster (*spondylus*) shells into tiny plaques, assembling over 1,200 into a cuirass or warrior shirt, and trimming the garment with olive and mother-of-pearl.
216 OPPOSITE BOTTOM Around 1000 CE, the Purépecha of the region near Lake Patzcuaro developed strong connections with the Toltec, adopting sculptural types and giving them a new geometric form. Excavated in 1938 at Ihuatzio, this *chacmool* is fully naked and exhibits genitalia.

has suggested to many the early colonial accounts of a fair and bearded Toltec king.

Tula was sacked in the late twelfth century CE. Its ravagers hurled the atlantean columns from the summit, interred them, and then dug a huge trench through Pyramid B, presumably looting any treasure there. The Aztecs later established a nearby hill as the locus of an important cosmic myth, so perhaps it was their ancestors, nomadic barbarians, who were among the despoilers of Tula. Whatever the truth of this, the Aztecs actively drew on the conventions and iconography of Tula when they designed their own capital, Tenochtitlan.

Tula was in many ways an experiment: a seeming union of the Maya and Central Mexico, with a center farther to the north than any other in Mesoamerican history. In the end, the experiment failed.

Chichen Itza: The greatest city of Mesoamerica at the turn of the millennium

The Toltec florescence at Chichen Itza is exuberant and expansive: similar architectural features and motifs appear to those at Tula, among them serpent columns, *chacmools*, and Toltec warrior pillars, but the innovation and skill at Chichen suggests Maya stimulus and craftsmanship as well as novel belief systems. To understand the transformation of Toltec Chichen, however, we must turn first to the city's earlier history as reflected in its architecture. Even when Toltec impact is most pronounced, Chichen was always a Maya city. The discovery in 2015 of a cenote underneath the earliest level of the Castillo makes its character as an *altepetl*, or "water mountain," also evident: Chichen inherited a complex past, both of the Maya and of Central Mexico. The city was a great repository of cultural knowledge, practice, and belief.

An examination of the city's plan reveals the different phases of construction. The south half of the mapped portion, perhaps focused on the use of water from the accessible Xtoloc Cenote, follows the more dispersed plan characteristic of older Maya cities, with a rambling emphasis on a north–south axis. The north half of the site, on the other hand, is dominated by ordered colonnaded structures, mostly built during the

217 OPPOSITE TOP Although crudely carved, this Early Postclassic stela from Tula is nevertheless dressed like a Maya warrior. The Tlaloc-and-year sign headdress is similar to that worn by the warrior in ill. 181.

218 OPPOSITE BOTTOM Plumbate wares mark the Toltec era of the ninth and tenth centuries, from Yucatan to Tula, although manufacture seems to have taken place in Chiapas. These ceramics carried new iconography across Mesoamerica, including the Maya god Pauahtun, featured on this vessel.

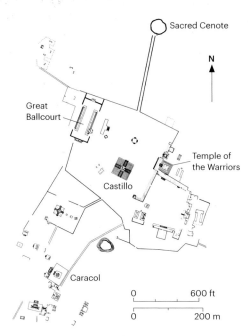

219 Plan of Chichen Itza.

Toltec era and perhaps all within a very short timespan, which
spread from east to west, defining their own axis. Probably
multi-ethnic, like Teotihuacan, Chichen Itza unified its peoples
through a program of public architecture, whether for Yucatec
or Itza Maya, or for Central Mexican Toltec. Causeways,
or *sacbes*, link different clusters: one *sacbe* terminates at
the Sacred Cenote, a great natural sinkhole, and the source
of the name of the site, literally, "the mouth of the well of the
Itza," referring to the particular Maya ethnicity who may have
reigned supreme in a city of diversity.

In "Old" Chichen, buildings such as the Temple of the Three
Lintels (a low-lying range-type structure) with hybrid Chahk/
Witz' – "rain god mountain" – masks at the corners) recall the
galleries of the Puuc. The Red House and the House of the Deer
are small temples set on raised platforms; their private rear
chambers and orientation to one another suggest the plan and
arrangement of the Cross Group temples at Palenque and the
ornament of Uxmal. In fact, the visual refinements of negative
batter and uneven spacing of doorways are entirely lacking

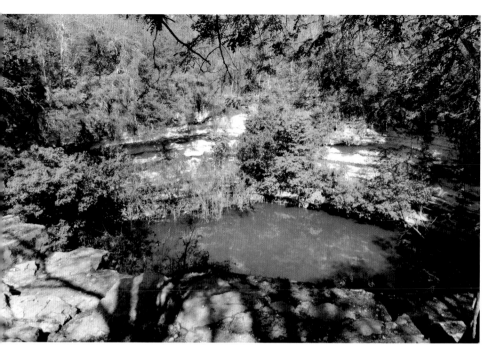

220 Maya pilgrims made offerings to the Sacred Cenote at Chichen for generations and continued to do so from time to time after the Spanish invasion. The murky green water has yielded human bones, jade, and gold.

in Chichen architecture, which in general does not match the lyrical quality of Uxmal.

The first building that shows a dramatic shift away from more traditional Maya architectural practices is the imaginative Caracol, so-called for its plan, the core of which may deliberately resemble the section of a conch shell. Concentric vaults lead to an upper chamber via a spiral staircase, all executed in stonework and vaulting of high quality. The great twentieth-century Mayanist Sir Eric Thompson decried its architectural style, claiming that it resembled "a two-decker wedding cake on the square carton in which it came." But one can equally well argue that the circles described within a trapezoid within a rectangle express a creative interest in geometry. The Caracol's unusual plan and placement of openings allow observation of the movements of Venus, whose synodic cycle of 236 days (Morning Star), 90 days (superior conjunction), 250 days (Evening Star), and 8 days (inferior conjunction) was of great importance to all Mesoamerican peoples. For the later Aztecs, round buildings were always dedicated to wind gods, and to breath and life.

221,
222,
223

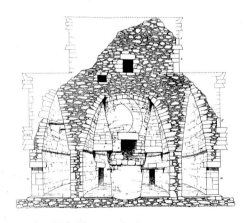

221, 222 TOP AND ABOVE The Caracol, Chichen Itza. Tiny windows in the uppermost story were oriented for astronomical observations. The principal entrance does not align with the staircase, creating the sense, visually, that the building is turning.
223 LEFT A cutaway drawing of the Caracol.

This wind god, known for his duck-bill mask, may have
been known in earlier times – perhaps even then associated
with feathered serpents, which can be seen on many of his
monuments – but it is clear that this god grew greatly in
significance during the Early Postclassic. But, as we have seen
in earlier constructions at Teotihuacan, feathered serpents bear
an integral relation to the cult of warfare. Just what this meant at
Chichen Itza remains unclear, but the era was one when some of
the tenets of Classic religion changed, with some new prominence
for different deities, especially those from Central Mexico.

The first Christian bishop of Yucatan, Diego de Landa,
visited Chichen in the mid-sixteenth century, and drew a plan
of what he called the Pyramid of Kukulcan, or Quetzalcoatl,
which is now generally known as the Castillo. His plan shows
a building of several levels with staircases flowing down all
four sides of the building: even more remarkable is his written
description of the ninety-one steps on a side of the structure,
with the north staircase heading off to the Sacred Cenote.

Landa's description includes many interesting observations
for the modern viewer, not only in what he said but also in what
he did not say. He noted the practice of making live human
sacrifices into the sacred well (the theory of virgin sacrifice
does not depend on Landa: for that we must turn to Tomás

224

224 The Castillo, Chichen Itza. Like the funerary pyramids of Palenque or Tikal
(ill. 157), the Castillo rises in nine distinct levels. This photograph was taken on
the autumnal equinox, when seven serpent segments are illuminated along the
main stairs. Archaeologists have detected a cenote under the pyramid.

Lopez, who had already visited the site in 1552) and speculated that "if this country possessed gold, it would be this well that would have the greater part of it." Once Brasseur de Bourbourg rediscovered Landa's manuscript in 1864, feverish imagination focused on the Cenote, with dreams of great treasure: divers at the turn of the twentieth century would indeed eventually haul gold disks with Maya imagery from the well.

203

Landa's ability to see this one particular cleared portion of the site, from the Castillo to the Cenote, suggests that this quadrant had remained in perpetual use. Landa's attention was also drawn to the particular number of steps on each side of the pyramid and to the massive serpent heads on the northern face, perhaps indicating that the observation of astronomical phenomena at this building, a giant chronographic marker, had continued unabated from the time of its construction.

Like the Caracol, the Castillo was oriented to acknowledge movements of the heavens, and on the equinoxes the nine levels of the pyramid cast a shadow that reveals a segmented serpent along the northern balustrade. The flight of stairs on that side has 92 steps, if one counts the serpent heads at the base; each of the other three staircases has 91, for a total of 365. Thus, both in numerology and orientation, the building recognizes the solar year. As we see the Castillo today, it is a radial pyramid of the sort first observed at Uaxactun in Late Formative times and whose primary role would seem to have been to commemorate the completion of time.

Today, twice annually, tens of thousands of visitors swarm onto the plaza in a modern ritual of equinox observation at the Castillo. The phenomenon was not rediscovered through careful archaeological observation and measurement, but rather seems to have grown up organically at Chichen, probably by means of local Yucatec Maya, who had kept the plaza cleared in Landa's day and sustained memory of the rites continuously through the Colonial era.

In 1937, Mexican archaeologists exploring the Castillo found within it a complete pyramid-temple, also of nine levels, but with a single stairway to the north. Preserved in the temple chambers were a *chacmool* and jaguar throne, which remain in situ today. Given the pattern known at Tikal and Palenque, where earlier pyramids of nine levels held tombs of great kings, it seems likely that this one may also house a royal burial, but how and where is mysterious, given the cenote within and below. Although the identity of that individual may never be known, the fact that this structure has always been associated with Kukulcan suggests that the great Toltec king himself may lie somewhere within the mass of the pyramid.

225 Temple of the Warriors, Chichen Itza. This structure shares the proportions and the use of a colonnade with Pyramid B of Tula, but the Chichen Itza building is larger and more carefully executed. The colonnade in front of the structure supported a perishable roof. Early Postclassic.

225

A typical feature of the final phase of construction at Chichen during the Early Postclassic is the colonnade, punctuated by serpent columns, particularly framing a raised shrine. The greatest of these is the Temple of the Warriors. Connecting colonnades extend to define a large, semi-enclosed court, the south side of which is flanked by the so-called Mercado and a small ballcourt, probably a palace compound. Like the Castillo, the outer building of the Warriors was discovered to enclose a smaller but similar structure, now known as the Temple of the Chacmool: these buried structures would have been known through memory and oral tradition.

One gains entry to the Temple of the Warriors itself through the field of square pillars that would once have supported a perishable roof. Each pillar is carved on four sides. Some reliefs feature standing warriors with Toltec "pillbox" headdress and weaponry; others show skirted figures, probably women, bearing offerings. Similar reliefs are worked on pillars of the rear chamber of Pyramid B at Tula, but the imagery there is limited to warriors. Anyone entering the Temple of the Warriors

must have felt both the guidance of the offering bearers and the threat of the warriors as one moved though darkness only to emerge into blinding light on the temple steps.

The doorway at the summit of the temple is flanked by erect feathered-serpent columns, whose upturned rattles once supported the door lintel. In the first chamber, a *chacmool* was set to receive offerings; in the rear chamber a great platform raised up by miniature atlanteans once served as the ruler's throne. A building such as the Temple of the Warriors may have been a seat of government, its function largely bureaucratic. The platform supports suggest the literal pillars of government, the warriors and offering-bearers the means of its sustenance. The abundance of administrative buildings at Chichen Itza is perhaps accounted for within a short construction phase if we imagine that every regional governor – possibly an individual similar to the *bacab*, or governor, of the colonial period – built a new establishment, both demonstrating fealty to the larger state and bringing wealth to the city.

The Temple of the Warriors undoubtedly bears a striking resemblance to Pyramid B at Tula, but it also provides contrasts, and the scale and quality are Maya. Chambers within the Temple of the Warriors, for example, supported corbeled vaulting; stonework was elaborate and finely crafted – and this temple

226 Almost too large to be played in by mere mortals, the Great Ballcourt of Chichen Itza is the largest in Mesoamerica. Entwined serpents are carved on the rings set high in the side walls; reliefs adorn the sloping walls at ground level.

is only one of several such buildings at Chichen. At Tula, the stonework seems mean and spare by comparison, poorly worked and dependent on stucco covering, and Pyramid B stands alone as an impressive edifice. It is almost as if Toltec ideals were first given architectural expression at Chichen, and were then returned to Tula around 1000 CE. With the recent restoration of the adjacent and similar Temple of the Tables, the extent and repetition of the Warriors template has become more obvious.

The most unusual structure at Chichen is the Great Ballcourt, the largest of all ballcourts in ancient Mesoamerica. Its playing area extends over a length of 479 ft (146 m) and a width of 118 ft (36 m), defining a surface almost identical in size to a modern American football field, and several times the size of the average ballcourt. Unlike most Maya courts, the Great Ballcourt has vertical sides, a feature it shares with the Uxmal design. Vertical walls rise above a sloping tablero that by itself is higher than most other ballcourts. Rings, carved with entwined rattlesnakes, set into these side walls – presumably hoops through which the solid rubber ball passed or against which it was hit – are placed 26 ft (8 m) above the playing surface, probably out of range of even the most skilled players.

Centered under the rings are reliefs, comprised of individual slabs that required carving in situ. They reveal grisly scenes, with references to ritual events on the court. On the east side, two opposing teams of seven members face one another. In the middle of the scene, the first player of the left team has decapitated the first player of the right, who, headless, kneels in front of a large ball marked by a great laughing skull. Six serpents of blood and a tree issue from the severed neck. The apparent victors on the left are more uniformly dressed than those on the right, who wear a variety of headdresses. All these ballplayers sport equipment of the sort generally associated with Classic Veracruz – yokes, palmas, and handstones, along with the padding on arms and knees designed to take the bruising blows of the heavy ball. An unusual, heavy shoe on one foot suggests some site-specific rules. Beaded scrolls with embedded crossed bands of the kind usually intended to represent precious liquid, particularly blood, form the background and take on vegetal shape, underscoring the renewal from death and sacrifice.

Three large platforms without superstructures guide supplicants toward the Sacred Cenote to the north. One of these platforms, the T-shaped *tzompantli*, or skull rack, is carved with rows of human skulls. A precedent for depicting human skulls on platforms exists at Uxmal, but the scale and number here indicate an increasing preoccupation with death at the end of Chichen's development, to which this platform and the two

associated with it are generally attributed. Alternating jaguars and eagles devour human hearts on the Platform of the Eagles. These motifs also appear at Tula, and at both sites they link the rituals of the ballgame to those of human sacrifice. By the time of the Aztecs, these motifs would be commonplace.

Three-dimensional sculpture regained prominence at Chichen during the Early Postclassic. Particular attention was given to thrones, *chacmools*, and mini-atlanteans, but even the design of plumbate pottery reflects the new concern for images in the round. Thrones and *chacmools* are generally found together – for instance in the inner Castillo structure, Temple of the Chacmool, Mercado, and Temple of the Warriors – and they seem to replace the stela and altar of Classic times. In this we see the office itself commemorated rather than its occupant, whereas previously the individual – and even the personality – who held such an office was the focus of the record. Thrones include large platforms supported by mini-atlanteans and built-in benches, but the most splendid one is the red jaguar found in the rear chamber of the inner Castillo structure. Bright red cinnabar covers the jaguar body, and green jade disks recycled from an earlier assemblage of some sort form feline spots in a color scheme characteristic of Classic thrones. On the seat of the red jaguar throne was a *tezcacuitlapilli*, or mosaic disk, a Toltec ornament worn at the back of the waist, assembled of precious shell and the rare turquoise traded from distant New Mexico or Arizona.

227 Chacmools sit in front of the majority of thrones. The most famous was excavated from the Platform of the Eagles in 1875 by Augustus Le Plongeon, who gave them the name by which they are known today. The variety and number of Chichen *chacmools* exceed that of Tula. Perhaps the inspiration for them came from the recumbent captives often carved beneath the feet of figures on Maya stelae, an image which the Toltecs transformed into the three-dimensional idiom of their day. In recent years it has become apparent that Maya materials, forms, and iconography, often with roots in the Classic period, made a more profound impact on Central Mexico than has been previously acknowledged.

228 Stucco paintings and low-relief narratives have miraculously survived throughout Chichen Itza. Scenes of Maya and Toltecs once covered the interior of the Temple of the Warriors, recovered in fragments in the 1930s. In the illustration shown here, dark warriors lead away their bound, naked captives with red-and-white candy-cane stripes, yet other striped figures reign victorious above. The thatched houses depicted appear to be Maya, though the stone architecture resembles Central

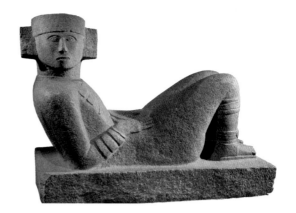

227 This *chacmool* was excavated from the Platform of the Eagles, Chichen Itza, in 1875 by Augustus LePlongeon, who unsuccessfully tried to take the stone sculpture to Philadelphia for the 1876 Centennial celebration.

Mexican models. One temple stands within a body of water: is it Lake Peten Itza, where the Itza Maya group may have lived before coming to Chichen? The naturalistic human renderings of earlier paintings, as at Cacaxtla or Bonampak, give way here to some shorter proportions, but non-naturalistic conventions reveal an intricate and lively landscape. Stylistically, the paintings have more in common with Teotihuacan painting than with the tradition of Maya murals, as do the carvings of feathered serpents.

Pilgrimages to the Sacred Cenote continued to be made into colonial times, and objects dredged from thick silt at the bottom spanned a millennium. The discovery of skeletons confirmed the long-held suspicion that human sacrifice had taken place at the well. Among the finds rescued from the Sacred Cenote muck were offerings of copal, jade, finely crafted repoussé gold disks, and copious amounts of blue pigment – and most of these materials were on fire as they were offered, the jades shattering to smithereens. The words of a much-later Aztec poet, when looking to a bleak future, provide a veritable description of practice at the Cenote's edge: "Though it be made of jade, it shatters; though it be made of gold, it is crushed."

Toltec, or Toltec-Maya, pre-eminence in the Early Postclassic may recall patterns of highland political dominance established earlier in Mesoamerica, and it certainly presages the tremendous success of the Aztecs. Such political success, however, does not guarantee priority in the aesthetic arena. Archaeologists may indeed prove one day that Tula truly reigned over the Maya, but the beauty, craft, and abundance of Maya works of the era will not be undermined.

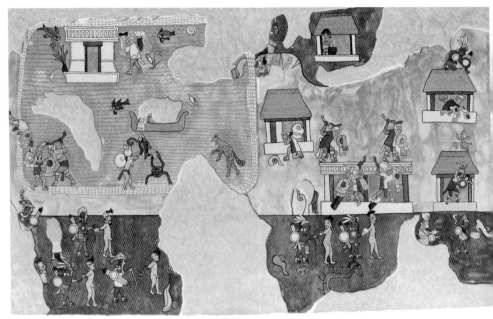

228 A wall painting from the Temple of the Warriors, Chichen Itza. Copy and reconstruction by Ann Axtell Morris. Such scenes would seem to show a foreign conquest. The lake may be Chichancanab, about 60 miles (100 km) to the southwest. A single female can be seen at the upper center, atop what seems to be a mountain.

The decline of Postclassic Maya art and architecture

Late Postclassic Maya art and architecture is mostly unimpressive, whether judged against Maya precedents or the splendors of Postclassic Central Mexico. Following the decline and abandonment of Chichen Itza, Yucatan was loosely governed in the fourteenth and fifteenth centuries by a confederacy based at Mayapan by Hunac Ceel, following a rebellion against Chichen. Mayapan in turn eventually fell prey to treachery and was abandoned in the mid-fifteenth century, as the peninsula became increasingly fractious and balkanized. Although remembered as a great city years later, Mayapan was poorly built and highly derivative of Chichen Itza in terms of its art and architecture.

What did set Mayapan apart, however, was its plan, which was unusual for a Mesoamerican city. It was apparently designed as a walled city, with a population that dwelt mainly within its bounds. Set at its center is the radial Castillo, a small and ill-executed structure built along the lines of Chichen Itza's Castillo. The Mayapan builders constructed the Castillo in roughly cut stone held together only by mud and stucco.

Mayapan lords also hauled old architectural masks from a site in the Puuc; they may have been delivered up as tribute to the lords of Mayapan.

229

At least ten stone stelae have been discovered at Mayapan. The local limestone from which they are cut is of poor quality, but the stelae nevertheless show interesting imagery. Stela 1, for example, depicts a pair of figures inside a thatched shrine, underneath a long but eroded glyphic text. Chahk sits on a throne and gestures at a smaller figure, who may be a stone or clay image, placed on a box, possibly once a *tun* glyph. This stela, and the others like it, may in fact bear scenes connected with the *acantun*, a part of the New Year's ceremonies illustrated in the Dresden Codex and discussed by Bishop Landa.

Large ceramic figures of the Late Postclassic have come to light throughout northern Yucatan. Most prevalent among these are images of Chahk, who was thought to exist both as a single deity and as a group of four. Typically, these figures hold human hearts in the hand: they must have looked gruesome anointed with blood, as Spanish chroniclers tell us they were. The Postclassic potters used coarse clay, with temper worked

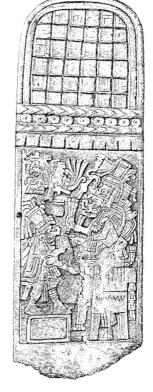

229 Despite the absence of stelae at Chichen Itza, the lords of Mayapan revived the practice of erecting such monuments, although with a change from the historical iconography of the Classic period. Texts do not survive, but glyph blocks construct a shrine, topped by thatch, in which the god Chahk receives adoration.

into the raw material to lower firing temperature. Most of the figures were once brightly polychromed, some with a stucco paint that obscured imperfections. Only the most tenacious pigments, particularly blue, survive.

Christopher Columbus's son Ferdinand accompanied his father on the Fourth Voyage to the New World, and he described the great seagoing canoes of Maya traders that they captured among the Bay Islands off Honduras in 1502. Some canoes were piled high with fine cotton mantles, a standard unit of exchange at the time that Europeans first encountered New World peoples. Women may have specifically journeyed to the coast to sell their cottons to the traders; we know that women were among the forty-odd persons taken by Columbus from the canoe. Other canoes carried foodstuffs – grains, roots, and fermented corn beverage – and copper bells and hatchets, as well as cacao beans, another unit of exchange. What is clear is that the Caribbean coast sustained considerable commerce, and that commerce in turn provided the basis for the growth of Caribbean Yucatan centers. Tulum and Tancah were probably the largest of these. On his voyage to Yucatan in 1518, Juan de Grijalva sighted what may have been Tulum, and reported that the city was bustling with activity. The small shrines on the island of Cozumel and at other places along the coast may have been no more than way stations for travelers – a function they later served for famous Caribbean pirates who worked the same coast. Additionally, women traveled to Caribbean coastal shrines when unable to conceive a child, and the movement of traders and travelers may have improved the odds of conception.

230 Tulum is beautifully situated overlooking the Caribbean. The sea forms the fourth side of a rectangle with the three walls that surround the main ceremonial structures. Unlike at Mayapan, the populace lived outside the walls; only high-ranking individuals probably lived within, in the low-ranging palace structures. The temples of Tulum are small, even diminutive, with some doors too small for easy entry. Most buildings were shabbily constructed and heavily stuccoed; the negative batter, used to subtle effect at Uxmal, was here carried to such an extreme that some buildings look as if ready to pitch over. The cornices of Structure 16 reveal great faces of aged deities, probably personified mountains, and the sharp outward slant of the structure makes the eyes bulge and the chin recede.

Elaborate paintings cover both the interior and exterior walls of many Tulum buildings. The palette of these works is limited to red, blue, and yellow, all outlined in black. Stiff conventional gestures as well as the proportional system suggest influences from Late Postclassic Mixtec painting. Some of the imagery also

230 The Castillo of Tulum turns its back to the Caribbean Sea; the watchtower at right is one of the few buildings that addresses the turquoise expanse.

231 hints at contact with Central Mexico: the example here shows a deity covered with turquoise mosaic; his eyes are banded, perhaps with gold. The most famous turquoise mosaic masks to have survived the Conquest were those given to Hernando Cortés by Motecuhzoma II, but Grijalva's record shows that he also collected some in Yucatan, and perhaps such costume elements provided the means by which religion was shared and performed. Although the Aztecs were not well informed about their Maya neighbors in Yucatan, the Maya nevertheless knew a great deal about this Central Mexican power. Foreign elements and even a foreign stylistic impact, however, should not be taken as evidence that Tulum was occupied by foreigners: the glyphs that accompany the paintings of Tulum are purely Maya, indicating that they were written for a literate Maya audience. Outside influences do nevertheless show the complicated iconographic interaction in the Late Postclassic. At Santa Rita, in what is now northern Belize, Thomas Gann had copies made of paintings that were destroyed shortly after he found them in

231 Many interior wall paintings have been preserved at Tulum. Here, a figure wears the turquoise mask and black eye band of the Aztec deity Tezcatlipoca (cf. ills 263, 264).

1896. The stiff poses suggest Central Mexico, but the unusual iconography is largely Maya, as is the writing.

Most Maya manuscripts were burned in *autos da fe*, or "acts of faith," conducted under Bishop Landa's direction in the sixteenth century. Only four survive. Of these, the finest and most complete is the Dresden Codex, preserved today in the Dresden State Library, perhaps among those Cortés was given in 1519, and which he sent to his king, Charles V of Spain, also the Holy Roman Emperor. Technically a screenfold rather than a bound codex, the Dresden was painted primarily in black and red, but with bright polychrome on some pages, on a stucco surface over native fig-bark paper. The painters – for there were several – may have used a quill in addition to a brush. The red-and-black color scheme may have been an ancient one for Mesoamerican writing, relating as it does to Maya ceramic vessels of the seventh and eighth centuries, a period from which no books survive. The Aztecs used the metaphor *in tlilli in tlapalli*, "the black, the red" – or perhaps to be generalized as "the colors" – to refer to writing. Pages are divided into registers, and the glyphs and figural illustrations create a unified text. Most of the book is filled with auguries and astrological predictions most useful in an agricultural context, along with New Year rituals. Calculations deep into the past and future are also related, as are the movements of the Venus

232

gods and Chahk, the rain god. The Venus calculations also provide confirmation of the standard correlation constant used to derive equivalents for Maya and Christian dates.

Only a few pages survive of the Paris Codex, and the third of the remaining Maya texts, the Madrid manuscript, is less interesting artistically: it appears to have been made with great haste. Its style is very close to paintings at Tancah, and its survival depended upon the seal of a papal bull, as John Chuchiak has demonstrated. In 1971, ten pages of a fourth text came to light, taking the name Grolier Codex after its original exhibition in New York, and now housed at Mexico's National Library. It has been renamed the Maya Codex of Mexico after its official authentication in 2018. Although its authenticity had been questioned, in some part because of its unknown

232 Pages 60 (LEFT) and 47 (RIGHT) of the Dresden Codex. Perhaps dating to as early as the thirteenth century CE, this folding-screen book written on fig-bark paper includes elements that may have been copied from an older, perhaps ninth- century CE, manuscript. At right the malevolent Venus gods prepare to unleash devastation onto earth.

provenience, new scientific data in Mexico argue for an eleventh-century date, making it the oldest known prehispanic manuscript, bar none.

The Maya under Spanish rule

In the sixteenth century, various highland Guatemala Maya ethnic groups – Kaqchikel, K'iche', Poqomam, and Tz'utujil – warred over territory and, perhaps more importantly, access to resources. Well-built hilltop acropolises provided strongholds during this era, at Iximche, Utatlan, Mixco Viejo, and Cahyup, among other places. Following successes in Central Mexico, victorious Spaniards swept down into Guatemala. From Iximche, the Kaqchikels took the foreigners' side against their old enemies, the K'iche', and the Spanish joined them there, occupying Maya palaces; Bernal Díaz del Castillo once lived at Iximche. By 1527, all highland Maya had been subjugated, and the Spanish were able to establish a new capital at Ciudad Real, the first in a series of modern capitals that would be wracked by severe earthquakes. Iximche, like the other fortified cities, was abandoned. Its plan reveals the nature of political organization there. To accommodate two important Kaqchikel lineages, buildings were largely executed in duplicate: two ballcourts, two palaces, and so forth.

233 Pyramidal platforms, Iximche. Kaqchikel lords reigned from Iximche at the time of Pedro Alvarado's brutal sweep into Guatemala. They helped the Spanish defeat the K'iche' Maya.

234 Page 23 from the book of Chilam Balam of Chumayel. By the time this manuscript was written during the colonial period, the glyphs – here showing the Maya months – were little more than vestigial ornaments. The text is in Maya, written in the Roman alphabet.

Sculptural efforts continued in what is now Guatemala after the Conquest. Cortés left his sick horse with the Itza lords in Tayasal, in the Peten, and after his departure, the horse died. Many years later, when Spaniards passed that way again, they found a stone or wooden image of the horse, enshrined in a temple! Stone cult objects have been made in Guatemala even more recently: on a hill near Chichicastenango, a stone image of Pascual Abaj is still venerated by local K'iche' Maya.

Both in highland Guatemala and in Yucatan, the Maya quickly adopted the Latin alphabet, and various systems of romanization of Maya languages developed. In some cases, ancient books were transcribed. The *Popol Vuh* – the single most important sixteenth-century document in terms of Maya religious narrative – was written down by a noble K'iche'. Other texts, such as the many books of Chilam Balam, emphasizing cyclical historical events and prophecies, were written by noblemen in Yucatan. In the margins of the Chumayel manuscript of Chilam Balam, the eighteenth-century scribe added glyphic cartouches, perhaps from the source he was copying. The glyphs he drew had lost most of their meaning, now instead carried by the alphabetic script. Here we see one step in the end of an ancient tradition and its transformation into the form that would help sustain memory in the modern world. Interestingly enough, in both Guatemala and Yucatan, some young Maya have seized on the opportunity to write in glyphs once again. The ancient writing may yet live on.

234

Chapter 9
The Aztecs:
A new world found

Around 1502 CE, early in the reign of Motecuhzoma Xocoyotzin (Motecuhzoma II), the most elite sculpture workshop in the Aztec capital, Tenochtitlan, perfected a huge basalt carving, the largest solar image that had ever been made in the city. Within what the modern – and ancient – viewer reads as the pointed solar diadem runs a band of day signs, giving this stone its first and most enduring name: the Aztec Calendar Stone. A frontal face stares out from the very center of the stone, and two fire serpents, with flames licking their bodies, ring the stone, their profile heads meeting at the base. Circle within circle within circle, the final band wraps the exterior rim of the stone, edging the solar imagery with symbols of vital stars and collectively describing a cosmogram of solar belief, movement, and the heavens themselves.

Within the round day-sign circle lies the outline of the glyph *Ollin*, the day sign for movement (also the glyph for rubber), studded with four dots as a coefficient. In a format unlike any other reference to the day 4 Ollin, the artists inscribed within the "arms" of the glyph what might read as the images of the four eras previous to the Aztecs, the day names of the cataclysms on which the peoples of Central Mexico believed the world to have come to an end in the past, only to be renewed each time: 4 Water (ending in floods), 4 Wind (ending in windstorms), 4 Rain (ending in a rain of fire – volcanic eruptions), and 4 Jaguar (when jaguars roamed the earth, devouring humans). In short, the great stone encapsulated not only the Suns of the past – usually known as the Legend of the Suns – but also the solar present. No useful calendar for keeping track of daily time, but only of cosmic time, the sculpture has taken other names, but the name Calendar Stone has endured in English, whereas it is known as Piedra del Sol in Spanish.

En route to its designated home within the Aztec ceremonial precinct, something happened to the 24-ton stone, or so a sixteenth-century friar, Diego de Duran, would recount sixty years after the European invasion. A fracture had opened up, making it risky to move the stone further. Was it an omen that the sun no longer approved of the Aztecs, or wished to communicate with them by means of the stone? The stone was thus abandoned within sight of the walled ceremonial precinct; Spanish soldiers found it on the edge of the Zócalo, or main plaza of Mexico City, face down, in 1790. For generations, prehispanic carvings had been destroyed whenever encountered by the Spanish authorities, but this stone survived, perhaps turned face down because of its original flaw, or perhaps because at 11.5 ft (3.5 m) in diameter it made a convenient paving stone, too useful to investigate for what might have been perceived as idolatry. With the revelation of the stone and its carving in 1790 came the first steps toward a renewed interest in the Aztec past.

Almost immediately, authorities installed the stone on the exterior of the city cathedral, much the same way that Romans deployed spolia from their provinces. Lacking legible religious imagery, the great stone was perceived as an appropriate – and

235 The great Calendar Stone features a solar diadem with an earth monster within at its center. Although not a functioning calendar by any means, the twenty day signs appear on the disk.

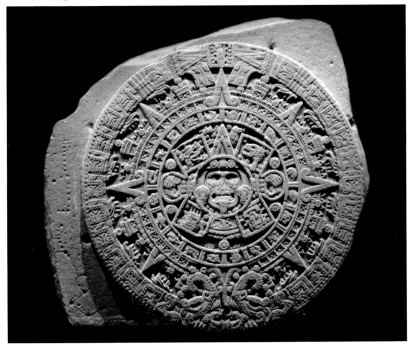

236 Tiffany & Co. produced this solid silver tray replica of the Aztec Calendar Stone for the 1893 World's Columbian Exhibition in Chicago.

236

safe – claim on the past. With the opening of the first national museum of Mexico in 1865, the Calendar Stone found modern shelter. It has been a shorthand of Mexican identity ever since, taking its place on the coins of Mexican currency, on ashtrays and coasters, on advertisements of every kind, and in the low-rider tradition of Mexican-Americans. In its mastery of material, its ideology, and sheer impact of scale, the Calendar Stone is more than an abbreviation for the Aztecs: it encapsulates their belief, the majesty of their cosmology, and their power in a single monument.

Not quite a Rorschach test, the meaning of the Calendar Stone has nevertheless been the subject of repeated and continuing interpretations, particularly of the central face, presumably part of a single anthropomorphic form along with the two clawed hands that hold human hearts. The central deity is often interpreted as the face of the daytime sun, Tonatiuh, proudly displaying a jade-studded diadem, or as that of Xiuhtecuhtli, the god of heat, light, and the day – and the god of the New Fire ceremony, a sacred ritual celebrated every 52 years. Yet the very frontality has prompted scholars to consider that it may belong to an underworld deity – perhaps the nocturnal sun, in a state of death during the night's transit, or perhaps to Tlaltecuhtli, the earth divinity sacrificed to form the heavens and earth at the dawn of creation. What has often been identified as a necklace of uneven beads may instead be the string of blood droplets traditionally depicted at Tlaltecuhtli's neck, the iconography of her decapitation and sacrifice.

If the stone does depict the earth lord, sacrificed and angry, then the full image is that of the sun collapsed on earth, the

fulfillment of 4 Ollin, which was to end in earthquakes. We can well imagine that the face of the earth was placated by human sacrifice to keep the cataclysm at bay. Such a reading makes more sense if we visualize the stone flat on the ground, despite the exhibition today as a wall panel. Wherever replicas of the stone are installed – the American Museum of Natural History in New York City or the cemetery at Forest Lawn in Los Angeles, among others – it is always vertically displayed.

The Calendar Stone was made on a monumental scale to garner the renown it would indeed come to earn – it is perhaps the best known of all Aztec monuments. Like many of the great monuments destined for the ceremonial precinct of Tenochtitlan, it offered both exquisite detail for those able to see the work close up and also a legibility from distance, if only because of its scale. In every respect the monument both encapsulates what is characteristic of Aztec art and provides a good introduction to the power of Aztec sculpture in the present day, in its power to command multiple interpretations, to astound us with its scale, and to inspire our awe at the last of the great Mesoamerican civilizations' achievements.

The Aztec fall was precipitous, brought on by the invasion of both Europeans and their germs, a death and destruction unlike any previously wrought by interregional warfare. But they did have some inklings and portents of change to come. Motecuhzoma II had spies along the Gulf Coast, who reported strange doings in the Caribbean; dangerous omens had alarmed him, starting with a comet in 1509. By 1515, rumors were circulating in the capital of great floating temples and mountains that had been seen in the sea. Was this Fifth Sun, so vividly portrayed on the Calendar Stone, about to come to an end? Would the world collapse in violent cataclysm, as the Calendar Stone predicted? The melancholic poetry of the king of neighboring Texcoco captured the sense of the end of the world:

I, Nezahualcoyotl, ask this:
Is it true one really lives on the earth?
Not forever on earth,
only a little while here
Though it be jade it shatters,
Though it be gold, it is crushed,
though it be quetzal plumage it is torn asunder.
Not forever on earth,
only a little while here.

(Adapted from Léon-Portilla and John Curl, *Aztec Architecture*)

The Mexica, who would become the heart of the Aztec empire, claimed to have journeyed from the north, from the legendary site of Aztlan, and they claimed the authority of fur-and-hide wearing nomads when they described their origins. According to the Codex Boturini, which may have been made in the first years of the colonial period, four lineage heads led their people in a long peregrination, carrying the sacred bundle of the chief god, the new solar warrior deity, Huitzilopochtli, on the back. Huitzilopochtli promised to lead his people to an island in a lake, where an eagle would sit on a cactus eating a snake – in fact the very image of the Mexican flag today. By 1300 CE, the Mexica were vassals to Culhuacan, a city that survives today at the southern extreme of Lake Texcoco. As they gained in number and power, they sought and received a bride from their overlords, but at Huitzilopochtli's direction the Mexica flayed the young woman and a priest donned the skin. In response to this obscenity, the offenders were driven into Lake Texcoco and took refuge on the island of Tenochtitlan, now Mexico City. The Aztec world would take shape from this sacred spot, born of violence, navel to the world of Mesoamerica.

During the fourteenth century CE, the Aztecs established some of the principles of their capital city, and from the beginning, the earliest temple shrine – although now difficult to explore because of rising water levels – honored both Huitzilopochtli, the new chief deity associated with warfare and the sun, and Tlaloc, probably the oldest god of the Valley of Mexico, dedicated to rain, water, and earth. The union with Tlaloc, the old established deity of the Toltecs and perhaps Teotihuacan, gave legitimacy to the new cult of the Aztecs. The two seasons of the tropical world, wet and dry, were also thus united. The theatrical union atop the twinned temples suggests, too, the expression *atltlachinolli*, literally "water-fire," used by the Aztecs to mean warfare, especially sacred war, an ancient juxtaposition known at Teotihuacan and perhaps from the beginning of Mesoamerican high culture. In the very pairing of Tlaloc and Huitzilopochtli, the Mexica made this metaphor the center of Aztec religion, at the heart of the known world of Mesoamerica, old and new, fire and water, harvest and planting.

The Spanish invaders would level Tenochtitlan, but a chance discovery by electrical workers at what was thought to be near, rather than atop – as it turned out – the sacred precinct in 1978, led to excavations that have yielded one discovery after another of the power, invention, and majesty of the ancient center of its universe, along with horror at the sacrifice and death embedded in it. The manuscripts and documents of the sixteenth century, many made by indigenous elites, along with

Spanish eye-witness accounts, have given up further secrets as well, making it possible in the twenty-first century to know more of this city than could be told in 1600. And the story continues to unfold.

Hernando Cortés, who led the land invasion of Mexico, wrote a series of letters to King Charles V, recounting his actions while attempting to justify the most egregious, including the death of a pagan king under his purported supervision, anathema to the Spanish ruler. The 1524 publication of the Second Letter in Latin was accompanied by a detailed woodcut map; it provides insights and information about the indigenous city that exceed what Cortés wrote in the letter itself and serves as an important source today regarding Aztec architecture. One of the soldiers of the mission – a man not considered worthy of mention by name in the Cortés letters, but today known to be Bernal Díaz del Castillo – wrote a better-known chronicle of the city in five volumes (usually read in a standard abridgment in English), all recounted late in his life, when he lived in Guatemala. For him, and for other soldiers of the invading party, Tenochtitlan was the fulfillment of a fantasy, the sort of place they had heard of in the late medieval romances of Amadís de Gaula. Díaz wrote:

When we saw so many cities and villages built both on the water and on dry land, and this straight, level causeway, we couldn't resist our admiration. It was like the enchantments in the book of Amadís, because of the high towers, cues [pyramids] and other buildings, all of masonry, which rose from the water. Some of our soldiers asked if what we saw was not a dream.

(*The Discovery and Conquest of Mexico,* trans. A. P. Maudslay, New York, 1906)

That Díaz emphasized the way that buildings rose up from the water underscores for the observer today that Tenochtitlan was the ultimate *altepetl,* or "Water Mountain." He also compared the general plan to Venice, a place where some of his comrades had served as soldiers, recognizing that one of the great European cities of their memory had also been crisscrossed by a web of intersecting canals, laid out on a grid.

Four main residential quadrants radiated from the walled ceremonial precinct. Just outside the walls stood the royal palaces. The frontispiece of the mid-sixteenth-century manuscript, the Codex Mendoza, can be read in many ways, but one is as a map of Tenochtitlan. At the center is the eagle in a cactus, the place name for Tenochtitlan and a symbol still

237

used on the Mexican flag today. As the frontispiece shows, the city was divided by water into four sections. The page can also be read as a plan of the walled ceremonial precinct. Like Mesoamerican maps (and on some European maps as well, including the Cortés map), east was at the top of the plan. Here we find a house, probably a reference to the great twinned pyramid of Huitzilopochtli and Tlaloc. It is set in opposition to the *tzompantli*, or skull rack, which was also a prominent feature of the ritual precinct. Fifty-one year names run as a border round the page (1 Reed is marked as the year of the invasion), placing the scene within the cyclical calendar. In the lower margin are two principal conquests of the Aztecs and, as typical of Maya stelae, captives, the symbols of dominion, lie beneath the heads of state, who are also represented above. For Tenochtitlan, the definition of the city was bound to its position in both space and time. Another sixteenth-century manuscript, the Primeros Memoriales, also shows the plan of the ceremonial precinct, known as the Templo Mayor, which also specifically refers to the twinned "great temple" itself. In this illustration the twinned pyramid lies at the top or east; a penitent in white

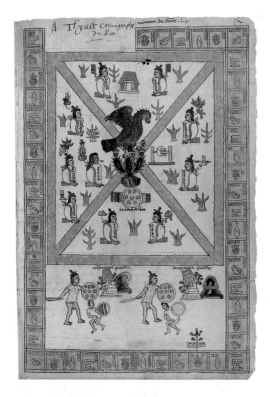

237 Folio 2, Codex Mendoza. Made in the mid-sixteenth century for the viceroy of New Spain, the Codex Mendoza is a record of history, tribute, and customs of the Aztecs. The "cosmographer" of French king Francis I signed his name at top. The central motif of the frontispiece shown here appears on the Mexican flag today.

238 TOP Known as the Nuremberg Map due to its publication by Cortés in that city in 1524, the map was the first to document the Aztec capital city. Made as a European woodcut, the map was nevertheless based on indigenous models. **239** BOTTOM Archaeologists recently uncovered a "tower" comprised of over 650 skulls in the Aztec sacred precinct, many pierced for display; ill. 238 shows this feature below the pyramids.

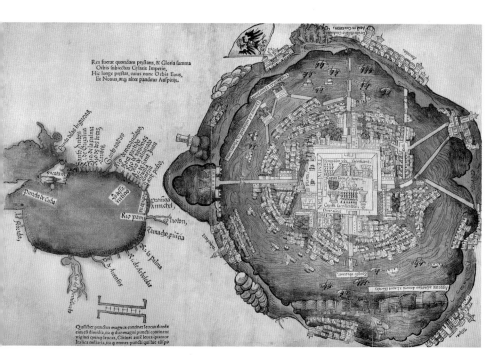

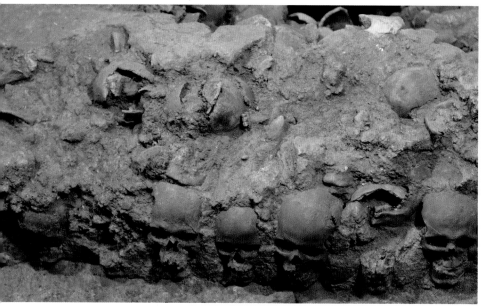

garb stands in front. This is the benevolent – one might say whitewashed – figure of Quetzalcoatl that developed in the later sixteenth century. Beneath Quetzalcoatl lie the *tzompantli* and an I-shaped ballcourt. The Cortés map makes it clear that the twinned pyramids, like the Pyramids of the Sun and Moon at Teotihuacan, captured the power of heavens: the small sun that peers between the two buildings reveals the equinoctial event in which the sun would rise between the soaring towers of the structures.

Despite the challenge of excavating in, under, and around the Templo Mayor, which has necessitated the demolition of some colonial buildings, the exploration of the foundations of the Cathedral, the disruption of traffic patterns, and the accommodation of increasing numbers of visitors to the site and the capacious museum that opened in 1987, the excavations continue apace. New discoveries that amplify the picture of the prehispanic past are made every year. The first campaigns explored the twinned pyramids of Tlaloc and Huitzilopochtli, which had been systematically rebuilt, ruler by ruler, over the course of the 200 years of Aztec domination. The excavations have also shown that some sort of ceremonial architecture preceded Aztec construction in the ceremonial precinct.

In 1487 CE, the final major building program was completed, and it was this version of the precinct that Cortés and his soldiers saw. Father Durán's history of the Aztecs describes the rededication ceremony of 1487. Sacrificial victims for the

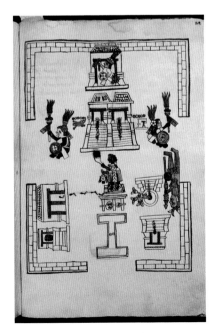

240 In the mid-sixteenth century, this plan of the center of the ancient Aztec capital was drawn up for Father Sahagún in a manuscript known today as the Primeros Memoriales. The twin pyramid of Huitzilopochtli and Tlaloc is at the center of the drawing. Beneath Quetzalcoatl, in white, are the skull rack and ballcourt. Only three doorways granted access to the precinct.

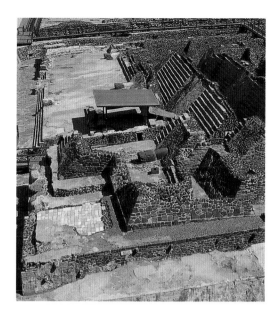

241 Seen from above, the Templo Mayor reveals its layered setbacks, all of which lie within the final version of the temple destroyed by the Spanish in the invasion of Mexico. Divided in two, the temple's Huitzilopochtli side is closer to the viewer here, with the Coyolxauhqui stone under the awning at center.

dedication were led in long processions from the Huastec region, some individuals tied together with ropes through their pierced noses. Thousands of sacrifices were offered, and blood ran in the streets and canals.

This city and temple plan, as might be expected, drew on precedents in the Valley of Mexico, from Tula and Teotihuacan to small cities along the lake. The canals laid out along a grid at Tenochtitlan were probably modeled on the rigid grid at Teotihuacan. The twinned pyramid appears to have been a Late Postclassic invention, known at Tenayuca, north of Tenochtitlan and on a spur of Lake Texcoco, among other places. The concept offered a parity between the two deities venerated in the shrines at the summit. It also provided the means for retaining a local deity while introducing a new one in conquered territories. For the Aztecs, such a structure facilitated the ready introduction of Huitzilopochtli wherever they made their impact felt.

Like that of Teotihuacan, the overall plan of Tenochtitlan took advantage of the natural topography of the Valley of Mexico. The twin pyramid was framed by the volcanoes Ixtaccihuatl and Popocatepetl to the east, recalling the positioning of the Pyramid of the Moon in relation to Cerro Gordo at Teotihuacan. The ceremonial precinct was also laid out to acknowledge the movement of heavenly bodies. During the wetter season, appropriate for agriculture, the sun rose every day behind the blue shrine of Tlaloc, the ancient rain and earth god; in

73

75

The Aztecs

the drier months, the sun emerged from the red shrine of
Huitzilopochtli, whose associations with warfare, hunting,
and fire were appropriate for this season. On the mornings
of the two annual equinoxes, however, the sun rose between
these two temples and reputedly faced the round Temple of
Quetzalcoatl/Ehecatl, although archaeology has yet to find
such a structure. In this way, Quetzalcoatl embodied the
wind, prevailing from the west.

242, 243
244

Each successive phase of construction was marked by caches
and deposits before the new structures of stone, stucco, and
paint completely encased their predecessors, rising higher
and higher. The final version may have reached 197 ft (60 m)
in height, just a bit shorter than the Temple of the Sun at
Teotihuacan or Temple IV at Tikal – and so among the very
tallest buildings ever constructed in Mesoamerica, each one
a pinnacle of achievement. The caches – some filling what had
been rooms of the temple, and so known as chambers – became
hidden architecture, perhaps more potent once hidden than
when visible, exuding the power of memory to amplify belief
in what cannot be seen. In this they recall the performative
offerings of Mesoamerica first documented among the
Olmec, with Offering 4 at La Venta (see pp. 40–42). Filled
with exotic and local materials, the offerings may be the only
physical traces of the vast quantities of tribute commanded
by Tenochtitlan, along with the nearly constant sequence of
festivals that required offerings and sacrifice. Some offerings
may reveal other meanings of the twinned temple itself: near
the join of the two temples, the complete skeletons of two
powerful felines, one a jaguar and one a puma, were found,
each with a ball of jade the size of a baseball in the mouth:
these offerings probably embody the jaguar deity known as
Tepeyollotl, "heart of the mountain," who held the power of
earthquakes. The interment of these skeletons may have been
to forestall the end of the Aztec world as called for on 4 Ollin,
spelled out on the Calendar Stone: the ideology so concisely
deployed there permeated the sacred center.

That the twinned pyramids each created a sacred mountain
can also be seen from the objects buried within and alongside

242 OPPOSITE TOP LEFT Archaeologists found several handsome carved urns on the
Huitzilopochtli side of the temple; they may have held funerary ashes.
243 OPPOSITE TOP RIGHT Aztec caches incorporated exotic materials. In this example,
three ceramic drums are visible at front, and the rattle staff held by many female
maize deities sits atop flint blades at left. Conchs and corals are among the other
offerings.
244 OPPOSITE BOTTOM Almost constantly in a state of renovation and expansion, the
Templo Mayor was rebuilt time and again, hiding within it chambers and caches of
offerings, buried sculptures and funerary ashes, and making of it a sacred mountain.

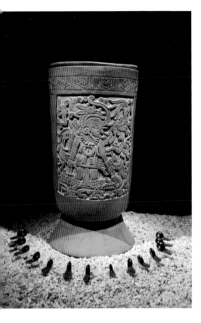

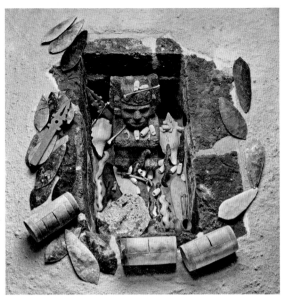

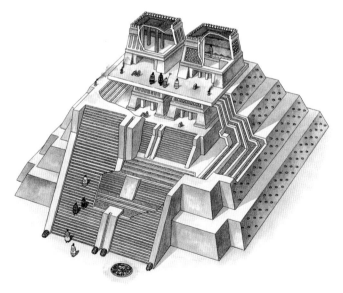

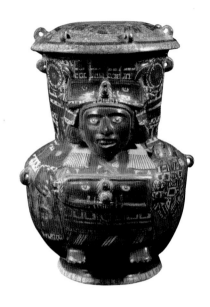

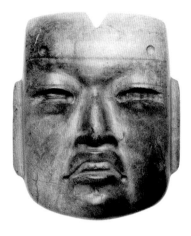

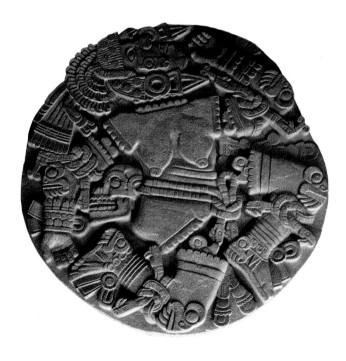

the structures. According to Aztec religious narrative, Quetzalcoatl turned himself into an ant in order to enter Tonacatepetl, the mythical Mountain of Sustenance, and to retrieve maize kernels and other valuable food seeds for humanity. Chamber 3 of the Tlaloc shrine held a pair of large ceramic vessels depicting Chicomecoatl, the Maize Goddess, with cobs in hand; each vessel held thousands of jade beads, symbolic seed corn, with ceramic lids of Tlaloc designed to be tied to the vessel, a perpetual source of water for the maize, and an appropriate offering within the mountain. Nearby, an offering included an Olmec mask, underscoring the associations of Tlaloc with the past.

The snake-lined Huitzilopochtli side of the twinned pyramid permanently commemorated Coatepec, the sacred snake-mountain of his rebirth. Within the Huitzilopochtli shrine was a sculpture of that deity, probably made of wood and now lost, like the rest of his images; the deity's representation survives only in manuscripts. At this snake-mountain, Coyolxauhqui decapitated her mother, Coatlicue, but a fully grown and armed Huitzilopochtli leapt from her severed trunk, mutilating and humiliating his sister. Excavations in the Templo Mayor revealed a great round stone of Coyolxauhqui at the foot of the Huitzilopochtli side of the pyramid, a permanent record of conquest and probably the place of much subsequent sacrifice. Coyolxauhqui was also understood to be the moon and Huitzilopochtli the sun, so the myth repeats the dominance of the greater heavenly body over the lesser, even the three-dimensional over the two-dimensional. Their positioning recalls the Codex Mendoza frontispiece, with defeated figures at the bottom of the page. In all this, the two temples formed symbolic mountains and paired sustenance, one through agriculture, and the other through warfare and sacrifice.

The grisly price of life in the Aztec capital came to light in 2015, when archaeologists began excavating the *tzompantli*, or skull rack, adjacent to the Huitzilopochtli shrine. Spanish

245 OPPOSITE TOP LEFT Found in Chamber 3 on the Tlaloc side of the Templo Mayor, a room jammed with offerings, this beautiful large vessel in the form of a female maize god held thousands of small jade beads to symbolize maize kernels. Not clearly visible in this view is the lid depicting Tlaloc, whose beneficial rain is necessary for the maize to grow.

246 OPPOSITE TOP RIGHT Buried on the Tlaloc side of the temple, this Olmec mask confirms the Aztecs' search for a usable past, and the beautiful jade materiality underscores shared appreciation for over 2,000 years.

247 OPPOSITE BOTTOM Dismembered limbs fly from the body of the goddess Coyolxauhqui on this massive stone that lay at the base of Huitzilopochtli's temple. Discovered by workmen excavating the cellar of a bookstore in 1978, this sculpture sparked renewed interest in the remains of the Aztec sacred center, subsequently the focus of extensive excavation.

chroniclers had speculated that more than 100,000 human skulls might have formed the tower of human bones they spotted; archaeologists have recovered fewer than 1,000 as of this writing, but there is no doubt that, punctured laterally to be put on horizontal posts, these skulls created an architectural form that resonated with Aztec friends and enemies. On the Cortés map, the feature is represented by what might be mistakenly read for grillwork; but this is, instead, shorthand for the *tzompantli*, a public monument incorporated into almost every Early Colonial depiction of the religious precinct. Archaeologists have identified a mixture of men, women, and children among the bone assemblage, testimony that the sacrificial practices and rituals required a diversity of victims. The adjacent stone of Coyolxauhqui, with her visible decapitation and dismemberment, may have offered a divine model for human practice.

Within the sacred precinct, archaeologists have now also found the ballcourt that chroniclers depicted, as the sketches of the past continue to come to life. Just outside the walls, Aztec rulers built their palaces. Spanish invaders were housed to the west, in the "old palaces" of Axayacatl, where they found a vast horde of precious materials behind a recently plastered wall, which they proceeded to melt down in preparation for shipment to Spain, and which they were forced to abandon when the Aztecs drove the invaders out, in what is usually called the "Noche Triste," June 30, 1520. Motecuhzoma II built what have generally been known as the "new palaces," southeast of the precinct, comprising five interrelated buildings, with large reception spaces and generous accommodations. In 2009, excavations by Elsa Hernández Pons under what had become the first Mint of the Americas (opened in 1536) revealed what archaeologists believe to have been Motecuhzoma II's special meditation room, a windowless space with floors and walls of dark basalt and painted black, adjacent to a garden of fragrant plants and still pools of water.

Motecuhzoma's throne chamber is known through the Codex Mendoza, where the brilliant turquoise of his robe is matched by that of his diadem, indicating his status. He held forth from the *icpalli*, or woven mat, a widespread symbol of rulership, with his two advisory councils in handsome chambers to either side below him. But strikingly, as Jorge Gómez Tejada has noted, the depiction emphasizes that his war council is no longer attended and is shown simply as an empty room, in distinction to the chamber for his wise advisers. In this representation, the Aztec world is at peace with its colonial government.

Among the wonders of the city that the Spanish observed was what they described as a zoo, depicted largely as an aviary on the Cortés map, and of great interest to Bernal Díaz, who was astounded by the predators – "a kind of wolf," he noted, along with "tigers" and two kinds of lions. From the excavations within the Pyramid of the Moon at Teotihuacan, where cages in burial chambers held eagles, larges felines, wolves, and other predators, one might also suspect that animals for such elite offerings would have come from these elite holding chambers, perhaps more like a Roman gladiatorial pen than a modern-day zoo. Yet like the aquatic offerings within the Templo Mayor, they also demonstrate dominion over the entire known world.

At this most systematically destroyed of all Mesoamerican cities, we can nevertheless see the execution of belief through architectural practice. In the twinned pyramids, the Aztecs brought the sun to earth, where he reigned as Huitzilopochtli. They invoked the water from the ground, to rule as Tlaloc. And on earth, all the creatures and all the stones and all the plumage came together in a single setting, the greatest *altepetl* ever built.

At other sites around the Valley of Mexico, the Aztecs carved the mountains themselves, transforming natural forms into manmade ones. At Texcotzingo, a hill east of Lake Texcoco, baths and shrines were worked directly into the cliffside, making of it a pleasure garden. Shrines were constructed at the summits of many other mountains in the Valley of Mexico too. At Tepeyacac, Tonantzin, an earth and mother goddess, received offerings at what would become the site of the Virgin of Guadalupe, Mexico's patron saint. To the east, the Tlaloque, or rain gods, dwelt atop Mount Tlaloc: to the Aztecs, it was the gods' raucous parties and the hurling of pots of water that led to thunderous rainstorms. At Malinalco, a ceremonial precinct was built into a mountainside. The most important building at Malinalco is a round structure carved out of the living rock. To enter the inner chamber, one steps through an open pair of monster jaws and onto a giant tongue. A circular bench with jaguars and eagles carved as seats curves round the interior, and a deep hole of narrow diameter at the center of the floor enters the heart of the mountain. The jaguar and eagle pelts carved into the benches suggest that this was a chamber for the military orders of Jaguar and Eagle Knights, who may have conducted penitential rites here, perhaps offering their own blood directly into the earth.

Sculpture

We have already taken a close look at the Calendar Stone, the best known of Aztec sculptures. But Aztec sculpture was

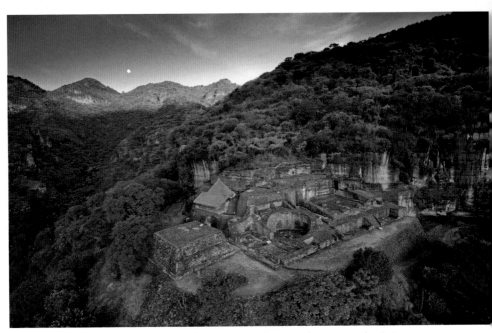

248 Conquered by the Aztecs in the 1470s, Malinalco served as a retreat for their military orders. The Aztecs demonstrated their power by forcing local workers to carve out live rock shrines.

exceptionally varied, ranging from the giant cosmograms to deceptively lifelike flora and fauna of the natural world to human figural representations that served as the chassis for the representation of deities. The Aztec word that comes closest to the European concept of a god is *teotl*, which even sounded to Spanish ears like a corruption of *dios*. But the Aztec concept of *teotl* is different from the European concept of god, and although Huitzilopochtli may have been a solar deity, he was not Apollo. Rather, *teotl* called up a series of natural forces, like the Polynesian *mana*. The Aztecs captured the representation of gods in stone and wooden images, but the true sacred force dwelled in sacred bundles kept separately inside shrines and temples. Huitzilopochtli's power lived in the bundle carried by the Aztecs on their long migration and then kept at the Templo Mayor, although the Spanish saw the sculptural representation as the focus of idolatry.

The ability of human blood to sustain ancestors and to nourish gods is embedded in many Aztec works of art. These references are not metaphorical: one Spanish soldier, Andrés de Tapia, described the experience of seeing a large and terrifying sculpture encrusted with jewels, gold, and human blood.

It carried the power not only of its visual impact but also of the stench that it emanated: smell was a way that power was conveyed. The sculpture that de Tapia described may have been similar to the great image of Coatlicue, or "serpent is her skirt," at Tenochtitlan, a depiction so fearsome that it was systematically re-interred – unlike the Calendar Stone, which would be attached to the Cathedral itself – at various times after its accidental discovery in 1790 in excavations near the Cathedral, within the old ceremonial precinct.

249

The Coatlicue is both a two-dimensional work, intricately patterned, and a great three-dimensional form. Interestingly, it was once part of a series, one of what may have been a set of four, as Elizabeth Boone has argued, and may have been visible at the Templo Mayor at the time of the Spanish invasion. As a multiple, its power would have been even greater, the full force of female terror unleashed. Like many Aztec sculptures, it is also carved on its underside with an earth monster – indeed some early observers therefore erroneously imagined that it was meant to be suspended in the air. The bulky figure leans forward, pressing upon viewers and enveloping them in shadow. Particularly in profile, she also resembles the great twin pyramid. The head is severed and replaced by two snakes, symbolic of flowing blood. Another snake descends from her groin, suggesting both menses and penis. Her hands and feet have been transformed into claws, and she wears a necklace of severed hands and extruded hearts. It is a nightmare cast within female form, a tour de force of misogyny. A dramatic three-dimensional fist protrudes near the base at the back, almost as if to pull the viewer into the body of the goddess, a startling effect. This carved stone is a powerful, imaginative sculpture, representative of the superb work created in Tenochtitlan.

247

So, too, is the Coyolxauhqui stone, 10.5 ft (3.4 m) in diameter, probably installed in 1469 CE when the ruler Axayacatl came to power. The stylized body of the fallen goddess features sagging breasts and rolls of stretchmarks; knobby bones peek out of severed limbs. Like the necklace of the later Coatlicue, puffy and slightly oversized hands seem more alive than the goddess herself, as if gently inflated. To make such a work, Aztec sculptors probably worked in teams, as we learn from an image in the manuscript of the sixteenth-century Dominican friar Diego Durán.

Such extraordinary Aztec sculptures reveal the energy given over to an imperial style. As new arrivals in Mesoamerica, the Aztecs had many established sources upon which to draw. Enclaves of foreign artists, particularly from Oaxaca, lived in Tenochtitlan, bringing their own styles and techniques to the

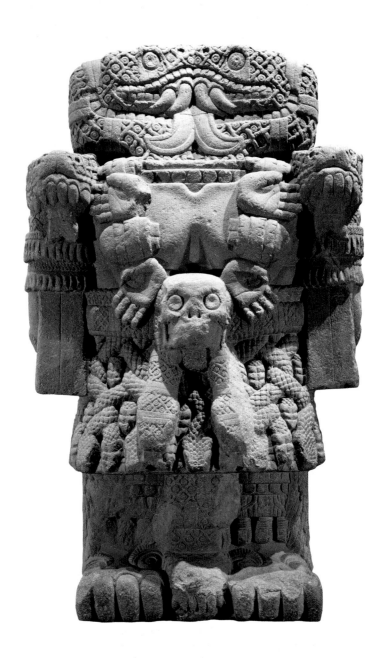

249 Rediscovered in the late eighteenth century, this sculpture of the goddess Coatlicue was so fearsome that it was reburied for some years. Two serpents form her head, and she wears a necklace of hands and hearts.

metropolis. The Aztecs returned to Tula, Hidalgo, to sack the site, and brought back Toltec sculptures – perhaps including *chacmools* and warrior figures – to their own capital. They also derived inspiration from the rich three-dimensional tradition of the Huastec region of the Gulf Coast, particularly after conquering much of the area in the mid-fifteenth century CE. The conquest of the Tehuacan Valley may have yielded a particularly skilled set of sculptors for Tenochtitlan's imperial program and opened up new valuable materials to be secured through tax and tribute. Stunning discoveries made only in 2014 had been systematically hidden ahead 250, 251 of the Aztec invasion in 1467. And, almost like archaeologists, the Aztecs were continually uncovering elements of the past. Excavations in the Templo Mayor precinct have revealed Olmec, Teotihuacan, and West Mexican stone pieces interred as offerings. Whether through tribute, looting, or the collection of heirlooms, the Aztecs were the recipients of many works of art that they studied, cherished, buried again, or incorporated into their own visual imagery.

252 The Stone of Tizoc is essentially a historical monument, worked in the conventionalized, stiff-figured manner characteristic of manuscript painting, particularly in Oaxaca, where historical screenfold writings had long been made. Like a Roman emperor depicted as Hercules, the minor Aztec ruler Tizoc (ruled 1481–86 CE, generally considered a failed military strategist) is shown to be a deity, with the smoking mirror and serpent foot of Tezcatlipoca (like K'awiil of the Maya) and the great headdress of Huitzilopochtli: in this role he takes a captive. A simplified victor appears fourteen more times on the Stone, all set within a cosmic scheme: a solar disk defines the upper surface of the stone; gnawing schematized earth monsters with reptilian skin lie under the protagonist's feet. From such a depiction, we can probably assume that the *tlatoani* – literally "great speaker" – was perceived to be the divine perpetuator of the sun by this time. Motecuhzoma II, we know, was thought of as a god during his lifetime.

At the Templo Mayor, further understanding of the threatening earth deity came when Leonardo Lopez Luján and his team discovered a thirteen-ton monolith of pink andesite under the remnants of a buried Early Colonial house and its gracious European columns in October 2006. The vast but simple representation was designed to be seen from the top of the completed temple, making it possible to perceive the scale of the pyramid. Skeletal, like the central face of the Calendar Stone, this massive Tlaltecuhtli is in the posture of giving birth, while a stream of blood flows upward to her mouth. The work's

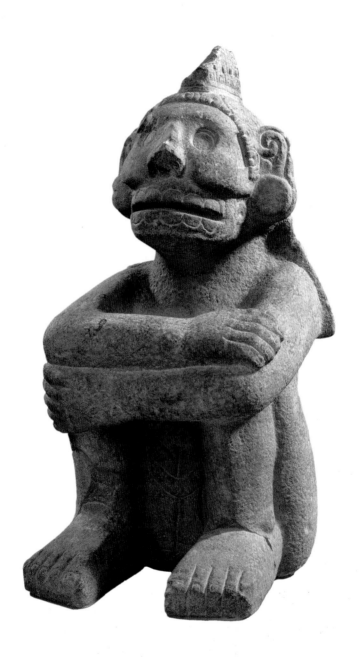

250 OPPOSITE Recent excavations at Tehuacan, Puebla, of sandstone sculptures buried when the Aztec invaded their city in the fifteenth century, provide rationale for attributing this British Museum example, known since 1849, to the region. The sculpture embodies several Aztec deities, including Mictlantecuhtli and Xochipilli. Three calendar glyphs run down the spine.

251 TOP These paired figures come from Coxcatlan in Puebla. The skeletal female figure in snake skirt is Coatlicue, the mother of Huitzilopochtli; the more enigmatic male figure may be that deity himself. Date glyphs on the backs of their heads, 8 Grass and 4 Crocodile, respectively, may have had local significance.

252 BOTTOM The Stone of Tizoc commemorates the brief reign of this minor fifteenth-century ruler. Victorious warriors hold captives by the hair, as do the victors in ill. 67. A solar disk is carved on the upper surface, and Tizoc himself appears in the large headdress at the center of this image.

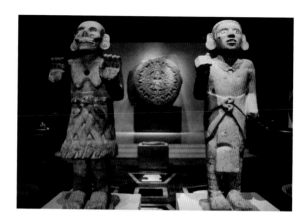

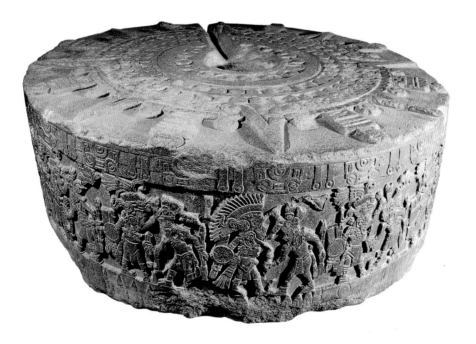

distinctive yellow body paint emphasizes the disturbing imagery, with details added in shades or red, brown, white, and black. According to Aztec belief, Tlaltecuhtli consumed the sun every day at dusk, giving birth to it at dawn; her destroyed navel may have been the setting for grand rituals, even funereal ones: grasped in the claws of her right foot is the date 10 Rabbit, a reference to the year 1502, when Motecuhzoma's predecessor, Ahuitzotl, had died. Chambers and caches underneath and adjacent to the sculpture have yielded treasures from the known Aztec world, including exotic birds, turquoise, and a canine wearing gold anklets. In 2017, a large stone box came to light behind the Cathedral: also from the reign of Ahuitzotl, it held a young wolf, seemingly with its heart removed, and adorned with twenty-two pieces of remarkable goldwork. The discoveries continue to astound.

Beyond the political and religious authority of Tenochtitlan, many small cult images were both made in the past and survived into the present. Most common among these are female maize deities, generally standing figures with headdresses like temple roofcombs. Provincial figures are flat and blocky, without the skilled execution of imperial works but also lacking the more horrifying Aztec imagery; the bodies of these female images usually conform to blocky stone. The potters of the period also produced a great many deity figures, some braziers designed to be carried like modern-day saints. In provincial works, emphasis thus fell on more beneficent images of fertility.

Another common fertility figure, this time male, was Xipe Totec, "our lord the flayed one." Xipe Totec was a god of planting, and his ritual imitated the observed natural life of the maize kernel. A human skin was flayed, and a young man wore it until it rotted off (one dreads to think of the stench, but this, too, conveyed the presence of the deity beyond the limitations of sight), allowing the new, clean youth to emerge, like a sprout from the husk of the old seed. Xipe's cult was at first celebrated along the Gulf Coast, especially among the Huastecs, but with Aztec domination, the cult spread in Central Mexico. Many ceramic and stone images of Xipe are known, and the flayed skin is often rendered with almost loving detail. Unlike the female maize deities, the Xipe figures were also executed in rich three-dimensional forms. Three-dimensional sculpture had a sustained life along the Gulf Coast, from Olmec times to the Spanish Conquest, and the sensual, rounded shapes of Xipe sculptures probably derive from this tradition.

The Gulf Coast also gave rise to a tradition of large, hollow ceramic sculptures. Excavations in the ceremonial precinct have produced two sets of extraordinary specimens. Fired in

254

253

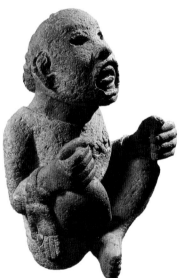

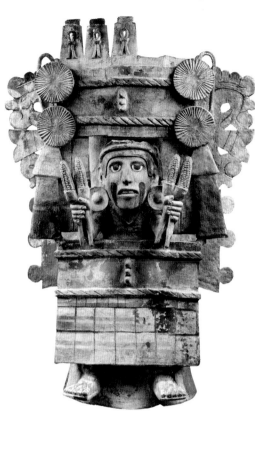

253 ABOVE LEFT The impersonator of Xipe Totec, "our lord the flayed one," wears the skin of a flayed human. By the end of a twenty-day ritual, the skin would have rotted away, like the husk of a seed. Note the extra set of hands that dangle limply from the wrist. An imitation of a plant life cycle, Xipe Totec was a god of springtime.

254 ABOVE RIGHT Discovered in hundreds of pieces in 1996, this large ceramic devotional image (3 ft 6 in. [106 cm] in height) represents Chicomecoatl, Goddess of Maize, who holds the ripe ears of grain. Part of a matching set, she was found with three other fertility deities, all made in the same workshop.

The Aztecs

four separate pieces and then assembled, the life-sized eagle
warriors are poised as if to take flight, inviting human warriors to action. Bits of stucco retain the prints of feathers. Another pair depicts death deities, also made in four parts, but if the Eagle Knight embodied youthful beauty, the hunched death deities reveal only decay, from the perforated skull, designed for strands of hair from sacrificial victims, to the skeletal body with lifelike three-dimensional lungs hanging down. In these two sets, perhaps from the very same workshop, we see a pluralism of aesthetic ideals rarely matched in history, and perhaps best compared with our own era. In some cases such disparate works may have been produced in a single workshop: a pair of death gods was produced using similar technique, to be adorned with human hair. Naturalism was enshrined at the same time as abstraction; beauty and terror both inspired awe. We know relatively little from the Aztecs of the conceptual ideals of their sculpture, but we do have a description of what a beautiful young male sacrificial victim should be:

[He was] like something smoothed, like a tomato, or like a pebble, as if hewn of wood.[He did] not [have] curly hair, [but] straight, long hair; [he had] no scabs, pustules, or boils...not with a gross face, nor a downcast one; not flat-nosed nor with wide nostrils, nor with an arched...nose nor a bulbous nose, nor bent nor twisted nor crooked – but his nose should be well-placed, straight...[he should be] not emaciated, nor fat, nor big-bellied, nor of prominent, hatchet-shaped navel, nor of wrinkled stomach...nor of flabby buttocks or thighs...

(Florentine Codex, Book 4, Sixth Chapter, trans. Dibble and Anderson)

In the face of the Eagle Knight, we see that perfection, but with death looming just beyond. Naturalism also inspired Aztec artists to make precious works of small scale, including
squashes, cacti, and shells. A grasshopper of red carnelian refers to Chapultepec, the "hill of the grasshopper," where Aztec rulers also had their portraits carved, as can be seen in an early colonial watercolor.

Other Aztec sculptures also served as temple or palace furnishings. *Chacmools* had probably long been used as receptacles for human hearts, and a number of Aztec examples have been found. The earliest known Aztec *chacmool* was discovered in situ on the Tlaloc side of the twin pyramid, from the mid-fifteenth century. It may even have been brought from Tula, with other looted treasures. It is the only *chacmool* to

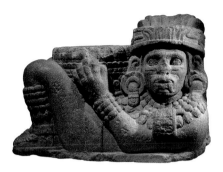

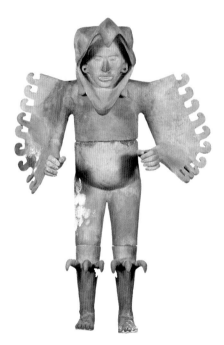

255 TOP LEFT The recumbent figure of this Rain God *chacmool* wears a Tlaloc mask and a pendant with an archaistic motif, as if to refer to antiquity in general. The underside of the monument is worked with aquatic motifs.

256 TOP RIGHT The Temple Stone. Also known as the "Monument of Sacred War," this miniature temple was probably a throne in Motecuhzoma II's palace. When the lord was seated, he would appear to carry the sun on his back.

257 BOTTOM LEFT Life-sized, this idealized young eagle warrior is poised as if to take flight. Gulf Coast sculptors, skilled in firing such large terracotta works, came to Tenochtitlan as the empire grew.

258 BOTTOM RIGHT This large red carnelite grasshopper, or *chapulin* in Nahuatl, probably refers to Chapultepec, "hill of the grasshopper," just west of Tenochtitlan and the source of the capital's fresh water. It is 1 ft 6 in. (45 cm) in length.

survive with bright polychrome, but most Aztec sculptures were probably painted in color schemes that the twenty-first century might read as garish. A very sensuously carved, three-dimensional *chacmool* excavated in 1943 outside the ceremonial precinct could have been moved away from the temple compound at the time of the Spanish invasion for preservation. The recumbent figure wears a Tlaloc mask and bears a *cuauhxicalli*, a vessel for sacrificed human hearts, on his chest. Tlaloc insignia are inscribed on the vessel's upper surface. The underside of the whole sculpture is worked with Tlaloc, among other aquatic, motifs, as if the monument were floating in a liminal state. This *chacmool* wears a jade plaque that appears to be either a Zapotec or Maya work, as if to associate the antique form of the sculpture with an antique culture. The *chacmool* seems very likely, therefore, to have come from the Tlaloc side of the twinned pyramid.

The Temple Stone was found near the palace of Motecuhzoma II in 1831, and probably functioned as his throne, although it has been called the "Monument of Sacred War". It records the date in 1507 CE of the last New Fire ceremony, normally celebrated at the completion of a 52-year cycle. On the sides, seated deities draw blood from their loins, and this blood drawn in penance supports the legitimate ruler. These seated deities all carry the symbol for stone, or *tetl*, on their backs, making the gods themselves the founders of the temple. Above, Motecuhzoma II would be seated on an earth monster, with the solar disk at his back. In this way, he bore the sun; he also prevented it from collapsing onto the earth. The *tlatoani* was thus the conduit of order, the figure whose very essence keeps the upperworld and underworld in place.

Small-scale arts

Many musical instruments were worked with designs that indicate their importance in Aztec ritual life, where they were central to performances at the sacred precinct. A number of *teponaztlis*, the higher-toned, longitudinal drums, and *huehuetls*, the deeper, upright drums, have survived from prehispanic times, their religious importance key to the survival of these wooden objects when almost all others were destroyed. A fine *huehuetl*, reputedly from Malinalco, may have been associated with the orders of Jaguar and Eagle Knights there and might even have been used to accompany rites in the Malinalco chambers. Jaguars and eagles dance ecstatically around the glyph 4 Ollin, the date of both the appearance and the destruction of the Fifth Sun – which is

also the central image of the Calendar Stone and the ideology that unified Tenochtitlan. They all emit speech scrolls of the twined *atltlachinolli,* "water-fire," or warfare symbols, and carry banners to indicate that they are sacrificial victims, as if to express their willingness to sustain the Fifth Sun at a ritual when this drum would have been played.

Other fine Aztec works were made of feathers or covered with feather mosaic, turquoise mosaic, and gold. The Spanish invaders sent objects of all these precious materials quickly to Europe, where crowds swarmed to see them. Albrecht Dürer visited Brussels at the arrival of the first shipment sent by Cortés. Many curiosities were on view: perhaps the Dresden Codex and the marvelous costume elements delivered to Cortés by Motecuhzoma's emissaries were among them. Dürer, the son of a fine goldsmith, was particularly impressed by the metalwork:

Also I saw the things which were brought to the King from the New Golden Land: a sun entirely of gold, a whole fathom broad; likewise, a moon, entirely of silver, just as big; likewise, sundry curiosities from their weapons, armor, and missiles; very odd clothing, bedding, and all sorts of strange articles for human use, all of which is fairer to see than marvels. These things were all so

259 Brittle turquoise, found in shallow deposits and only rarely in the sorts of mines that are still productive today in the American Southwest, easily sheers and fractures into thin tesserae. Mixtec craftsmen, renowned for their skill at the time of the Spanish invasion, may have made this double-headed serpent for the Aztec court.

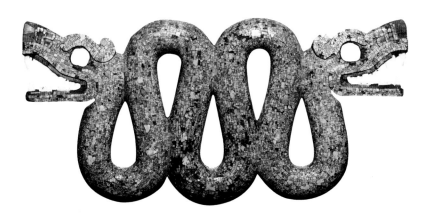

precious that they were valued at a hundred thousand guilders. But I have never seen in all my days that which so rejoiced my heart, as these things. For I saw among them amazing artistic objects, and I marveled over the subtle ingenuity of the men in these distant lands. Indeed I cannot say enough about the things which were there before me.

(*Albrecht Dürer: Diary of His Journey to the Netherlands, 1520–1521*, intro. by J.-A. Goris and G. Marlier)

No material vanished more thoroughly than New World goldwork, melted into bullion, repurposed for church plate, or lost to shipwrecks. The 2017 discovery of the sacrificed wolf behind the Cathedral (see p. 260) dramatically amplified the known pieces of Aztec gold. Both in Tenochtitlan and at home in Oaxaca, Mixtec craftsmen produced the finest metalwork of the era, working with lost wax to create fake filigree alongside hammering and repoussé. The malleability, color, and inert nature of gold have always made it an appealing raw material, although the Aztecs valued jade and feathers more highly, referring to gold as *teocuitlcatl*, or "excrement of the gods." When the Aztec drove the Spanish from their city in 1520, some Spaniards weighed down their pockets with gold, but Bernal Díaz knew to take jade beads that would sustain him for months.

High-quality Aztec featherwork has also not survived, although detailed feather paintings are known with Christian imagery. Aztec headdresses and shields, on the other hand, have endured. At an 1890 conference in Paris, Zelia Nuttall first suggested that the fine featherwork preserved in Vienna might be Motecuhzoma's headdress. With its extraordinary green quetzal and blue cotinga feathers, gold, and beads, the original headdress certainly may have been a royal garment, but there is no evidence that it was the property of Motecuhzoma II in particular. Illustrations in the chapter on featherworking in the Florentine Codex, the sixteenth-century encyclopedia, show the making of a similar headdress. Skilled craftsmen worked Christian designs in finely applied feathers throughout the Colonial era, the dazzling material adapted to new purposes.

Motecuhzoma II sent Cortés a chest containing turquoise mosaic masks and feather costumes of various deities in 1519. Guided by Doña Marina, Cortés may have given the calculated impression that he impersonated a god when he donned a costume and mask. These curiosities were then sent to Europe – where Albrecht Dürer would see them – but it is no longer certain which ones were in the gift. A mask in the British Museum depicts the deity Tezcatlipoca, with black obsidian

260 TOP Caches excavated at the Templo Mayor continue to yield novel works; in this case twenty-one pieces of hammered gold, the sacrificial attire of a young wolf.
261 BOTTOM LEFT Don Diego de Alvarado Huanitzin, the indigenous governor of Mexico City, commissioned this devotional image in feather mosaic for Charles V, king of Spain, to whom it was dedicated in 1539. The subject, the Mass of St. Gregory, was drawn from a European print.
262 BOTTOM RIGHT Florentine Codex. Father Sahagún's team recorded the preparation of fancy feather goods, including the headdress that looks very much like the one shown in ill. 6. This may have been a very standard noble headdress.

263 TOP LEFT Probably part of a whole costume of the deity Tezcatlipoca (see ill. 231), this mask is made of turquoise mosaic, obsidian, and gold pyrites over a human skull. The jaw is moveable.

264 TOP RIGHT The reputation of Mixtec craftsmen was affirmed by the 1930s discovery of this turquoise-encrusted skull, excavated from Tomb 7, Monte Alban.

265 BOTTOM LEFT Prized across the Aztec realm at the time of the Spanish invasion, Mixteca-Puebla wares served the nobility in disparate locations. This elegant cup comes from Tomb 7 at Monte Alban, as does ill. 264. The artist perched the little bird on the rim of the cup and painted it with post-fire Maya blue pigment.

266 BOTTOM RIGHT Hundreds of Tlaloc effigies were unearthed from the Tlaloc side of the Templo Mayor. This unusual ceramic effigy vessel was painted bright blue after firing.

bands set against a bright blue face. Built over a human skull, it could not have been worn; rather, it may have been worn mid-body, like Coatlicue's belt. An exceptional turquoise-encrusted skull also came to light in Tomb 7 of Monte Alban, along with carved bones and goldwork of Mixtec craftsmanship.

249
264

Bernal Díaz described the sumptuous meals prepared for Motecuhzoma II. Tens of dishes would be served up for the king's pleasure, including turkey, boar, venison, rabbit, quail, duck, pigeon, and human flesh. Motecuhzoma would sit and eat behind a screen, alone. Díaz informs us that Motecuhzoma ate only from the pottery made in Puebla and Oaxaca, especially the wares of Cholula. With their rich polychrome slip design over fine, thin pottery, Cholula wares were far superior to the Aztec product. Many designs and color patterns can be related to the Borgia group of manuscripts (see below), which may also have been made in the Cholula region. Ceramics of related style and subject matter have been found as far north as Nayarit. Another valued style was worked exclusively in red and black, as if capturing the Aztec metaphor for writing, "the black ink, the colored inks," in ceramic form.

265

Some unusual ceramics have been recovered from the Templo Mayor excavations. Fine vessels were found on the Huitzilopochtli side that were made in an archaizing fashion, imitating Toltec work, and the cremated remains they contained were of an elite young man, including an obsidian ring. Remarkable bright blue pigment was preserved on a Tlaloc effigy vessel, found on the Tlaloc side of the temple. Like many fifteenth- and sixteenth-century Aztec Tlaloc images, the deity

266

267 At the time of the Spanish invasion, stamps were widely used to press designs into clay, and perhaps more commonly, for pigments on human skin.

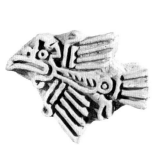

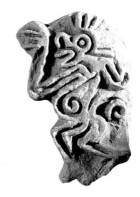

has the braided twist over his nose that characterizes the Maya Jaguar God of the Underworld, and may link ancient concepts of war and water. The side lugs and plump form are typical of vessels for *pulque*, Tlaloc's preferred beverage and a nutritious, festive offering.

267 Rocker stamps and roller stamps, used from earliest times for body decoration, may also have been used in Aztec times to mark the body, paper, and fabric with geometric designs, many of which resemble those achieved in weaving. Exceptional textiles commanded fancy prices as barter in the marketplace, and the Aztec demanded large quantities in tribute.

Manuscripts

Shortly after his accession in 1426 CE, the ruler Itzcoatl worked to consolidate power: one of his first acts was to collect and destroy manuscripts, making way for a new record of official Aztec history and religion. Nevertheless, it is obvious from the variety of historical and mythic information later written down in the Roman alphabet that a great diversity of religious and historical ideas continued long after Itzcoatl's reign. Powerful as the *tlatoani* was, his authority was not effectively centralized, and local traditions, languages, and practices all continued under Aztec rule. The supremacy of Huitzilopochtli

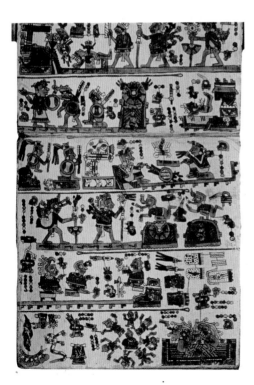

268 Page 7, Codex Selden. Although additions were made after the Spanish invasion to this Mixtec manuscript on deerskin, most of the pages were completed in prehispanic times. A young woman named 6 Monkey is the heroine of this portion of the genealogy. The story reads from bottom to top, following the red guidelines. In the lowest register visible here, 6 Monkey takes a pre-wedding bath with her fiancé and receives wedding gifts. In the third register up, 6 Monkey rides in a backpack on a visit to enemies who speak with "flinty tongues."

as a cult god was contested throughout the region, and in fact
Tezcatlipoca seems to have remained the supreme deity among
those claiming Toltec descent.

Sadly, the Spanish invasion was more effective than Itzcoatl's
purge, and, even though books were common among the Aztecs,
no manuscript survives that can be attributed to prehispanic
Tenochtitlan. Examples from other regions remained intact,
however, and from various schools of manuscript painting and
mapmaking that existed through most of the sixteenth century.
Books served many purposes for the Aztecs: genealogies were
kept, 260-day ritual calendars were consulted, and religious
esoterica were guarded in screenfold manuscripts. For
generations under colonial rule, maps, scrolls, and screenfolds
were brought to court to document testimony in land disputes.
Painted in thin stucco on deer hide, these manuscripts were
sometimes scraped and re-used; for sixteenth- and seventeenth-
century purposes, "idolatrous" lore might be purged in order
to allow legal use of the genealogical records. The Codex
Selden relates the genealogy of one prominent Mixtec family.
Red guidelines indicate the *boustrophedon*, or back-and-forth,
reading order of the manuscript, and we can observe the
highly conventionalized nature of representation. In the
section illustrated here, which reads from bottom to top,
the heroine 6 Monkey heeds her advisers. Footprints indicate
travel or movement: at the bottom of the page, 6 Monkey
and her betrothed bathe together in preparation for marriage.
Subsequently, she fights the battles that will regain her
kingdom for her. She can be identified by her name glyph,
which appears like a cartoon bubble above her. Her potency
as a cultural heroine is attested by her depiction and name
on a Zapotec deer hide of the seventeenth century: in this
work, the prehispanic past is sustained, even among peoples
who were rivals before the Spanish invasion document.

There are many surviving Mixtec genealogies, and although
they are embedded within a context of mythic origins (some
families derive from trees, others from stones), they are
essentially historical. They are also not without interesting
contradictions: the heroic 8 Deer of one narration can be
revealed as a villainous assassin in another. The complexity
of such interlocked families and narratives gives modern
scholars a better view of ancient life and political organization.

Another collection of manuscripts to survive is known as
the Borgia Group, which share subject matter and style; they are
named after the largest and most complex of these screenfolds,
now in the Vatican. Of these, the Borgia, Cospi, and Vaticanus B
manuscripts may also share a common origin in Puebla or

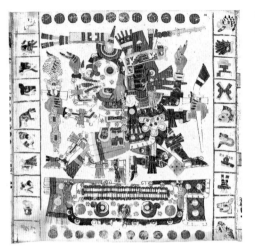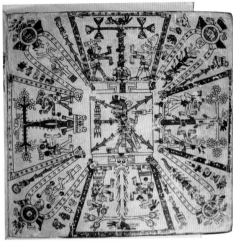

269 LEFT Page 56, Codex Borgia. Framing one end of a divination cycle are these paired deities, Mictlantecuhtli and Quetzalcoatl in the guise of Ehecatl, the wind god. They stand over an openmouthed earth monster, and the twenty day names run along the sides of the page.

270 RIGHT Folio 1, Codex Féjerváry-Mayer. The cover page of this Prehispanic manuscript presents concepts of the world order: the four cardinal points are associated with particular colors, birds, and trees with a Maltese-cross frame of 260 dots, referring to the calendar round and its completion.

269

270

Tlaxcala; new scientific studies led by Davide Domenici of Bologna are revealing material origins. Most of the Borgia manuscripts incorporate divining almanacs of the 260-day calendar with other religious material. No histories are known. Calendrical and cosmic concepts are expressed together on the front page of the Féjerváry-Mayer, also part of the Borgia Group, and the page has the character of a medieval carpet page. Two-hundred-and-sixty dots are laid out in the form of a Maltese cross, recalling the Maya completion sign. Radiating in four directions are four world trees surmounted by four directional birds, and the strewn body parts of Tezcatlipoca, sacrificed by Xiutecuhtli, who stands triumphant at center. Such a picture conveys notions of world creation and world order within the frame of the calendar.

The Codex Borgia is the single most complex surviving Mesoamerican book. The Venus pages in the center of the manuscript track the travels of Quetzalcoatl in the underworld in imagery that continues to defy interpretation. The divination pages of the 260-day calendar are framed by paired deities, who bookend the calendar. The opposition of Mictlantecuhtli, the chief death god, with Ehecatl, an aspect of Quetzalcoatl, emphasizes the principle of duality in Mesoamerican thought,

for Quetzalcoatl was also perceived to be a creator god, endowed with the gift of life and breath ("wind").

The Aztecs under Spanish rule

After the Spanish invasion, the production of indigenous art and architecture quickly changed, many forms coming to a complete and dramatic end. Temples were dismantled and their stones used to build the churches, civic buildings, and houses of the conquerors. Disease, strife, and despair all took their toll, as did forced labor in mines and what we might call sweatshops. In the sixteenth-century history of New Spain, the only light for the native population was the arrival of mendicant preaching friars, charged by Charles V with the mission. They came in groups of twelve, emulating the Apostles, and among their number were educated, enlightened individuals, instilled with ideas of the Renaissance. Just as Europe was in the throes of the Reformation, the new souls for conversion presented the Catholic church with another and different sort of challenge. The millions of converts needed schools and churches, the attendant infrastructure of the new religion, giving rise to one of the most energetic building programs in the history of the world, and even the waterworks, such as the rediscovered "Caja de Agua," a walk-in well at Santiago Tlatelolco, featured didactic instruction in Christianity. Native workers constructed hundreds of monastic complexes under the direction of friars who rarely had any knowledge of architectural principles. The Franciscans arrived first and built establishments throughout the Valley of Mexico; Dominicans came next and entered Oaxaca. The Augustinians, who arrived last, led the conversion to the north.

The predominant type of church constructed was the open-air chapel, a medieval form revived to meet the needs of the Mesoamerican population, who were unused to large interior spaces. The architecture was Christian, but prehispanic imagery persisted in both obvious and subtle ways as Mesoamerican ideas, formats, or styles were used to convey the new teachings. At the Augustinian establishment at Ixmiquilpan, Hidalgo, the paintings that line the nave show heroic Eagle and Jaguar Knights doing battle with villainous centaurs wrapped in acanthus vines. On one level, we can understand this to show a converted indigenous population in native armor fighting the pagan Chichimecs of the north. The Spaniards, however, were interpreted at first by native Mesoamericans to be combinations of man–horse, like centaurs. By the eighteenth century, such ambiguity of interpretation would earn these paintings a thick coat of whitewash.

271

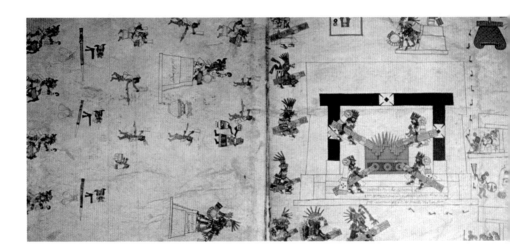

271 TOP LEFT Battle of Eagle Knights and Centaurs, Ixmiquilpan, Hildalgo. Under the guidance of Augustinian friars, native artists incorporated European and Precolumbian motifs in many sixteenth-century mural programs.

272 TOP RIGHT Tribute from the Province of Tepecoacuilco, Matricula de Tributos. Strings of amber, tubes of gold, jaguar pelts and fancy bird feathers flowed to the capital from distant provinces, in this case far to the south, from near what is today the Mexico–Guatemala border.

273 BOTTOM Painted shortly after the Spanish invasion, the Codex Borbonicus records both a 260-day calendar of divination and a calendar of seasonal and occasional events, the rarest of which was the completion of the 52-year cycle, featured at right. Huitzilopochtli stands at his temple while below, fire priests launch the new fire. Commoners shield themselves with blue masks, lower right.

Much of the architectural sculpture associated with the monastic establishments was worked in very low relief, a technique typical of Aztec ornament but one that also came about when woodcut images were transferred to three-dimensional forms. Many of the large atrium crosses, however, had obsidian embedded in them, recalling the prehispanic Central Mexican practice of incorporating an obsidian heart into many sculptures.

The two prehispanic art forms that succeeded above all others in the early colonial era were manuscript-making and feather-painting. Native scribes recorded histories, divinatory almanacs, and religious tracts, generally under the guidance of Franciscan priests. The earliest manuscript of the early colonial period, the Codex Borbonicus, was long thought to predate the Conquest, but it has been shown that throughout this screenfold on native paper, spaces were left for romanized 273 glosses. The first part of the manuscript is a divinatory guide of the 260 days, with auguries and patrons. The two center pages relate complex notions of calendar and time, and the last pages chart the 365-day cycle and the feasts of the months. The European influence is most obvious in this last section. In the rendering of a New Fire ceremony, the priests bear tied bundles of wood whose bindings are angled, as if informed by knowledge of perspective.

European paper soon replaced native fig paper; the screenfold gave way to the bound book. But indigenous painting traditions and conventions survived for some time, perhaps inspired by prehispanic books still available for consultation. The frontispiece of the Codex Mendoza may have its roots in a 270 carpet page, such as the first page of the Féjerváry-Mayer. The 272 luxurious tribute list of the Mendoza must have been copied directly from a similar record kept by Motecuhzoma II, but transferred from screenfold to bound book form, to describe the riches of New Spain for the Spanish Crown. In its third section, the Mendoza accounted for human life, from infancy to old age, with family elders depicted at the book's end as tipplers to be attended to by the young. Father Diego Durán compiled histories of the Indies and New Spain, with lively hybridic 274 illustrations that draw on both European and Aztec models.

The aim of the friars was to understand indigenous religion in order to extirpate it, but in the Florentine Codex, *The General History of the Things of New Spain* (*c.* 1566–77; 1585) – a twelve-book encyclopedia organized along the lines of a medieval compendium such as that of Bartholomeus Anglicus – one senses that Father Bernardino de Sahagún's goals exceeded mere religious duties. His interest in the New World was truly

274 Dominican Diego Durán compiled important histories and ritual books. Here, a page from his History of the Indies shows Motecuhzoma II directing the carving of his portrait at Chapultepec. Motecuhzoma poses for his portrait at right as if a Roman emperor; the results, center, follow an Aztec formula.

catholic and he sought to understand history, religion, and the natural world. His bilingual Nahuatl/Spanish record, written and illustrated by native scribes, many of whose names can now be identified, is the single most important document of Aztec life. Father Sahagún's manuscript went through several drafts; illustrations for an early version show stronger prehispanic traditions, and less concern for shading and landscape, both of which interest the illustrators of the later Florentine Codex. One volume of the more comprehensive later work features information on metalwork and feather-painting, lavishly illustrated, and a headdress like the one in Vienna today is shown. The most unusual volume is the twelfth, which tells the story of the Spanish invasion from the indigenous viewpoint. Diana Magaloni has revealed the way indigenous scribes manipulated the new visual language of Christianity, using it to tell the story of their recent past, where the seizing of Motecuhzoma by Spanish soldiers is likened to the taking of Christ by the Romans. The words to the right also echo the Gospels, labeling Motecuhzoma's supporters as abandoning him, like the apostles who abandoned Jesus. Whose past was being recorded?

The Mexican past took on new forms both in Mexico and Europe, drawing, in some cases, on forms that likened it to a safely "past" Roman antiquity. The benign representation of Tlaloc in the Codex Ixtlilxochitl, for example, bears a

275

genealogical relationship to the Apollo Belvedere, perhaps based on Marcantonio Raimondi's widely circulated print of the sculpture, excavated on Rome's Palatine Hill in 1489. The Ixtlilxochitl images make of Tlaloc an acceptable god of a distant, and now extinct, belief system.

This manuscript tradition was the final phase of Mesoamerican art. By the end of the sixteenth century, the intellectual friars had been supplanted by parish priests, who took less interest in their native flocks. The ravaged indigenous population had shrunk from what might have been 20 million on the eve of the Spanish invasion to a mere million. Perhaps not quite the cosmic cataclysm predicted by the Aztecs, it was, along with the demographic disaster assailing the rest of the hemisphere, from Tierra del Fuego to the Arctic, the greatest societal collapse of recorded history. The art and architecture of Mesoamerica vanished under modern buildings or encroaching modern development, or in other instances were simply destroyed or abandoned. Modern looting adds further insult to the indigenous past. But as each year passes, through patient study of the ancient writing and iconography, and increasingly smart archaeology, the results of which are rapidly disseminated through the technology of the present, the mesmerizing Mesoamerican past can be better known.

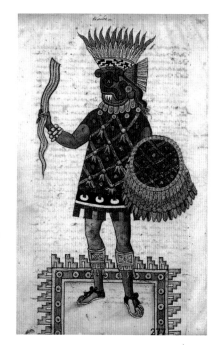

275 The work of an indigenous artist familiar with European prints, this page of the Ixtlilxochitl shows Tlaloc gently lifting a thunderbolt and standing in *contrapposto*; subtle shadows at the deity's feet suggest a European-style play of light.

Chronological table

		CENTRAL MEXICO	OAXACA	GULF COAST	WEST MEXICO	MAYA HIGHLANDS/ PACIFIC COAST	LOWLAND MAYA — South	LOWLAND MAYA — North
1519	LATE POSTCLASSIC	Tenochtitlan, Tlaxcala, Tula	Mixtec independent kingdoms	Totonacs, Cempoala	Tarascans	Maya independent city-states Mixco Viejo, Iximche, Utatlan	Tayasal (Itza)	Tulum, Santa Rita, Mayapan
1200	EARLY POSTCLASSIC	Xochicalco	Mitla, Yagul	Huastecs				Chichen Itza
900	TERMINAL CLASSIC / LATE CLASSIC	Cacaxtla	Monte Alban IIIb	Classic Veracruz, Remojadas		Cotzumalhuapa	Tepeu Late Classic Maya	Puuc and Central Yucatan
600	EARLY CLASSIC		Monte Alban IIIa	Cerro de las Mesas	Ixtlan del Río	Kaminaljuyu, Escuintla	Tzakol: Early Classic Maya	Oxkintok
300	PROTO CLASSIC		Monte Alban II		Chupicuaro	Izapa, Kaminaljuyu,	Cerros	
CE / BCE	LATE FORMATIVE	Cuicuilco		Tres Zapotes	Colima	Takalik Abaj	El Mirador, San Bartolo	
300			Dainzu, Monte Alban I	La Venta				
600	MIDDLE FORMATIVE	Tlatilco						
900	EARLY FORMATIVE			San Lorenzo				
1200					Teopantecuanitlan, Xochipala, Capacha	Ocos		
1500	ARCHAIC							

Vertical labels: Aztecs / Toltecs; Teotihuacan Phases I–IV; El Tajín; Olmecs

Select bibliography

that can barely be mentioned in this book, from Cantona to Cholula, and topics that Spanish readers may well wish to study in depth, from the ballgame to skullracks. Many journals are available online and through JSTOR.org, but much of what is published and has been published in this field is to be found in books, in English and Spanish, and they will require visits to libraries, even if snippets can be read online. The bibliographic search tool at famsi.org indexes articles as well as books, and is the best tool to use for research in Mesoamerica in both English and Spanish. The *Grove Encyclopedia of Latin American Art and Architecture,* ed. T. Cummins, is scheduled to go online in 2019. The online *Oxford Bibliographies in Art History* include many focused areas of Mesoamerican research.

AA American Anthropologist
AM Arqueología Mexicana
AncM Ancient Mesoamerica
BAEB Bureau of American Ethnology, Bulletin
CIW Carnegie Institution of Washington
INAH Instituto Nacional de Antropologia e Historia, Mexico
LACMA Los Angeles County Museum of Art
MARI Middle American Research Institute, Tulane University
PARI Pre-Columbian Art Research Institute, San Francisco
PMM Peabody Museum, Harvard University, Memoirs
PNAS Proceedings of the National Academy of Sciences
RRAMW Research Reports on Ancient Maya Writing
UNAM Universidad Nacional Autónoma de México

Chapter 1. Introduction

For general sources, students almost always start with a digital search. In this field of study, the outcomes of such searches are often homogenized, repetitious, and inaccurate; Wikipedia tends to be the most informative, but provides no novel or unique study. There are excellent, specialized digital resources, including: mesoweb.com, famsi.org (some of whose content has now taken up a new home at ancientamericas.org, at LACMA), ARTstor.org, archaeology.org, nationalgeographic.com, decipherment.wordpress.com, arqueomex.com, and INAH.gob.mx, in addition to the web sites of many major museums in the United States and elsewhere. Arqueología Mexicana devotes individual issues to many archaeological sites

For an alternative survey in English of prehispanic art and archaeology, one might turn to R. Townsend, *Indian Art of the Americas at the Art Institute of Chicago* (Yale), 2016; see also G. Kubler, *Art and Architecture of Ancient America* (Pelican), 3rd edition, 1984 (both of these books include the art and architecture of Central and South America). The 16 vols and 6 supplements of the *Handbook of Middle American Indians,* ed. R. Wauchope et al. (Univ. Texas), 1964–2000, typically found in library reference collections, offer consideration of Mesoamerica but with little attention to art. Valuable archaeological surveys that encompass the entire Mesoamerican region include S. Evans's *Ancient Mexico and Central America: Archaeology and Culture History* (Thames & Hudson), 3rd edition, 2013; and M. Coe's paired volumes, *Mexico* (Thames & Hudson), 7th edition (now co-authored with R. Koontz), 2013, and *The Maya* (Thames & Hudson), 9th edition (now co-authored with Stephen Houston), 2015. Many older art historical surveys have sharp insights into particular works of art, even if some of the archaeological data is now out of date: P. Kelemen, *Medieval American Art* (Macmillan), 1943; E. Easby and J. Scott, *Before Cortés: Sculpture of Middle America* (Metropolitan Museum of Art), 1970; M. Covarrubias, *Indian Art of Mexico and Central America* (Knopf), 1957; J. Pijoán, *Historia del arte precolombino* (Summa Artis X, Espasa-Calpe), 1952; Ignacio Marquina, *Arquitectura Prehispánica* (INAH), 1951; E. Seler, *Gesammelte Abhandlungen* (Asher & Co.), 1902–23 (English edition, 6 vols, 1997). Journals, among them RES, *Mexikon, Latin American Antiquity, Ancient Mesoamerica,* and *Latin American and Latinx Visual Culture,* serve as up-to the-minute

sources, as does the lavishly illustrated *National Geographic Magazine*. Smart perceptions have been filed at the International Congress of Americanists, held since 1875, resulting in what are often, unfortunately, recondite publications with valuable contributions. Since 1993, *Arqueología Mexicana* has transformed the publication of Mesoamerican materials, publishing both recent discoveries and thoughtful considerations of well-known materials, all with excellent photographs and line drawings, and with many special issues that can serve as mini-textbooks. The new volumes of the collections at Dumbarton Oaks Museum, Washington, DC, are masterful assemblages of current thinking on a wide range of topics, focused as Maya, Olmec, and Central Mexico.

Of great value are two encyclopedias, both issued in 2001: D. Carrasco's *The Oxford Encyclopedia of Mesoamerican Cultures: The Civilizations of Mexico and Central America*; and S. Evans and D. Webster's *Archaeology of Ancient Mexico and Central America, An Encyclopedia* (Garland). For religion, see M. Graulich, *Myths of Ancient Mexico* (Univ. Oklahoma), 1997; D. Carrasco, *Religions of Mesoamerica* (Waveland), 2nd edition, 2013; and M. Miller and K. Taube's *Gods and Symbols of Ancient Mexico and the Maya* (Thames & Hudson), 1993. On the indigenous body, see A. Lopez Austín, *The Human Body and Ideology: Concepts of the ancient Nahuas* (Univ. Utah), trans. T. and B. Ortíz de Montellano, 1988.

The term "Mesoamerica" has been in use since the mid-twentieth century (P. Kirchhoff, "Mesoamerica," *Acta Americana* 1, 1943: 92–107). *A Pre-Columbian World* (Dumbarton Oaks), ed. J. Quilter and M. Miller, 2006, questions the boundaries of Mesoamerica, looking both north and south, and evidence continues to grow: "Evidence of Cacao Use in the Prehispanic American Southwest," P. L. Crown and W. J. Hurst, PNAS, 2009, 106(7): 2110–13. N. Davies re-examined and evaluated diffusionist thought in a highly readable book: *Voyagers to the New World* (W. Morrow), 1979. G. Early tackles Afrocentrism: "Adventures in the Colored Museum," AA 100(3): 11, 1999. Bernal Díaz del Castillo wrote the most comprehensive and lucid eye-witness report of the Spanish invasion; various abridgments are available today, but the 5-vol. translation of A. P. Maudslay (1908–16) remains invaluable. Of all early travelers who looked at ancient ruins, John Lloyd Stephens's accounts are the most interesting: *Incidents of Travel in Central America, Chiapas, and Yucatán* (Harper), 2 vols, 1841; see also E. Matos Moctezuma and J. García-Barcena, *Descubridores del Pasado* (INAH), 2001. Bernardino de Sahagún's *Florentine Codex, A General History of the Things of New Spain*, trans. A. J. O. Anderson and C. Dibble, in 13 books (School of American Research and University of Utah), 1950–82, is an encyclopedia of prehispanic life in Central Mexico, and is now recognized to be written by dozens of indigenous authors alongside Sahagún. Long bounded chronologically as well as geographically, Mesoamerica can now be productively understood to incorporate art-making that extends well into the sixteenth century, if not beyond. Two Dumbarton Oaks conference volumes, *Collecting the Pre-Columbian Past*, ed. E. H. Boone, 1993, and *Past Presented*, ed. Joanne Pillsbury, 2012, consider the collection and exhibition of these works. *Mesoamerican Architecture as a Cultural Symbol* (Oxford), ed. J. K. Kowalski, 1999, provides intelligent consideration of architectural history. *Pre-Columbian Architecture of Mesoamerica* (Abbeville), ed. M.T. Uriarte, 2010, provides a new comprehensive survey (available in multiple languages). I have found E. Pasztory's *Thinking with Things* (Univ. Texas), 2005, to open useful perspectives.

On materials: See C. Costin, *Making Value, Making Meaning: Techné in the Pre-Columbian World* (Dumbarton Oaks), 2016. For feathers, see *Images Take Flight: Feather Art in Mexico and Europe* (Hirmer), ed. A. Russo, G. Wolf, and D. Fane, 2016; for jade, see the Dumbarton Oaks catalogue on the Olmec (above); for pigments, see S. Houston et al., *Veiled Brightness* (Univ. Texas), 2009; for flints and chert, R. Agurcia, K. Taube, and P. Sheets, *Protecting Sacred Space* (Mesoweb), 2016. *Golden Kingdoms* (Getty), ed. J. Pillsbury, T. Potts, and K. Richter, 2017, looks at "luxury arts" broadly across the Americas. E. Abrams's *How the Maya Built Their World* (Univ. Texas), 1994, is helpful to think about architecture across Mesoamerica. S. Houston's *Life Within* (Yale), 2014, although specifically addressing Maya materiality has application more broadly.

Chapter 2. The Olmecs: Establishing Mesoamerican foundations

Cyphers and D. Grove both offered synthetic opinions in the 2014 Cambridge *World Prehistory*, vol. 2; for La Venta one should consult S. Gillespie

and M. Volk, "A 3d model of Complex A, La Venta, Mexico," *Digital Applications in Archaeology and Cultural Heritage* 2014: 72–81. L. Filloy and D. Magaloni, *La Ofrenda 4 de La Venta. Un tesoro Olmeca reunido en el Museo Nacional de Antropología* (INAH), 2013, have analyzed the most enigmatic of Olmec offerings. See also A. Cyphers, "Nuevos hallazgos olmecas en San Lorenzo Tenochtitlán," *Boletín Antropológicas* 1(1), 2013: 1–3, and *Escultura Olmeca de San Lorenzo Tenochtitlán* (Instituto de Investigaciones Antropológicas and the Coordinación de Humanidades, UNAM), 2nd edition, 2018.

For the earliest Olmec objects in Maya context: T. Inomata et al., "Early Ceremonial Constructions at Ceibal, Guatemala, and the Origins of Lowland Maya Civilization," *Science* 340(6131), 2013: 467–71. J. Blomster and D. Cheetham, eds, assemble new Olmec and Olman views in *The Early Olmec and Mesoamerica* (Cambridge), 2017. See also C. Pool, "Asking More and Better Questions: Olmec Archaeology for the Next Katun," AncM 20(2), 2009: 241–52, and J. E. Clark, "The Arts of Government in Early Mesoamerica," *Annual Review of Anthropology* 26, 1997: 211–34.

The 2010 exhibition *Olmec: Colossal Masterworks of Ancient Mexico* (Yale), ed. K. Berrin and V. Fields, brought exceptional works and new excavation data together at US museums, as did *Olmec Art of Ancient Mexico* (National Gallery of Art), ed. E. P. Benson and B. de la Fuente, 1996, and *The Olmec World: Ritual and Rulership* (Art Museum, Princeton), 1995; and two additional edited volumes, *Olmec Art and Archaeology in Mesoamerica* (Yale), ed. J. E. Clark and M. E. Pye, 2000, and *Los Olmecas en Mesoamerica* (Citibank), ed. J. E. Clark, 1994, have made Olmec archaeology, research and new discoveries widely available. R. Diehl's study, *The Olmecs: America's First Civilization* (Thames & Hudson), 2004, is worth reading alongside M. Coe's 1968 book of the same title. Studies of Olmec art continue to ask new questions. C. Tate's book, *Reconsidering Olmec Visual Culture* (Univ. Texas), 2012, makes a sweeping reassessment of Olmec art, with attention to fetal imagery. Attacks on the authenticity of the "Wrestler" sculpture have been countered: A. Cyphers, A. Lopez Cisneros, "El Luchador: Historia Antigua y reciente," AM 15(88), 2007: 67–71; and M. Coe and M. Miller, "The Olmec Wrestler: A Masterpiece of the Ancient Gulf Coast," *Minerva* 2004 16(1): 18–19. See also K.

Reilly, "The Shaman in Transformation Pose: A Study of the Theme of Rulership in Olmec Art," *Record of the Art Museum, Princeton University* 46(2), 1989: 4–21. The theory of "recycled" monuments has been articulated by J. Porter: "Olmec Colossal Heads as Recarved Thrones," RES 17/18, 1989: 22–29. Painting and petroglyphs are discussed by D. C. Grove, "The Olmec Paintings of Oxtotitlan Cave," *Dumbarton Oaks Studies in Pre-Columbian Art and Archaeology* no. 6, 1970; and Grove, *Chalcatzingo: Excavations on the Olmec Frontier* (Thames & Hudson), 1984; see also D. C. Grove and S. D. Gillespie, "People of the Cerro: Landscape, Settlement, and Art at Middle Formative Period Chalcatzingo," in *The Art of Urbanism* (Dumbarton Oaks), ed. W. L. Fash and L. Lopez Luján, 2009, 53–76. A. Pohorilenko addresses "A Formalistic Approach to Olmec Representation" in *Acercarse y mirar: homenaje a Beatriz de la Fuente* (UNAM), ed. M.T. Uriarte, L. Staines Cicero, 2004, 107–166. J. Blomster asks, "What and Where is Olmec Style? Regional Perspectives on Hollow Figurines in Early Formative Mesoamerica," AncM 13.02, 2003: 171–95. On modern earthworks and Michael Heizer, D. Goodyear, see "A Monument to Outlast Humanity," *The New Yorker,* August 26, 2016.

Chapter 3. Late Formative: A diverse Mesoamerica comes of age

Exciting archaeological reports and fresh interpretations of ancient West Mexican art are all included in *Ancient West Mexico*, ed. R. F. Townsend (Thames & Hudson), 1998, the catalogue of a major exhibition organized by the Art Institute of Chicago. See also P. Furst, "West Mexican Tomb Sculpture as Evidence for Shamanism in Prehispanic Mesoamerica," *Antropológica* 15, 1965: 29–80; and H. von Winning and O. Hammer, *Anecdotal Sculpture of West Mexico* (Ethnic Arts Council of Los Angeles), 1972. Catalogues by M. Kan et al., *Sculpture of Ancient West Mexico* (LACMA), 2nd edition, 1985, and J. Gallagher, *Companions of the Dead* (Los Angeles Museum of Cultural History), 1983, provide both clear interpretations and excellent illustrations.

For Oaxaca, one might start with *Zapotec Civilization* by J. Marcus and K. Flannery (Thames & Hudson), 1996. For specific problems and sites, readers might turn to J. Urcid, "Zapotec Hieroglyphic Writing," *Dumbarton Oaks Studies in Pre-Columbian Art and Archaeology* no. 34, 2001, and his "Efigies de Ceramica Benizaa," AM 121,

2013: 18–24; J. Scott, "The Danzantes of Monte Alban," 2 vols, *Dumbarton Oaks Studies in Pre-Columbian Art and Archaeology* no. 19, 1978; and I. Bernal, "The Ball Players of Dainzu," *Archaeology* 21(4), 1968: 246–51.

Archaeoastronomical principles in ancient American art and architecture are discussed in A. F. Aveni, *Skywatchers of Ancient Mexico* (Univ. Texas), 1981, revised/updated edition 2001, and D. M. Earle and D. R. Snow, "The Origin of the 260-day Calendar: The Gestation Hypothesis Reconsidered in Light of its Use among the Quiche-Maya," in *Fifth Palenque Round Table*, 1985: 241–44. A compelling picture of early Maya civilization and religious formation has been drawn by D. Freidel, L. Schele, and J. Parker in *Maya Cosmos* (W. Morrow), 1993. For Izapa, Takalik Abaj, and Kaminaljuyu, see also J. Guernsey, J. Clark, and B. Arroyo, eds, *The Place of Stone Monuments: Context, Use, and Meaning in Mesoamerica's Preclassic Transition* (Dumbarton Oaks), 2010, and J. Guernsey, *Ritual and Power in Stone: The Performance of Rulership in Mesoamerican Izapan Style Art* (Univ. Texas), 2006; A.V. Kidder, J. D. Jennings, and E. Shook, *Excavations at Kaminaljuyu* (CIW), 1946; and J. Kaplan and M. Love, *The Southern Maya in the Late Preclassic: The Rise and Fall of an Early Mesoamerican Civilization* (Univ. Colorado), 2011. F. Estrada-Belli's *The First Maya Civilization: Ritual and Power Before the Classic Period* (Routledge), 2010, adds to the conversation.

One of the key concepts first evident in this era is of sacred mountains: see K. Taube, "Flower Mountain: Concepts of Life, Beauty, and Paradise among the Classic Maya," RES 45, 2004: 69–98; L. Schele and J. Guernsey Kappelman, "What the Heck's Coatepec? The Formative Roots of Enduring Mythology," in *Landscape and Power in Ancient Mesoamerica* (Westview Press), ed. R. Koontz, K. Reese-Taylor, and A. Headrick, 2001, 29–53.

The San Bartolo wall paintings have been partly published in *National Geographic*, with more to come: W. A. Saturno, K. A. Taube, and D. Stuart, "The Murals of San Bartolo, El Petén, Guatemala. Part 1: The North Wall," *Ancient America* 7, 2005. Many Late Formative works were freshly interpreted in the exhibition at the Los Angeles County Museum of Art, and in the catalogue of the same name, V. Fields and D. Reents-Budet, *The Lords of Creation* (LACMA), 2005. See also F. Winfield Capitaine, "La Estela 1 de La Mojarra,

Veracruz, Mexico," RRAMW 16, 1988; M. Stirling, "An Initial Series from Tres Zapotes, Vera Cruz, Mexico," *National Geographic Society, Contributed Technical Papers*, 1:1, 1940. For the earliest inscriptions, see the essays in S. D. Houston, ed., *The First Writing* (Cambridge), 2004, which included the controversial Cascajal block. A. Caso, *Los calendarios prehispánicos* (UNAM), 1967, remains a major resource; S. Houston, O. Chinchilla, and D. Stuart collected key articles that led to *The Decipherment of Ancient Maya Writing* (Univ. Oklahoma), 2001. *Research Reports on Ancient Maya Writing*, published since 1986 (Center for Maya Research), offer a steady diet of new hieroglyphic readings. D. Stuart's "Ten Phonetic Syllables," RRAMW 14, 1987, is a model of carefully argued decipherment. M. Coe's *Breaking the Maya Code* (Thames & Hudson), 3rd edition, 2012, offers insights into the foibles and successes of decipherment.

Chapter 4. Teotihuacan: City of fire, city of water

The exhibition catalogue, *Teotihuacan: City of Water, City of Fire* (Univ. California), ed. M. Robb, 2017, encompasses decades of major excavations and new interpretations. The journal *Ancient Mesoamerica* featured a special section on the latest excavations at the Moon pyramid in 2007 (18:1), 107–190, and the exhibition catalogue, S. Sugiyama, *Voyage to the Center of the Moon Pyramid: Recent Discoveries in Teotihuacan* (INAH), 2004, brought these to public attention in Mexico. The gripping story of destruction in the Xalla complex is recounted in L. Lopez Luján, L. Nadal, B. Fash and W. Fash, "The Destruction of Images in Teotihuacan: Anthropomorphic Sculpture, Elite Cults, and the End of a Civilization," RES 49–50, 2006. Warfare and sacrifice are at the heart of Sugiyama's *Human Sacrifice, Militarism, and Rulership: Materialization of State Ideology at the Feathered Serpent Pyramid, Teotihuacan* (Cambridge), 2005, as is K. Taube, *Temple of Quetzalcoatl and the Cult of Sacred War at Teotihuacan*, RES 21, 1992: 53–87.

R. Millon's archaeological 2-vol. report, *Urbanization at Teotihuacan, Mexico* (Univ. Texas), 1974, remains useful, as do some of the ideas floated by Laurette Séjourné in *Un palacio en la ciudad de los dioses* (INAH), 1959. K. Taube's "The Teotihuacan Spider Woman," *Journal of Latin American Lore* 9:2, 1983: 107–89, initiated new thinking about the female cults at the site.

The "goddess" concept has been critiqued in A. Paulinyi, "The 'Great Goddess' of Teotihuacan: Fiction or Reality?" AncM 17, 2006: 1–15. Also bear in mind J. Berlo, ed., *Art, Ideology, and the City of Teotihuacan* (Dumbarton Oaks), 1992; K. Berrin and E. Pasztory, eds, *Teotihuacan: Art from the City of the Gods* (The Fine Arts Museums of San Francisco, Thames & Hudson), 1993; and K. Berrin, ed., *Feathered Serpents and Flowering Trees* (The Fine Arts Museums of San Francisco), 1988. The Pintura Mural project of B. de la Fuente has now provided complete records of paintings at *Teotihuacan* (UNAM), 1995, 2 vols, and *Bonampak*, 1998, 2 vols. The Museo Nacional de Antropologia organized a major exhibition, with catalogue, in 2008: *Teotihuacan: Ciudad de los dioses* (INAH).

Chapter 5. Classic cities from coast to coast
On Monte Alban, see sources under Chapter 3; also: A. Miller, *Painted Tombs of Oaxaca, Mexico: Living with the Dead* (Cambridge), 1995; R. E. Blanton, *Monte Albán: Settlement Patterns at the Ancient Zapotec Capital* (Academic Press), 1978; J. Paddock, ed., *Ancient Oaxaca* (Stanford), 1966. A. Caso and I. Bernal studied the urns of Oaxaca: *Urnas de Oaxaca*, INAH *Memorias* 2, 1952; J. Marcus considers the urns in *The Cloud People* (Exeter), 2003 (see Chapter 8). Recent speleological discoveries have been published by M. Winter, T. Ballensky, J. Ballensky and J. Perez Guerrero, "La Cueva del Rey Kong-Oy," in M. Winter and G. Sánchez Santiago, eds, *Panorama Arqueológico: Dos Oaxacas*. Oaxaca: INAH, 2014: 293–320. For more on the caves, see also M. Stoll, "Ball games and community relations in Oaxaca and the Sierra Sur," AM 146, 2017: 58–63.

On Classic Veracruz sculpture, see M. Goldstein, ed., *Ceremonial Sculpture of Ancient Veracruz* (Hillwood Art Gallery, Long Island University), 1988. Archaeology is treated in B. Stark, ed., *Settlement Archaeology of Cerro de las Mesas, Veracruz, Mexico* (Institute of Archaeology, UCLA), 1991. C. Wyllie has published the Las Remojadas excavations, "The Mural Paintings of El Zapotal, Veracruz, Mexico," AncM 21:2, 2010: 209–27.

For El Tajín, see R. Koontz, *Lightning Gods and Feathered Serpents: The Public Sculpture of El Tajín* (Univ. Texas), 2009, and A. Pascual Soto, *El Tajín: en busca de los orígenes de una civilización* (UNAM), 2006. O. Chinchilla Mazariegos has both excavated at Cotzumalhuapa and addressed the sculptures removed from the site: "Peor es nada:

el origen de las esculturas de Cotzumalguapa en el Museum für Völkerkunde, Berlin," *Baessler Archiv* 44, 1996: 295–357.

For the Mesoamerican ballgame, one might start with *Arqueología Mexicana*, special issue 146 (2017), and M. Whittington's *The Sport of Life and Death: The Mesoamerican Ballgame* (Thames & Hudson), 2001; T. Leyenaar and L. A. Parsons, *Ulama: the Ballgame of the Mayas and Aztecs, 2000 BC–AD 2000* (Leiden), 1988; R. Koontz, "Ballcourt Rites, Paradise, and the Origin of Power in Classic Veracruz," in *An Introduction to Pre-Columbian Landscapes of Creation and Origin*, ed. J. Staller (Springer), 2008; M. Miller and S. Houston, "The Classic Maya Ballgame and its Architectural Setting: A Study of Relations between Text and Image," RES 14, 1987: 46–65.

Chapters 6 and 7. Classic Maya cities
Several important books have dramatically changed the history of Maya art and archaeology since the first edition of this book was released. For a survey, start with M. Miller and M. O'Neil, *Maya Art and Architecture* (Thames & Hudson), 2nd edition, 2014; alongside Coe and Houston, above. Key works include the 2015 *Mayas: Revelation of an Endless Time* (INAH), ed. M. de la Garza. See also: L. Schele and M. Miller, *The Blood of Kings: Ritual and Dynasty in Maya Art* (Kimbell Art Museum and Thames & Hudson), 1986 and 1992; L. Schele and D. Freidel, *A Forest of Kings: The Untold Story of the Ancient Maya* (W. Morrow), 1990; and L. Schele and P. Mathews, *Code of Kings* (Scribner), 1999. S. Houston and D. Stuart's article, "The Ancient Maya Self: Personhood and Portraiture in the Classic Period," RES 33, 1998, has been influential.

Other key works on the bookshelf include M. Miller and S. Martin, *Courtly Art of the Ancient Maya* (Thames & Hudson), 2004; S. Martin and N. Grube, *Chronicle of the Maya Kings and Queens* (Thames & Hudson), 2nd edition, 2008; D. Finamore and S. Houston, eds, *The Fiery Pool* (Yale), 2010; S. Houston and T. Inomata, *The Classic Maya* (Cambridge), 2009; *I Maya*, the catalogue of the vast Venice exhibition, curated by P. Schmidt, M. de La Garza, and E. Nalda, also published in English as *Maya* (Rizzoli), 1998; A. Stone and M. Zender, *Reading Maya Art: A Hieroglyphic Guide to Ancient Maya Painting and Sculpture* (Thames & Hudson), 2011; S. Houston, D. Stuart, and K. Taube, *The Memory of Bones:*

Body, Being, and Experience among the Classic Maya (Univ. Texas), 2006. R. Sharer and L. Traxler last updated The Ancient Maya (Stanford), 6th edition, the most encyclopedic archaeological resource on the Maya, in 2005. J. Pillsbury et al., eds, Ancient Maya Art at Dumbarton Oaks (Dumbarton Oaks), 2012, encompasses jade, chert, figurines, and ceramics, with broad attention across the Maya world.

Both Early and Late Classic sculptures are discussed and illustrated in S. G. Morley, Inscriptions of Petén CIW Pub. 437, 5 vols, 1937–38; A. P. Maudslay, Biologia Centrali-Americana: Archaeology (Dulan & Co.), 5 vols, 1899–1902; Corpus of Maya Hieroglyphic Inscriptions (Peabody Museum, Harvard University), vols 1–9, 1977–. T. Proskouriakoff's Classic Maya Sculpture, CIW Pub. 593, 1950, retains key insights.

On Palenque: T. Vera and A. Cucina, eds, Janaab' Pakal of Palenque: Reconstructing the Life and Death of a Maya Ruler (Univ. Arizona), 2006. A. Gonzalez Cruz, La Reina Roja: una tomba real in Palenque (INAH), 2011. M. Greene Robertson, The Sculpture of Palenque (Princeton), 4 vols, 1983–92; D. Stuart and G. Stuart, Palenque, Eternal City of the Maya (Thames & Hudson), 2008. E. Barnhart's dissertation, "The Palenque Mapping Project: Settlement and Urbanism at an Ancient Maya City," (Univ. Texas, unpublished), 2001, has provided a new baseline for studying ancient waterways and settlement. See also K. D. French, Palenque Hydro-Archaeology Project, 2006–2007 Season Report (2008), at famsi.org.

On Belize: D. Pendergast, Altun Ha, British Honduras (Belize): The Sun God's Tomb, Royal Ontario Museum of Art and Archaeology, Occasional Paper 19, 1969; A. F. Chase and D. Z. Chase, Investigations at the Classic Maya City of Caracol, Belize: 1985–87 (PARI), 1987.

For Bonampak: M. Miller, "The Willfulness of Art: The Case of Bonampak," RES 42, 2002: 8–23; M. Miller and C. Brittenham, The Spectacle of the Late Maya Court: Reflections on the Paintings of Bonampak (Univ. Texas), 2013, and de la Fuente, as listed under Chapter 4.

For Tikal: P. Harrison, The Lords of Tikal: Rulers of an Ancient Maya City (Thames & Hudson), 1999.

For Calakmul: Volume 2 of Maya Archaeology (Mesoweb), 2012, is largely devoted to new paintings.

On Piedras Negras: A. Stone, "Disconnection, Foreign Insignia, and Political Expansion: Teotihuacan and the Warrior Stelae of Piedras Negras," in Mesoamerica after the Decline of Teotihuacan AD 700–900, eds R. Diehl and J. Berlo (Dumbarton Oaks), 1989, 153–72; M. O'Neil, Engaging Ancient Maya Sculpture at Piedras Negras, Guatemala (Univ. Oklahoma), 2012. A. Villacorta and C. A. Villacorta, Codices Maya, (Tipografía Nacional), 1930; the codex formerly known as Grolier has been renamed Códice de México and transferred to the Biblioteca Nacional. See M. Coe, S. Houston, M. Miller, and K. Taube, "The Fourth Maya Codex," in Maya Archaeology 3, 2016: 117–67.

The Popol Vuh has been translated many times, and the newest version by A. Christensen, Popol Vuh (Univ. Oklahoma), 2007, is recommended. For Bishop Landa, see W. Gates's translation, Yucatán Before and After the Conquest (The Maya Society Baltimore), 1937, reprinted by Dover, 1978. On religious practice at the time of the Conquest, I. Clendinnen, Ambivalent Conquests: Maya and Spaniard in Yucatán, 1517–1570 (Cambridge), 1987, 2nd edition 2003; J. Chuchiak, "Writing as Resistance: Maya Graphic Pluralism and Indigenous Elite Strategies for Survival in Colonial Yucatan, 1550–1750," Ethnohistory 57(1), 2010: 87–116, and M. Restall, Maya Conquistador (Beacon Press), 1999.

For Copan and Quirigua, see E. Boone and G. Willey, eds, The Southeast Classic Maya Zone (Dumbarton Oaks), 1988, 149–94; W. Fash, Scribes, Warriors, and Kings: The City of Copán and the Ancient Maya (Thames & Hudson), 2nd edition, 2001; D. Webster, ed., The House of the Bacabs (Dumbarton Oaks), 1989; E. Bell, M. Canuto, and R. Sharer, eds, Understanding Early Classic Copan (Univ. Pennsylvania), 2004; S. G. Morley, Inscriptions at Copán, CIW Pub. 219, 1920; C. Bandez, Introducción a la Arqueología de Copán, Honduras, 3 vols, Proyecto Arqueológico de Copan, Tegucigalpa, Honduras, 1983; M. Looper, Lightning Warrior: Maya Art and Kingship at Quirigua (Univ. Texas), 2003; A. Herring's "A Borderland Colloquy: Altar Q, Copan, Honduras," Art Bulletin 87(2), 2005: 194–229, offers keen insights for art historians. Eccentric flints of Copan have been studied in greater detail than any others: R. Agurcia Fasquelle, P. Sheets, and K. Taube, Protecting Sacred Space: Rosalila's Eccentric Chert Cache at Copan and Eccentrics among the Classic Maya (Mesoweb), 2016.

For Yucatan: J. Kowalski, *The House of the Governor* (Univ. Oklahoma), 1986; Harry Pollock, *The Puuc* (PMM), 1980; V. Miller, *The Frieze of the Palace of the Stuccoes, Acanceh, Yucatán, Mexico* (Dumbarton Oaks), 1991.

For Yaxchilan: C. Tate, *Yaxchilán: Design of a Maya Ceremonial Center* (Univ. Texas), 1992.

For religious iconography, see K. Taube, *The Major Gods of Ancient Yucatán* (Dumbarton Oaks), 1992; E. Benson and G. Griffin, eds, *Maya Iconography* (Princeton), 1988; M. G. Robertson, ed., *Mesa Redonda de Palenque* (Palenque Round Table) (R. L. Stevenson School, Univ. Texas, PARI), vols 1–10, 1973–93; O. Chinchilla Mazariegos, *Art and Myth of the Ancient Maya* (Yale), 2017.

For figurines, see C. Halperin, *Maya Figurines* (Univ. Texas), 2014; L. Lowe and A. Sellen, *Una pasión por la antigüedad: la colección arqueológica de Don Florentino Gimeno en Campeche durante el siglo XIX*, Estudios de Cultura Maya 2010; D. Freidel, M. Rich, and K. Reilly, "Resurrecting the Maize King," *Archaeology* 63(5), 2010: 42–45; M. Gallegos, A. Benavides, and A. Velazquez, *Mayas. El lenguaje de la Belleza* (INAH), 2015; M. Miller, *Jaina Figurines* (Art Museum, Princeton), 1975; R. Piña Chan, *Jaina, la casa en el agua* (INAH), 1968; L. Schele, *Hidden Faces of the Maya* (ALTI), 1998; M. Miller, "Molded Magic practice: Standardization and innovation in the making of Jaina figurines," RES forthcoming 2019.

On Maya jades: Tatiana Proskouriakoff, *Jades from the Cenote of Sacrifice, Chichen Itzá, Yucatán*, PMM 10(1), 1974.

The chronology and terminology for Maya ceramics derives from the Uaxactun excavations: R. E. Smith, *Ceramic Sequence at Uaxactún, Guatemala*, 2 vols, MARI Pub. 20, 1955. M. D. Coe transformed the study of ceramics in the two following: *The Maya Scribe and His World* (Grolier Club), 1973; R. E. W. Adams, *The Ceramics of Altar de Sacrificios*, PMM 63:1, 1971. For the Early Classic, see N. Hellmuth, *Mönster und Menschen* (Graz), 1987. J. Kerr published much of the complete corpus: *The Maya Vase Book*, vols 1–7, 1989–; and continued at mayavase.com. See also D. Reents-Budet, *Painting the Maya Universe* (Duke), 1994, and M. Coe and J. Kerr, *The Art of the Maya Scribe* (Abrams and Thames & Hudson), 1998. A. Herring, *Art and Writing in the Maya Cities, AD 600–800: A Poetics of Line* (Cambridge),

2005, treats the relationship between line and thought.

Architecture receives its due in *Royal Courts of the Ancient Maya* (Westview), ed. T. Inomata and S. Houston, 2001; and *Function and Meaning in Classic Maya Architecture* (Dumbarton Oaks), ed. S. Houston, 1998. T. Proskouriakoff based her careful reconstructions on archaeological reports (*An Album of Maya Architecture*, CIW Pub. 558, 1946). For technical observations on Maya architecture, see L. Roys, "The Engineering Knowledge of the Maya," CIW Contributions, II, 1934.

Chapter 8. Mesoamerica after the fall of Classic cities

Useful in association with this chapter is *Mesoamerica after the Decline of Teotihuacan* (Dumbarton Oaks), eds R. Diehl and J. Berlo, 1989.

On Xochicalco, see B. de la Fuente et al., *La Acrópolis de Xochicalco* (Instituto de Cultura de Morelos), 1995, and K. Hirth, *Archaeological Research at Xochicalco* (Univ. Utah), 2000.

A flurry of publications accompanied the discovery of the Cacaxtla paintings, including D. McVicker, "The Mayanized Mexicans," *American Antiquity* 50(1), 1985: 82–101. See also Marta Foncerrada de Molina, "La pintura mural de Cacaxtla, Tlaxcala," *Anales del IIE*, UNAM 46, 1976: 5–20. C. Brittenham, *The Murals of Cacaxtla: The Power of Painting in Ancient Central Mexico* (Univ. Texas), 2015, is the most comprehensive.

Articles in K. V. Flannery and J. Marcus, eds, *The Cloud People: Divergent Evolution of the Zapotec and Mixtec Civilizations* (Academic Press), 1983, consider the Early Postclassic in Oaxaca. The volume is also valuable for earlier eras in Oaxaca. Modern-day practice at Mitla is documented in W. Arfman, *Visiting the Calvario at Mitla, Oaxaca* (Sidestone Press), 2008.

Renewed interest in the Huastecs has been addressed in K. Faust and K. Richter, *The Huasteca* (Univ. Oklahoma), 2015. On Tula and Chichen Itza: various reports summarize the many years of excavations by the Carnegie Institution of Washington at Chichen Itza. The most important studies: K. Ruppert, *Chichen Itzá*, CIW Pub. 595, 1952; A. M. Tozzer, *Chichen Itzá and its Cenote of Sacrifice*, PMM 12, 1957; E. Morris, J. Charlot,

and A. Morris, *The Temple of the Warriors at Chichen Itzá, Yucatán*, 2 vols, CIW Pub. 406, 1931, documented a vast program that remains of keen interest. On Toltec art forms at Chichen Itza, see W. Ringle, T. Gallareta, and G. Bey, "The return of Quetzalcoatl: Evidence for the spread of a world religion during the Epiclassic period," AncM 9(2), 1998: 183–232; K. Taube, "The Iconography of Toltec Period Chichen Itza," in *Hidden Among the Hills* (Bonn), ed. H. Prem, 1994, 212–46. See also: C. Coggins and O. Shane, eds, *Cenote of Sacrifice: Maya Treasures from the Sacred Well at Chichen Itzá*, (Univ. Texas), 1984. J. K. Kowalski et al., eds, *Twin Tollans: Chichén Itzá, Tula, and the Epiclassic to Early Postclassic Mesoamerican World* (Dumbarton Oaks), revised edition 2011, provides a fresh look at the assumptions that have shaped all Chichen work. On the Toltecs, see A. G. Mastache, R. Cobean and D. Healan, *Ancient Tollan: Tula and the Toltec Heartland* (Univ. Colorado), 2002; R. Diehl, *Tula: the Toltec Capital of Ancient Mexico* (Thames & Hudson), 1983; J. Acosta, "Resumen de los informes de las exploraciones arqueológicas en Tula, Hidalgo, durante las VI, VII y VIII temporadas 1946–1950," INAH *Anales* 8, 1956: 37–116. D. Charnay first noted the resemblances between Tula and Chichen Itza: *Ancient Cities of the New World* (Harper), 1888. See also B. de la Fuente, S.Trejo and N. Gutiérrez Solana, *Escultura en Piedra de Tula* (UNAM), 1988. New books on the Chichen Itza problem include V. Tiesler, A. Cucina, T. Stanton, and D. Freidel, *Before Kukulkan* (Univ. Arizona), 2017, and *Landscapes of the Itza* (Univ. Florida), eds L. Wren, C. Kristan-Graham, T. Nygard, and K. Spencer, 2017. R. García Moll and R. Cobos, *Chichén Itzá, Patrimonio de la Humanidad* (Grupo Azabache), 2009, is magnificently illustrated and argued. For Toltecs in Michoacan: A. Oliveros, *Tzintzuntzan, Capital del reino purépecha* (Fondo de Cultura Económica), 2011.

The final Carnegie project was carried out at Mayapan: H. E. D. Pollock, T. Proskouriakoff, and E. Shook, *Mayapán*, CIW Pub. 619, 1962. For Tulum, see S. K. Lothrop, *Tulum: An Archaeological Study of the East Coast of Yucatán*, CIW Pub. 335, 1924; also, particularly for copies of the murals there: A. Miller, *On the Edge of the Sea: Mural Painting at Tancah-Tulum, Quintana Roo, Mexico* (Dumbarton Oaks), 1982. T. Gann visited Santa Rita and published the murals there: "Mounds in Northern Honduras," BAEB, 19th Annual Report, 1900. A. L. Smith,

Archaeological Reconnaissance in Central Guatemala, CIW Pub. 608, 1955, presents Postclassic architecture of the Guatemalan highlands.

On Maya pre- and post-Conquest books: J. E. S. Thompson, *The Dresden Codex* (American Philosophical Society), 1972; M. Coe, S. Houston, M. Miller, and K. Taube published a definitive edition of the Grolier Codex in 2016: *The Fourth Maya Codex*, *Maya Archaeology 3* (Mesoweb Press).

Chapter 9. The Aztecs: A new world found

Major exhibitions of Aztec materials in London (2003; 2009), New York (2004), and elsewhere refocused modern attention on their art. See particularly *Aztecs* (Royal Academy), ed. E. Matos M. and F. Solís O., 2003; *The Aztec Empire* (Guggenheim), ed. F. Solís O., 2004; and C. McEwan and L. Lopez Luján, eds, *Moctezuma: Aztec Ruler* (British Museum Press), 2009.

Other books to consider include E. Pasztory, *Aztec Art* (Univ. Oklahoma), 2000; R. Townsend, *The Aztecs* (Thames & Hudson), 3rd edition, 2010; E. Boone, *The Aztec World* (Smithsonian), 1994. R. Townsend's "State and Cosmos in the Art of Tenochtitlan," *Dumbarton Oaks Studies in Pre-Columbian Art and Archaeology* no. 20, 1979, is a fine examination of a few major sculptures. See also H. B. Nicholson and E. Q. Keber, *Art of Aztec Mexico: Treasures of Tenochtitlan* (National Gallery, Washington), 1983.

M. Miller and K. Villela have recently assembled every major study of the most famous Aztec monument, *The Aztec Calendar Stone* (Getty), 2010. J. Fernandez treated a key Aztec sculpture's reception through the mid-twentieth century, *Coatlícue, estética del arte indígena antigua* (UNAM), 1954. For precious metals, see Pillsbury, Potts, and Richter, above. Mixtec goldwork is discussed by A. Caso, *El Tesoro de Monte Albán* (INAH), 1969. For featherwork, see T. Castelló Yturbide, *El Arte Plumaria en México* (Banamex), 1993. Many aspects of Aztec life are documented in B. de Sahagún, *Florentine Codex* (see Chapter 1); see also M. Leon-Portilla, *Aztec Thought and Culture* (Univ. Oklahoma), 1963. For music, see R. Stevenson, *Music in Aztec and Inca Territory* (Univ. California), 1968. On excavations at the Templo Mayor: J. Broda, D. Carrasco, and E. Matos Moctezuma, *The Great Temple of Tenochtitlan: Center and Periphery in*

the Aztec World (Univ. California), 1987; E. Boone, ed., *The Aztec Templo Mayor* (Dumbarton Oaks), 1987. The latest work, including the excavation of the Tlaltecuhtli, is being conducted by L. Lopez Luján, *Offerings of the Templo Mayor of Tenochtitlan* (Univ. New Mexico), revised edition 2005; E. Matos Moctezuma and L. Lopez Luján, "La diosa Tlaltecuhtli de la casa de Ajaracas y el rey Ahuitzotl," AM 14(83), 2007: 23–29. D. Carrasco's *City of Sacrifice* (Beacon), 2000, is an influential summary.

The manuscripts mentioned in this chapter are all available in facsimile editions and increasingly available online. *Codex Selden*, commentary by A. Caso, glosses by M. E. Smith (Sociedad Mexicana de Antropologia), 1964; Codex *Féjerváry-Mayer* (Akademische Druck u. Verlagsanstalt), 1971; *Codex Borgia*, commentary by Eduard Seler (Fondo de Cultura Económica), 1963; S. Milbrath, *Heaven and Earth in Ancient Mexico: Astronomy and Seasonal Cycles in the Codex Borgia* (Univ. Texas), 2013; E. Boone, *The Codex Magliabechiano* (Univ. California), 1983; F. Berdan and P. Anawalt, eds, *The Codex Mendoza* (Univ. California), 1992; Serge Gruzinski, Painting the Conquest (UNESCO), 1992; *Codex Borbonicus*, Graz (Akademische Druck u. Verlagsanstalt), 1974; *Matrícula de Tributos*, Graz, 1980. The Postconquest manuscripts are described by D. Robertson, *Mexican Manuscript Painting of the Early Colonial Period: The Metropolitan Schools* (Yale), 1959; and also E. Boone, *Stories in Red and Black* (Univ. Texas), 2000 and *Cycles of Time and Meaning in the Mexican Books of Fate* (Univ. Texas), 2007.

The most readable history of the Aztecs is N. Davies, *The Aztecs* (Macmillan, 1973, and Univ. Oklahoma, 1980); he follows fairly closely the information from Father D. Durán's *Historia de las Indias de Nueva España*. For the Conquest of Mexico, see B. Díaz del Castillo (see Chapter 1) and Hernando Cortés, *Letters from Mexico* (Yale), trans./ed. A. R. Pagden, 1986. I. Clendinnen's *Aztecs: An Interpretation* (Cambridge), 1991, provides an engaging social history; S. Gruzinski, *The Conquest of Mexico* (Polity/Blackwell), 1993, offers the freshest take on the Mesoamerican mind since T. Todorov, *The Conquest of Mexico* (Harper), 1981, first raised the possibility of entering it.

F. Columbus wrote his father's biography, and reported the great canoes of the Maya in *The Life of the Admiral Christopher Columbus by his Son*

Ferdinand (Rutgers), trans./ed. B. Keen, 1959. J. de Grijalva collected exotic objects from the Maya, as recorded in *The Discovery of New Spain in 1518* (Cortés Society), trans./ed. H. R. Wagner, 1942.

Early Postconquest life and art are examined in R. Ricard, *The Spiritual Conquest of Mexico* (Univ. California), 1966; C. Reyes, *Arte Indocristiano* (INAH), 1981; M. Toussaint, *Colonial Art of Mexico* (Univ. Texas), rev. and trans. E. Wilder Weismann, 1967; G. Kubler, *Sixteenth-Century Architecture of Mexico* (Yale), 1948; J. McAndrew, *The Open-Air Churches of Sixteenth-Century Mexico: Atrios, Posas, Open Chapels, and Other Studies* (Harvard), 1965; S. Gruzinski, *Conquest of Mexico: The Incorporation of Indian Societies into the Western World, 16th–18th Centuries* (Blackwell), 1993; and J. Schwaller, *Sahagún at 500: Essays on the Quincentenary of the Birth of Fr. Bernardino de Sahagún* (Academy of American Franciscans), 2003. *Reframing the Renaissance: Visual Culture in Europe and Latin America 1450–1650* (Yale), ed. C. Farago, 1995, posed many questions; some have been answered in B. Mundy, *The Mapping of New Spain* (Univ. Chicago), 2000; E. Wake, *Framing the Sacred* (Univ. Oklahoma), 2010; and B. Mundy, *The Death of Aztec Tenochtitlan, the Life of Mexico City* (Univ. Texas), 2015, in what is a fast emerging field of study.

Illustration credits

1 The Metropolitan Museum of Art, New York. The Michael C. Rockefeller Memorial Collection, Bequest of Nelson A. Rockefeller, 1979 (1979.206.953); 2 Drawing Philip Winton; 3 Yale University Art Gallery, New Haven. Stephen Carlton Clark, B.A. 1903, Fund (1989.96.1); 4 Courtesy of the Division of Anthropology, American Museum of Natural History (H/3225); 5 Peabody Museum Expedition, 1907–1910. © President and Fellows of Harvard College, Peabody Museum of Archaeology and Ethnology (PM# 10-17-20/C7678, 10-71-20/C7670.1-2); 6 Museum für Völkerkunde, Vienna/Bridgeman Images; 7 Brooklyn Museum, New York; 8, 9 © The Trustees of the British Museum, London; 10 From Frederick Catherwood, *Views of Ancient Monuments in Central America, Chiapas, and Yucatan*, 1844 (London); 11 The John Carter Brown Library, Brown University, Rhode Island; 12 Courtesy of the Division of Anthropology, American Museum of Natural History (30/7552); 13, 14 Instituto Nacional de Antropología e Historia, Mexico City, Mexico City; 15 Photo Jorge Pérez de Lara; 16 Photo Ann Cyphers; 17 Drawing Felipe Dávalos, from Michael D. Coe and Richard A. Diehl, *In the Land of the Olmec*, 1980 (The University of Texas Press); 18 Jean-Pierre Courau/Gamma-Rapho/Getty Images; 19 Museo de Antropología de Xalapa, Veracruz; 20 Instituto Nacional de Antropología e Historia, Mexico City; 21 David Hilbert/Alamy; 22 Photo Ann Cyphers; 23 Yuri Cortez/AFP/Getty Images; 24 From M. D. Coe, 1984; 25 Alexander Sanchez/Alamy; 26 age fotostock/Alamy; 27 Werner Forman Archive/REX/Shutterstock; 28 Brian Overcast/Alamy; 29 Smithsonian Institution, Washington, D.C.; 30, 31 G. Dagli Orti/DeAgostini/Diomedia; 32, 33, 34 Instituto Nacional de Antropología e Historia, Mexico City; 35 Kenneth Garrett/Danita Dellmont/Diomedia; 36, 37 Drawing Andrew Turner; 38 Photo David C. Grove; 39 Courtesy New World Archaeological Foundation, Provo. Drawing Ayax Moreno, courtesy John Clarke; 40 Instituto Nacional de Antropología e Historia, Mexico City; 41 Photo Dr. Antonio Rafael de la Cova; 42 Drawing Linda Schele; 43 Photo Jorge Pérez de Lara; 44 From Christopher Beekman and Robert B. Pickering, *Shaft Tombs and Figures in West Mexican Society: A Reassessment*, 2016. Gilcrease Museum, Tulsa, Oklahoma. Photo Erik Campos; 45 Yale University Art Gallery, New Haven. Stephen Carlton Clark, B.A. 1903, Fund (1973.88.28.b); 46 Yale University Art Gallery, New Haven. Stephen Carlton Clark, B.A. 1903, Fund (1973.88.28.a); 47 Artokoloro Quint Lox Limited/Alamy; 48 Yale University Art Gallery, New Haven. Katharine Ordway Collection (1980.13.13); 49 Photo © Thames & Hudson Ltd; 50 Nick Bonetti/Eye Ubiquitous/Diomedia; 51 Drawing P. Gallagher; 52 Photo © Thames & Hudson Ltd; 53 Cleveland Museum of Art, Ohio/Bridgeman Images; 54 Photo Scala, Florence; 55 Photo Dr. Antonio Rafael de la Cova; 56 Drawing Richard D. Hansen, UCLA RAINPEG Project; 57 William Saturno; 58 Travelpix/Alamy; 59 Gianni Dagli Orti/REX/Shutterstock; 60 Photo Mary Ellen Miller; 61 Photo Studio Michel Zabé; 62 Diego Lezama/Lonely Planet Images/Getty Images; 63 Biblioteca Medicea Laurenziana, Florence; 64 Drawing © Thames & Hudson Ltd; 65 Drawing Stephen D. Houston; 66 Drawing George Stuart; 67 Drawing I. Graham, 1977; 68 Photo Studio Michel Zabé; 69 Division of Anthropology, American Museum of Natural History, New York; 70 Proyecto Tlalocan/Instituto Nacional de Antropología e Historia, Mexico City; 71 Instituto Nacional de Antropología e Historia, Mexico City; 72 Georg Gerster/Panos Pictures; 73 After G. Kubler; 74 After Marquina; 75 Stephen Lloyd/Alamy; 76 Nick Saunders/Werner Forman Archive/Diomedia; 77 Felix Lipov/Alamy; 78 Orbon Alija/E+/Getty Images; 79 Gianni Dagli Orti/REX/Shutterstock; 80 After L. Séjourné; 81 Photo Saburo Sugiyama; 82, 83 Instituto Nacional de Antropología e Historia, Mexico City; 84 Granger Historical Picture Archive/Alamy; 85 Gianni Dagli Orti/REX/Shutterstock; 86 Photo Studio Michel Zabé; 87l Natural History Museum of Los Angeles County; 87c, r Los Angeles County Museum of Art; 88 Photo Jorge Pérez de Lara; 89 Richard Maschmeyer/Design Pics/Diomedia; 90 Photo Studio Michel Zabé; 91 Instituto Nacional de Antropología e

fotostock/Alamy; 208 Christie's Images, London/ Scala, Florence; 209 G. Dagli Orti/DeAgostini/ Getty Images; 210, 211 Brooklyn Museum, New York. Frank Sherman Benson Fund and the Henry L. Batterman Fund (37.2897PA); 212 wildfires/Alamy; 213 imageBROKER/Alamy; 214 Paul Almasy/Corbis/VCG/Getty Images; 215 Instituto Nacional de Antropología e Historia, Mexico City; 216 Photo Mary Ellen Miller; 217 INTERFOTO/Alamy; 218 Yale University Art Gallery, New Haven. Gift of Mr. and Mrs. Fred Olsen (1958.14.55); 219 After Morley and Brainerd; 220 Stefan Kiefer/imageBROKER/REX/ Shutterstock; 221 C. Sappa/DeAgostini/Diomedia; 222 Richard MaschmeyerRobert Harding/REX/ Shutterstock; 223 American Museum of Natural History, New York; 224 Photo Mary Ellen Miller; 225 Nelly Boyd/Robert Harding/Diomedia; 226 Photo Mary Ellen Miller; 227 Gianni Dagli Orti/ REX/Shutterstock; 228 Ann Axtell Morris, The Carnegie Institution of Washington; 229 Drawing Tatiana Proskouriakoff; 230 Fedor Selivanov/ Alamy; 231 After copy by M. A. Fernández 1939-40, Instituto Nacional de Antropología e Historia, Mexico City; 232 Sächsische Landesbibliothek, Dresden; 233 Philip Baird/www.anthroarcheart. org; 234 Firestone Library, Princeton University, New Jersey; 235 World History Archive/Alamy; 236 Brooklyn Museum, New York. Modernism Benefit Fund (87.182); 237 Bodleian Library, Oxford; 238 Newberry Library, Chicago/Bridgeman Images; 239 Carlos Tischler/REX/Shutterstock; 240 Oronoz/ Album/akg-images; 241 Photo Great Temple Project; 242 John Mitchell/Alamy; 243 Photo Studio Michel Zabé; 244 Drawing Philip Winton; 245 Gianni Dagli Orti/REX/Shutterstock; 246 Instituto Nacional de Antropología e Historia, Mexico City; 247 Gianni Dagli Orti/REX/ Shutterstock; 248 Peter Essick/Aurora Photos/ Diomedia; 249 G. Dagli Orti/DeAgostini/ Diomedia; 250 © The Trustees of the British Museum, London; 251 Witold Skrypczak/Alamy; 252 Museo Nacional de Antropología, Mexico City; 253 Museum für Völkerkunde, Basel; 254 Photo Studio Michel Zabé; 255 Gianni Dagli Orti/REX/ Shutterstock; 256 DeAgostini/Diomedia; 257 Photo Great Temple Project; 258 Photo Irmgard Groth-Kimball © Thames & Hudson Ltd; 259 Eileen Tweedy/REX/Shutterstock; 260 Henry Romero/Reuters; 261 Art Collection 2/Alamy; 262 Facsimile published by Archivo General de la Nación, Mexico City; 263 Erich Lessing/ akg-images; 264 Dorothy Alexander/Alamy; 265 Photo Studio Michel Zabé; 266 A. Gregorio/ DeAgostini/Getty Images; 267 British Museum,

London/Werner Forman Archive/Diomedia; 268 Bodleian Library, Oxford; 269 ART Collection/ Alamy; 270 Charles Walker Collection/Alamy; 271 Gilles Mermet/akg-images; 272 Instituto Nacional de Antropología e Historia, Mexico City; 273 API/ Gamma-Rapho/Getty Images; 274 Biblioteca Nacional de España, Madrid; 275 Bibliothèque nationale de France, Paris

Index